THE INSTITUTION OF
PHILOSOPHY

THE INSTITUTION OF PHILOSOPHY

A DISCIPLINE IN CRISIS?

EDITED BY

AVNER COHEN

AND

MARCELO DASCAL

OPEN ✹ COURT

LA SALLE, ILLINOIS

Library of Congress Cataloging-in-Publication Data

The Institution of philosophy : a discipline in crisis? / edited by Avner Cohen and Marcelo Dascal.

 p. cm.
Includes bibliographies and index.
ISBN 0-8126-9093-1. — ISBN 0-8126-9094-X (pbk.)
1. Philosophy, Modern—20th century. I. Cohen, Avner, 1951-
II. Dascal, Marcelo.
B804.I54 1989
101—dc20 89-34581
 CIP

ACKNOWLEDGMENTS

First and foremost, we wish to thank all the contributors to this volume, for their patience and cooperation throughout the long process of bringing this book to fruition.

Lindsay Waters was with us at the very inception of this book, and we thank him for his ideas and suggestions. Richard Koffler provided useful editorial advice. Carlin Romano generously suggested stylistic changes in our introductions (the remaining flaws are, of course, our fault). The American Philosophical Association graciously granted us permission to print here a revised version of A. J. Mandt's essay, originally published in *Proceedings and Addresses of the APA* (vol. 60[2], November 1986).

At different stages, two institutions provided essential logistic support for the completion of this book: in 1985-1986, the Netherlands Institute for Advanced Studies (NIAS), where M.D. was a fellow, and in 1987-1988, the Center for Science and International Affairs (CSIA), of the Kennedy School of Government, Harvard University, where A.C. has been a fellow. We are grateful for their assistance.

A.C. AND M.D.
TEL AVIV
OCTOBER 1988

TABLE OF CONTENTS

NOTES ON THE CONTRIBUTORS

Hector-Neri Castañeda is the Mahlon Powell Professor of Philosophy of Indiana University. His research has ranged from moral philosophy and action theory (*The Structure of Morality* and *Thinking and Doing*) to the theory of knowledge, philosophy of language, philosophy of mind, and metaphysics (*Thinking, Language and Experience* and *Sprache und Erfahrung*), through meta-philosophy (*On Philosophical Method*). He has developed his views further in James E. Tomberlin, ed., *Agent, Language and the Structure of the World: Essays Presented to Hector-Neri Castañeda with His Replies*, in James E. Tomberlin, ed., *Hector-Neri Castañeda*, and in Klaus Jacobi and Helmut Pape, eds., *Die Struktur und der Weld, Castañeda's Epistemische Ontologie, Darstellung und Kritik*. He is the founding editor of *Noûs*.

Avner Cohen is Lecturer in Philosophy at Tel Aviv University, and has been a fellow at the Center for Science and International Affairs, Harvard University (1987–1988). He is co-editor of *Nuclear Weapons and the Future of Humanity*, and has written on skepticism, postmodernism, and nuclear proliferation.

Marcelo Dascal is Associate Professor of Philosophy at Tel Aviv University. He is the author of *La Sémiologie de Leibniz, Pragmatics and the Philosophy of Mind*, and *Leibniz: Language, Signs and Thought*; editor of *Dialogue—An Interdisciplinary Approach, The Just and the Unjust* (Hebrew); and co-editor of *Knowledge and Politics* and of the forthcoming *Handbuch der Sprachphilosophie*. He is the editor of the international journal of philosophy *Manuscrito*.

Nancy Fraser teaches philosophy and comparative literature and theory at Northwestern University. In 1987–88 she was a fellow at the Bunting Institute, Radcliffe College. She is the author of *Unruly Practices: Power, Discourse, and Gender in Contemporary Political Thought*.

A. J. Mandt is Associate Professor of Philosophy at The Wichita State University. He has written on Fichte, Kant, Mill, creativity, and silence.

Joseph Margolis is Professor of Philosophy at Temple University. He is the author of many books, including *The Language of Art and Art Criticism, Psychotherapy and Morality, Negativities: The Limits of Life, Persons and Minds, Philosophy of Psychology, Culture and Cultural Entities*. His three-volume opus *The Persistence of Reality* has been published since 1986.

Linda Nicholson is Associate Professor at the Women's Studies Program of the State University of New York, Albany. She has written extensively on feminism and related topics. She is the author of *Gender and History: The Limits of Social Theory in the Age of the Family*.

Mark Okrent is Associate Professor of Philosophy at Bates College. He has written about the relations between analytic and continental philoso-

phy, philosophy of mind, and philosophy of social science. He is the author of *Heidegger's Pragmatism: Understanding, Being, and the Critique of Metaphysics.*

Hilary Putnam is Walter Beverly Pearson Professor of Modern Mathematics and Mathematical Logic at Harvard University. He is the author of *Meaning and the Moral Sciences, Reason, Truth, and History, The Many Faces of Realism* and *Representation and Reality.* Three volumes of his *Philosophical Papers* have so far been published by Cambridge University Press.

Harry Redner is Senior Lecturer in Politics at Monash University, Australia and has been Fullbright Fellow at Yale, Berkeley, and Boulder (1987-1988). He is the author of *In the Beginning was the Deed, Anatomy of the World, The Ends of Philosophy,* and *The Ends of Science.*

Carlin Romano, literary critic of *The Philadelphia Inquirer*, is a visiting scholar in the Columbia University Philosophy Department and a Fellow at Columbia University's Gannett Center for Media Studies.

Amelie Oksenberg Rorty is Matina Horner Distinguished Visiting Professor at Radcliffe College, and Professor at Mount Holyoke College. She is the author of *Mind in Action.* She has recently co-edited *Perspectives on Self-Deception* and *Essays on Aristotle's De Anima.*

Richard Rorty is University Professor of Humanities at the University of Virginia. He is the author of *Philosophy and the Mirror of Nature, Consequences of Pragmatism,* and *Contingency, Irony, and Solidarity.*

David M. Rosenthal is Professor of Philosophy at the City University of New York, Graduate School and Lehman College. He has written on philosophy of mind, philosophy of language, and Descartes. He is currently at work on a book about consciousness.

PREFACE

Not to care for philosophy is to be a true philosopher.

—Blaise Pascal

To live without philosophizing is to have one's eyes closed without ever trying to open them.

—René Descartes

Ostensively, this book is about "the institution of philosophy". Yet, this phrase is not as clear and unambiguous, nor as biased as it might seem to be. For different philosophers have different ideas about what that institution consists of, where it is to be found, or whether it makes sense at all to talk about philosophy as an "institution".

Indeed, the philosophical community today is marked by the absence of agreement about its own purpose and identity. Any way one tries to approach the issue of what philosophy is or should be, one immediately stumbles upon fundamental disagreements. Suppose, for example, we were to begin this preface with a truism like the following: "Discussing the 'institution of philosophy' is one way of doing 'metaphilosophy', for it requires taking philosophy as an object of analysis, and talking about it." This description could be immediately countered by the claim that to posit a clearcut distinction between an 'object-level' and a 'meta-level' is in itself a basic (and therefore unwarranted) assumption of *one* style of philosophizing. But surely—its proponent would respond—this distinction is independent of one's philosophical position, since it is a merely *formal* one. It goes along with other indispensable philosophical distinctions such as conceptual versus empirical, external versus internal, and necessary versus contingent. Applied to our case, this means that one can distinguish between those ways of talking about philosophy that count as 'metaphilosophical' and those that do not. The latter would include all kinds of external (for example, psycho-socio-cultural) investigations of the nature of philosophical skills.

Reply: this reliance upon the external/internal distinction is no more than an unwarranted appeal to one's philosophical intuitions about what

is 'fundamental' or 'essential' to philosophy. It thus begs the question. In the same vein, the reply might also point out that the apparently noncontroversial (and philosophically innocuous) 'external' investigations described above are themselves based on problematic presuppositions. After all, what makes skills or texts 'philosophical'? Ostensively, the former are those skills displayed by 'acknowledged philosophers' and the latter are pieces of discourse produced by 'acknowledged philosophers'. We are back then to our starting point: Who should be acknowledged as a philosopher? What counts as a genuine philosophical activity? What counts as a product of such an activity?

It is as a response to such questions that an appeal to an institutional definition seems useful. Philosophers are individuals employed by philosophy departments at reputable higher learning institutions, who read (and eventually publish in) prestigious philosophical journals, participate in philosophical conventions, and so forth. Similarly, a philosophical text is a piece of discourse produced *qua* exercise of one of the institutionally acknowledged forms of philosophizing, or else a piece not so produced but recognized as of philosophical value by philosophers.

Would this much constitute a basis for a consensus? Probably not. The problem is not just the variability of such institutional criteria (e.g., how does one establish the prestige of a journal or the 'seriousness' of a professional meeting?). Rather, the difficulty has to do with the legitimacy of the notion of philosophy as an 'institution'. For those who reject an essentialist conception of philosophy there is no difficulty here. But for essentialists this may be a heresy: institutionally-defined philosophers are not necessarily *true* philosophers. Though academic philosophy certainly has institutional features, these features are contingent for the very *idea* of philosophy. In itself, philosophy is *not* a social institution, the way the institution of, say, the American presidency is. Philosophy is not like any other human invention, something which comes into being at one time and may pass away at another. If anything, philosophy is the ever-present product of Self-Reflective Thought. For its opponents, however, this view itself is nothing but a cultural creation, often called Platonism, born in a certain context. They contend that the history of philosophy must be viewed as taking place within the history of culture at large. Such a cultural perspective may eventually lead to the acknowledgment that, whereas philosophy had a role to play in one historical environment, it may no longer have a role in another. Can a disagreement as deep as this one be settled?

To refer to the institutional practices in order to solve disputes and settle disagreements is useful only as long as there is a relatively broad *consensus* about the field. But what happens when such a consensus is

shattered? What happens when the profession and its institutions are challenged, i.e., when dissidents question the accepted standards on all fronts? Clearly, under such circumstances, the appeal to these standards does indeed beg the question.

In fact, the disagreement may even affect the perception of the situation as a "crisis". The camp that stresses continuity would describe the situation quite differently from the camp that emphasizes discontinuity. For the former, what is happening at present in philosophy is merely one more metamorphosis *within* the tradition, a change that shows, incidentally, how healthy that tradition is. For the latter, what is happening is nothing less than a massive *breaking away* from that tradition, paving the way for an entirely new and radically different condition.

Paradoxically, it turns out that it is precisely in a situation of profound disagreement at all levels that talk about the institution of philosophy is bound to become truly metaphilosophical. On such occasions, one cannot forego the need to discuss the *nature* of philosophy itself. For it is not just the consensual basis of the institutional framework that cannot be taken for granted any more. The possibility of doing philosophy without reflecting or caring about what it is—as urged by Pascal—also seems to vanish. The very fact that the worth of philosophizing is questioned mandates that to open our eyes—as Descartes insists—is to look into the very nature of what we are doing *qua* philosophers. In times such as the present one, it seems that philosophy cannot be anything but self-reflective and self-searching; its self-questioning cannot be other than truly metaphilosophical.

Despite their deep divergences, the two camps are not so wide apart. For one thing, they share to some extent an institutional approach. For the defenders of the natural kind conception of philosophy certainly rely on the continuity of the genre 'philosophy' in the Western tradition, i.e., on an institutional definition of their trade. The difference is that, unlike their opponents, they refuse to consider the radical historicity of their trade, which entails the possibility that it may come to a historically-, rather than intrinsically-determined, end. For another, the postmodern critics have no monopoly on the longing to bring philosophy to its end. The phantom of being the 'last philosopher', the one who performs the final move to end all philosophical moves, has deep roots in the history of philosophy. To announce the ultimate philosophical truth means also to declare all future philosophies unnecessary. The grand system builders are, in this respect, not as distant from the grand system destroyers. For the former, closing philosophy means bringing it to its final completion. Philosophy is ended, so to speak, because there is nothing left for it to discover. Once such a stage is reached, philosophy will no longer have a

history. For the latter, to bring philosophy to its end means to dissolve it, showing the superfluousness of the philosophical enterprise. The irony is that, in the long run, it is the recurrence of the desire to stop the wheels of the history of philosophy that actually pulls these wheels from one historical stage to the next.

A high degree of historical awareness is one of the symptoms of a disciplinary crisis. Whenever a given social group, or field of activity, or institution, is in turmoil, its members look back at their shared past. This is understandable, since a group's perception of its legacy is a primary vehicle for shaping the group's identity. The more so when the *raison d'être* of the group is called into question by some of its members. It is no accident, therefore, that philosophers' interest in the history of philosophy is as strong now as ever before. After hermeneutics, it is a commonplace to say that every historical account reflects the circumstances of its own time. Recent attempts to rewrite the history of philosophy, or to reconsider the principles of philosophical historiography do not escape this rule. They tell perhaps more about the concerns and trends of the present than about the past.

In referring to the institutional dimension, we intend to render the debate concrete in yet another sense. For it is the actual individual attitudes of practicing philosophers that are at issue. As a practitioner, each of us has to face the question of self-definition in his or her daily activities, from grading papers, through writing recommendations, to curriculum and recruitment decisions. It is this sense of personal involvement that led the two of us to initiate this project. Though we disagree about the proper description, assessment, and prognosis of the current situation in philosophy, our experience has been that an appearance of incommensurability does not preclude fruitful dialogue. Above and beyond our particular disagreements, we share the belief that rethinking philosophy is an urgent task today. It is in this task that all the contributors to this volume are engaged here, whether pessimistic or optimistic about philosophy's future.

Self-questioning is the leitmotif in an era that has been so prone to talk about the-end-of-. . . and to proclaim the advent of post-. . ., for almost anything. In philosophy, the turning point is marked by the collapse of the paradigms of philosophizing that dominated the scene in most of this century, e.g., phenomenology, Marxism, logical positivism and its analytic heirs. While in continental Europe the discomfort with these forms of philosophical modernism has been in the air since the end of World War II, in Anglo-American philosophy such a phenomenon is more recent. Analytic philosophy proved to be resistant to such trends, for both internal and circumstantial reasons. Internally, analytic philosophy saw

itself as a revolt against the traditional ways of philosophizing and offered an alternative, canonical, route. The circumstance of the expansion of American higher education after World War II brought about the rise of a fairly homogeneous community of philosophers, professionally defined by their skill in applying the analytic paradigm. Against this background, the intensity of the aftershocks provoked by the critique of that paradigm—especially when such a critique came from its own quarters, as in the case of Rorty—is hardly surprising.

Whether we call it Philosophy or philosophy, what is important for both the philosophical community and the culture at large is to reach a new understanding of what that community is supposed to contribute to culture. We believe that all the chapters confront this problematic. The tripartite division of the book is intended simply to suggest differences in focus, ranging from personal readings of the current situation in philosophy, through analyses of the 'crisis', to concrete proposals for future forms of philosophizing.

We have tried to include here a broad spectrum of positions. Our focus is, admittedly, philosophy in North America, where the impact of the self-questioning of philosophy has been most recent and intense. Even so, a collection such as this cannot pretend to be representative of the wide variety of opinion in the philosophical community about the controversial topics it brings to the fore. Nor can it pretend to offer a solution to the problems it raises. The best it can hope for is to clarify the issues and thus to contribute to a continuing and crucial debate—whose outcome remains to be seen.

PART I

PHILOSOPHY: SELF-IDENTITY QUESTIONED

By all indications, Western philosophy is now experiencing another self-questioning phase in its history. From various postmodernist quarters, we hear that the philosophical enterprise may have come to the end of its career, that philosophy may have exhausted itself. Whether this implies a crisis or not, the philosophical profession nowadays surely is in the grip of a self-searching mood. Philosophy is now in pursuit of a new identity. The four chapters in this part can be read as four statements, by experienced philosophers, about the present and future identity (or identities) of philosophy.

Richard Rorty contrasts three views of philosophizing that evolved in our century: the 'scientistic' (Husserlian/positivistic), the 'poetic' (Heideggerian), and the 'political' (pragmatist). The last two are depicted by him as reactions to the former, whose foundationalist/objectivist/contemplative attitude they are said to reject. While in his previous critical work Rorty was mainly concerned with debunking that attitude by using a mixture of Heideggerian and Deweyan themes, in this contribution he explores the differences between these two approaches. To underline these differences, he focuses on the role of metaphor and its political implications for metaphilosophy.

Rorty begins by recalling the distrust, shared by both Heidegger and Dewey, toward the dominant, foundationalist visual metaphors, so central for the philosophical longing for a God's-eye view. He goes on to argue that pragmatists and Heideggerians pursue this anti-foundationalist track along different paths. Heidegger is known to have placed much emphasis on the role of *live* metaphor as the only genuine expression of Being, and hence as the only authentic form of expression fit for philosophy. But, despite his insistence on its significance and his extensive use of metaphor it can hardly be said that Heidegger had a *theory* of metaphor. To articulate such a theory—one that rejects both the cognitivist and the emotivist reduction of metaphor to a second-rate linguistic phenomenon—Rorty adopts the key elements of Davidson's account. On this view, metaphor is considered, along with perception and inference, as one of the sources of new beliefs; metaphor is another way to revise the whole fabric of our beliefs and desires, rather than as merely *another way* of saying things. Metaphorical sentences are, in fact, the forerunners of new uses of language; *by the same token* they shape new beliefs.

Whereas Davidson stresses the positive, yet mundane, process whereby metaphors expand 'logical space' through their 'literalization', Heidegger views this process as a loss of the metaphors' creative insight and original expressive power. Accordingly, he downgrades the painstaking work of exploring the new paths opened up by the great metaphors of what he calls the "Thinkers". The 'poetic' conception of philosophy "is not to facilitate but only to make more difficult, not to reweave our fabric of beliefs and desires, but only to remind us of its historical contingency".

Here lies what Rorty takes to be a crucial difference between the pragmatists and the Heideggerians: the former, contrary to the latter, "think that such exploration is the pay-off from the philosopher's work".

Rorty traces such a metaphilosophical difference to a deeper difference in political attitude. Whereas "Heidegger thinks of the social world as existing for the sake of the poet and the thinker, the pragmatist thinks of it the other way round . . . : the point of individual human greatness is its contribution to social freedom". The pragmatist, thus, views his task as inherently social in its orientation. A thinker must "serve the community" in its endless reweaving of its web of belief. For the pragmatist, "the proper honor to pay to new, vibrantly alive, metaphors, is to help them become dead metaphors as quickly as possible, to rapidly reduce them to the status of tools of social progress". Since the pragmatist rejects—like the Heideggerian—scienticism, this task cannot be interpreted as providing a better 'systematization' or 'grounding' for the community's Weltanschauung. On the contrary, it implies a truly open-ended, highly flexible, picture of society, "one in which every human potentiality is given free rein", i.e., one in which "every new metaphor will have its chance for self-sacrifice". It is a task deeply intertwined with a Deweyan conception of the role of democracy in social life. Though less confident and hopeful than Dewey, Rorty shares his belief in democracy. The philosopher, for him, cannot be indifferent to the democracy-versus-totalitarianism issue.

Applying this analysis to the question of the present and future of philosophy, Rorty stresses the need to de-philosophize the "conversation of mankind" as much as possible. Some philosophical items (such as the supra-sensory world, ideas, God, the moral law, the authority of Reason) are "dead metaphors which pragmatists can no longer find uses for", while others (such as progress, the happiness of the greatest number, culture, civilization) "still have a point", but need no special argument or standpoint. Yet Rorty does not foresee that such de-philosophizing will dominate the scene. He rather predicts that the analytic/non-analytic divide will continue to prevail in the philosophical profession. In fact he discerns not one institution of philosophy but two. Analytic philosophy, though aware of its inability to achieve its grandiose ambitions, will continue to pursue them. As to non-analytic professionals, they are bound to pursue somehow their de-philosophizing efforts. Rorty takes notice of internal opposition in each camp, but does not believe that this is enough to allow for any real contact or dialogue between them. In the non-analytic camp, a major divide exists: pragmatists want to see their activity as continuous with politics (specifically, with the defense of democracy), whereas Heideggerians, dominated more by despair than by political hope, prefer to view themselves as contributing, at best, to literature. In

both cases, however, philosophy dissolves itself in the web of culture at large. There is a tension in Rorty's present text between his theoretical anarchism—the absolutely radical and total freedom he assigns to the use of language—and his actual political position—a conservative, liberal-democratic view of political action. Unfortunately, Rorty does not elaborate here upon the interconnections of these contrasting positions. One might think that he believes that the latter, by restraining social change so as to prevent totalitarianism, is necessary in order to preserve the former. But—one could ask—can the former exist at all, can *every* new metaphor be given a real chance, if it is not given the chance of becoming political action?

In contrast to Rorty's pessimistic assessment of the philosophical profession, Hector-Neri Castañeda presents a rather optimistic picture of the current state of philosophy. According to him, "philosophy is blooming": it "has never before been in as great a shape as it is today. All topics are available; all its applications are legitimate; all methods are feasible; all interdisciplinary connections are accessible". Not surprisingly, he denies the existence of a real crisis of identity. The only crisis he sees is due to the overwhelming wealth of choice: "a professional crisis in terms of what philosophical career to choose, or even a personal crisis in terms of finding a place for oneself in the midst of the encompassing waves of new developments". Castañeda's optimism goes as far as seeing "a healthy rapprochement between analytic philosophy and continental philosophy", where Rorty discerns a persistent divide. What Rorty sees as fragmentation, Castañeda diagnoses as constructive proliferation. What for the former is a welcome mark of the hoped-for dissolution of "the Philosophical", is seen by the latter as a step toward the genuine pluralism required for the accomplishment of the task of Philosophy.

Castañeda advocates both an "unlimited topical freedom" and a "boundless methodological freedom", which are in line with his conception of the "perennial grounds of philosophical activity" as aiming at a greater understanding of all aspects of reality. Castañeda's metaphilosophical pluralism is unabashedly motivated by metaphysics. Whereas Rorty wants to dismiss the metaphysical as a misguided by-product of cultural contingencies, Castañeda insists on the necessity, and hence the legitimacy, of metaphysics. Indeed, for him, it is the fact that "the [same] world is capable of being different in different contexts or perspectives" that necessitates philosophical pluralism as the only possible framework for achieving an understanding of the world. Furthermore, for Castañeda, the most general problems of philosophy (mind, language, reality, practical thinking) are truly *foundational* problems. Philosophers must deal

with them, as well as with the more difficult problems of *applied philosophy*, in a cooperative spirit that reflects the underlying unity of their enterprise and of the world. This unity can only be revealed through a plurality of contexts and perspectives because it is the unity of a complex, multilevel, hierarchically structured, universe of experience.

So, Castañeda appears to have a substantive, not merely sociological, answer to the question of what constitutes "the Philosophical": the overall and perennial goal of philosophizing is, broadly speaking, "the systematic pursuit of an increased understanding of human nature and the world in which it is deployed". Such a broad characterization of philosophy is very close, except for its vocabulary, to the one Rorty inherited from Sellars, namely: "an attempt to see how things, in the broadest possible sense of the term, hang together, in the broadest possible sense".[1] This brings to light a further difference between Rorty and Castañeda. Whereas Rorty interprets Sellars's description in strictly historicist terms and takes it to imply the abandonment of any attempt to provide a Grand Narrative (to use Lyotard's phrase), Castañeda remains loyal to the foundationalist project. For him, historical contingencies are grounded in a deeper metaphysical order; hence, a plurality of perspectives does not imply Nietzschean perspectivism, but rather, in a Leibnizian spirit, cumulatively and jointly reveal that order.

Is this a satisfactory answer to the question of what constitutes "the Philosophical" as opposed to the non-Philosophical? Castañeda is prepared to admit that philosophy is ubiquitous. But, unlike Rorty, who draws from this the moral that there is no need for any *special* professional field or discipline (*Fach*) to be called 'Philosophy', Castañeda claims that philosophy *does* have a "special role". For him, there are specific "philosophical experiences", which, "unlike ordinary ones, . . . are transactions with structural aspects present in other types of experience". It is not quite clear precisely what those experiences are, aside from the generality of their scope. Nor is it clear why one should consider the philosophical profession as one 'Master Team' having a common task. To be sure, some further hints about the nature of the philosophical endeavor, in Castañeda's view, can be gleaned from his examples and from the way he uses expressions such as "human nature", "experience", and "rich data" in characterizing philosophy. But such expressions—we should recall—are paradigmatic cases in Rorty's blacklist of dead and fruitless metaphors.

Castañeda distinguishes between two complementary ways of doing philosophy, which he calls the "Forest" and the "Bush" approach. Both are essential for bringing to full fruition the philosophical experience. The Forest Approach aims at seeing the "very general structural lines of the world we experience", while the Bush Approach focuses "upon small as-

pects of experience". Castañeda believes that the development, by means of both the Bush and Forest approaches, of "*all* the possible most comprehensive master theories of world and experience will produce a harmonious unison . . . representing the totality of philosophical wisdom". One cannot but sense the role of a metaphysical invisible hand ensuring such an optimistic outcome.

Unlike Castañeda, Hilary Putnam's reading of the current scene in philosophy highlights the dangers it poses for the future. He sees the dominant trends in both analytic and continental philosophy as having evolved into intellectual fashions, insensitive to their self-contradictory consequences. Putnam describes his own recent work as an attempt to stop these fashions "because they begin to threaten the possibility of a philosophical enterprise".

Behind the obvious stylistic and thematic differences between logical positivism and the relativistic tendencies of French philosophy, Putnam discerns a deep affinity: both operate within a "reductive post-Darwinian picture of the world" where representation (or, in general, intentionality) cannot fit. As opposed to this, he suggests that such a picture, and its consequent definition of the problem, should be modified. On the one hand, by taking into account history and other contextual factors, a measure of relativism and fallibilism should be added to all claims to knowledge and truth. On the other, this should not be taken to entail wholesale relativism or subjectivism, in the sense of an elimination of any notion of 'correctness'. That is to say, the proper reaction to the self-destructive fashions that came to dominate philosophy lies in some form of realism.

But in the postmodern era, there is no longer room for a revival of the seventeenth-century version of representational realism, which viewed "concepts as entities immediately available to the mind . . . and capable of fixing reference to the world". Putnam's 'internal realism' rejects these assumptions, based on his well-known arguments about the 'linguistic division of labor' and the contribution of the non-mental environment to the determination of reference. Giving up the metaphysical realist's mysterious relation of correspondence as a warrant of truth and reference, the internal realist admits that "reference is internal to 'texts' (or theories)". Yet, he does not thereby become a Protagorean relativist, because he insists that there are "better and worse 'texts'", though not in an absolute, ahistorical, God's-eye-view sense. Acknowledging the role of historical context and purpose does not imply that "rightness" becomes subjective, nor undistinguishable from actual justification. The indispensable normative element in the concept of rightness (or truth) is, for Putnam, purged of its subjectivism by its being viewed as connected to *ideal* justification, rather than to justification-on-present-evidence.

Putnam admits his inability to provide a "metaphysical story" that would convincingly underpin internal realism as an account of the possibility of reference, truth, warrant, and value. But he contends that, no matter how deeply entrenched and honorable, the urge to "have a totalistic explanation" led to a philosophical project which failed because "it goes beyond the bonds of any notion of explanation that we have". This implies, as for Rorty, abandoning the grand projects of metaphysics and epistemology. Were he to say that such projects should be abandoned for good, Putnam could be blamed for being, after all, a relativist of sorts— and an inconsistent one. What he asks, instead, is only a *moratorium* on Ontology and Epistemology.

What is then left for philosophers to do, if anything, once they follow Putnam's advice? Putnam offers no clear answer to this question. On the one hand, he still believes that "philosophers inherit a field" and "philosophy should go on", though he recommends that "each philosopher ought to leave it problematical what is left for philosophy to do". On the other hand, Putnam does not tell us how philosophers should cultivate their field, apart from going on in their practice of constructing distinctions, and following arguments, once metaphysics and epistemology are disqualified. It seems that Putnam cannot but resort to an *institutional* definition of philosophy (epitomized by such expressions as 'philosophical training' and 'inherited field'). Any genuinely substantive characterization of philosophy's identity would ultimately involve him, like Castañeda, in metaphysical and epistemological assumptions.

Putnam's only substantive recommendation is a return to the *Lebenswelt*, to the world of common sense and common human beings. This should lead us back to a healthy concern with the judgments of reasonableness and truth that we constantly make in our daily lives. At this level, both the skeptical suspicions that lead to relativism, and the urge to know that leads to metaphysical and epistemological *pronunciamientos* have no room. Yet, the weight of the philosophical tradition to which he remains loyal does not allow him to adopt Rorty's call for the dissolution of philosophy within the rest of our cultural endeavors. Unlike Rorty, Putnam preserves a strong sense of the *debts* and *obligations* (e.g., "to preserve some notion of rightness") inherited from Philosophy's past. As the metaphor of a moratorium ably suggests, he feels that we philosophers, though momentarily insolvent, should not lose sight of our long-term (perhaps perennial) responsibilities, no matter how immersed in common concerns and practices we are—for the time being—required to be. We cannot simply walk away from philosophy, even when Ontology and Epistemology are no longer there.

A. J. Mandt closely examines philosophy as now practiced in North

America, through the prism of the recent challenges (notably by the Committee for Pluralism) to the 'analytical establishment' over the leadership of the American Philosophical Association (APA). Though this struggle could be seen as nothing but a power struggle between competing factions—the kind of internal politics commonly found in any organization—Mandt shows that significant philosophical insight can be gained from its closer examination. In a way, *both* parties have tended to describe the conflict in political terms. For the 'pluralists' the formation of the Committee signifies a genuine rebellion against a tight block of powerful 'insiders', whom they have long perceived as a monolithic and rigid ideological establishment. From their point of view, the politicization of the APA was the only means available to express their sense of grievance against the illegitimate and oppressive professional oligarchy. For the analytic leadership, to politicize the profession was clearly an anti-philosophical (hence unfair) move—a way of making "political connection rather than philosophical merit the basis of preferment". Viewed in this way, Mandt points out, the argument over the politicization of the profession seems to turn on "whether a natural aristocracy of talent is being usurped by unprincipled factionalism, on the one hand, or a self-perpetuating oligarchy is being overturned and replaced by some sort of democratic polity on the other."

But, for Mandt, this politicized way of reading the conflict obscures the underlying metaphilosophical disagreement. For the real issue is "the legitimacy of the currently employed criteria of philosophical evaluation". In essence, the pluralists' complaint is that "analytic philosophy is being passed off *without justification* as philosophy itself" (our italics), and hence the analytic establishment rules by "imposing criteria of merit derived from this ideology on philosophers of different persuasions". The response of the establishment to this charge was to deny that there is a collective entity properly called 'analytic philosophy', recognizable as an ideologically coherent group. Their point, of course, was that there is nothing philosophically or ideologically significant in the existence of such an establishment. No doubt they were right in pointing out that the practitioners of philosophical analysis diverge enormously on any single topic. But can they infer from this fact that "it is all just philosophy"?

At this level of the dispute, a genuine gap of perceptions about the nature of analytic philosophy shows up: "pluralists describe the external form of 'analysis' as a closed, exclusive system. Analytic philosophers defend it from an internal perception of its formless confusion of voices. To each the other's perception seems so skewed as to be attributed to bad faith". Yet, as Mandt points out, both perceptions are correct to an extent: "analysis is both hegemonic and incoherent". To resolve this impasse,

Mandt suggests we regard mainstream contemporary philosophy—analysis—as a 'community of discourse', not as an 'ideological system' (as the pluralists insisted, and the analysts denied). Such a community is bound together by factors such as personal associations, shared experience, style of discourse, a common history, teachers, journals, and the like. Standards of philosophical excellence reflect the norms regulating the discursive practice of the community. Furthermore, analytic philosophy is not a single community of discourse, but rather a "web of smaller sub-communities, largely autonomous, partly overlapping and partly discontinuous with each other". A significant part of Mandt's analysis consists in reconstructing the social processes whereby local norms of one sub-community are adopted by neighboring ones, and eventually evolve to become the norms of the community at large.

On the basis of this account, it becomes possible to explain the seemingly incompatible perceptions of philosophical analysis. Furthermore, it becomes understandable why for insiders the accepted norms appear authoritative, obvious, and rational, whereas for outsiders they seem arbitrary and conventional. It is this unavoidable sense of circularity that made mutual charges of bad faith almost inevitable in the debate between the 'pluralists' and the 'establishment'. The merit of the pluralist critique has been to call attention to the fact that judgments of what counts as 'good philosophy' are ultimately conventional. Nevertheless, according to Mandt, the pluralist critique "errs when it implies that no standards of philosophical excellence exist. The standards exist, but they tend to be only local in scope."

The philosophical lesson Mandt draws from this anthropological/sociological analysis is twofold. First, "philosophy is grounded in its own practice". Second, and it follows from the first, "community practice is intrinsic, not extrinsic to the nature of philosophy". The irony is, it seems, that it is precisely the sociological and political facts of the institution of philosophy that demonstrate, once again, the utter poverty of philosophical relativism. As for the future of the profession, Mandt appears much more cautious than Castañeda, Rorty, and Putnam: "There are no general rules or principles of custom that govern . . . these processes of conventionalization. The direction of philosophical discourse, the waxing and waning of its sub-communities, is unpredictable".

Curiously enough, all the contributors to Part I, despite their widely divergent views, agree that the current situation of the profession is philosophically significant. For Castañeda, it both illustrates and makes possible the kind of proliferation and complementation of approaches and topics his pluralistic metaphilosophy strives for. For Rorty, it signifies a

welcome fragmentation of discourses, at best connectable in 'conversation', thus announcing the immersion of philosophy in culture at large, which he considers mandatory. For Putnam, the situation requires both a firm stand against wholesale self-destructive intellectual fashions, yet without a commitment to the grand agenda of the past. For Mandt, the very same situation is seen as the overthrow of a philosophical 'establishment' which assumed without justification the existence of universal standards of merit in philosophizing, thus paving the way for a realist—rather than utopian—pluralism, while at the same time avoiding the pitfalls of relativism.

The notion of a self-identity crisis is, of course, a psychological metaphor. In the lifetime of an individual, three identity-crises are usually discerned. The adolescent faces a bewildering multiplicity of possibilities, many—if not all—of which he or she would like to embrace as his or her 'identity'. The aging person has the leisure to look at her or his past life, trying to gather some worthwhile unifying principle in what he or she has done so far. And the now much talked-about middle-age crisis is a brief pause in life, where new possibilities open up, some requiring a radical departure from the past, others more minor re-orientations. We are tempted to see Castañeda's optimism, expressed in his wish to have more time to follow up all the new paths now open for philosophizing, as representing present-day philosophy in its adolescent phase. Rorty's pessimism, tinged by a sort of lassitude, with its recurrent appeal to the metaphor of the death or end of philosophy, represents the profession as in the grip of the aging crisis. Mandt's politically self-conscious realistic attitude, neither enthusiastically optimistic nor disenchantedly pessimistic, would seem to represent the discipline as undergoing a process of mature self-examination. Putnam's position might be said to involve elements of all three crises: philosophy cannot simply overthrow its adolescent choice of identity, nor is it ready to die away; it has a family, a house, a field to keep. But, like today's developing countries, only by temporarily removing the burden of past debts can it find a way to keep going.

NOTE

1. R. Rorty, *Consequences of Pragmatism* (Minneapolis: University of Minnesota Press, 1982), xiv.

1

Richard Rorty

PHILOSOPHY AS SCIENCE, AS METAPHOR, AND AS POLITICS

I. INTRODUCTION

Three answers have been given, in our century, to the question of how we should conceive of our relation to the Western philosophical tradition, answers which are paralleled by three conceptions of the aim of philosophizing. They are the Husserlian (or 'scientistic') answer, the Heideggerian (or 'poetic') answer and the pragmatist (or 'political') answer. The first answer is the most familiar, and was common to Husserl and his positivist opponents. On this view, philosophy is modeled on science, and is relatively remote from both art and politics.

The Heideggerian and pragmatist answers are reactions to this familiar 'scientistic' answer. Heidegger turns away from the scientist to the poet. The philosophical thinker is the only figure who is on the same level as the poet. The achievements of the great thinkers have as little to do with either mathematical physics or statecraft as do those of the great poets. By contrast, pragmatists such as Dewey turn away from the theoretical scientists to the engineers and the social workers—the people who are trying to make people more comfortable and secure, and to use science and philosophy as tools for that purpose. The Heideggerian thinks that the philosophical tradition needs to be reappropriated by being seen as a series of poetic achievements: the work of Thinkers, people who "have no choice but to find words for what a being *is* in the history of its Being."[1] The pragmatist thinks that the tradition needs to be utilized, as one utilizes a bag of tools. Some of these tools, these 'conceptual instruments'—including some which continue to have undeserved prestige—will turn out no longer to have a use, and can just be tossed out. Others can be refurbished. Sometimes new tools may have to be invented on the spot. Whereas the Heideggerian sees Husserl's "faith in the possibility of philosophy as a

task, that is, in the possibility of universal knowledge"[2] as a scientistic, mathematizing, misunderstanding of the greatness of the tradition, the pragmatist thinks of it as sentimental nostalgia, an attempt to keep old slogans and strategies alive after they have outlived their practical utility.[3]

Husserl thought the suggestion that we drop the ideal of universal, ahistorical, foundational philosophical knowledge, a suggestion common to pragmatism and to Nietzsche, was the final stage of a disastrous "change which set in at the turn of the past century in the general evaluation of the sciences."[4] On his view, "the total world-view of modern men, in the second half of the nineteenth century, let itself be determined by the positive sciences and be blinded by the 'prosperity' they produced" and this in turn produced "an indifferent turning-away from the questions which are decisive for a genuine humanity."[5]

Husserl thought of traditional rationalism and of empiricist skepticism as two sides of the same 'objectivist' coin.[6] He tried to place both within the framework of his own transcendental phenomenology. Heidegger agreed with Husserl about the relative unimportance of the empiricist-rationalist distinction, and also about the dangers of a technologized, pragmatic, culture. But Heidegger thought of pragmatism and transcendental phenomenology as merely two further products of the 'objectivist' tradition. He tried to place both pragmatism's abjuration of 'spirit' and Husserl's attempt to reclaim it within his own account of 'Western metaphysics'. He agreed with Husserl that

> an autonomous philosopher with the will to liberate himself from all prejudices . . . must have the insight that all the things he takes for granted *are* prejudices, that all prejudices are obscurities arising out of a sedimentation of the tradition . . . and that this is true even of the great task and idea which is called 'philosophy'.[7]

But Heidegger thought that neither Husserl nor the pragmatists were radical enough in their criticism of their predecessors' self-understanding. He distrusted the pragmatist attempt to replace the Platonic-Cartesian idea of "universal knowledge" with the Baconian dream of maximal control over nature. But he also distrusted Husserl's attempt to see Galilean *techne* as 'founded' in something 'transcendental'. For Heidegger, projects of 'founding' culture—either upon concrete human needs or upon transcendental subjectivity—were simply further expressions of the 'prejudices' which needed to be overcome.

Although Heidegger's assessment of our century's dangers was closer to Husserl's, his actual philosophical doctrines were closer to Dewey's. Like Husserl, Heidegger thought that "the European crisis has its roots in a misguided rationalism."[8] But he thought that a demand for foundations was itself a symptom of this misguided rationalism. *Sein und Zeit* is filled

with criticisms of the doctrines which Husserl shared with Descartes. The treatment in that book of 'objective scientific knowledge' as a secondary, derivative, form of Being-in-the-World, derivative from the use of tools, is of a piece with Dewey's Baconianism.[9] Heidegger's dissolution of philosophical pseudo-problems through letting social practice be taken as a primary and unquestioned datum, rather than an explanandum, exemplifies what Robert Brandom has called "the ontological primacy of the social."[10]

Another way in which Heidegger and pragmatism belong together is in their deep distrust of the visual metaphors which link Husserl to Plato and Descartes. Husserl and Carnap shared the traditional Platonic hope to ascend to a point of view from which the interconnections between everything could be seen. For both, the aim of philosophy is to develop a formal scheme within which every facet of culture can be placed. Both are philosophers of what Hilary Putnam has called "the God's-eye view". Heidegger's term for such attempts at a God-like grasp of the realm of possibility, attempts to have a pigeonhole ready for every actual event which might occur, is 'the mathematical'. He defines *ta mathemata* as "that 'about' things which we really already know."[11] The search for the mathematical, for a formal ahistorical scheme, was, in Heidegger's view, the hidden link between Husserlian phenomenology, Carnapian positivism, and the objectivist tradition.

Dewey's insistence on the subordination of theory to practice, and his claim that the task of philosophy is to break the crust of convention, expresses the same distrust of the contemplative ideal, and of attempts to have an a priori place prepared for everything that may happen. But Heidegger's and Dewey's conceptions of philosophy were nevertheless very different. Their common opposition to foundationalism and to visual metaphors took radically different forms. In what follows I want to discuss these differences under two headings: their different treatments of the relationship between the metaphorical and the literal, and their different attitudes towards the relation between philosophy and politics. By turning from Dewey to a philosopher whose work seems to me to be the best current statement of a pragmatist position—Donald Davidson—I hope to be able to bring out the relevance of a theory of metaphor to the critique of foundationalism. By focusing on Heidegger's assimilation of philosophy to poetry, I hope to bring out the difference between what I have called the 'political' and the 'poetic' answers to the question of our relationship to the philosophical tradition.

II. Metaphor as the Growing Point of Language

Let me open up the topic of metaphor by making a curt, dogmatic, claim: there are three ways in which a new belief can be added to our previous beliefs, thereby forcing us to reweave the fabric of our beliefs and desires—viz., perception, inference and metaphor. Perception changes our beliefs by intruding a new belief into the network of previous beliefs. For example, if I open a door and see a friend doing something shocking, I shall have to eliminate certain old beliefs about him, and rethink my desires in regard to him. Inference changes our beliefs by making us see that our previous beliefs commit us to a belief we had not previously held—thereby forcing us to decide whether to alter those previous beliefs, or instead to explore the consequences of the new one. For example, if I realize, through a complicated detective-story train of reasoning, that my present beliefs entail the conclusion that my friend is a murderer, I shall have to either find some way to revise those beliefs, or else rethink my friendship.

Both perception and inference leave our language, our way of dividing up the realm of possibility, unchanged. They alter the truth-values of sentences, but not our repertoire of sentences. To assume that perceptions and inference are the *only* ways in which beliefs ought to be changed is to adopt what Heidegger identified as the 'mathematical' attitude. It is to assume that the language we presently speak is, as it were, all the language there is, all the language we shall ever need. Such a conception of language accords with the idea that the point of philosophy is what Husserl took it to be: to map out all possible logical space, to make explicit our implicit grasp of the realm of possibility. It supports the claim, common to Husserlian phenomenology and to analytic philosophy, that philosophizing consists in clarification, in patiently making explicit what has remained implicit.

By contrast, to think of metaphor as a third source of beliefs, and thus a third motive for reweaving our networks of beliefs and desires, is to think of language, logical space, and the realm of possibility, as open-ended. It is to abandon the idea that the aim of thought is the attainment of a God's-eye view. The philosophical tradition downgraded metaphor because recognizing metaphor as a third source of truth would have endangered the conception of philosophy as a process culminating in vision, *theoria*, contemplation of what is *vorhanden*. Such visual metaphors contrast with the auditory metaphors which Heidegger preferred (e.g., *Ruf des Gewissens, Stimme des Seins*). The latter are better metaphors for metaphor, because they suggest that cognition is not always recognition, that the acquisition of truth is not always a matter of fitting data into a pre-

established scheme. A metaphor is, so to speak, a voice from outside logical space, rather than an empirical filling-up of a portion of that space, or a logical-philosophical clarification of the structure of that space. It is a call to change one's language and one's life, rather than a proposal about how to systematize them.

Such a view of metaphor requires that we follow Davidson in rejecting the claim that "a metaphor has, in addition to its literal sense or meaning, another sense or meaning".[12] Davidson's point is that it is misleading to interpret the expression 'the metaphorical use of language' as implying that lots of 'metaphorical meanings', in addition to lots of 'literal meanings', are already *vorhanden* in our language. On such a view, metaphor cannot expand logical space, for to learn the language is already to have learned all the possibilities for metaphor as well as all the possibilities for fact. A language is not changed by the invention of metaphor, since metaphorical speech is not invention but simply utilization of tools already at hand. By contrast, Davidson's view is that there is a strict distinction between meaning (the property which one attributes to words by noting standard inferential connections between the sentences in which they are used and other sentences) and use, and that "metaphor belongs exclusively to the domain of use".[13]

Davidson says that "most metaphors are false" but it would be better to say that most metaphors take the form of sentences which seem, *prima facie*, obviously false. Later on, however, these same sentences may come to be thought of as literally true. To take a trivial case, mentioned by Davidson, "Once upon a time . . . rivers and bottles did not, as they do now, literally have mouths".[14] To take a more important case, the first time someone said 'Love is the only law' or 'The earth moves around the sun' the general response would have been 'You must be speaking metaphorically'. But, a hundred or a thousand years later, these sentences become candidates for literal truth. Our beliefs were, in the interval, rewoven to make room for these truths—a process which was indistinguishable from the process of changing the meanings of the words used in these sentences in such a way as to make the sentences literally true.

Notice that the claim I have just made—that large-scale change of belief is indistinguishable from large-scale change of the meanings of one's words—follows from the definition of 'meaning' which I inserted parenthetically above. This definition of meaning encapsulates the Quine-Davidson approach to philosophy of language. This approach makes meanings neither Platonic essences nor Husserlian noemata but rather patterns of habitual use—what Sellars calls 'linguistic roles'. It thereby makes the Carnapian quest for 'analysis' of meanings seem a misleadingly 'formal' and 'transcendental' way of describing the project of charting the

behavior of a group of language-users. *Mutatis mutandis*, it does the same for the Husserlian project of 'grounding' culture through an inspection of noemata. More generally, it undermines any scientistic philosophical project, any project which depends upon the ahistorical version of what Davidson calls 'the dualism of scheme and content'. This version is the claim that philosophy can make explicit a scheme, a permanent neutral matrix of possibilities, which lies in the background of all our inquiries and practices.

I have argued elsewhere that Davidson's attack on this distinction is the best current expression of the pragmatist attempt to break with the philosophical tradition.[15] Here I want to present this attack as paralleling Heidegger's attack on the tradition's attempt to 'mathematize' the world (in the specifically Heideggerian sense of 'mathematical' mentioned above.) To think of metaphorical sentences as the forerunners of new uses of language, uses which may eclipse and erase old uses, is to think of metaphor as on a par with perception and inference, rather than thinking of it as having a merely 'heuristic' or 'ornamental' function.[16] More specifically, it is to think of truth as something which is *not* already within us. Rather, it is something which may only become available to us thanks to an idiosyncratic genius. Such a conception of truth legitimizes auditory metaphors: a voice from far off, a *Ruf des Gewissens*, a word spoken out of the darkness.

Another way of putting this point is to say, with Davidson, that "the irrational" is essential to intellectual progress. In a paper on Freud, Davidson notes that "mental causes which are not reasons"—that is, beliefs and desires which play a role in determining our behavior but which do not fit into the scheme of beliefs and desires which we would claim as ours—are needed not only to explain "deviant" behavior (as Freudian psychoanalytic theory employs them) but also to "explain our salutary efforts, and occasional successes, at self-criticism and self-improvement".[17]

Davidson's insistence in that paper on the importance of "mental causality that transcends reason" is focused on self-criticism and self-improvement in individual human beings, but I think his point is even more striking and plausible for the self-criticism of cultures. The "irrational" intrusions of beliefs which "make no sense" (i.e., cannot be justified by exhibiting their coherence with the rest of what we believe) are just those events which intellectual historians look back upon as 'conceptual revolutions'. Or, more precisely, they are the events which spark conceptual revolutions—seemingly crazy suggestions by people who were without honor in their countries, suggestions which strike *us* as luminous truths, truths which must always have been latent in 'human reason'. These events are

the words spoken by the people Heidegger calls "Thinkers". From a point of view common to Heidegger and Davidson, the philosophical tradition is a long sequence of attempts to exhibit intellectual history as exhibiting a 'hidden rationality', as achieved by *die List der Vernunft*, where 'Vernunft' names something that has been there all the time, rather than simply some recently literalized metaphors.

Heidegger is concerned to deny that there is a topic of ahistorical inquiry called 'human reason' or 'the structure of rationality' or 'the nature of language' which has been the object of philosophical inquiry in all ages. Even in the '20s, before the 'Kehre', Heidegger was contradicting Husserl's criticism of historicism[18] by saying such things as

> Construction in philosophy is necessarily destruction, that is to say, a de-constructing (Abbau) of traditional concepts carried out in a historical recursion to the tradition... Because destruction belongs to construction, philosophical cognition is essentially at the same time, in a certain sense, historical cognition.[19]

In the '40s he was to conclude that in *Sein und Zeit* he had not yet been historicist enough to accomplish this destruction. Referring to that early book he says "This destruction, like 'phenomenology' and all hermeneutical-transcendental questions, has not yet been thought in terms of the history of Being."[20] Heidegger identified 'human reason', 'rationality', and 'sound common sense', as these terms are used by philosophers, with the unselfconscious, *uneigentlich*, unquestioning, use of an inherited language. Philosophy is not simply the utilization of that tradition—not simply the distribution of truth-values over a range of sentences which are already "present" in the language—because "all essential philosophical questioning is necessarily untimely... Philosophy is essentially untimely because it is one of those few things that can never find an immediate echo in the present."[21]

We may identify what finds no echo in the present with the sort of metaphor which is prima facie a pointless falsehood, but which nevertheless turns out to be what Heidegger calls "a word of Being", one in which "the call of Being" is heard. Consider, in the light of this identification, two pregnant sentences in which Heidegger describes "the task of philosophy":

> ...the ultimate business of philosophy is to preserve the *force of the most elemental words* in which Dasein expresses itself, and to keep the common understanding from leveling them off to that unintelligibility which functions in the end as a source of pseudo-problems.[22]

> It is the authentic function of philosophy to challenge historical being-there (Dasein) and hence, in the last analysis, Being (Sein) pure and simple.[23]

These sentences express what I am calling Heidegger's 'poetic' answer to the question of our relation to the tradition. On his account the aim of philosophical thought is to free us from the language we presently use by reminding us that this language is not that of 'human reason' but is the creation of the thinkers of our historical past. These thinkers are the poets of Being, the transcribers of "Being's poem—man".[24] To remind us of these thinkers, and to permit us to feel the force of their metaphors in the days before these had been leveled down into literal truths, before these novel uses of words were changed into familiar meanings of words, is the *only* aim which philosophy can have at the present time—not to facilitate but only to make more difficult, not to reweave our fabric of belief and desires but only to remind us of its historical contingency. Heidegger thinks that our time cannot profit from redistributing truth-values among the sentences currently in our repertoire. But he holds out little hope of a new prophetic age, one in which new words will be spoken, words which will enlarge this repertoire in unexpected ways. The most he will say is that such hopes will not be fulfilled without the preparatory work of restoring force to "the most elementary words" in which Dasein has expressed itself in the past. Our relation to the tradition must be a rehearing of what can no longer be heard, rather than a speaking of what has not yet been spoken.

III. POETRY AND POLITICS

To see the difference between Heidegger's 'poetic' view of our relation to the tradition and the 'political' view which I wish to attribute to American pragmatism, consider the distinction between 'pseudo-problems' and 'real' problems which Heidegger shares with Carnap. On the pragmatist view, as on Carnap's, a pseudo-problem is one which there is no point in discussing because, as William James put it, it turns upon a difference which "*makes* no difference". It is a "merely verbal problem"—that is, one whose resolution would leave the rest of our beliefs unchanged. This is close to Heidegger's own meaning, as is shown by the fact that some of his examples of pseudo-problems ("other minds", "the external world") are the same as Carnap's.

But there is a crucial difference. Whereas Carnap and the pragmatists think of traditional philosophy as pseudo-science, Heidegger thinks of it as hackneyed poetry—poetry so banal as to be unconscious self-parody. That is, he thinks of the pseudo-problems of the philosophical tradition as pointless reenactments of cliché situations. His objection to them is not that, unlike the real (technologically-oriented) problems solved by scien-

tists, considering them will do us no practical good. Rather, it is that they debase a genre—the genre called 'philosophy'. He is complaining that this genre, which should be the one in which everything is made more difficult, has become an easy game, one which any fool can play. He despises the suggestion, found in scientistic philosophers like Husserl and Carnap, that philosophers might cooperate in the way that engineers do, that they should divide up the work that needs to be done into bite-sized chunks and assign one to each member of a team for 'linguistic analysis' or 'phenomenological description'.

The pragmatist would grant Heidegger's point that the great thinkers are the most idiosyncratic. They are the people like Hegel or Wittgenstein whose metaphors come out of nowhere, lightning bolts which blaze new trails. But whereas Heidegger thinks that the task of exploring these newly suggested paths of thought is banausic, something which can be left to hacks, the pragmatist thinks that such exploration is the pay-off from the philosopher's work. He thinks of the thinker as serving the community, and of his thinking as futile unless it is followed up by a reweaving of the community's web of belief. That reweaving will assimilate, by gradually literalizing, the new metaphors which the thinker has provided. The proper honor to pay to new, vibrantly alive, metaphors, is to help them become dead metaphors as quickly as possible, to rapidly reduce them to the status of tools of social progress. The glory of the philosopher's thought is not that it initially makes everything more difficult (though that is, of course, true), but that in the end it makes things easier for everybody.

Because the pragmatist rejects scienticism just as Heidegger does, he or she rejects the scientistic idea that some new metaphor, some new philosophical idea, might reveal the permanent neutral matrix of inquiry, a matrix which now simply needs to be filled in by systematic teamwork. The reweaving of the community's fabric of belief is not to be done systematically; it is not a research program, not a matter of filling in what Heidegger calls a *Grundriss*.[25] It is a matter of scratching where it itches, and only where it itches. But whereas Heidegger thinks of this scratching, this liberating of culture from obsolete vocabularies through the work of weaving new metaphors into our communal web of beliefs and desires, as a process of banalization, the pragmatist thinks of it as the only suitable tribute to render the great philosopher. Without this utilization of his work, the great philosopher would have no social role to play, no political function. The pragmatist and Heidegger can agree that the poet and the thinker (in Heidegger's special 'elitist' senses of these terms) are the unacknowledged legislators of the social world. But whereas Heidegger thinks of the social world as existing for the sake of the poet and the thinker, the pragmatist thinks of it the other way round. For Dewey as for Hegel, the

point of individual human greatness is its contribution to social freedom, where this is conceived of in the terms we inherit from the French Revolution.

So the crucial difference between the Heideggerian and the pragmatist attitude towards the philosophical tradition stems from a difference in attitude towards recent political history. The basic motive of pragmatism, like that of Hegelianism, was, I have argued elsewhere, a continuation of the Romantic reaction to the Enlightenment's sanctification of natural science.[26] Once scientistic rhetoric (which persists in both Hegel and Dewey, and obscures their more basic Romanticism) is cleared away, both Hegelianism and pragmatism can be seen as attempts to clear the ground for the kind of society which the French Revolution hoped to build: one in which every human potentiality is given free rein. In the terms I have been using in this paper, this aspiration amounts to the hope that every new metaphor will have its chance for self-sacrifice, a chance to become a dead metaphor by having been literalized into the language. More specifically, it is the hope that what Dewey calls "the crust of convention" will be as superficial as possible, that the social glue which holds society together—the language in which we state our shared beliefs and hopes—will be as flexible as possible.

One can only have such a hope if one thinks that, despite the fears of Husserl, Julien Benda, and contemporary communitarian critics of political liberalism, a democratic society can get along without the sort of reassurance provided by the thought that it has 'adequate philosophical foundations' or that it is 'grounded' in 'human reason'. On this view, the most appropriate foundation for a liberal democracy is a conviction by its citizens that things will go better for everybody if every new metaphor is given a hearing, if no belief or desire is held so sacred that a metaphor which endangers it is automatically rejected. Such a conviction amounts to the rejection of the claim that we, the democratic societies of the West, know what we want in advance—that we have more than a tentative and revisable *Grundriss* for our social projects. One task of the intellectuals in these societies will be to help their fellow-citizens live with the thought that we do not yet have an adequate language, and to wean them from the idea that there is something out there to be 'adequate' to. This amounts to suggesting that we try to eschew scientistic pronunciamentos which take for granted that we now have a secure grasp on the nature of the society, or of the good. It means admitting that the terms in which we state our communal convictions and hopes are doomed to obsolescence, that we shall *always* need new metaphors, new logical spaces, new jargons, that there will never be a final resting-place for thought, nor a social philosophy which is a *strenge Wissenschaft*.

It will be apparent that, in formulating the pragmatist view in this way, I am trying to turn such Heideggerian notions as 'clearing', 'opening', 'authenticity' and 'historical being-there' to un-Heideggerian purposes. I want to yoke them to political movements which Heidegger himself distrusted. For him, the political life of both the liberal democracies and the totalitarian states was of a piece with that 'technological frenzy' which seemed to him the essence of the modern age. The difference between the two did not really matter. By contrast, I want to suggest that we see the democracy-versus-totalitarianism issue as as basic as an intellectual issue can get. We need to eschew the idea, common to Heidegger and Adorno as well as to many contemporary *Marxisant* writers, that there is a phenomenon called 'modernity' which encompasses both bourgeois democracy and totalitarianism, and that one can achieve a philosophical grasp of this phenomenon in which the distinction between these two forms of social life is *aufgehoben*.

One way of putting this point is that although Heidegger was only accidentally a Nazi,[27] Dewey was essentially a social democrat. His thought has no point when detached from social democratic politics.[28] His pragmatism is an attempt to help achieve the greatest happiness of the greatest number by facilitating the replacement of language, customs, and institutions which impede that happiness. Heidegger dismissed this attempt as one which we can no longer take seriously. He thinks that Nietzsche helped us see that

> Metaphysics is history's open space, wherein it becomes a destining that the suprasensory world, the Ideas, God, the moral law, the authority of reason, progress, the happiness of the greatest number, culture, civilization, suffer the loss of their constructive force and become void.[29]

But for Dewey, "progress, the happiness of the greatest number, culture, civilization" do not belong on the same list as "the suprasensory world, the Ideas, God, the moral law, the authority of reason". The latter are dead metaphors which pragmatists can no longer find uses for. The former still have a point. The pragmatist does not claim to have an argument against the latter items and for the former items. He is not scientistic enough to think that there is some neutral philosophical standpoint which would supply premises for such an argument. He simply takes his stand within the democratic community and asks what an understanding of the thinkers of the past and of the present can do for such a community.

Heidegger thinks that a non-reductive, non-anachronistic, hearing of the words of these thinkers might put us in a position to appreciate where we now are (where, as Heidegger would say, Being now is). The pragmatist agrees, but reads them differently. He hears them as the young Hegel did—as urging us in the direction of greater human freedom, rather than

in the direction of technological frenzy, of an age in which "human creativity finally passes over into business enterprise."[30] He agrees with both Husserl and Heidegger (and with Horkheimer and Adorno) that the age of scientific technology *may* turn out to be the age in which openness and freedom are rationalized out of existence. But his reply is that it *might* turn out to be the age in which the democratic community becomes the master, rather than the servant, of scientific rationality.

IV. THE PRESENT SITUATION

In what precedes I have sketched what I take to be the central metaphilosophical disagreements of recent times. On my account, there are two basic lines of division: one between the scientism common to Husserl and positivism, and the other between two reactions to this scientism. The first reaction—Heidegger's—is dictated by a tacit and unarguable rejection of the project of the French Revolution, and of the idea that everything, including philosophy, is an instrument for the achievement of the greatest happiness of the greatest number. The second—Dewey's—is dictated by an equally tacit and unarguable acceptance of that project and that idea.

By way of a conclusion, I shall try to bring these distinctions to bear on the contemporary situation of the philosophical profession, of philosophy as an institution. One can look at this situation from the inside, and concentrate on the relations, within the profession, of competing philosophical schools. Or one can look at it from the outside, at the relations between the profession and the rest of culture.

Taking the inside view first, it is clear that there are really two institutions rather than one. Analytic philosophy has pretty well closed itself off from contact with non-analytic philosophy, and lives in its own world. The scientistic approach to philosophy which Husserl shared with Carnap lives on, forming a tacit presupposition of the work of analytic philosophers. Even though analytic philosophy now describes itself as post-positivistic, the idea that philosophy 'analyzes' or 'describes' some ahistorical formal 'structures'—an idea common to Husserl, Russell, Carnap, and Ryle—persists. However, there is little explicit metaphilosophical defense or development of this claim. Analytic philosophers are not much interested in either defining or defending the presuppositions of their work. Indeed, the gap between 'analytic' and 'non-analytic' philosophy nowadays coincides pretty closely with the division between philosophers who are not interested in historico-metaphilosophical reflections on their own activity and philosophers who are.

This difference in interests parallels a difference in reading habits, a difference in philosophical canons. If the preeminent figures in one's canon include Berkeley, Hume, Mill, and Frege, one will probably not be much interested in metaphilosophy. If they include Hegel, Nietzsche, and Heidegger, one probably will—not metaphilosophy in the form of methodology, the form it took in Husserl and in Russell, but rather in the form of an historical narrative which places the works of the philosophers within the historical development of the culture.

More analytic philosophers simply take for granted that such figures as Hume and Frege have isolated central, deep, problems—problems which are definatory of the discipline. They see no more need to construct or study historical narratives than students of physics do to study the history of physics. But some less complacent members of this school (e.g., Cora Diamond, Hilary Putnam, Thomas Nagel, Stanley Cavell) have a more ambivalent and nuanced relation to the analytic canon, and a less distant relation to historical narrative. Nagel, for example, suggests that the familiar textbook 'problems of philosophy'—the problems of which he himself proceeds to treat—are characteristic of 'the childhood of the intellect'. But he thinks that "a culture that tries to skip it [this stage of childhood] will never grow up."[31] He cautions against "deflationary metaphilosophical theories like positivism and pragmatism, which offer to raise us above the old battles."[32] On Nagel's view "Philosophy cannot take refuge in reduced ambitions. It is after eternal and nonlocal truth, even though we know that is not what we are going to get."[33]

On the 'non-analytic' side of the divide, by contrast, the realization that we are not going to get this sort of truth is a reason for dropping old ambitions. For the tacit presupposition which unites non-analytic philosophers—those philosophers who reject metaphilosophical scientism—is that Nagel is wrong when he says that

> . . . philosophy is not like a particular language. Its sources are preverbal and often precultural, and one of its most difficult tasks is to express unformed but intuitively felt problems in language without losing them.[34]

The mark of intellectual immaturity is, on this alternative account, precisely an ahistorical account of philosophy such as Nagel's, an account whose grip has only been broken in the last two hundred years. On the alternative account, philosophy is very much like a 'particular language' and the idea that a particular philosophical canon has isolated problems which are 'often precultural' is just the latest version of the empiricist 'Myth of the Given'. So these philosophers try to place the analysts' canon, and their list of problems, in history, rather than seeing both as in touch with something ahistorical, something natural to the species. The reason why Hegel, Nietzsche, and Heidegger loom so large in the alterna-

tive canon is that these philosophers specialize in narratives which 'place' rival canons.

There is little common ground between these two sets of metaphilosophical presuppositions, and therefore little possibility of debate between their proponents. The result is that the philosophical profession is divided into two institutionalized traditions which have little contact. Analytic philosophy, in so far as it takes notice of its rival, views it as an aestheticized and historicized form of idealism.[35] The 'continental' tradition, by contrast, views the 'analytic' tradition as escaping from history into a dogmatic and outworn realism, but it too takes little notice of the opposition.

Because neither side has much use for the notion that philosophy has a distinctive method, neither is about to offer large metaphilosophical self-descriptions of the sort in which Russell and Husserl indulged. Yet the crucial difference between them is, I think, still caught by the formula which I have used to catch the difference between Husserl on the one hand and Heidegger and Dewey on the other: they differ on the question of whether philosophy has a prelinguistic subject-matter, and thus on the question of whether there is an ahistorical reality to which a given philosophical vocabulary may or may not be adequate. The analytic tradition regards metaphor as a distraction from that reality, whereas the non-analytic tradition regards metaphor as the way of escaping from the illusion that there is such a reality. My hunch is that these traditions will persist side-by-side indefinitely. I cannot see any possibility of compromise, and I suspect that the most likely scenario is an increasing indifference of each school to the existence of the other. In time it may seem merely a quaint historical accident that both institutions bear the same name.[36]

What, then, of the place of the philosophical profession in the culture as a whole? For philosophers who think of themselves as quasi-scientists, this is not an important question. Analytic philosophy has little influence on other academic disciplines, and little interest either for practitioners of those disciplines or for the intellectuals. But analytic philosophers are not distressed by this fact. It is natural, given their scientistic metaphilosophy, that analytic philosophers are content to solve philosophical problems without worrying about the source of those problems or the consequences of their solution.[37]

By contrast, non-analytic philosophers typically dislike the thought that philosophy is (or is only) an academic discipline, merely one more *Wissenschaft*. They would like their work to be continuous either with literature on the one hand or with politics on the other, or both. Insofar as they succeed in making their work continuous with literature, they cease to belong to a separate institution: they are simply writers who happen to

be familiar with a certain literary tradition (a tradition that starts with Plato and runs up through Hegel to the present). Thus there is little point in drawing institutional lines between the study of Sartre's treatises, of his critical essays, and of his stories. There is equally little point in worrying whether Nietzsche counts as a figure in the history of German literature (as he used to, before Heidegger helped him to a place in the philosophical canon) or in the history of philosophy. Anybody interested in Derrida's treatment of Socrates in *La Carte Postale* is likely also to be interested in Valery's treatment of him in *Eupalinos* and Nietzsche's in *The Birth of Tragedy*, and is unlikely to know or care that only one among these three great writers earned his bread as a philosophy professor.

When it comes to attempts to make non-analytic philosophy continuous with politics, however, things become more complex and problematic. For non-analytic philosophy is, with some exceptions, dominated by a Heideggerian vision of the modern world rather than a Deweyan one, and by despair over the condition of the world rather than by social hope. Because the typical member of this tradition is obsessed with the idea of 'radical criticism', when he or she turns to politics it is rarely in a reformist, pragmatic, spirit, but rather in a mood either of deep pessimism or of revolutionary fury. Except for a few writers such as Habermas, 'continental' philosophers see no relation between social democratic politics and philosophizing.[38] So the only sort of politics with which this tradition is continuous is not the actual political discourse of the surviving democratic nations, but a kind of pseudo-politics reminiscent of Marxist study-groups of the thirties—a sort of continual self-correction of theory, with no conceivable relation to practice.[39]

As Deweyan social democrats, philosophers can be politically useful in the same way as can poets, playwrights, economists, and engineers. Members of these various professions can serve reformist social democratic politics by providing piecemeal nudges and cautions in respect to particular projects at particular times. But this sort of retail political utility is not the wholesale sort which Marxists, post-Marxist radicals, and neo-conservatives would like philosophers to have. They see political theory and philosophy as foundational because they see it as penetrating to a reality behind contemporary appearances. By contrast, the Deweyan sees the relevant 'reality'—human suffering and oppression—as already having been made clearly visible in the course of the last two centuries' attempt to realize the ideals of the French Revolution. The Deweyan is ruefully willing to admit that there are always going to be new varieties of suffering and oppression to be exposed (e.g. those endured by women as a class). He sees philosophy's role in exposing them as continuous with that of literature and of the social sciences. But he thinks contemporary democratic

societies are *already* organized around the need for continual exposure of suffering and injustice, and that no 'radical critique' is required, but just attention to detail. So he thinks of the philosopher not as exposing the false or corrupt foundations of this society but as playing off the good and the bad features of this society against each other.

To my mind, the persistence on the left of this notion of 'radical critique' is an unfortunate residue of the scientistic conception of philosophy. Neither the idea of penetrating to a reality behind the appearances, nor that of theoretical foundations for politics, coheres with the conception of language and inquiry which, I have been arguing, is common to Heidegger and to Dewey. For both ideas presuppose that someday we shall penetrate to the true, natural, ahistorical matrix of all possible language and knowledge. Marx, for all his insistence on the priority of praxis, clung to both ideas, and they became dominant within Marxism after Lenin and Stalin turned Marxism into a state religion. But there is no reason why either should be adopted by those who are not obliged to practice this religion.

The moral I wish to draw from the story I have been telling is that we should carry through on the rejection of metaphilosophical scientism. That is, we should let the debate between those who see contemporary democratic societies as hopeless, and those who see them as our only hope, be conducted in terms of the actual problems now being faced by those societies. If I am right in thinking that the difference between Heidegger's and Dewey's ways of rejecting scientism is political rather than methodological or metaphysical, then it would be well for us to debate political topics explicitly, rather than using Aesopian philosophical language.

If we did, then I think that we would realize how little theoretical reflection is likely to help us with our current problems. For once we have criticized all the self-deceptive sophistry, and exposed all the 'false consciousness', the result of our efforts is to find ourselves just where our grandfathers suspected we were: in the midst of a struggle for power between those who currently possess it (in our day: the oilmen of Texas or Quatar or Mexico, the *nomenklatura* of Moscow or Bucharest, the generals of Indonesia or Chile) and those who are starving or terrorized because they lack it. Neither twentieth-century Marxism, nor analytic philosophy, nor post-Nietzschean 'continental' philosophy has done anything to clarify this struggle. We have not developed any conceptual instruments with which to operate politically that are superior to those available at the turn of the century to Dewey or Weber.

The vocabulary of social democratic politics—the vocabulary which Dewey and Weber helped cobble together—probably does not require fur-

ther sophistication by philosophers (though economists and sociologists and historians have done some useful up-dating). There are no facts about economic oppression or class struggle, or modern technology, which that vocabulary cannot describe and a more 'radical' metaphoric can. The horrors peculiar to the end of our century—imminent nuclear holocaust, the permanent drug-riddled black underclass in the U.S., the impossibility of feeding countries like Haiti and Chad except by massive charity which the rich nations are too selfish to provide, the unbreakable grip of the rich or the military on the governments of most of the Third World, the unbreakable grip of the KGB on the Russian people and of the Soviet army on a third of Europe—are no better describable with the help of more recent philosophical vocabulary than with the vocabulary used by our grandfathers. Nobody has come up with any proposal for ending any of these horrors which draws on new conceptual resources. Our political imagination has not been enlarged by the philosophy of our century. This is not because of the irrelevance or cowardice or irresponsibility of philosophy professors, but because of the sheer recalcitrance of the situation into which the human race has stumbled.

Dewey was lucky. His generation may have been the last which could feel confident of a future in which the race would work out its destiny without needing the religious and scientistic myths which had comforted it in the past—a future in which human freedom was entrusted to as yet undreamt-of metaphors, vocabularies still unborn. As the century has darkened, we find it less and less possible to imagine getting out of our present trap and into such a future. But Dewey was also right. If we ever have the courage to drop the scientistic model of philosophy without falling back into a desire for holiness (as Heidegger did), then, no matter how dark the time, we shall no longer turn to the philosophers for rescue as our ancestors turned to the priests. We shall turn instead to the poets and the engineers, the people who produce startling new projects for achieving the greatest happiness of the greatest number.[40]

NOTES

1. . . . keine Wahl haben, die vielmehr zum Wort bringen müssen, was das Seiende je in der Geschichte seines Seins *ist*: Heidegger, *Nietzsche II* (Pfullingen: Neske, 1962), 37. Translated in Heidegger, *Nietzsche*, vol. IV, trans. F. A. Cappuzi (New York: Harper and Row, 1982), 7.

2. Husserl, *The Crisis of European Sciences and Transcendental Phenomenology*, trans. David Carr (Evanston: Northwestern University Press, 1970), 17.

3. My failure to discuss Marxism in what follows, and to use it, rather than American pragmatism, to represent the "political" conception of the activity of

philosophizing, is due to the conviction that Marxism is an inconsistent mixture of the pragmatism of the 'Theses on Feuerbach' with the scienticism common to Marxism and positivism. Kolakowski's history of Marxism shows, I think, how every attempt to make Marxism more pragmatic and less scientistic has been firmly suppressed by the institutions which Marxism has created.

4. Ibid., 5.

5. Ibid., 6.

6. See ibid., 83, on Descartes and Hobbes.

7. Ibid., 72.

8. Ibid., 290.

9. As Hubert Dreyfus and John Haugeland make clear, Husserl's reaction to this portion of *Sein und Zeit* was marked by an assumption that the *zuhanden* was as much grist for the phenomenological mill as the *vorhanden*, and specifically that a *Zeug* was "something identical, something identifiable again and again", and so something which would exhibit a universal essence. See Dreyfus and Haugeland, 'Husserl and Heidegger: Philosophy's Last Stand' in Michael Murray, ed., *Heidegger and Modern Philosophy* (New Haven: Yale University Press, 1978), 222–238 (especially the quotation from a fragmentary manuscript of Husserl's labeled "das ist gegen Heidegger" at p. 233).

10. Robert Brandom, 'Heidegger's Categories in *Being and Time*', *The Monist*, vol. 66 (1983), 389.

11. Heidegger, *What is a Thing?*, trans. Barton and Deutsch (South Bend: Gateway, 1967), 74.

12. Donald Davidson, *Inquiries into Truth and Interpretation* (Oxford: Clarendon Press, 1984), 246.

13. Ibid., 247. See also p. 259: "No theory of metaphorical meaning or metaphorical truth can help explain how metaphor works. Metaphor works on the same familiar linguistic tracks that the plainest sentences do . . . What distinguishes metaphor is not meaning but use—in this it is like assertion, hinting, lying, promising and criticizing."

14. Ibid., 252.

15. See 'Pragmatism, Davidson and Truth' in *Essays on "Inquiries into Meaning and Truth"*, ed. Ernest LePore (Oxford: Blackwell's, 1986) and 'The Contingency of Language' (*London Review of Books*, vol. 8, no. 7, April 17, 1986).

16. But this is not to say that it has a 'cognitive' function, if this means 'telling' us something, answering a previously formulated question. Its contribution to cognition is rather to give us a sentence which we are tempted to try to 'literalize' by changing the truth-values of, so to speak, various surrounding sentences. Davidson says about attempts to give 'cognitive content' to metaphors:

> But in fact there is no limit to what a metaphor calls to our attention, and much of what we are caused to notice is not propositional in character. When we try to say what a metaphor "means", we soon realize that there is no end to what we want to mention. (*Inquiries*, p. 263)

He goes on to analogize metaphors to pictures and to say that "words are the wrong currency to try to exchange for a picture". The attempt to think of metaphors as telling us something is the attempt to think of pictures or metaphors as being interchangeable with a set of sentences, instead of as providing (as do surprising perceptual data) a challenge to (a) redistribute truth-values among familiar sentences, and (b) invent further unfamiliar sentences.

17. Davidson, 'Paradoxes of Irrationality', in Richard Wollheim and James

Hopkins, *Philosophical Essays on Freud* (Cambridge: Cambridge University Press, 1982), 305.
 18. In, e.g., *Philosophie als Strenge Wissenschaft*.
 19. Heidegger, *The Basic Problems of Phenomenology*, trans. Hofstadter (Bloomington: Indiana University Press, 1982), 23. The original is at *Grundprobleme der Phänomenologie* (Frankfurt: Klostermann, 1975), 31.
 20. Aber diese Destruktion ist wie die 'Phänomenologie' und alles hermeneutisch-transzendentale Fragen noch nicht seinsgeschichtlich gedacht: Heidegger, *Nietzsche* II, p. 415. I am grateful to Herbert Dreyfus for calling my attention to this passage. The English translation is from Heidegger, *The End of Philosophy*, ed. and trans. Joan Stambaugh (New York: Harper and Row, 1973), 15.
 21. Die Philosophie ist wesenhaft unzeitgemäss, weil sie zu jenen wenigen Dingen gehört, deren Schicksal es bleibt, nie einen unmittelbaren Widerklang in ihrem jeweiligen Heute finden zu können und auch nie finden zu dürfen: Heidegger, *Einführung in die Metaphysik* (Tübingen: Niemeyer, 1953), 6. The English translation is at *Introduction to Metaphysics*, trans. Manheim (New Haven: Yale University Press, 1959), 8.
 22. . . . ist es am Ende das Geschäft der Philosophie, die *Kraft der elementarsten Worte*, in denen sich das Dasein ausspricht, davor zu bewahren, dass sie durch den gemeinen Verstand zur Unverständlichkeit nivelliert werden, die ihrerseits als Quelle fuer Scheinproblem fungiert. Heidegger, *Sein und Zeit* (Tübingen: Niemeyer, 1979), 220. English translation at *Being and Time*, trans. John Macquarrie and Edward Robinson (New York: Harper and Row, 1962), 262.
 23. Erschwerung des geschichtlichen Daseins und damit im Grunde des Seins schlechthin ist vielmehr der echte Leistungsinn der Philosophie: Heidegger, *Einführung in die Metaphysik*, p. 9 (*Introduction to Metaphysics*, p. 11).
 24. From Heidegger's prose-poem *Aus der Erfahrung des Denkens*. Translated in Heidegger, *Poetry, Language, Thought*, trans. Hofstader (New York: Harper and Row, 1971), 4: "We are too late for the gods and too early for Being. Being's poem, just begun, is man."
 25. See Heidegger, 'Die Zeit des Weltbildes' in *Vorträge und Aufsätze*, p. 71.
 26. This claim may, in the light of Dewey's obsessive 'scientistic' rhetoric, seem paradoxical. I have tried to defend it in 'Nineteenth Century Idealism and Twentieth Century Textualism' (in my *Consequences of Pragmatism* (Minneapolis: University of Minnesota Press, 1982)), in 'Pragmatism Without Method' (in *Sidney Hook: Philosopher of Science and Freedom*, ed. Paul Kurtz (Buffalo: Prometheus Books, 1983), and in 'Reply to Sleeper and Edel', *Transactions of the C. S. Peirce Society*, vol. 21 (1985).
 27. I would grant that Heidegger was, from early on, suspicious of democracy and of the 'disenchanted' world which Weber described. His thought was, indeed, essentially anti-democratic. But lots of Germans who were dubious about democracy and modernity did not become Nazis. Heidegger did because he was both more of a ruthless opportunist and more of a political ignoramus than most of the German intellectuals who shared his doubts. Although Heidegger's philosophy seems to me not to have specifically *totalitarian* implications, it does take for granted that attempts to feed the hungry, shorten the working day, etc., just do not have much to do with philosophy. For Heidegger, Christianity is merely a certain decadent form of Platonic metaphysics; the change from pagan to Christian moral consciousness goes unnoticed. The 'social gospel' side of Christianity which

meant most to Tillich (a social democratic thinker who was nevertheless able to appropriate a lot of Heideggerian ideas and jargon) meant nothing to Heidegger.

28. For an account of Dewey as a contributor to social democratic thought, see James T. Kloppenberg, *Uncertain Victory: Social Democracy and Progressivism in European and American Thought, 1870–1920* (New York: Oxford University Press, 1986). For some acute comments on the relation between my own version of pragmatism and political liberalism, see Christopher Norris, *Contest of Faculties: Philosophy and Theory after Deconstruction* (London: Methuen, 1985), chapter 6 ('Philosophy as a Kind of Narrative: Rorty on Post-modern Liberal Culture').

29. Die Metaphysik ist der Geschichtsraum, worin zum Geschick wird, dass die uebersinnliche Welt, die Ideen, Gott, das Sittengesetz, die Vernunftautorität, der Fortschritt, das Glück der Meisten, die Kultur, die Zivilisation ihre bauende Kraft einbüssen und nichtig werden: Heidegger, *Holzwege* (Frankfurt: Klostermann, 1972), 204, trans. W. Lovitt at Heidegger, *The Question Concerning Technology and Other Essays* (New York: Harper and Row, 1977), 65.

30. Das Schöpferische . . . geht zuletzt in das Geschäft über: *Holzwege*, p. 203 (*The Question Concerning Technology* . . . , p. 64).

31. Thomas Nagel, *The View from Nowhere* (New York: Oxford University Press, 1985), 12.

32. Ibid., 11.

33. Ibid., 10.

34. Ibid., 11.

35. Nagel, for example, sees those who adopt alternative canons as being less closely in touch with reality than those who adopt his own—as 'idealist', in the sense of believing that "what there is and how things are cannot go beyond what we could in principle think about." (Ibid., 9) They suffer from "an insufficiently robust sense of reality and of its independence of any particular form of human understanding." (Ibid., 5) Nagel's attitude toward pragmatism parallels the attitude which Heidegger adopts toward what he calls "humanism" in the 'Letter on Humanism'.

36. Occasionally a university sets up an 'alternative' philosophy department, bowing to the fact that two noncommunicating disciplines are currently going by the same name. This usually creates trouble, because the word 'philosophy' is still an honorific, and both departments resent its use by the other. Eventually some genius will resolve this entirely verbal issue by hitting upon just the right names for the two sorts of philosophy departments, names which will permit peaceful coexistence of the sort which now obtains between classics departments and departments of modern literature. (It is sometimes forgotten that classicists once objected furiously to the creation of departments of the latter sort. On their view, putting recent novels on a syllabus for a degree was a degradation of the university.)

37. There are exceptions. Analytic philosophers who specialize in 'applied ethics' have sometimes claimed that there are special skills associated with analytic philosophy which are useful in resolving policy dilemmas (on such matters as abortion, job discrimination, disarmament, and the like). But it is very hard to isolate any skills employed by philosophy professors who take up such issues which were not routinely employed by people (philosophers like J. S. Mill and non-philosophers like Macaulay) who took up similar issues in the last century, or are not being routinely employed by non-philosophers who write on such topics today. The notion of 'analytic skills' is, I think, a relic of the earlier idea of a special

'method of philosophical analysis'. Analytic philosophers have often written very well indeed on current policy dilemmas, but it is pointless to view their work as the product of a distinctive professional ability.

38. Habermas is (despite what are, to my mind, unfortunate residues of scientism in his thought) the contemporary philosopher who most resembles Dewey—not only in doctrine but in his attitude toward his society, and in the role which he has played in the day-to-day, nitty-gritty, political debates of his time. Like Dewey, Habermas's thought is dominated by the question 'What sort of philosophical vocabulary and approach would serve human freedom best?' and by the conviction that the modern industrialized technological world is not hopeless, but, on the contrary, capable of continual self-improvement.

39. This is particularly evident in the U.S. and Britain, where there is often thought to be some natural affinity between neo-Heideggerian philosophizing and leftist politics.

40. This paper is a revised version of one prepared for a conference at the University of Vienna on the occasion of the 50th anniversary of the publication of Husserl's *Krisis*. The earlier version appeared, in German translation, in Michael Benedikt and Rudol Berger, eds., *Die Krise der Phänomenologie und die Pragmatik des Wissenschaftsfortschritts* (Vienna: Verlag der Österreichischen Staatsdruckerei, 1986).

2

Hector-Neri Castañeda

PHILOSOPHY AS A SCIENCE
AND AS A WORLDVIEW

Preface

I do not trust my predictive powers to dare a guess about the future of philosophy, although I have some hopes. On the other hand, I am delighted with its present, which I regard as an enormous improvement from its recent 1950s past. Philosophy is blooming: new problems have been posed, connections with other disciplines have been made; all the old problems have been re-opened; there is a healthy boom in the history of philosophy; recent dogmatisms have receded, and nothing is taboo, not even the pessimism of some philosophers about the end of philosophy as it has been practiced by the great philosophers of the past.

This multi-directional growth has provoked a certain 'crisis of identity'. But it seems to me that it is not so much a crisis in the discipline itself, at least not in the sense that certain questions should (as has often been said) not be asked, that the history of philosophy is a history of the human misunderstanding of either human nature, or the nature of language, or the nature of natural science, or whatever. The crisis seems to me—old-fashioned that I am and uncouth and myopic that I may be—rather a professional crisis in terms of what philosophical career to choose, or even a personal crisis in terms of finding a place for oneself in the midst of the encompassing waves of new developments.

Yet those who see an end to philosophy as it has been hitherto known are right in a strictly professional sense: in the long run the richness of topics and methods has altered the institution of philosophy, and in the short run the narrow domains of problems and methodology of the Anglo-Saxon analytic philosophy has been surpassed, and a healthy rapprochement between analytic philosophy and continental philosophy has taken place. Nevertheless, the major pattern of philosophizing and the

core of themes and problems remain, even if surrounded by new ones. While I certainly appreciate the recent changes, which I have lived in my own work, I am also deeply appreciative of the continuity of my own work with the work of the great philosophers of the past. I rejoice in adding my little footnotes to their work. I surmise that philosophy will continue to be topical, dialectical, and sensitive to changes in technology, culture, and morals, which revolve around the problems of the place of humankind in the world. I have solid opinions about the current character of the philosophical profession. These are convictions gained and firmed up through my living the recent history of professional philosophy, both as a concerned practitioner and as the dedicated supervising Editor of *Noûs*. My practice has been personally rewarding; its modest successes have nourished my congenital optimism. The present is clear to me, and I hope, yet am not bold enough to predict, that the future will simply expand the intensity, the richness, and the multifariousness of the present.[1]

I. GREAT TIMES IN PRESENT DAY PHILOSOPHIZING, FOUNDATIONAL AND APPLIED

The ultimate goal of philosophical activity has always been to attain a growing understanding of human nature and its situation in the world. Through the cumulative efforts of many generations of assiduous and keen philosophers we have achieved an impressive amount of understanding. Thus, I am elated by the recent opening of philosophical reflection to all problems, and by the development of connections between philosophy and other disciplines. I am sanguine about the greater progress in the offing. My temperament and my training prevents me from sharing the view of those iconoclastic critics who see philosophy—as this has been practiced by Plato and Aristotle, Thomas Aquinas and Descartes, Hume and Kant, Hegel and Peirce, Frege and Husserl, Brentano and Quine, Sellars and Chisholm—as having reached a dead end, and proclaim that the only worthwhile thing to do is to expose the errors to which past philosophers, as well as the unwary philosophers of the present, have been led to commit by the bewitchment of language, the prestige of physics, the beauty and precision of mathematics, or what not. Undoubtedly, these evils have occurred, and will recur. Yet behind errors of that sort often times lie marvelous insights that must be treasured.

We must certainly understand how science contributes to our understanding of the world, but we must insist that the whole of human culture lies beyond science. We must also protect the philosophical problems from sterile formalisms. Similarly, we must understand how language

functions in experience, in whatever type of experience. This in fact has been ONE of my central philosophical preoccupations, and I am not unhappy with my results. What worries me is the shortness of human life and the magnitude of the philosophical project.

Consequently, since there is in philosophy so much to understand and so many philosophical perspectives to create, I have little time to spend in order to merely keep the conversation going about philosophical conversation about whether the only decent job left for so-called philosophers is to continue the philosophical conversation because philosophy as practiced by the great philosophers is an error based on the mistaken assumption that mind is the mirror of nature to be studied by non-empirical methods.[2] Here is a general sign that things have recently changed: I accept this critique of many a philosophical exercise; what worries me is the moral drawn from it: that philosophy is bankrupt and should be jettisoned.

I have never assumed that mind is the image of nature to be studied by non-empirical methods. Indeed, it may be better to say that after Kant many a philosopher has assumed that nature is the mirror of mind, and since Hegel or Marx many of us have seen nature as a partial image of social structures. I have, for quite sometime, insisted that philosophy is empirical. After all, our objective is to understand *this* world where we *find ourselves in* through the kinds of experiences *we* are capable of enjoying or suffering.[3] I cannot see that Aristotle's or Kant's projects were misguided, or that the only proper thing to do in the future is simply to engage in sustained conversation, not in the pursuit of truth, but seeking edification. I cannot see this partly because this proposal—to bring philosophical dialogue to its true fruition by seeking after edification rather than truth—is palpably not aiming at intelligibility, and in that sense it is indeed an abandonment of philosophy as has been traditionally understood: as the quest for understanding the human condition. What is it to be edified? What are the *topics* of conversation we ought to focus on? I am so naive as to need a specification of the topics of the philosophical-successor conversations, and I need a determination of what truly is to be edified without seeking truth. I am too corrupted by the practice of my profession to see any philosophical crisis that requires jettisoning the traditional goals in favor of bull sessions about. . . what? I am methodically so much beyond repair that I cannot fathom how we engage in a dialogue, aimed at gaining a deeper understanding of human nature and the human condition, without being focused on specified philosophical topics.

My philosophical practice has centered on the most general problems of mind, language, reality, and practical thinking. These may be called

foundational problems. They are the easiest ones. The hard problems are those of *applied philosophy*, which require of their practitioners, in addition to the appropriate philosophical skills, a large amount of specialized knowledge.

The hard problems of applied philosophy were for the most part marginated during the middle third of the twentieth century. Many tactics of rationalization were employed. A lofty one was to claim that philosophy was an a priori discipline and that nothing empirical was philosophical. The teaching of philosophy was then often conceived as having the single pedagogical role of teaching certain skills of reasoning well and of developing certain open-mindedness. Philosophers and philosophy teachers tended to be arrogantly humble in their timid disregard of the important issues of human living: many of them disclaimed any special insight into the empirical or the axiological, and proclaimed that their opinions were typically inferior to those of the scientists on matters scientific, to those of the moralists on things moral, to those of the theologians on issues theological, and so on. It is, of course, most commendable to instill open-mindedness and cultivate powers of critical thinking.

Nevertheless, philosophers have a special role to play in discussions of the important issues of life. Thus, I have welcomed with profound satisfaction and cheerfulness the dramatic changes in the practice of philosophy that have occurred during my own lifetime. I am pleased by the truly glorious spectacle of philosophers working on normative projects, ranging from detailed discussions of particular problems of personal ethics (e.g., abortion, euthanasia), through problems of public morality, through business ethics, through problems of social morality, to moral problems of national policy, to the role of morality in international relationships, to major axiological problems of political theory and the sources of law. I hope very much that philosophers continue to do and help instill a more human sense of tolerance and respect for others in the heads and hearts of politicians, businessmen, and administrators. Yet this is, not a prediction, but a hope, hopefully not a mere pious hope.

Recently other philosophers have also left their academic cubicles and have spread themselves about in other directions. Some are now engaging in joint research projects with other scientists: in linguistics, in artificial intelligence, in cognitive psychology, in applications of computers to law, etc. These are great developments long overdue. Philosophers have studied the structures of the basic human abilities, and their structural knowledge should be of assistance in the fuller study of human capacities carried out by other scientists. That knowledge can be of guidance in the development of models or theories and can provide criteria of adequacy for such models and theories. In particular, I personally and profession-

ally am very optimistic about artificial intelligence and its applications. For instance, the development of computer programs as aids to legal reasoning should confirm my purely conceptual theories on the logic of normative reasoning. Similarly, I expect corroboration of my main theses about the nature of intentions and intentional action.

In brief, philosophy nowadays enjoys an *unlimited topical freedom*. This topical freedom has spread to philosophical history of philosophy, which is now flourishing as never before.

On another side, the monolithic days of lexicalist ordinary language philosophy are gone.[4] Of course, ordinary language continues to be, as it has always been, the fundamental tool, topic, foil, and goal of philosophy. Recall Plato's declaration: "Thus, it became evident to me that it was necessary to resort to words (concepts), sentences (propositions), and reasonings (discourses), to study in them the truth of realities." (*Phaedo* 99b5–7) Now we are concerned with the syntax and the semantics of ordinary language as the hinges of experience, and with the different layers of linguistic activity as the embodiments of particular experiences. The detailed rich studies of the experiential content of language and speech I have called *phenomenological linguistics*;[5] it is of one piece with the *proto-philosophical* role Plato assigned to the study of language.

The interdisciplinary connections of philosophy, the broader view of ordinary language, the richer view of experience fomented by existentialism and Wittgenstein, the re-discovery of the immense treasures of the history of philosophy, have all connived to break the conventional barriers among problems—let alone philosophical problems. They have also conferred on the current practitioners of philosophy a hitherto unbeknownst freedom to apply to each problem whatever tools we deem appropriate. Thus, in current philosophizing there is a *boundless methodological freedom*.

To sum up, philosophy has never before been in as great a shape as it is today. All topics are available; all its applications are legitimate; all methods are feasible; all interdisciplinary connections are accessible. Furthermore, probably there are nowadays more philosophers than there have been from the dark beginnings of history up to 1900. Moreover, contemporary philosophers have never had so many opportunities for a superior training as they have today. I am most optimistic about the future of philosophy. Yet I cannot make any predictions about what should be a rosy future. I only wish I could have started my philosophical career in the present climate.

II. Philosophy, Method, Dia-Philosophy, Sym-Philosophy, and the Unity and Cultural Integration of the Philosophical Profession

Philosophy as an intellectual discipline and activity has always been the systematic pursuit of an increased understanding of human nature and the world in which it is deployed. That activity is itself deeply rooted in human nature, which in its turn is realized through each human being building her own biography through some understanding of herself and her situation.

The human situation is as many-sided as is our human nature. It consists of our responses to our profound need to deal with the world in multifarious ways. World dealings we call experiences. These focus on particular items—a woman or man we love, a flowering tree we plant, a book we read, a symphony we listen to, a typo we correct. But we deal with these particular items as parts of encompassing wholes: we deal directly with parts of objects or persons as parts thereof, and we deal with these as parts of networks or domains, which are inserted in more and more comprehensive environments within reach, which themselves lie within more comprehensive rings of entities beyond, all hierarchically lined up within the huge but unitary world. Each of our experiences of objects, persons, sensations, theories, or whatever, is immediately a transaction with the surface apex of a multiple-tiered iceberg, mostly beneath the experience in question, but whose firm hierarchical structure we need, and we need to take, and do in fact take, for granted. In further experiences we sometimes delve into the icebergs of overlapping experiences.

Philosophy is concerned with delivering understanding of the general structures of the world we find ourselves in and of the pervasive patterns of our experiences of what belongs, or could belong, to the world. All patterns of experience—perceptual, esthetic, literary, scientific, mathematical, economic, political, pedagogical, of planning, of carrying out plans, of failing to achieve plans, of feeling defeated, of being unable to cope with one's friends, of being in despair, and so on—and their unity have always been the central topics of philosophy.

A minimal understanding of human nature is a necessary requisite for living as a human being. To reflect on oneself and on one's own needs and powers to cause changes is a necessary condition for building an autobiography. This need of self-understanding and the ability to reflect and self-reflect are the perennial grounds of philosophical activity.

Thus, philosophy has always been, and seemed to be, within the reach of every human being worthy of the name. This has promoted philosophical activity, but it has occasionally also fostered the confused idea that

mere chatting along, merely keeping the conversation going, is a serious philosophical activity. The magnitude of full, comprehensive philosophizing can easily escape appreciation. Or it can cause despair and abandonment of the activity. It has certainly led some philosophers to substitute all sorts of things, more manageable or more certain or more fashionable, for philosophizing: pseudo-mathematization, vicarious literature of counter-examples, arm-chair pseudo-psychology, and mysticism are just a few major *Ersatz* activities.

We must, however, seize upon the complexity of the topic: being a human being is a most complex phenomenon of which each of us is, necessarily, bound to illustrate a small portion. Yet the full phenomenon of being human, of being capable of, and actually, building one's autobiography piecemeal—out of a huge number of alternatives from which we choose—through the adoption of diverse plans and the living of variegated experiences, is the topic of philosophy. Thus, philosophy is ubiquitous. Its task is enormous, too large for any one man to accomplish.

Philosophy, as a whole, *sub specie aeternitatis*, has been concerned with understanding the whole of human nature and its total peculiar role in the universe, namely: as the source and creator of its surrounding world, through its peculiar powers of variegated experiences, its theoretical posits, its technological advances, and its forging of institutions. All philosophers—regardless of their opposite views, their despising their opposition, and their unease before counter-arguments—are members of the overall human project of achieving understanding of human nature. We are divided in antagonistic schools and argue against one another even within the same school or point of view. Nevertheless, we are, precisely because of our very opposition, united as cooperative members of the one *master team* composed of the whole philosophical profession. Succinctly put, the philosophical task is so enormous that philosophers have to specialize, and they work best in an adversary relationship; at any rate the light of understanding breaks out of the collisions of opposite views. There is a superficial reason for this; but there is a deep reason, elucidated below, for this crucial fact of philosophical illumination.

Perhaps all philosophers desire originality. This motivates personal rivalry, and this in its turn promotes criticism as well as the search for alternative views. This search is excellent. Regardless of its motivation. Furthermore, one pursues a thesis if one believes it, or hopes that it may be true. Thinking that a thesis is THE ONLY truth pertaining to a topic impels forcefully to search for support of that thesis. Again, the personal and the professional motives are immaterial. Yet these motives also promote unnecessary heat in philosophical polemics, and this heat in turn causes slow development. Oftentimes a philosopher believes that to be justified

in proposing a view on a certain issue, he must refute the existing views on that issue. Such efforts at refutation are perfectly valid and needed *if* there is JUST ONE truth, which must be reached by only one route, then the standing views that mislead us in other directions must be extirpated to clear the royal road to *the* truth.

Here we can still be sympathetic to the views of our predecessors: they have (perhaps) taken us up to a point where the road forks and they have followed the wrong path. We have learned through their work what errors to avoid. This is the superficial sense in which we are all members of the whole philosophical team: we work our erroneous views for others to see as erroneous and reject. This superficial unity of the philosophical profession can be used to justify the fact that historical dialectics runs in cycles: the history of philosophy is thus the changing of the tides of later appreciation of the 'silly' views of the preceding philosophers. This does suggest that we are all part of ONE diachronic philosophical enterprise by virtue of being part of one wave or cycle out of which the unified and unitary truth about human nature will reveal itself.

There is, however, a deeper sense of total professional unity across the total diversity of philosophical schools, approaches, and views.

Philosophical experiences are, like all other experiences, dealings with surface aspects of complex hierarchical icebergs: many tiers of presuppositions are simply taken for granted. But, unlike ordinary ones, philosophical experiences are transactions with structural aspects present in other types of experience. Thus, in the practice of philosophy there are two major tendencies, each correct—up to the point where the other tendency is not joined but shunned. One is the *Forest Approach*, the tendency to see very general structural lines of the world or of experience. The other, the *Bush Approach*, is the tendency to dwell upon small aspects of experience. Each approach can be, and has been, exercised in varying degrees. This is not bad. What is bad is the policy of *merely* exercising the extreme degrees. (This applies here, too: since this discussion is so general we must finish this essay with some complementary discussion of a particular illustration.) Clearly, the Forest Approach can be applied just in its most general version and then deliver nothing but trivial platitudes. Similarly, the Bush Approach can be applied in its most extreme form in which, for instance, a formidable discussion of a dry leaf of an innocuous thesis is counter-exampled into total obscurity.

Fruitful philosophical experiences are combinations of the two approaches: taking a full attentive look at the forests of the structures of experience and seeing their measure and reach in their realizations in the particular bushes and trees of experience: *the pervasive general in the particular: the abstract structures within the concrete empirical.* We want to

understand the very large structures of experience, but we must understand them in their concrete setting in human life in its full social niche within the world at large—with occasional considered guesses at what things might be outside the human situation.

Some philosophers do not see the large picture of the theories or approaches within which they attempt to shed light on some small pieces of the philosophical topics. This happens not infrequently in some exercises of so-called analytic philosophy: refined little lamps are set to cast the most intense light on the smallest aspects of human experience. Sometimes the light is lost on the empty spaces surrounding the minuscule points under consideration. No wonder, then, that even many of those philosophers working within a school, or approach, whose scope and organization they see fully, may yet fail to appreciate the contributions by philosophers in other schools. Some fail to see the richness and complexity of human experience; yet, more importantly, some fail to see that *the world is capable of being different in different contexts or perspectives*. Often the presupposition is straightforward: there is one world and an indivisible unity of man and world, hence, they assume, there is just one theory of the structure of man and world. This, as remarked above, gives us the polemical-approximation unity of the philosophical profession.

Here I wish neither to defend nor to attack this assumed view of philosophical truth. I submit instead a first-order *philosophical pluralism*: to understand human nature we need all the theories, all the models we can invent. I am not proposing a relativistic Protagorean metaphysics.[6] I am recommending, first, a methodological *theoretical* pluralism. This will be made clear in the Bush Approach illustration promised above. Perhaps I should hasten to confess that I am rather dogmatic concerning the *methodological* requirement of building detailed theories on *rich data*. Below I urge a higher-order pluralism under the heading of dia-philosophy.

Perhaps human-world reality is not a monolith, but a many-sided perspectival structure. Perhaps the greater understanding will be achieved by being able to see human reality now one way and now another way. Thus, *we need ALL philosophical points of view to be developed*, and 'developed' is meant in earnest: the more it illustrates the harmonious unison of the encompassing Forest Approach and the riches of the Bush Approach. Hence, *all* philosophers are part of one team collectively representing the totality of philosophical wisdom, and individually working the details of a point of view: we are ALL parts of the same human project. Looking at things this way, we realize that we need not polemicize against the most fashionable views hoping to supplant them with our own view. *Instead*, with a clear conscience, we may urge the defenders of those views to extend them, to consider further data to make them more and more compre-

hensive, pursuing the goal of maximal elucidation of the structure of experience and of the world. At the same time we urge other philosophers to develop equally comprehensive views that are deliberately built as alternatives. The aim is to have ALL the possible most comprehensive master theories of world and experience.

To be sure, we cannot foretell that such a plurality of views as envisaged is ultimately feasible. But neither can we prove that in the end there must be just one total view, bound to overwhelm all others. *If* many master views are feasible, then the greatest philosophical illumination will consist of being able alternatively to see reality through ALL those master views. It would be still true that the greatest philosophical light comes, so to speak, from the striking of theories against each other, but not in the destruction of one theory in the striking process, but rather in the complementary alternation among them. Each master theory would be like a pair of colored glasses with different patterns of magnification so that the same mosaic of reality can appear differently arranged. Here Wittgenstein's reflection of the duck-rabbit design are relevant.[7] The different theories of the world give us different views, the rabbit, the duck, the deer, the tiger, and so on, all embedded in the design of reality. The analogy is lame in one crucial point: the master theories of the world and experience must be forged piecemeal: with an eye on the Bush Approach, patiently exegesizing the linguistic and phenomenological data, and, with another eye on the Forest Approach, building the theoretical planks (axioms, principles, theses, rules) carefully and rigorously.

This pluralistic meta-philosophy has several important consequences. *First*, we are all partners in the philosophical enterprise, precisely because of our different views and styles and methods: we are working, not so much within alternatives to be ultimately rejected in the march to the one truth of the world, but within master views for alternative *use* in philosophical experience. *Second*, we must place in the inventory of views not only the fashionable ones, but also the unfashionable views. Most likely, if we are to enjoy the beauty and color and grace of a non-fashionable view, we will have to erect it ourselves. *Third*, a later stage in the development of philosophy will be the comparative study of master theories of the world and experience. That branch of philosophy I call *dia-philosophy*. Perhaps then we (our successors) can say that the 'real' underlying structure of reality as we experience it is the system of isomorphisms, partial or otherwise, across the different master theories. *Fourth*, but before we become able to practice dia-philosophy we need not only a plurality of views, but rich comprehensive views.

In short, the fundamental philosophical task nowadays is for many philosophers to work in the development of as many rich and comprehen-

sive master theories of the most general structures—hereafter called *philosophical structures*—of the world and of our experience of it. Let us, by all means, be stimulated by the natural adversary attitude. But let us remember that the criticisms across systems or theories are important, not as refutations or as strong objections, but as contributions of new data and as formulations of hurdles for steady development. Let us ponder some types of standard criticism.

Counterexamples may refute some local theses, but they do not refute an approach. Yet counterexamples are important because, on the one hand, philosophical theorization must, as we said above, proceed piecemeal and leave no phenomenon unaccounted for, and, on the other hand, a relevant counterexample is a concrete addition of a datum. Counterexamples, then, are not so much means of refutation, but stimuli for further theoretical development.[8]

In the end, however, the only *valid criticism is holistic and dia-philosophical*: it, first, compares two equally comprehensive theories catering to exactly the same rich collection of data, and, second, assesses the compared theories in terms of their diverse illumination of the data. It is of the utmost importance to fasten to the principle that as long as we do not have the finished master theories, the comparison of theories cannot yield a final refutation. We cannot even be sure that comparative simplicity is preserved. A theory T1 may be simpler than a theory T2, both catering to the same data D; notwithstanding, when we subsume data D in a more comprehensive collection of data D* and extend T1 to T1* and T2 to T2* it may very well be that T2* is simpler than T1*. It may, of course, happen alternatively that there is no clear way of establishing that T1* is simpler than T2* or vice versa. In any case, while philosophy has not really come to an end, valid criticism, which must be holistic, is also not so much effective refutation but should be moving dia-philosophic stimulation.

The urgent activity of developing *comprehensive master theories* of the world and of experience for dia-philosophical comparison I have called *sym-philosophy*. Thus, the deeper sense in which ALL philosophers are members of one and the same team is the sense in which we are all sym-philosophers: playing our varied instruments in the production of the dia-philosophical symphony.[9]

We should compare rich theories with one another even if they are far from being the master theories we are aiming at. There are two heuristic reasons for partial dia-philosophical exercises. First, all theories are ad hoc in that they are erected on particular collections of data. Hence, we must look at other theories to borrow their data. Second, if we set ourselves the task of building a fresh new theory we must make sure that it is at least initially different from the existing theories. Notwithstanding, we

must look with little tolerance to small local theories, especially if they are presented with arrogance and irrelevance, e.g., with the claim that another theory is, *simpliciter*, by itself, too complicated.

III. THE PERVASIVENESS AND THE EMPIRICAL CHARACTER OF PHILOSOPHY

The difference between the typically called sciences and philosophy is essentially one of generality. Because of the maximal generality and pervasiveness of philosophical structures, they can be found anywhere underlying any claim whatsoever about reality, even about irreality and fiction. Any experience whatever, or any entity whatever, is an inexhaustible fountain of philosophical questions.

Just consider, for instance, the tiny dot at the end of this sentence. I do not mean, of course, the one I have just typed, but the one to be printed on page 46 line 12 of the one-thousandth copy of Cohen and Dascal's volume. In fact, the dot I am talking about is currently a nonexisting individual, and for all I know at this moment of writing, perhaps it may never exist. Perhaps the one-thousandth copy of C&D's volume may fail to contain that dot: perhaps the ink runs out at the time of its being printed, or perhaps the whole edition may be defective because the printer or galley-reader leaves out all those dots. It does not matter. Still that dot raises all sorts of philosophical questions. It is an individual or particular dot, at least it is being conceived as an individual or particular dot: what makes it an individual? What does its individuality consist of? What individuates it? Apparently the dot's individuality is independent of its existence. It is a dot, and it is meant to be located after the token of the words 'this sentence' above to stand in relations to all marks and words on that copy of C&D's book, and to my original typescript, indeed, if it exists it will stand in relations to all other objects in the world, and it will have a shade of color and a size and other internal properties. Here we have a manifold of questions: What is it for the dot, and for anything, to possess properties? Does the existing dot possess properties in the same way even if it fails to exist at all? How can this be so? Does the existing dot possess all its properties and relations in the same way? Is what individuates the dot the self-same entity as what accounts for its being a possessor of properties? Moreover, our dot will be very similar to all its counterpart dots on the other copies of C&D's volume page 46, line 12; indeed all those dots may be so internally indistinguishable that one of them could be cut out and another pasted in its place without the world being any worse, or better, off. How then does the differentiation of our dot connect to its individual-

ity? How does their difference or indistinguishability connect to their existence? Presumably our dot will come into existence at printing time and will vanish later on; it will be subject to changes and will have its own history, truly unimportant by human concerns, but its history nonetheless. What is it for the dot to exist? To belong to the causal order and have a location in physical space and time?

Our dot, even if it never comes into existence, is present in my experience now, and has a definite location in the time of my life-long experience. If it exists it will probably be a part of some persons' visual fields. Will it be the same dot if it does not come into existence and a reader of this text hallucinates 'it' and examines 'its' color and design?

That dot as conceived is a part of a plan of action I have adopted. If it exists it will be immediately brought into existence by the manipulator of the printer's machine, but there will be other agents involved. It will be the culmination of a sequential social action built up on different individual intentions: my original intention to produce an unobtrusive and trivial entry point into philosophy, the editors' intentions to publish, and the intentions of all those involved in the printing process. Then there will be the different readers' intentions. These intentions are not merely intentions to perform an act, but are intentions to conform with certain responsibilities and to carry out certain obligations of variegated sources: promises, contracts, relevant laws, specific assignments, etc.

Furthermore, that dot is enveloped by a complicated network of deep psychological and linguistic structures through which it is a token of a linguistic sign. It is a period thanks to its appearing in the midst of strings of marks that count as tokens of English words. That dot, as a period, sits at the convergence of phonetic structures that are themselves molded as linguistic units by syntactic and semantic structures. These are such because they represent, and are causally involved with, the more pervasive structures that connect the mental with the physical. And our tiny dot is all wrapped up by these pervasive structures.

Our little dot lies at the convergence of many hierarchical tiers of philosophical structures. Thus, it packs, if not all, at least a large part of foundational philosophy. This seems on reflection to be right, but it raises further questions. On the one hand, there is just one world, so that it does not seem out of order to think that each individual is connected to everything else. On the other hand, we want to know whether those principles of object connection are all there is to the oneness and the unity of the world.

In any case, our little dot not only raises the general ontological questions, but also raises the central questions in the philosophy of mind, the philosophy of language, the philosophy of action, the philosophy of the social sciences.

Evidently, any object whatever is an ontological bobbin containing the yarn out of which philosophical reflection can weave the patterns of the world. Any object whatsoever gives rise to the same battery of philosophical questions. This has sometimes been misinterpreted and has fomented the view that philosophy is a non-empirical, entirely a priori discipline that needs no empirical data. The situation as just described belies this view. We *can* start our philosophical investigation with *any* physical object whatever in its empirical context as it is at a given time. But so to start is to start with empirical data. Therefore, we must distinguish between the pervasiveness of certain data and the non-empirical character of the same data. Philosophy needs the *initial empirical data and the existential assumption* that the universe contains certain entities, at least it contains the philosophizing philosopher and his or her many experiences, and his or her mechanisms of thinking.

IV. LANGUAGE, EXPERIENCE, AND WORLD

Natural languages have been developed for many purposes: as a means of thinking, as a means of experiencing, as a means of communication of thoughts, as a means of causation of action, as a means of expression of feelings or attitudes.

The diachronic unity of our lives requires that we assume the world to hold a certain reliable form to which we have at least some partial access. This must be a presupposition, a taking for granted, tacitly undergirding our transactions with the world. It must be questioned only on occasion; otherwise we would be involved in a tedious and perhaps infinite or vicious regress. We cannot question our entire faith on the world every time we think of something or decide to do something. Hence, that presupposition must be built into our means of dealing with the world in some way that is both unobtrusive and yet pervasive.

The locus of those presuppositions that are at once both pervasive and unobtrusive is precisely the semantic syntax of our means of thinking and communicating. Thus, the semantico-syntactic structures of each of our natural languages are the repositories of the cumulative wisdom of mankind concerning the form of the world. They are, therefore, fundamental pieces of philosophical data.

Philosophical methodology demands that we examine abundant and abundantly rich and diversified specimens of experience. Since experiences are lived typically through the use of language, we must both examine in tandem cases of experience and their instrumental discourses, and make the experiences reveal the large semantico-syntactic patterns

partially manifested in such discourses. The operative principle is that *experience is the key to semantics and syntax*. Syntax, like phonetics, has no intrinsic connection with semantics; this is made palpable by the existence of many languages with different grammars, and different phonemes. But not only is thinking representational and, hence, in need of some symbolic medium whatever its form and shape; but communication needs a transferable embodiment of communicated messages. Thus, upon an arbitrary selection (natural selection) determined in part by certain physiological capacities to produce and articulate sounds or other potential signs, causal patterns of personal and social encoding of thinkable content evolve, and once well entrenched can be intentionally modified and conventionally adopted. For reasons of convenience, of generalizational analogy, of economy, of conceptual unclarity, and others, ordinary syntactic structures have been invented to serve different purposes, in particular, different semantic purposes. Ordinary syntactic structures do not come with labels describing their philosophical roles. These must be gleaned by a patient and careful exegesis that disentails the different experiential roles of the syntactic structures and families thereof.

Some syntactic constructions are parochial in their semantic or pragmatic aspects. These do not serve the philosophical role of bringing to bear in our experiences the general ontological structures we need to assume. Some syntactic as well as some morphological and lexical mechanisms may function passively to preserve ancient parochial views of certain aspects of the world; such mechanisms may represent nothing to their contemporary users. Other mechanisms, equally widespread across a natural language, may reveal parochial aspects of a worldview build into the language, so that contemporary speakers are bound to see the world in a certain way. This is illustrated by the common experience of skillful polyglots who find that certain thoughts or feelings can be better formulated in one language than in another.

Depending on the degrees of generality of the aspects entrenched in the grammar and the lexicon of a language, there is a hierarchy of types of study of the grammatical mechanisms and the dictionary of a natural language. Here again philosophy differs from science, from cultural anthropology and sociology, by degrees of generality. Philosophy is concerned with the most general *structures* of worldviews. We aim at revealing the structure *shared* across different intertranslatable languages—at least to the extent that they are intertranslatable.

For foundational philosophy no particular natural language is ontologically privileged. Each natural language is only *epistemologically* primary for the philosopher who speaks it. But every foundational philoso-

pher aims at transcending his or her native languages: he or she is philosophizing for all of those who share enough concrete views about the world to speak at least a partially intertranslatable language: the partial intertranslatability reveals a shared view of the structure of the world. Hence, philosophy presumes a catholic interlinguistic perspective.

Consequently, for philosophy, in contradistinction to cultural anthropology, it does not matter how English—or any other language—assigns a given semantics to a certain syntactic construction: what matters philosophically are the *syntactico-semantic contrasts themselves*. These are intertranslatable across different languages.

Now, given the varied purposes to which syntactic patterns are used, there are different ways of translating syntaxemes from language to language. There is, further, the crucial point I have been insisting on, namely, that what is typically called philosophy is a manifold of issues that differ from clearly non-philosophical ones in a degree of pervasiveness and generality. Hence, there is no fixed criterion for segregating the philosophical from the non-philosophical, but fortunately we do not need it. We want to understand the whole of experience and the world. Here is one place where we can see the fruitfulness of the breaking down of the barriers among the disciplines. We all form the grandmaster team of inquiry contributing our little insight or theoretical posit. Therefore, without worrying about whether this or that question is really philosophical, we must pitch our queries at the level of generality we can handle and then tackle them.

V. PHILOSOPHY IS VIABLE FROM THE INSIDE OF EACH NATURAL LANGUAGE

The penultimate methodological point above is of the greatest importance and deserves illustration and further elucidation. An English semantico-syntactic contrast of major significance is that between indicative clauses expressing belief and infinitive clauses expressing intention. At this juncture the semiotic function of syntax is of gigantic and dramatic proportions: on the one hand, we confront here the major ontological divide between the ways in which what is intended and what is believed enter in or relate to the world; on the other hand, we face also the major psychological and epistemological difference between believing and intending. For the sake of concreteness let us ponder on the following reflective declaration by Professor John Shearle:

> *I'll go to the Faculty meeting!*. . .Yes, *I* intend *to go*. But. . .I don't believe I WILL GO. Barbara will most likely succeed in keeping me away from that meeting.

The two italicized clauses formulate the same intention, but with a difference: first it is presented by itself, in direct speech (*oratio recta*), then it is presented in indirect speech (*oratio obliqua*) as the content of Professor Shearle's state of intending. The capitalized clause expresses the corresponding prediction as the content of Shearle's believing. The intention is neither true nor false; the prediction is true or false. Intending and believing differ by their characteristic causal properties, but also by their accusatives. This difference is beautifully signaled by the contrast between the infinitive clause *I...to go* and the indicative clause *I WILL GO*, subordinated, to verbs denoting the appropriate mental states involved. More specifically, the sentence *I intend to go* may be said to have the force of 'I intend I to go' or better 'I intend myself to go', where the second 'I', or 'myself', is what I have called a quasi-indicator.[10] Quasi-indicators are devices that in English are relative pronouns or adverbs used in subordinate clauses to depict indexical references. For instance, in (S) 'Shearle believes that *he himself* will attend the meeting' the quasi-indicator 'he himself' depicts Shearle's potential self-reference: reference by means of the indexical first person pronoun. Thus, in the first person counterpart of (S), Shearle's 'I believe that *I* will attend the meeting', the italicized second 'I' is the first person quasi-indicator corresponding to 'he himself' in (S).[11]

Yet the syntactico-semantic constructions themselves are of little moment. What counts is the abstract *contrast* they together represent. Indeed, as the foregoing discussion reveals, what matters is a family of related contrasts. We can conceive of another language, say *Renglish*, very much like English, except for a reversal: in subordinate clauses like the above Renglish pairs the infinitive with beliefs, and the indicative with intentions. Patently, this is utterly immaterial.

Likewise, that an ontological semantic aspect S may be in a language L featured by a prefix P and in another language, L', by an adverb A is intrinsically of little philosophical value. The contrast <<Prefix P, S>, L> vs. <<Adverb A, S>, L'> is a useful datum. Yet we must fasten firmly to this principle:

LISP. *Each language is internally sufficient for philosophy:* Each natural language can develop the conceptual machinery its speakers need to describe the categories it contains: *Philosophical insight is fully available from inside each language.*

Interlinguistic comparison is a powerful therapeutics for the correction of the philosophical errors of linguistic parochialism: it shows how different intralinguistic contrasts match in different languages in terms of their semantico-pragmatic functions. Thus, what we need in the present example is the co-relation between intralinguistic contrasts of the form:

In L: <Prefix P, S> vs. <construction X, semantic aspect Z>;
In L': <Adverb A, S> vs. <construction X', semantic aspect Z>.

This pair of contrasts constitutes a partial syntactico-semantic isomorphism between L and L'.

VI. PHILOSOPHICAL PLURALISM: REFERENCE AND ONTOLOGY, AND GUISE THEORY

1. Caution

The preceding exposition of the metaphilosophy of foundational philosophy is, as it must be, general. Yet it may feel somewhat dogmatic, a mere fatuous exercise of the Forest Approach. We need some concrete illustration, a little exercise of the Bush Approach. Furthermore, as my friend Oscar Thend never tires of iterating, philosophy has the anti-Augustinian property: one knows very well what a good philosophical method is, if one is *not* doing philosophy, but as soon as one begins to philosophize one finds that knowledge difficult to muster.

2. The Paradox of Reference: A Reminder

As is widely well known, the failure of substitutivity of co-referring terms to preserve truth-value in belief contexts creates a serious problem about the interpretation of the terms in such contexts. More explicitly, the following seven statements, according to standard principles of logic, imply a contradiction:

(1) At the time of the pestilence Oedipus believed that: Oedipus's father was the same as his own father but the previous king of Thebes was not the same as his own father;

(2) Oedipus's father was the same as the previous King of Thebes;

(3) It was not the case that at the time of the pestilence Oedipus believed that: the previous King of Thebes was the same as his own father but the previous King of Thebes was not the same as his own father.

(T1) For any individuals x and y: if x is (genuinely or strictly) identical with y, then whatever is true of x is true of y, and vice versa.

(T2) The sentential matrix occurring in (1) and (3), namely: 'at the time of the pestilence Oedipus believed that: _____ was the same as his own father but the previous King of Thebes was not the same as his own father' expresses something true of (a property of) the individual denoted by the singular term that by fill-

ing the blank in the matrix produces a sentence expressing a truth.

(T3) The expression 'is the same as' in (2) expresses genuine or strict identity.

(T4) The singular terms 'the previous King of Thebes' and 'Oedipus's father' have exactly the same meaning and denotation in direct speech and in indirect speech.

The contradiction arises from the tension between a sameness and a difference. In Oedipus's mind or doxastic system, there is the *difference* between Oedipus's father and the previous King of Thebes. This is the difference revealed by premises (1) and (3) taken together. On the other hand, there is the *sameness* between these two entities, formulated by premise (2); this sameness holds in reality, or at least in the mind of whoever believes premise (2).

3. Seven Initially Distinct Alternative Theories of Reference

A contradiction can only be solved by subtraction. Hence, at this juncture a non-invidious dia-philosophical commentary becomes appropriate. There are initially four interesting approaches or types of theory for the solution of the paradox, depending on which of the major assumptions (T1)–(T4) one rejects to start the construction of a solution. There actually are, however, seven different theoretical avenues, since one can also start by rejecting any of the singular factual premises (1)–(3). Most contemporary philosophers prefer to reject (T2) and hold on to (T1) and (T3). For my part I have proposed to experiment with the approach that starts off by holding on to (T1), (T2), and (T4) but rejects (T3). The outcome is Guise Theory, which we shall introduce below.

Several points are worth keeping in mind. *First*, the issues, of which referential opacity is only a major symptom, have to do with our understanding of the general structure of the world and of our experience. Hence, they require complex theorizing that delivers comprehensive theories of such structures. *Second*, the data cannot underwrite just one theory. In my opinion the greatest illumination and understanding of the general structure of the world and of experience can be attained by living our experiences through different comprehensive alternative theories. Hence, I am most anxious to urge philosophers to construct very different alternative, but comprehensive theories. Given the stimulating and bandwagon effect of the fashions, no mere perversity motivates me to erect a non-fashionable theory. If one is to achieve the enormous benefit of a dia-philosophical comparison of fashionable with non-fashionable views, one must, it appears, construct the non-fashionable views oneself. *Third*, an

important corollary of the above is that one does NOT have to show any rich comprehensive theory false—let alone merely local and narrowly focused theories—in order to earn the right to construct alternative *comprehensive* theories: indeed, for dia-philosophical exercises we need several such theories. (For details see *On Philosophical Method.*)

4. Frege's Solution to the Paradox of Reference

To resolve the Paradox of Reference, as is well-known, Frege rejected (T4) and was, thus, forced to introduce the thesis of the double semantic connection between a singular term and the objects in the world. A term, e.g., 'The previous king of Thebes' has a (primary) sense and, sometimes, a (primary) referent. Frege also introduced the thesis that a singular term in indirect speech refers to its (primary) sense. He apparently postulated higher and higher senses and referents in order to account for iterated embedding of indirect-speech constructions in indirect-speech constructions. But we shall ignore this third thesis here.

Frege's solution consists of avoiding the collision between the sameness and the difference in tension in premises (1)–(3) by assigning them to different entities: thus he removes the common ground where they could collide. The sameness in reality (or in the doxastic system of whoever believes premise (2)) Frege assigns to the common primary referent of the two terms 'Oedipus's father' and 'the previous King of Thebes'. On the other hand, the difference in Oedipus's mind he assigns to the different primary individual senses of these terms. Thus, Frege's solution belongs in the category of individuals, which he multiplies appropriately to his theoretical needs. We must be utterly cautious and not mention "Ockam's razor", for the reasons discussed above in connection with attacks on theories alleged not to be simple (see the materials mentioned in notes 8 and 9); it will be difficult to show that Frege's approach does not need the entities he postulates.

Concerning the problem of identity, which a useful theory has a deal with, Frege maintains (T1), which he himself is responsible for being called Leibniz's law, as a full characterization of genuine identity. He endorses (T3), thus allowing genuine identity and sameness to conflate. He keeps a generally simple view of predication, but it is not clear how individual senses relate to properties. Yet he maintains a version of (T2), thus allowing psychological properties as the one postulated by (T2), but they are relations between thinkers and senses.

5. Guise Theory

An alternative to Frege's Sense/Referent solution to the paradox of refer-

ence is Guise Theory. It agrees with Frege's solution by respecting the three factual premises (1)–(3) and endorsing theses (T1) and (T2); but it contrasts with Frege's View in preserving (T4) and starting with the denial of premise (T3) and then proceeding to solve the paradox, not within the category of individuals, but within the category of properties. Guise Theory eliminates the tension between the sameness that in reality links the previous King of Thebes to Oedipus's father and the difference separating them in Oedipus's mind or doxastic world at the time of the pestilence, by taking this distinction between sameness and difference at face value. The tension arises because premise (T2) blurs the distinction by postulating just one sameness or identity. By jettisoning (T3) Guise Theory accepts that there are (at least) *two* distinct relations of the sameness family: genuine identity governed by Leibniz's law, i.e., (T1), and the contingent, factual, existential sameness postulated in premise (2), hereafter called *consubstantiation*. (Later on Guise Theory introduces other members of the sameness family.) The genuine identity between Oedipus's father and the previous King of Thebes does not hold, and this difference belongs both to reality and to Oedipus's mind (and Jocasta's, too); it underlies Oedipus's belief, according to premise (1), that they are, also, not contingently the same, i.e., not consubstantiated. The individuals the previous King of Thebes and Oedipus's father, we are dealing with, that are different (i.e., non-identical) yet consubstantiated (i.e., contingently the same) are, therefore, constitutive of a big chunk in the world: they are like thin slices of such a chunk, and we call them *individual guises*.

Obviously, *any two singular terms* that are normally said to be co-referring can be passed through a differentiating test like the one above involving Oedipus's beliefs and assumptions (T1)–(T4). A person's beliefs are, thus, sifting devices that discriminate between identity and consubstantiation, and also between genuinely identical and merely the same individual guises. In general, this is true of the mental, both propositional and practical attitudes, which we refer to as *ontological sieves*, or *ontological prisms*. These chunks of the world are thus somehow composed of infinitely many fine-grained individual guises. At this juncture two serious problems loom large. First, what is the constitution of individual guises? Second, how do individual guises enter into the composition of such massive chunks in the world? One thing is clear at this juncture: singular terms denote individual guises, and we believe that they belong to, or are involved with, such massive chunks through contingent existential sameness or consubstantiation.

Guise Theory would be an irresponsible artifact if it merely rejected (T3) and proceeded to derive the consequences above noted. It *must*, like any other theory, deal with the problems of predication, individuation,

etc. This it does. It goes on to conceive of the two samenesses just mentioned as members of a larger sameness family, and then takes the members of these family as forms of predication. Thus, ordinary properties—as opposed to the sameness properties—are ultimately not predicative, but compositional of individuals. This leads to a non-substratist bundle view of individuation. But Guise Theory is a general *thinking semantics* for language as a means of thinking, regardless of what we think and in which types of experience we think what we think, but anxious to uphold and account for the unity of all thought contents. Thus, e.g., we think of nonexistents not only in literature, but also in planning courses of action, or in contemplating and proposing scientific theories. Thus the thinkable individual guises need not exist. This leads to the view that ordinary infinitely-propertied objects are special bundles of existing guises. Then the account of existing objects or substances culminates in a bundle-bundle view of individuation.

Perhaps another peek into Guise Theory may be helpful.

Palpably, by the same ontological prisms of Oedipus's beliefs we establish the following:

(11) The number 2 is the same as the square root of 4;
(12) The number 2 is not strictly identical with the square root of 4.
(21) Sancho Panza is the same as Don Quixote's squire.
(22) Sancho Panza is not strictly identical with Don Quixote's squire.

Palpably, the sameness mentioned in (11) is not the self-same sameness as that mentioned in (2). The former depends exclusively on the a priori principles of logic and arithmetic, the latter depends on those as well as on the facts of the world. We must distinguish these samenesses. The a priori sameness between number guises we call *conflation*.

Likewise, we must distinguish consubstantiation and conflation both from the sameness mentioned in (21). The sameness between Don Quixote's squire and Sancho Panza is certainly not a priori: it depends on the empirical facts of Miguel de Cervantes's creation of *Don Quixote*. Still we must not confuse it with consubstantiation, and we call it *consociation*. Consubstantiation is nature-made (or God-made, if you wish); consociation is man-made; the former is complete in that an existing object has consubstantiationally a property of the property's complement, whereas fictional characters have consociationally only the properties their creators assign to them.

Furthermore, there are indexical guises that account for perception. Again, in the standard approach to semantics there has been a heavy concentration on the existents and on what we believe, yielding what I call a *doxastic semantics*. Just consider the following situation.

Perceptual Situation. Jones is jogging in a forest on a muggy foggy morning. He is confronted with a visual field and he forms a perceptual judgment. There are four cases to be considered.

(A) He judges naively, correctly taking what he sees as true:
 (1) That is a drowning man.
(B) He judges naively, but incorrectly taking what he sees as true:
 (1) That is a drowning man.
(C) He is in doubt about his perceptions, and even though he is not hallucinating he gingerly judges:
 (2) That seems to be [looks as if it were] a drowning man.
(D) He is in doubt about his perceptions, rightly so because he is hallucinating, and cautiously judges:
 (2) That seems to be [looks as if it were] a drowning man.

Let us exegesize the situation. Several points are crucial. *First*, the semantics and the pragmatics of the speech situation require that the demonstrative 'That' should have precisely the same meaning and referent in whatever of the four cases actually obtains. *Second*, the differences in the cases is not semantic or referential, but in reality or in attitude. *Third*, reality lies beyond Jones's present perception: in the examples it comes in as OUR commentary, since we function here as the repositories of reality and truth. *Fourth*, Jones's attitudes are available to Jones. He expresses them by means of the copulas 'is' and 'seems to be' [or 'looks as if it were'].

The standard doxastic semantics seizes on case (A) and gives us an account of the meaning and referent of 'that' in (A)(1). It naturally takes that referent to be the infinitely-propertied entity in the real world which is the SAME (in which sense?) as what he sees and calls *that*. But then the byplay between (A) and (B)–(C) becomes troublesome. Language as a means of thinking has a general semantics that allows it to be impervious to what reality has as well as to his attitude to what he experiences. Here Guise Theory fastens to the semantic unity of the demonstrative 'that', which allows it to function in (A) as well as in (B)–(D). Clearly, then, the *strict semantico-pragmatic referent* of 'that' is not a massive infinitely-propertied physical object or person. In the case in which the belief is existential, as in (1), and veridical, as in case (A), then there exists such a massive object as *doxastic* referent—over and above the strict semantico-pragmatic referent. This must be a thinner individual: a demonstrative individual guise that exists in the perceptual field.[12]

VII. CONCLUSION

These rudiments of Guise Theory should suffice here to illustrate the philosophical process described above: the proto-philosophical exegesis of facts of experience and of the language describing those facts; the analysis of the problem; the consideration of dia-philosophical alternatives; the non-invidious, cooperative construction of a sym-philosophical theory.

Guise Theory is, of course, just one comprehensive account and elucidation of the enormous collection of data it caters to. Other theories are possible. Other theories should be developed. It is not that I am liberal concerning different theories. I need them myself to satisfy my romantic desire to see the world in as many different ways as possible. And the most I can do is to design the schema of one view—hoping that others will work out the requisite full battery of views. But I am liberal with respect to views. I am dogmatic, however, concerning philosophical method. Theories should be *developed* to the hilt, so that they offer a comprehensive account of the most pervasive structures of the world and our most diverse types of experience, illuminating the ubiquitous role of thinking and language in experience. The crucial demand is Leibniz's: we need the most comprehensive theories that are as simple as this is compatible with comprehensiveness. (In connection with this see the discussion of the Coffee-pot Approach to philosophical problems in *On Philosophical Method*.)

I hope that the preceding discussion both places in relief my optimistic view of and attitude toward the practice of philosophy, and shows some of my reasons why.

NOTES

1. My optimistic and pluralistic conception of philosophy as well as some of its methods for the core problems of philosophy are discussed in detail, with a critical appreciation of its background recent history, in Hector-Neri Castañeda, *On Philosophical Method* (Bloomington, Indiana: Noûs Publications, 1980). My living through the recent developments in philosophy and my personal reaction in terms of research programs to those developments are briefly discussed in 'Self-Profile: *De Dicto* and *De Re*' in James E. Tomberlin, ed., *Hector-Neri Castañeda* (Dordrecht: Reidel Publishing Company, Profiles No. 6, 1986).

2. This sentence is a combination of parts of two sentences, one on p. 12, and the other on p. 377, of Richard Rorty, *Philosophy and the Mirror of Nature* (Princeton: Princeton University Press, 1979).

3. See *On Philosophical Method*, chapters 2 and 4.

4. See *On Philosophical Method*, chapter 3.

5. See 'The Semiotic Profile of Indexical (Experiential) Reference', *Synthese*

49 (1981): 275–316. See also Esa Saarinen, 'Castañeda's Philosophy of Language' in Tomberlin 1986.

6. See Plato's *Theaetetus* for his presentation and ultimate refutation of Protagoras's metaphysics. See Hector-Neri Castañeda, *The Structure of Morality* (Springfield, Illinois: Charles Thomas, 1974), toward the end of chapter 1, for a rebuttal of several versions of moral relativism. The argument, adopted from an argument by Jonathan Harrison against Emotivism, pivots on the thinkability of error. It is applicable to metaphysics.

7. See Ludwig Wittgenstein, *Philosophical Investigations* (New York: The Macmillan Company, 3rd ed. trans. G. E. M. Anscombe, 1968), 194–199, 205 ff.

8. See 'Philosophical Refutations', in James H. Fetzer, ed., *Principles of Philosophical Reasoning* (Totowa, New Jersey: Rowman and Allanheld, 1984), 227–258.

9. See *On Philosophical Method*, chapter 4, especially sections 4, 7–9.

10. See 'Indicators and Quasi-indicators', *American Philosophical Quarterly*, 4: 85–100, which still contains the richer collection of data about indexical and quasi-indexical reference. See also 'The Semiotic Profile' mentioned above in note 5.

11. What I say about 'I intend to go' seems to agree with some linguists' claim that 'I intend to go' results from a deletion transformation of the duplicate subject 'I'. This may be true. But my claim is different. For one thing, my discussion is meant to be phenomenological, that is, to exegesize the sentence for its experiential content, and is meant to be neutral with respect to linguists' linguistic theory. This can be appreciated by observing that if linguists decide to throw away the theory of transformations, my discussion remains intact. For another thing, I am actually positing a different bit of linguistic theory: as I see it, in 'I intend myself (I) to go' the subordinate clause does *not* really have the same subject as the main clause: whereas the main subject is the indicator 'I', the subordinate subject is the quasi-indicator 'myself', or 'I', if you wish. (Marcelo Dascal showed me the need for this clarification.)

12. For a discussion of the large collection of data on which Guise Theory is founded see Hector-Neri Castañeda, 'Thinking and the Structure of the World', *Philosophia* 4 (1974): 4–40; 'Perception, Belief, and the Structure of Physical Objects and Consciousness', *Synthese* 35 (1977): 285–351, or *Sprache und Erfahrung* (Frankfurt: Suhrkamp, 1982, a translation of some of my essays in semantics and ontology with an introduction by Helmut Pape). For major critical discussion of Guise Theory see the following studies:

1) James E. Tomberlin, ed., *Hector-Neri Castañeda*, cited in note 1;
2) James E. Tomberlin, ed., *Agent, Language, and the Structure of the World* (Indianapolis: Hackett Publishing Company, 1983);
3) Hector-Neri Castañeda, 'Method, Individuals, and Guise Theory (Response to Alvin Plantinga)', in 2);
4) Hector-Neri Castañeda, 'Belief, Sameness, and Cambridge Changes (Response to Romane Clark)', in 2);
5) Romane Clark, 'Predication Theory: Guised and Disguised' in 2);
6) Alvin Plantinga, 'Guise Theory' in 2);
7) Jay Rosenberg, 'Castañeda's Ontology' in 1);
8) David Woodruff Smith, 'Mind and Guise' in 1);
9) Jeffrey Sicha, 'Castañeda on Plato, Leibniz, and Kant' in 1);
10) Jig-Chuen Lee, 'Guise Theory', *Philosophical Studies* 46 (1984): 403–415;

11) James E. Tomberlin, 'Identity, Intensionality, and Intentionality', *Synthese* 61 (1984): 111–131;
12) William Rapaport, 'Meinongian Theories and the Russell Paradox', *Noûs* 12 (1978): 53–80; Errata: 13 (1979): 125;
13) William Rapaport, 'Logical Foundations for Belief Representation', *Cognitive Science* (forthcoming).

3

Hilary Putnam

WHY IS A PHILOSOPHER?

The great founders of analytic philosophy—Frege, Carnap, Wittgenstein, and Russell—put the question 'How does language "hook on" to the world?' at the very center of philosophy. I have heard at least one French philosopher say that Anglo-Saxon philosophy is 'hypnotized' by this question. Recently a distinguished American philosopher[1] who has come under the influence of Derrida has insisted that there is no 'world' out there for language to hook on *to*. There are only 'texts'. Or so he says. Certainly the question 'How do texts connect with other texts?' exerts its own fascination over French philosophy, and it might seem to an American philosopher that contemporary French philosophy is 'hypnotized' by *this* question.

My aim in recent years has not been to take sides in this debate about which the question should be, for it has come to seem to me that both sides in this quarrel are in the grip of simplistic ideas—ideas which do not work, although this is obscured by the fact that thinkers of genius have been able to erect rich systems of thought, great expressions of the human metaphysical urge, on these shaky foundations. Moreover, it has come to seem to me that these ideas are intimately related, that the great differences in style between French (and more generally 'continental') philosophy and 'anglo-saxon' philosophy conceal deep affinities.

Relativism and Positivism are Self-refuting

To engage in a broad but necessary oversimplification, the leading movement in analytic philosophy was logical positivism (not from the beginning of analytic philosophy, but from 1930 to about 1960). This movement was challenged by 'realist' tendencies (myself and Kripke), by

Published in French in *Encyclopédie Philosophique*, Vol. I, translated by Jacques Riche.

'historicist' tendencies (Kuhn and Feyerabend), and by materialist tendencies. I will not take the risk of identifying the leading movement in French philosophy today but if logical positivist ideas were for a long time (thirty crucial years) at the center of 'anglo-saxon' philosophy, *relativist* ideas were (and perhaps continue to be) at the center of French philosophy. This may seem surprising because philosophers in all countries regularly remark that positivist and relativist ideas are self-refuting (and they are right to do so). But the fact of self-contradiction does not seem to stop or even slow down an intellectual fashion, partly because it is a fashion, and partly for the less disreputable reason that people don't want to stop it as long as interesting work is being produced under its aegis. Nevertheless, in my recent work[2] I have been trying to stop these fashions because they begin to threaten the possibility of a philosophical enterprise that men and women of good sense can take seriously.

Relativists do not, indeed, generally go quite all the way. Paul Feyerabend *is* willing to go all the way, that is, as far as to refuse to admit *any* difference between saying 'It is raining' and '*I think* it is raining' (or whatever). For Feyerabend *everything* he thinks and says is merely an expression of his own subjectivity at the instant. But Michel Foucault claims that he is not a relativist; we simply have to wait for the future structuralist Copernican Revolution (which we cannot yet predict in any concrete detail) to explain to us how to avoid the whole problem of realism versus relativism.[3] And Richard Rorty[4] simultaneously denies that there *is* a problem of truth (a problem of 'representation') at all and insists that some ideas do, and some do not, 'pay their way'.

If there is such a thing as an idea's paying its way, that is *being right*, there is, inevitably, the question of the *nature* of this 'rightness'. What makes speech more than just an expression of our momentary subjectivity is that it can be appraised for the presence or absence of this property— call it 'truth', or 'rightness', or 'paying its way', or what you will. Even if it is a culturally relative property (and what relativist really thinks that relativism is only *true-for-my-subculture*?), that does not exempt us from the responsibility of saying *which* property it is. If being true (or 'paying one's way' as an idea) is just being successful by the standards of one's cultural peers, for example, then the entire past becomes simply a sort of logical construction out of one's own culture.

It is when one notices this that one also becomes aware how very *positivist* the relativist current really is. Nietzsche himself (whose *Genealogy of Morals* is the paradigm for much contemporary relativist-cum-post-structuralist writing) is at his most positivist when he writes about the nature of truth and value. It seems to me that what bothers both relativists and positivists about the problem of representation is that representa-

tion—that is to say, intentionality—simply does not fit into our reductive post-Darwinian picture of the world. Rather than admit that that picture is only a partial truth, only an abstraction from the whole, both positivists and relativists seek to content themselves with oversimplified, in fact with patently absurd, answers to the problem of intentionality.[5]

Logical Empiricism and the Realist Reaction

In the United States, these relativist and historicist views were virtually ignored until the nineteen-sixties. The dominant currents in the forties and fifties were empiricist currents—the pragmatism of John Dewey and (much more) the Logical Empiricism transported to the United States by Rudolf Carnap, Hans Reichenbach, and others. For these latter philosophers the problem of the nature of truth took back place to the problem of the nature of confirmation.

The primary kind of *correctness* and *incorrectness* that a sentence possesses was thought to be the amount of inductive support the sentence receives on the basis of the evidence as the speaker perceives and remembers that evidence. For Quine, who has many affinities to these philosophers, although he must be counted as a post-positivist, *truth* is not a property at all; "to say a sentence is true is merely to reaffirm the sentence". (Quine also says that the only truth he recognizes is 'immanent truth'—truth from within the evolving doctrine. Note how very 'French' this sounds!) But if truth and falsity are not properties at all—if a sentence is 'right' or 'wrong' in a *substantive* sense only epistemically (only in the sense of being confirmed or disconfirmed by the present memories and experiences of a speaker)—then how do we escape from solipsism? Why isn't this picture *precisely* the picture of solipsism-of-the-present-instant? (To say that it is only a *methodological* solipsism is hardly a clear answer. It sounds as if saying that there are past times, other speakers, and truths which are not confirmed right now is correct 'speaking with the vulgar' but not really the right standpoint thinking as a philosopher.)

Perhaps on account of these questions, by the end of the nineteen-sixties I (joined by Saul Kripke, whom I learned in 1972 had been working along similar lines) began to revive and elaborate a kind of realism. Our realism was not simply a revival of past ideas, however, because it consisted in large part in an attack on conceptions which had been central to realism from the seventeenth century on.

The Theory of Direct Reference

The seventeenth century thought of concepts as entities immediately available to the mind, on the one hand, and capable of fixing reference to

the world, on the other. On this picture, the concept *gold*, for example, is in the mind of any speaker (even if he uses a Greek word, or a Latin word, or a Persian word) who can refer to gold; the 'extension', or reference, of the word 'gold', or 'chrysos', or whatever, is determined by the concept. This picture of language is both individualistic (each speaker has the mechanism of reference of every word he uses in his own head) and aprioristic (there are 'analytic truths' about the natural kinds we refer to, and these are 'contained in our concepts').

It is not hard to see that this picture does violence to the facts of language use and conceptual thought, however. Few speakers today can be certain that an object is gold without taking the object to a jeweler or other expert. The reference of our words is often determined by other members of the linguistic community to whom we are willing to defer. There is a *linguistic division of labor* which the traditional picture entirely ignores.[6]

Kripke pointed out[7] that this linguistic division of labor (or 'communication' of 'intentions to refer', in his terminology) extends to the fixing of the reference of proper names. Many people cannot give an identifying description of the prophet Moses, for example. (The description, 'The Hebrew prophet who was known as "Moses"' is not even correct; in Hebrew, Moses is called 'Mosheh', not Moses.) This does not mean that those people are not *referring* when they speak of 'the prophet Moses'; we understand that they are referring to a definite historic figure (assuming Moses actually existed). Experts today can tell us that that figure was called (something like) 'Mosheh', but that is not an identifying description of Moses. There might have been Hebrew prophets who have been forgotten who were called 'Mosheh', and the actual 'Mosheh' might have had an Egyptian name which became corrupted to 'Mosheh' centuries later. The 'right' Mosheh or Moses is the one at the end of a *chain*, a chain leading backward in time. Or, to put it the right way around, the 'right' Moses—the one we are referring to—is the one at the *beginning of a history*, a history which causally underpins our present uses and which is knitted together by the intention of speakers to refer to the person previous speakers referred to.

We may use descriptions to indicate to whom or to what we mean a word to refer, but even when those descriptions are correct they do not become *synonymous* with the word. Words acquire a kind of 'direct' connection with their referents, not by being attached to them with metaphysical glue, but by being used to name them even when we suppose the identifying description may be false, or considering hypothetical situations in which it is false. (We have already had an example of this: we can refer to Moses as 'Moses' even when we know that this was not the name he actually bore. And I can explain which Richard Nixon I mean by saying 'the

one who was president of the United States' and then go on to imagine a situation in which 'Richard Nixon was never elected President of the United States'. I repeat, calling these cases 'cases of direct reference' is merely denying that the name—'Moses' or 'Richard Nixon'—is synonymous with a description: 'the Hebrew Prophet named "Moses"' or 'The President of the United States named "Richard Nixon"'—the mechanisms by which this 'direct reference' is established are just the opposite of direct, involving chains of linguistic communication and division of linguistic labor as they do.)

A second way in which the seventeenth-century model of reference as fixed by concepts in individual minds does violence to the facts is, perhaps, more subtle. The reference of our words is determined (in some cases) by the non-human environment as well as by other speakers. When I speak of 'water' I mean to be speaking of the liquid that falls as rain in *our* environment, the one that fills the lakes and rivers *we* know, etc. If somewhere in the universe there is a Twin Earth where everything is much as it is here *except* that the liquid that plays the role of 'water' on Twin Earth is not H_2O but XYZ, then that does not falsify *our* statement that 'Water is H_2O'. What we refer to as 'water' is whatever liquid is of the composition, etc., of *our* paradigmatic examples of water. Discovering that composition, the laws of behavior of the substance, etc., may lead scientists to say that some liquid which a layman would take to be water is not really water at all (and the layman would defer to this judgement). In this way, the reference of the terms 'water', 'leopard', 'gold', etc., is partly fixed by the substances and organisms themselves. As the nineteenth-century pragmatist Charles Peirce long ago put it, the 'meaning' of these terms is open to indefinite future scientific discovery.

Recognizing these two factors—the division of linguistic labor and the contribution of the environment to the fixing of reference—goes a long way to overcoming the individualistic and aprioristic philosophical Weltanschauung that has long been associated with realism. If what a term refers to depends on other people and on the way the entire society is embedded in its environment, then it is natural to look with skepticism at the claim that armchair 'conceptual analysis' can reveal anything of great significance about the nature of things. This kind of 'realism' goes with a more fallibilistic spirit in philosophy. But, as I was soon to realize, the traditional problems connected with realism are thereby considerably sharpened.

"Brains in a Vat"

The new realism gives up the idea that our mental 'representations' have any *intrinsic* connection with the things to which they refer. This can be

seen in the example of "Twin Earth" mentioned above: our 'representations' of water (prior to the learning that that *water is H₂O/water is XYZ*) may have been phenomenologically identical with the Twin Earthers 'representations', but, according to the 'theory of direct reference' we were referring to H_2O (give or take some impurities) all along, and the Twin Earthers were referring to XYZ all along. The difference in the reference was, so to speak, 'sleeping' in the substance itself all along, and was awakened by the different scientific discoveries that the two cultures made. There is no magical connection between the phenomenological character of the representation and the set of objects the representation denotes.

Now, imagine a race of people who have been literally created by a mad super-scientist. These people have brains like ours, let us suppose, but not bodies. Instead of bodies, they have the illusion of bodies, of an external environment (like ours), etc. In reality they are brains suspended in a vat of chemicals. Tubes connected to the brains take care of the circulation of blood, and wires connected to the nerve-endings produce the illusion of sensory impulses coming to the 'eyes', 'ears', etc., and of 'bodies' executing the motor-commands of these brains.

A traditional skeptic would have used this case (which is just the scientific version of Descartes's demon) to show that we may be radically deceived about the existence of an external world at all like the one we think we inhabit. The major premise in this skeptical argument is that the race we just imagined is a race of beings who *are* radically wrong in their beliefs. But are they?

It certainly seems that they are. For example, these people believe "We are not brains in a vat. The very supposition that we might be is an absurd philosopher's fantasy." And obviously they *are* brains in a vat. So they are wrong. But not so quick!

If the Brain-in-a-Vatists' word 'vat' refers to what *we* call 'vats' and the Brain-in-a-Vatists' word 'in' refers to spatial containment and the Brain-in-a-Vatists' word 'brain' refers to what we call 'brains', then the sentence 'We are brains in a vat' has the same truth condition for a Brain-in-a-Vatist as it would have for one of us (apart from the difference in the reference of the pronoun 'we'). In particular, it is (on this supposition) a true sentence, since the people who think it are, in fact, brains spatially contained in a vat, and its negation, 'We are not brains in a vat' is a false sentence. But, if there is no intrinsic connection between the word 'vat' and what are called 'vats' (any more than there is an intrinsic connection between the word 'water' and the particular liquid, H_2O, we call by that name), why should we not say that what the word 'vat' refers to in Brain-in-a-Vatish is phenomenological appearances of vats and not 'real' vats? (And similarly for 'brain' and 'in'.) Certainly the *use* of 'vat' in Brain-in-a-

Vatish is dependent on the presence or absence of phenomenological appearances of vats (or of features in the program of the computer that controls the 'vat reality'), and *not* on the presence or absence of real vats. Indeed, if we suppose there aren't any real vats in the mad scientist's world except the one that the brains are in, then it seems as if there is no connection, causal or otherwise, between actual vats and the use of the word 'vat' in Brain-in-a-Vatish (except that the brains wouldn't be able to use the word 'vat' if the one real vat broke—but this is a connection between the one real vat and *every* word they use, not a differential connection between real vats and uses of the word 'vat'.)

This reflection suggests that when the Brains-in-a-Vat think "we are brains in a vat" the truth-condition for their utterance must be that they are *brains-in-a-vat in the image*, or something of that kind. So this sentence would seem to be *false*, not true, when *they* think it (even though they are brains in a vat from *our* point of view). It would seem that they are *not* deceived—not thinking anything radically false. Of course there are truths that they cannot even express; but that is, no doubt, true of every finite being. The very hypothesis of 'radical deception' seems to depend on the idea of a predetermined, almost magical, connection between words or thought-signs and external objects that Transcendent Realism depends on.

Indeed, symbolic logic tells us that there are many different 'models' for our theories and many different 'reference relations' for our languages.[8] This poses an ancient problem: *if there are many different 'correspondences' between thought-signs or words and external objects, then how can any one of these be singled out?*

A clever form of this problem (which, of course, goes back to the middle ages) is due to Robert Nozick (unpublished communication). Let C_1 and C_2 be two different 'correspondences' (reference-relations, in the sense of model theory) between our signs and some fixed sets of objects. Choose them so that the same sentences come out true no matter whether we interpret our words as 'referring' to what they correspond to in the sense of C_1 or as referring to what they correspond to in the sense of C_2. That this can be done—that there are alternative ways of putting our signs in correspondence with things which leave the set of true sentences invariant—was emphasized by Quine in his famous doctrine of Ontological Relativity.[9] Now, imagine that God arranged things so that when a man uses a word he refers to the things which correspond-C_1 to that word (the things which are the 'image' of the word under the relation C_1) while when a woman uses a word she refers to the things which correspond-C_2 to that word. Since the truth conditions for whole sentences are unaffected, no one would ever notice! So how do we know (how can we even give sense to

the supposition) that there *is* a determinate correspondence between words and things?

There are many quick answers to this question. Thus, a philosopher is likely to say, "When we come to learn the use of the word 'vat' (or whatever), we don't merely associate the word with certain visual sensations, certain tactile sensations, etc. We are *caused* to have those sensations, and the beliefs which accompany those sensations, by certain external events. Normally those external events involve the presence of vats. So, indirectly, the word *vat* comes to be associated with vats."

To see why this answer fails to speak to what puzzles us, imagine it being given first by a man and then by a woman. When the woman says this she is pointing out that certain ones of a speaker's beliefs and sensations are in a certain relation—the relation *effect$_2$*—to certain external events. In fact they are caused$_2$ by the presence$_2$ of a vat$_2$. When a male philosopher says this, he is pointing out that the same beliefs and impressions are caused$_1$ by the presence$_1$ of vats$_1$. Of course, they are both right. The word 'vat' is 'indirectly associated' with vats$_2$ (in the way pointed out by the woman) and also 'indirectly associated' with vats$_1$ (in the way pointed out by the man). We still haven't been given any reason to believe in the One metaphysically singled out correspondence between words and things.

Sometimes I am accused (especially by members of the materialist current in analytic philosophy) of caricaturing the realist position. A realist, I am told, does not claim that reference is fixed by the connection in our theory between the *terms* 'reference', 'causation', 'sensation', etc.; the realist claims that reference is 'fixed by causation itself'.

Here the philosopher is ignoring his own epistemological position. He is philosophizing as if naive realism were true for him, or, equivalently, as if he and he alone were in an *absolute* relation to the world. What *he* calls 'causation' really is causation, and *of course* there is somehow a singled-out correspondence between the word and one definite relation in his case. But how this can be so is just the question at issue.

Internal Realism

Must we then fall back into the view that 'there is only the text'? That there is only 'immanent truth' (truth *according to* the 'text')? Or, as the same idea is put by many analytic philosophers, that 'is true' is only an expression we use to 'raise the level of language'? Although Quine, in particular, seems tempted by such a view (supplemented by the idea that a pure cause-effect story is a complete scientific and philosophical description of the use of a language), the problem with such a view is obvious. If the cause-effect description is complete, if all there is to say about the

'text' is that it consists in the production of noises (and subvocalizations) according to a certain causal pattern; if the causal story is not to be and need not be supplemented by a normative story; if there is no substantive property of either warrant or truth connected with assertion; then there is no way in which the noises that we utter or the inscriptions we write down or the subvocalizations that occur in our bodies are more than expressions of our subjectivity. As Edward Lee put it in a fine paper on Protagoras and Plato,[10] a human being resembles an animal producing various cries in response to various natural contingencies, on such a view, or better, a plant putting forth now a leaf and now a flower. Such a story leaves out that we are *thinkers*. If such a story is right, then not only is representation a myth; the very idea of thinking is a myth.

In response to this predicament, the predicament of being asked to choose between a *metaphysical* position on the one hand and a group of *reductionist* positions on the other, I was led to follow Kant in distinguishing between two sorts of realism (whether Saul Kripke, whose work I alluded to above, would follow me in *this* move I rather doubt). The two sorts I called "metaphysical realism" and "internal realism".[11] The *metaphysical realist* insists that a mysterious relation of 'correspondence' is what makes reference and truth possible; the internal realist, by contrast, is willing to think of reference as internal to 'texts' (or theories), *provided* we recognize that there are better and worse 'texts'. 'Better' and 'worse' may themselves depend on our historical situation and our purposes; there is no notion of a God's-eye view of truth here. But the notion of a right (or at least a 'better') answer to a question is subject to two constraints: (1) *Rightness is not subjective.* What is better and what is worse to say about most questions of real human concern is not just a matter of *opinion*. Recognizing that this is so is the essential price of admission to the community of sanity. If this has become obscure, it is in part because the tides of philosophical theory have swept so high around the words 'subjective' and 'objective'. For example, both Carnap and Husserl have claimed that what is 'objective' is the same as what is 'intersubjective', i.e., in principle public. Yet this principle itself is (to put it mildly) incapable of 'intersubjective' demonstration. That anyone interested in philosophy, politics, literature, or the arts should really equate being the better opinion with being the 'intersubjective' truth is really quite amazing! (2) *Rightness goes beyond justification.* While Michael Dummett[12] has been extremely influential in advocating the sort of non-metaphysical-realist and non-subjectivist view of truth I have been putting forward, his formula that 'truth is justification' is misleading in a number of ways, which is why I have avoided it in my own writings. For one thing, it suggests something which Dummett indeed believes and I do not: that one

can *specify* in an effective way what the justification conditions for the sentences of a natural language are. Secondly it suggests something on which Dummett's writing is rather ambiguous: that there is such a thing as *conclusive* justification, even in the case of empirical sentences.

My own view is that truth is to be identified with idealized justification, rather than with justification-on-present-evidence. 'Truth' in this sense is as context sensitive as *we* are. The assertibility conditions for an arbitrary sentence are not surveyable.

If assertibility conditions are not surveyable, how do we learn them? We learn them by acquiring a practice. What philosophers in the grip of reductionist pictures miss is that what we acquire is not a knowledge that can be applied as if it were an algorithm. The impossibility of formalizing the assertibility conditions for arbitrary sentences is just the impossibility of formalizing human rationality itself.

The Fact-Value Dichotomy

If I dared to be a metaphysician, I think I would create a system in which there were nothing but obligations. What would be metaphysically ultimate, in the picture I would create, would be what we *ought* to do (ought to say, ought to think). In my fantasy of myself as a metaphysical superhero, all 'facts' would dissolve into 'values'. That there is a chair in this room would be analyzed (metaphysically, not conceptually—there is no 'language analysis' in this fantasy) into a set of obligations: the obligation to think that there is a chair in this room if epistemic conditions are (were) 'good' enough, for example. (In Chomskyan language, one might speak of 'competence' instead of 'obligation': there is the fact that an ideally 'competent' speaker would say (think) *there is a chair in this room* if conditions were sufficiently 'ideal'.) Instead of saying with Mill that the chair is a "permanent possibility of sensations", I would say that it is a *permanent possibility of obligations*. I would even go as far as to say that my 'sense-data', so beloved of generations of empiricists, are nothing but permanent possibilities of obligations, in the same sense.

I am not—alas!—so daring as this. But the reverse tendency—the tendency to eliminate or reduce everything to description—seems to me simply perverse. What I do think, even outside of my fantasies, is that fact and obligations are thoroughly interdependent; there are no facts without obligations just as there are no obligations without facts.

This is, in a way, built into the picture of truth as (idealized) justification. To say that a belief is justified is to say that it is what we ought to believe; justification is a normative notion on the face of it.

Positivists attempted to side-step this issue by saying that which definition of justification (which definition of 'degree of confirmation') one

accepts is conventional, or a matter of utility, or, as a last resort, simply a matter of accepting a 'proposal'. But proposals presuppose ends or values; and it is essential doctrine for positivism that the goodness or badness of ultimate ends and values is entirely subjective. Since there are no universally agreed upon ends or values with respect to which positivist 'proposals' are *best*, it follows from the doctrine that the doctrine itself is merely the expression of a subjective preference for certain language forms (scientific ones) or certain goals (prediction). We have the strange result that a completely consistent positivist must end up as a total relativist. He can avoid inconsistency (in a narrow deductive sense), but at the cost of admitting that all philosophical propositions, including his own, have no rational status. He has no answer to the philosopher who says, "I know how you feel, but, you know, positivism isn't *rational in my system.*"

Metaphysical realists attempted to deal with the same issue by positing a total logical cleavage between the question of what is *true* and the question of what is *justified*. But what is *true* depends on what our terms *refer to*, and—on any picture—determining the reference of terms demands sensitivity to the referential intentions of actual speakers and an ability to make nuanced decisions as to the best reconstruction of those intentions. For example, we say that the term 'phlogiston' did not refer to anything. In particular, it did not refer to valence electrons, although a famous scientist (Cyril Stanley Smith) once proposed that "there really is such a thing as phlogiston; it turns out that phlogiston is valence electrons". Why do we regard it as reasonable of Bohr to keep the same word 'electron' (*Elektron*) in 1900 and in 1934, and thereby to treat his two very different theories, his theory of 1900 and his theory of 1934, as theories which described the same objects and unreasonable of Cyril Smith to say that 'phlogiston' referred to valence electrons?

It seems to me that there are two alternatives open to the metaphysical realist who wishes to avoid realism about *justification* and other values. He might say that there is a fact of the matter as to what is a good 'rational reconstruction' of a speaker's referential intentions (and that treating 'Elektron' as a designator of whatever sort of entity is responsible for certain effects and approximately obeys certain laws is such a good 'rational reconstruction'), but not an objective fact about justification in science or daily life. Or, secondly, he might say that interpretation *is* subjective, but that this does not mean that reference ('correspondence') is subjective. The first option would involve him in the claim that deciding on a proper 'rational reconstruction' of a speaker's semantic intentions is an activity isolated from full human rationality, full 'inductive competence', etc. But how can the decision that something does or does not 'approximately' fit certain laws (near enough, anyway)—the decision that electrons as we

conceive them 'fit' the referential intentions of Bohr in 1900 but not the referential intentions of phlogiston theorists a little earlier—possibly be isolable from or different in nature than decisions about *reasonableness* in general? The second option would involve one in the claim that we have a notion of reference which is independent of the procedures and practices by which we decide that people in different situations with different bodies of belief do, in fact, refer to the same things. This claim seems unintelligible. If this possibility is put forward seriously, then I have to throw up my hands!

Of course, a metaphysical realist might be a realist about justification *as well as* a realist about truth. But that is, in a way, my point: neither a positivist nor a metaphysical realist can avoid absurdities if he attempts to deny any objectivity whatever to the question what constitutes *justification*. And *that* question, metaphysically speaking, is a typical *value* question.

The argument I have just briefly rehearsed (it is developed at length in my book *Reason, Truth and History*) has been called a 'companions in the guilt' argument. The structure is: 'You say (imagine this addressed to a philosopher who believes in a sharp fact-value dichotomy) that value-judgments have no objective truth-value, that they are pure expressions of preference. But the reasons that you give—that there are disagreements between cultures (and within one culture) over what is and is not valuable; that these controversies cannot be settled "intersubjectively"; that our conceptions of value are historically conditioned; that there is no "scientific" (reductive) account of what value *is*—all apply immediately, and without the slightest change, to judgments of justification, warrant, reasonableness—to epistemic values generally. So, if you are right, judgments of epistemic justification (warrant) are also entirely subjective. But judgments of coreferentiality, and hence of reference and truth, depend on judgments of reasonableness. So instead of giving us a fact-value *dichotomy* you have given us a reason for abandoning epistemic concepts, semantic concepts, indeed, abandoning the notion of a *fact* altogether.' Put more simply, the point is that no conclusion should be drawn from the fact that we cannot give a 'scientific' explanation of the possibility of values until we have been shown that a 'scientific' explanation of the possibility of reference, truth, warrant, etc. is possible. And the difficulties with the correspondence theory suggest that to ask for this latter is to ask for a we-know-not-what.

Why am I not a Relativist?

My failure to give any metaphysical story at all, or to explain even the

possibility of reference, truth, warrant, value and the rest, often evokes the question, 'But then, why aren't you a relativist too?'

I can sympathize with the question (and even with the querulousness which often accompanies it), because I can sympathize with the urge to *know*, to *have* a totalistic explanation which includes the thinker in the act of discovering the totalistic explanation in the totality of what it explains. I am not saying that this urge is 'optional', or that it is the product of events in the sixteenth century, or that it rests on a false presupposition because there aren't really such things as truth, warrant, or value. But I am saying that the project of providing such an explanation has failed.

It has failed not because it was an illegitimate urge—what human pressure could be more worthy of respect than the pressure to *know*?—but because it goes beyond the bounds of any notion of explanation that we have. Saying this is, perhaps, not putting the grand projects of Metaphysics and Epistemology away for good—what another millenium, or another turn in human history as profound as the Renaissance, may bring forth is not for us today to guess—but it is saying that the time has come for a moratorium on Ontology and a moratorium on Epistemology. Or rather, the time has come for a moratorium on the kind of ontological speculation that seeks to describe the Furniture of the Universe and to tell us what is Really There and what is Only a Human Projection, and for a moratorium on the kind of epistemological speculation that seeks to tell us the One Method by which all our beliefs can be appraised.

Saying 'a moratorium on these projects' is, in fact, the opposite of relativism. Rather than looking with suspicion on the claim that some value-judgments are reasonable and some are unreasonable, or some views are true and some false, or some words refer and some do not, I am concerned with bringing us back to precisely these claims, which we do, after all, constantly make in our daily lives. Accepting the 'manifest image', the *Lebenswelt*, the world as we actually experience it, demands of us who have (for better or for worse) been philosophically trained that we both regain our sense of mystery (for it *is* mysterious that something can both be *in* the world and *about* the world) and our sense of the common (for that some ideas are 'unreasonable' is, after all, a *common* fact—it is only the weird notions of 'objectivity' and 'subjectivity' that we have acquired from Ontology and Epistemology that make us unfit to dwell in the common).

Am I then advocating a return to 'ordinary language philosophy' in the sense of Wittgenstein or Austin? But what on earth *is* 'ordinary language' (*normales Sprachverkehr*)?

Am I then leaving anything at all for philosophers to do? Yes and No. The very idea that a poet could tell poets who come after him 'what to do'

or a novelist could tell novelists who come after him 'what to do' would and should seem absurd. Yet we still expect philosophers not only to achieve what they can achieve, to have insights and to construct distinctions and follow out arguments and all the rest, but to tell philosophers who come after them 'what to do'. I propose that each philosopher ought to leave it more problematical what is left for philosophy to do, but philosophy should go on. If I agree with Derrida on anything it is on this: that philosophy is writing, and that it must learn now to be a writing whose authority is always to be won anew, not inherited or awarded because it is Philosophy. Philosophy is, after all, one of the humanities and not a science. But that does not exclude anything—not symbolic logic, or equations, or arguments, or essays. We philosophers inherit a field, not authority, that is enough. It is, after all, a field which fascinates a great many people. If we have not entirely destroyed that fascination by our rigidities or by our posturings, that is something for which we should be truly grateful.

NOTES

1. Richard Rorty. See his *Philosophy and the Mirror of Nature* (Princeton: Princeton University Press, 1979) and *Consequences of Pragmatism* (Minneapolis: University of Minnesota Press, 1982).

2. See my *Reason, Truth, and History* (Cambridge: Cambridge University Press, 1982) and *Philosophical Papers, vol. 3: Realism and Reason* (Cambridge: Cambridge University Press, 1983).

3. *Les Mots et les choses*, especially the concluding discussion of 'the human sciences'.

4. See the works cited in note 1.

5. For a more detailed discussion, see my *Reason, Truth and History*, especially chapter V, and 'Why Reason Can't be Naturalized', in *Realism and Reason*.

6. On this, see 'The Meaning of "Meaning"', in my *Philosophical Papers, vol. 2: Mind, Language and Reality* (Cambridge: Cambridge University Press, 1975.) See also 'Explanation and Reference' in the same volume; published in French as 'Explication et reférence' in *De Vienne à Cambridge*, ed. Pierre Jacob (Paris: Editions Gallimard, 1980).

7. See his *Naming and Necessity*, Cambridge: Harvard University Press, 1982. (Lectures given at Princeton University in 1972.) Published in French as *La Logique des Noms Propres*, trans. Pierre Jacob and François Recanati (Paris: Editions de Minuit, 1982).

8. See my 'Models and Reality' in *Realism and Reason (cit.)* (First published in *The Journal of Symbolic Logic* XLV (1980): 464–82.)

9. See his *Ontological Relativity and Other Essays* (New York: Columbia University Press, 1969).

10. 'Hoist with His Own Petard', in *Exegesis and Argument: Studies in Greek*

Philosophy Presented to Gregory Vlastos, ed. E. N. Lee, A. P. D. Mourelatos and R. M. Rorty (Assen: Van Gorcum, 1973).

11. See the essay titled 'Realism and Reason' in my *Meaning and the Moral Sciences* (London: Routledge and Kegan Paul, 1976).

12. See *What is a Theory of Meaning*, I, II, (Oxford: Oxford University Press, 1975, 1976).

4

A. J. Mandt

THE INEVITABILITY OF PLURALISM: PHILOSOPHICAL PRACTICE AND PHILOSOPHICAL EXCELLENCE

I. THE POLITICS, SOCIOLOGY, AND PHILOSOPHY OF PHILOSOPHY

The task of philosophers who seek to define their subject is akin to that of fools who attempt to shovel smoke. It is not exactly that there's nothing there, but whatever it is, it isn't amenable to shovelling. Those who discover smoke are well-advised to look for fire, not to fetch their shovel. Similarly, when philosophers are discovered trying once again to define the nature of philosophy, it is better to examine whatever has precipitated their effort, not to pay too careful attention to what they newly profess. American philosophy is once again in the throes of a debate ostensibly about the nature or proper definition of philosophy. The first thing to notice about this debate is that it has all happened before—only the particular identities of the suspects and heroes has changed. The second thing to notice is that despite its historic improbability (now, at last, the truth about philosophy) the debate is significant not only sociologically or politically, but philosophically. Behind the rhetorical smoke smoulders a philosophical fire.

Renewed interest in the question of the nature or definition of philosophy (never altogether absent in any case) reflects several factors. The philosophical factor is surely the waning authority of 'analytic philosophy', once so pervasive and dominant that it was styled 'Anglo-American phi-

Some of this material appeared in a different form as 'The Triumph of Philosophical Pluralism? Notes on the Transformation of Academic Philosophy', in the *Proceedings and Addresses of the American Philosophical Association*, vol. 60, no. 2 (November 1986), and is reprinted with permission.

losophy' (as if nothing much else existed philosophically in the English-speaking world). Despite its cacophonious appearance, 'analysis' once enjoyed a sufficiently compact core of common beliefs to be more than just an intellectual style. That core of beliefs is now in an advanced state of dissolution. Where once its tenets were advanced in textbooks without argument, they can now be safely ignored in grant applications, without argument.[1]

The sociological factor is represented by a breakdown of institutional authorities in the academic culture of philosophy. The changing pattern of philosophical debates, combined with student demands, have led many prominent graduate departments to diversify their faculties, adding specialists in Heidegger, Derrida, or Hegel to the epistemologists, logicians, and metaethicists previously established. Even earlier, several leading philosophical presses established lines that would hardly have been published if members of the same university's philosophy department had doubled as philosophy editors for the university press. Several new presses have achieved considerable visibility by specializing in books outside the limits of the traditional analytic canon.[2]

The political factor is represented by the emergence of the Committee for Pluralism in Philosophy. Within the dominant Eastern Division of the American Philosophical Association, this organization has become the leading faction. It has elected three Presidents of the Division in recent years, in addition to other officers, and pressed successfully for the adoption of such devices as contested elections, mail ballots, and a more inclusive program at the annual meeting. The culmination of this democratization of the Association is a proposal to reconstitute the governing National Board of Officers.[3] These changes have transformed some philosophers, at least, into politicians. Divisional officers must negotiate compacts with various factions if they wish to meet the responsibilities of office, and candidates for office must behave with due regard to voting blocks, including soliciting their support, if they wish preferment. No longer can they act as if nomination to office was equivalent to having one's name on the Christmas Honors List.

Discussion of these changes has been uneven and disconnected. Not surprisingly, the intellectual dissolution of 'analytic philosophy' has received the most consideration. The appearance of Rorty's *Philosophy and the Mirror of Nature* served to make the 'end of philosophy' and the possibilities of a 'post-Philosophical culture' important topics.[4] However, the debate engendered by Rorty's book quickly expanded in several directions. One consequence was the development of various historicist interpretations of philosophy. These efforts have drawn fruitfully on historicist philosophies of science, which had already demolished the traditional

positivist foundations of analytic philosophy. Writers like MacIntyre, Hacking, and Yolton have labored to make philosophy historically self-conscious; their success has narrowed dramatically the gap between conventional American philosophers, still rooted in the analytic tradition, and contemporary representatives of pragmatism, Hegelianism, phenomenology, existentialism, and Marxism. In the face of these developments, it has proved impossible to sustain the former authority of analytic philosophy. Too many 'serious' philosophers are now reading the contemporary French and German masters for the latter to be dismissed out-of-hand. Compared with 20 years ago, philosophy now has much more the outward appearance of Rorty's 'conversation' than of Carnap's 'rigorous science'.

The sociological and political changes in American philosophy have received much less serious consideration. The natural explanation for this is that philosophers are constitutionally disinclined to grant that philosophy has a sociological or political aspect; to affirm either is to commit a fallacy akin to psychologism. Regardless, the neglect of these issues is apparent in the philosophically unself-conscious discussion of the political significance of the Committee for Pluralism and its activities. The pluralists themselves have focused on their immediate grievances, the general theme being the arrogance of the philosophical establishment and its unfair treatment of philosophers whose only fault is their interest in what the establishment regards as unfashionable philosophical topics. For its part, the establishment appears to perceive in the pluralists nothing but a gang of sore losers, second-rate philosophers who seek to gain politically what they have been denied on the basis of merit considerations.

Why this sharp division between changes that are and those that are not the subject of serious discussions? The prevailing view represents philosophy in a manner congenial to metaphysical idealists. The real process of philosophical life operates independently of its material circumstances. 'Philosophy' is composed of various claims advanced and defended on the basis of intrinsic philosophical considerations, above all, on the basis of the net persuasiveness of the arguments put forward to buttress the various propositions advanced. Assessment of arguments in the first instance is on the basis of their logical properties. This focus serves to conceal the lack of comparably objective criteria for judging the soundness of premises or the significance of non-argumentative discourse in the total economy of philosophical discussion. It is precisely reflection on these sorts of things that has made the history of science central to the philosophical assessment of scientific theories, forcing radical revisions in the classical positivist account of scientific knowledge. Rorty's challenge has introduced similar considerations into the self-assessment of philosophy, but this process has not extended to the point that sociologi-

cal or political conditions have appeared to have any philosophical effi-
cacy. Instead, Rorty's own account of the internal dissolution of the repre-
sentational theory of mind (which encompasses classical analytic
philosophy) is entirely concerned with the waxing and waning of seminal
philosophical *Gestalten* (complexes of analysis, argument, and persua-
sion). His book is a kind of attempted inversion of Hegel's *Phenomenol-
ogy*: an ordering of thought-forms culminating in 'absolute knowledge' is
replaced by an ordering of thought-forms culminating in the reduction of
philosophy to 'edifying conversation'.

As long as philosophy is depicted in purely conceptualist-idealistic
terms, there will be no visible connection between discussion of Rorty's
work and similar critiques of the contemporary tradition on the one hand,
and various changes in the culture of philosophy or the political life of the
American Philosophical Association on the other. These latter will be
treated as autonomous, non-philosophical matters. On this basis, it will
be impossible to find any philosophical significance in the efforts of the
pluralist movement. This is true whether one supports or opposes its ef-
forts. Many pluralists themselves share the view of philosophy I have
sketched, with variations, a situation more becoming in them than in their
opponents, since not a few pluralists are avowed metaphysical idealists,
and thus entitled to understand themselves idealistically.

However, there are a number of reasons to regard the standard view of
philosophy as seriously distorted. The philosophical merit of the pluralist
challenge is that it provides a means of understanding that distortion for
what it is. In what follows, my intention is to show how the pluralist cri-
tique of what they generally call 'analytic philosophy', and the response to
that critique by the philosophical establishment together illuminate the
practice of philosophy in a way that undercuts the traditional view of phil-
osophical thought as an autonomous intellectual domain. That view re-
gards the political affairs of philosophers as entirely distinct from the in-
tellectual development of philosophy. It is on the basis of this distinction
that the pluralists have been charged with seeking to substitute political
preferment for philosophical merit in matters of professional recognition
and honor. Generally, the pluralists have defended themselves against this
charge by claiming that the philosophical work of those they put forward
for honors is just as worthy of respect as that previously honored. In other
words, they accept the established standard, but argue about its proper
application to cases. However, the argument is not as simple as this repre-
sentation of it suggests, since in order to make their case the pluralists
have raised questions about the nature of the appropriate criteria of evalu-
ation in philosophy. These questions have not been adequately addressed
by either side in the political debate, a deficiency I seek to remedy in this

essay. In doing so, I will offer an analysis of the practice of philosophy in which criteria of merit and the evaluative process can be distinguished in conception, but not in fact. The meaning of evaluative criteria by which philosophical work is judged is determinable only in philosophical practice, which means, not merely in philosophical discourse, but additionally in the on-going life of philosophical communities. The personal, social, and political associations of individual philosophers necessarily condition their application of alternative standards. This is not to say that these standards can be reduced to little more than ideological reflexes of the academic power structure; materialistic reductionism has as little to recommend it as the idealistic reductionism of the common view. Rather, my view is that 'philosophy' properly refers both to a province within the republic of letters, an intellectual domain governed by the laws of logic and rationality, and to the community of philosophers, governed by laws of rhetoric and politics. Philosophy is both a rational enterprise and a community of practice.

II. THE PHILOSOPHICAL IMPLICATIONS OF THE POLITICS OF PHILOSOPHY

The Committee for Pluralism in Philosophy is a loosely organized coalition of philosophers that brings together phenomenologists and existentialists, Whiteheadians and American pragmatists, Catholic philosophers and traditional metaphysicians, with additional support from less easily identified tendencies, and from individual philosophers of every persuasion. These allies share a grievance against the so-called philosophical establishment, which has, in their view, systematically excluded philosophers of certain academic or ideological antecedents from positions of honor and preferment. It has done so, the pluralists argue, on the illegitimate basis that some varieties of philosophy are intrinsically insignificant, so that achievement in them is a small thing, undeserving of general regard and recognition. Against this, the pluralists argue that all varieties of philosophy should be accorded equal respect—that achievement by a phenomenologist should be honored as highly as achievement by a philosopher of science.

The Pluralist Committee has been attacked by establishment apologists on various grounds. Sometimes it is denied that representatives of any philosophical tendency have been excluded, in whole or part, from leadership in organized professional philosophy. At other times, the existence of a philosophical establishment, except as defined by achievement in the field, has been denied. There is, it is said, no such thing as 'analytic

philosophy', the name most commonly assigned by pluralists to what they oppose. And, most heatedly, the pluralists have been criticized for 'politicizing' the profession, for making political connection rather than philosophical merit the basis of preferment.

This political polemic conceals some important philosophical questions. That this is so becomes apparent when one reflects on the central issue addressed in the polemic. That issue is whether or not there is a *philosophical* establishment in American philosophy. That there are differences in prestige between departments, journals, and individual philosophers is not in dispute. The dispute concerns the basis for these differences and their legitimacy. The pluralists are not concerned that some philosophers receive special honors and recognition; they are concerned that not all of those who are deserving receive them, and argue that in the past such preferments have been awarded on the basis of whether or not one is an analytic philosopher of ability rather than on the basis that one is an able philosopher. Opponents have responded by defending the notion that preferments have been based on philosophical merit, not on some special ideological allegiance. They charge the pluralists with politicizing the profession—a charge that presupposes both that politics in philosophy is an innovation and that it is an evil. This charge is unintelligible unless those who advance it are prepared to deny that there is, in fact, some sort of ideological establishment in American philosophy. If such an establishment did exist, the profession would already be politicized in the sense that extra-philosophical considerations would partly determine professional practices, and the pluralists could be faulted only for failing to ascribe to the prevailing ideology.

The apparent issue between the two camps is, therefore, whether the establishment in philosophy roughly reflects the distribution of philosophical merit, or instead the philosophical allegiances of philosophers, with analytic philosophers eligible for significant recognition, and others mostly not eligible for it.

No one denies that there are various centers to the organized profession, including highly regarded, prestigious graduate departments and widely read and respected journals. What is sometimes denied is that these professional institutions are dominated by a hegemonic philosophical ideology, which their institutional power and prestige buttress and sustain. Thus, for example, it is said that Harvard's graduate program is among the best, because Harvard's department has the most talented philosophical faculty; *The Philosophical Review* is a highly regarded journal because it publishes consistently better work than all but a few other journals. If these claims are largely sound, then the success of the Pluralist

Committee in promoting philosophers working outside the center can be plausibly condemned as advancing mediocrity over ability.

Nobody seriously pretends that organized philosophy is unpolitical. Institutions always operate in political terms. The argument over the politicization of the profession is an argument about whether a natural aristocracy of talent is being usurped by unprincipled factionalism, on the one hand, or a self-perpetuating oligarchy is being overturned and replaced by some sort of democratic polity on the other. The pluralists have been condemned not for introducing politics where it did not exist but rather for advancing the interest of philosophers undeserving of such preferment, grounding their actions in false judgments of merit, or even in disregard of all questions of merit.

In the face of the pluralist challenge, the case for the defense is that the establishment earned its place on the basis of philosophical ability, and the pluralists propose to substitute pure politics for meritocracy. The pluralists have claimed in reply that the established criteria of merit lack justification, and that defending the status quo on the basis of these criteria begs the question. They propose that the profession adopt pluralistic canons of merit—good philosophy is what any faction of philosophers says is good philosophy. This view is urged on the profession at large either because there actually are discontinuous, incommensurable criteria of merit in philosophy or because we presently have no practicable means of adjudicating between competing sets of criteria. Thus the basis of the claims of the pluralists has been sometimes metaphysical, sometimes conventional.

The theses advanced on both sides of the political debate presuppose certain conceptions of philosophy. The establishment's defense of itself as a genuine meritocracy assumes that there are recognized criteria of merit in philosophy. The claim that there are such criteria itself presupposes a correct understanding of the nature of philosophy, for otherwise the criteria of merit are reduced to general criteria of intellectual ability. While the latter broad standards are usually invoked when 'good philosophy' is being described, nearly everyone agrees that good philosophers are good at something distinctively philosophical as well. No one ingenious at logical argumentation will be highly regarded unless she also has superior judgment, or powers of insight for determining what is philosophically worth arguing about.

In fact, there is no canonical statement of the recognized criteria of merit. Some of the pluralists take this as proof that there are no such criteria. This conclusion does not follow. It is quite possible that the criteria are either not formulatable, or else not univocal (existing as sets of partly overlapping but logically independent criteria). In each case, it would be

reasonable to say that the criteria cannot be stated (completely and adequately) but that they nonetheless exist. Understanding them might be a kind of 'know how' acquired in philosophical practice but formally inarticulable. This would be annoying to outsiders, but it would not mean that the criteria either do not exist, or exist only in some bogus, illegitimate form.

However it is interpreted in detail, the established notion of philosophical merit asserts that there is one (possibly equivocal) meaning of 'good philosophy'. The criteria that correspond to this notion of merit are relevantly applicable to all forms of legitimate philosophy, and in fact define it. Properly to claim that one is 'doing philosophy' is to claim by implication that what one is doing would be regarded by other philosophers as a form of 'philosophy'. However, it will be so regarded only if it is done well enough to be recognizable *as* philosophy. Many intellectuals generate streams of ideas; philosophers view much of this as harmless, some of it as intellectual dementia, and only certain kinds of it, reasonably well performed, as philosophy. Academic philosophy is Aristotelian in its self-understanding: it defines its enterprise by reference to what it is like when it is flourishing.

Reflective pluralists necessarily reject this account. They claim that no single set of criteria of merit in philosophy exists, and some add that no such criteria can exist. Proponents of the first view are methodological or 'moderate' pluralists; adherents of the second position are the 'radical' pluralists, the 'strict constructionists'. The large majority of contemporary pluralists are moderates, because they are also systematic philosophers of one sort or another. Systematic thinkers have pronounced views about philosophy and its true nature, and, whatever the content of these views, the notion that there is in principle a single measure of philosophical merit cannot be alien to them. However, they need not believe that anyone is in possession of this measure. They can note that systematic philosophical reflection assumes many forms, and that several of these forms imply inconsistent claims about the nature of philosophy, and hence inconsistent criteria of philosophical merit. From this it is reasonable to infer that philosophers working from incompatible assumptions will arrive at different assessments of philosophical activity, and that insisting on one's own view begs the question against all competing views. So long as the truth-claims of various sets of basic assumptions are undecidable, a methodological skepticism is in order. The only reasonable policy is to permit each system to be judged by its own criteria and otherwise to restrict assessments to common matters, such as general indications of intellectual ability. One might be as clever at defending Hegel's notion of *Geist* as others are at demolishing it. What cannot be decided is

whether Hegel's philosophy has any intrinsic philosophical value. Some are convinced that it does (Hegelians), others concede that it has some (Deweyan pragmatists), others admit the possibility but strongly suspect it does not (Whiteheadians), and still others are absolutely certain that it has none whatsoever (neo-empiricists and neo-positivists). For the moderate pluralists, this state of affairs is both expected and accepted as inevitable in the nature of things. What is illicit is not any one of these assessments, but any effort to impose one of them on philosophy as a whole.

The radical or strict pluralists believe that philosophy does not exist; there are only philosophers. Unlike moderate pluralists, who while mostly metaphysicians interpret pluralism methodologically, the radical pluralists are anti-metaphysicians who interpret pluralism metaphysically. They deny that philosophy has a nature or an essence, even when viewed purely as a practice or an activity. The term 'philosophy' is partly honorific and otherwise merely conventional. The name is attached to all sorts of things, and its use changes for all sorts of reasons. There is no conceivable meaning to the notion of 'philosophical merit', and the only means of assessing work that describes itself as philosophical is on the ground that it is interesting, thought-provoking, fruitful, or inspiring. If I am a philosopher and something engages my interest, it must itself be philosophical and, to the extent that it interests me, worthwhile or 'good'. From this perspective, it is absurd to imagine that one possesses a correct account of the nature of philosophy or that one is capable of applying the criteria of merit in philosophy.

Both moderate and radical pluralists agree that there is no single authoritative definition of philosophical merit. From this, they conclude that it is inappropriate for the American Philosophical Association—institutional philosophy—to give its imprimatur to members of the profession except on a democratic basis.

The pluralists draw a political conclusion from their analysis of the question of merit criteria in philosophy. For a large majority of pluralists, the moderates, this position involves some ambiguity, since they do not deny the existence of general philosophical merit in principle. Their concern is with whether or not we can gain access to legitimate criteria for judging such merit. Their complaint against the establishment is that it cannot offer a reasoned defense for its notions of what merit consists in, and in the absence of such a case, behaves like a self-serving oligarchy. One could well ask these moderate pluralists why, if their analysis of the merit issue is correct, they do not disavow making merit judgments altogether on the grounds that what cannot be done on a principled basis should not be done at all. The policy they recommend amounts to one of sharing honors among all of those philosophers who advance some sort of

plausible claim of merit, even though such claims are sometimes based on contradictory premises. It is this posture that leads some establishment spokesmen to dismiss the pluralists out of hand: what can be done with those who are willing to embrace a contradiction? If there is something we can describe as philosophical merit, and it is unequally distributed among philosophers, it follows that not everybody can be reasonably honored for possessing it. In accepting the *principle* of general philosophical merit, the moderate pluralists commit themselves to the *consequence* of unequal honors.

This criticism of the pluralists is, I think, the source of much of the hot temper displayed in the debate on the side of the establishment. If the pluralists accept the principle of philosophical merit, why do they oppose a merit system of institutional rewards within the profession? This way of putting the matter is revealing, since it brings out an unstated premise in the establishment position. What angers the establishment is that pluralists have opposed certain specific colleagues whose work is greatly admired. The pluralists have done this, of course, in order to honor colleagues whose work *they* greatly admire, the merits of which have, in their view, been ignored by the establishment. What the pluralists offer as justice accomplished is seen by the establishment as a kind of outrageous insult. The problem here is that the establishment assumes that it is employing the appropriate general criteria of merit when it awards honors. It is this premise that leads them to suppose that the pluralists are opposing in practice the merit system they support in theory, and it is, of course, precisely this claim that the pluralists deny. According to the pluralists, the establishment judgment substantively presupposes the point of view and methodological canons of analytic philosophy. For their part, analytic philosophers, while disclaiming any sort of ideological bias, do generally acknowledge that their philosophical judgments reflect their 'analytic' approach to philosophizing. What else could it reflect, afterall? There is, surprisingly, an implicit agreement between the two sides on the question of whether or not institutional judgments of merit have reflected the point of view of analytic philosophy. The disagreement is about whether or not this constitutes an illicit ideological bias. If the pluralists are correct on this question, they may reasonably insist that their belief in the principle of philosophical merit in no way commits them to any particular assignment of honors intended to recognize such merit. Perhaps, afterall, every philosophical point of view has a 'biased' conception of philosophical merit, that is, a conception which it can justify only by employing question-begging arguments. Should that prove to be the case, the only non-arbitrary institutional practice would be either not to award honors on the basis of merit, or else to award honors on the basis of all

available conceptions of merit. If, on the contrary, the establishment is correct in its belief that analytic philosophy provides a basis for reasonable assessment of general philosophical merit, then the pluralists are indeed fundamentally mistaken. However, it should be apparent that whatever the outcome of this debate, the pluralists do not lack a serious position, one worthy of philosophical consideration.

III. PHILOSOPHICAL ANALYSIS AND PHILOSOPHICAL PLURALISM

The central issue posed by the pluralist critique of contemporary philosophy comes down to the legitimacy of the currently employed criteria of philosophical evaluation. Any assessment of that critique depends on a better understanding of how evaluative criteria in philosophy arise, and whether or not they possess general application. Once again, I suggest that the political debate between pluralists and their opponents provides a key for unlocking this difficult problem.

The public controversy has been shaped from the beginning by the pluralists' attack on what they describe as the philosophical establishment. From its inception, this critique has implied that the establishment is a kind of illegitimate professional oligarchy. According to the pluralists, this oligarchy rules in the name of a philosophical ideology—'analytic philosophy'—and has maintained its rule by imposing criteria of merit derived from this ideology on philosophers of different persuasions. The force of this critique turns on the claim that analytic philosophy is being passed off without justification as philosophy itself; in pluralistic rhetoric, analytic philosophy looms as a monolithic behemoth, its disciples narrow-minded, if often quite clever, acolytes. The chief defense against this attack has been a denial that any such establishment exists. As Professor Burton Dreben of Harvard put it recently at an American Philosophical Association symposium on recent changes in philosophy, there is no such thing as 'analytic philosophy'. So-called analytic philosophers don't agree about anything of substance, not even something so basic as the analytic/synthetic distinction. This is surely true. Putnam, Quine, Rorty, and Davidson are as diverse a lot as you could hope to find in any period of the history of philosophy, yet if there are analytic philosophers, they are among them.

Granting this, however, does not answer the pluralists' challenge. The difficulty is suggested by Dreben's admission that he teaches a course in analytic philosophy, a course in which he finds it necessary to acquaint his students with Hegelian and neo-Hegelian metaphysics in order to show them what analytic philosophers are *against*. Is analytic philosophy then

much like virtue according to the sophists—something that doesn't really exist, but *can* be taught? The situation is less paradoxical than it seems. Analytic philosophy is not a type of philosophy, a particular twentieth-century ideology born in Oxford and Cambridge, with Moore and Russell serving as midwives. Analytic philosophy is just philosophy in the twentieth century, the philosophy that succeeded German metaphysics and its English derivations, beginning about the time that G. E. Moore discovered that 'good' is an unanalyzable property and Russell put forward his theory of descriptions. By labyrinthian paths, these events brought us to the philosophical present. The pathway twisted through logical atomism and logical empiricism, leaped from ideal language theory to ordinary language analysis, travelled recently on Quine's ever-rebuilding ship, and picked up essentialist metaphysics in Kripke's baggage. No method—least of all 'analysis'—guided us on this course; no shared convictions link A. J. Ayer and Nelson Goodman. It is all just 'philosophy'—some of it anti-metaphysical, some of it metaphysical, some of it foundationalist, some of it radically anti-foundationalist, some of it empiricist, some of it rationalist. There is nothing here that can be plausibly described as a common ideology. In fact, there is nothing here at all except a highly selective history, a history that excludes John Dewey and Martin Heidegger, Bernard Lonergan and Jean-Paul Sartre, Maurice Merleau-Ponty and Alfred North Whitehead, among others.

The selective history that reaches from Russell to Quine and Dummett by way of Carnap and Wittgenstein defines the pluralists' grievance with precision. Whether or not the narration of this history has a continuous plot, as was once fancifully imagined, it provides contemporary philosophers with a usable past. That past sets limits to the central conversation of philosophy, fixes its main themes, provides its vocabulary, erects signposts—in the form of famous forbearers and their words—to guide the continuing conversation. Internally, this history is a collection of dissonant voices; externally, it has the look of a compact, closed system of discourse, participation in which is restricted to those reared within it. The polemical debate over the monolithic character of analytic philosophy is a dysfunctional dialectic. Pluralists describe the external form of 'analysis' as a closed, exclusive system. Analytic philosophers defend it from an internal perception of its formless confusion of voices. To each, the other's perception seems so skewed as to be attributed to bad faith. The debate degenerates into vituperative mudslinging. In fact, both the picture of analysis as a hegemonic ideology and the denial that any sort of coherent ideology exists are correct—to an extent. Analysis is both hegemonic *and* incoherent; there is no one thing that it is, but it dominates contemporary philosophy.

This interpretation offers the best prospect of accounting for some of the most curious aspects of the debate between pluralists and the establishment. Typically, proponents of each side accuse colleagues on the other of failing to perceive the obvious. The pluralists insist that 'analysis' is a monolithic power in contemporary academic philosophy. The establishment denies with equal insistence that there is a coherent enterprise called 'analysis'. Both seemingly contradictory claims are offered as self-evident. The failure of the other side to perceive the obvious is then taken as direct evidence of either utter obtuseness or willful bad faith. Very rarely does either side credit the other with sincerity or more than rudimentary self-understanding. Escape from this unprofitable dialogue requires an interpretation that preserves, with modifications, the self-perception of each side.

IV. Norms, Conventions, and the Structure of Contemporary Philosophy: A Model

I suggest that contemporary philosophy—'analysis'—is a community of discourse, not an ideological system. As an ideological system, it would at least have to aspire to possession of a coherent, inclusive or encyclopedic picture of the philosophical world. But there is no such shared aspiration in contemporary philosophy. Some of the chief philosophical programs in its ancestry did have such aims. Logical atomism and ordinary language analysis, for example, sought through reductionistic programs to encompass all philosophy within one framework. However, the dominant self-understanding in contemporary philosophy today has been importantly shaped by the *failure* of such hegemonic programs. The idea that philosophy has ever been a single enterprise, rather than a collection of enterprises, or possessed anything resembling a fixed nature is under serious assault by such respected figures as Richard Rorty and Ian Hacking. Rorty's attack on the very idea of 'philosophy' is, if anything, typical.[5] Recent work in the history of philosophy pictures the tradition stretching back to the Greeks as a mostly discontinuous series of thought experiments, an interpretation closer to the position of the radical pluralists than to that of any other participants in the current debate.[6] Much of this work suggests that the existence of 'philosophy' is only a convention convenient to self-styled philosophers. In these circumstances, characterizing contemporary philosophy as a normal sort of ideological system is absurd, even granting that positions such as Rorty's are regarded as avant-garde.

By contrast, the conception of contemporary philosophy as a commu-

nity of discourse makes it possible to explain both its closed, systematic appearance when viewed from without and its lack of coherence and unity of conviction when viewed from within. At the same time, it accounts for how contemporary philosophers can possess intelligible norms for judging the value of philosophical activity and yet be incapable of asserting effective intellectual authority in the face of the pluralists' critique. The failure of the establishment to assert such authority has been crucial to the success of the pluralist movement. From the beginning the claim that the establishment occupies its position on the basis of philosophical ability and achievement has implied that its judgments of merit are authoritative, that it possesses and knows how to apply valid criteria of philosophical merit. The pluralists have advanced in proportion to the inability of the establishment to wield this authority to any effect. Establishment leaders have merely asserted that the pluralists represent at best marginal varieties of philosophy; they have been unable to make out a case for this, and have rarely even tried to do so.[7] How this can be so while at the same time philosophers have exacting and authoritative standards within their specialties requires explanation.

Compared to a discipline such as quantum physics, philosophy is fragmented. Not only are the traditional branches of philosophy—metaphysics, epistemology, ethics, logic—disparate, but work within (or between) each of these is divided into a large number of active subspecialties. An epistemologist may focus on information theory (Fred Dretske) or on linguistic conceptual schemes and their transformations (W. V. O. Quine and Nelson Goodman). Each such specialization forms a community of discourse in its own right, often centered in a few leading graduate departments, with recognized journals of record for communicating work to others, and, typically in the past few years, a philosophical society devoted to advancing the work of the community. Within each such subcommunity, there are norms that define the limits of significant and intelligible discourse, and permit detailed, critical judgments of merit. These norms emerge from the community and are subject to periodic revision whenever some individual or group of colleagues succeeds in persuading his or her co-workers to change their standards. The community may come to recognize an important new distinction, for example, or to acknowledge that a certain type of counterexample has effectively undermined a claim once widely accepted. Within this community of discourse certain works are canonical, as Quine's *Word and Object* is canonical for those interested in the translatability of meaning between conceptual schemes (or cultures). Within each sub-community, the local criteria of merit are usually clear, consistent, and generally understood. Even when they are not, implicit standards sufficiently definite to demarcate the com-

munity from others exist. Thus, if members were asked to identify their outstanding colleagues, responses would cluster around certain names, and differences of opinion could be adjudicated in part by explanations citing considerations that others would regard as relevant, if not decisive.

Each philosophical sub-community exists in some sort of relation to other, neighboring communities. They recognize one another as engaged in related, parallel, or even contradictory enterprises. There is some sense in which they acknowledge shared problems, and they frequently refer to some of the same canonical texts. It is not unlikely that significant work within one sub-community will have interesting implications, directly or indirectly, for another. The norms governing discourse in the two communities will partly overlap, and where they do not, members of one community are likely to regard the disjunct norms of its neighbor-collaborator as valid within that community, although not within their own. They will often have an account of why this is properly so, an account rooted in the different interests and purposes of the two communities. There will be things members of one *should* know about and understand that members of the other need not, and may be expected to appreciate only from a distance, if at all.

Contemporary philosophy is a web of such communities of discourse, partly overlapping and partly discontinuous with one another. Some in epistemology overlap with a great many others, since epistemological questions arise in a great many otherwise non-epistemological contexts. Some are relatively isolated. The totality forms a 'great community' that is highly organized even though its constituent parts are largely autonomous. The great community has norms that define its limits, but these norms are equivocal and conventional. They are interpreted differently in various sub-communities. In some they function centrally, in others peripherally. Although in each locality norms operate productively as conventions that shape philosophical activity, their extension to the larger community makes them the basis for *merely* conventional justifications.

Norms that originate in one sub-community may be extended to some neighboring community directly. This occurs when, for example, an advance in general epistemology is assimilated by philosophers of science on the grounds that the new insight is directly relevant to the task of understanding scientific knowledge. In other cases, a norm is extended beyond its community of origin by analogy. In his *A Theory of Justice*, John Rawls provides an example of this when he interprets moral reasoning partly in terms drawn from decision theory. In doing so, Rawls seeks to establish a more rigorous notion of moral rationality than existed previously. Whether extended directly or by analogy, extended norms can become general philosophical norms in at least two ways. In the first in-

stance, they may be sufficiently generalized so as to appear to have general philosophical application. However, a local norm can also acquire general validity simply on the basis that the larger philosophical community comes to *recognize* its applicability within some sub-community, and henceforth expects work in that field to satisfy the normative principle it has recognized. In both cases, the originally local norm acquires more putative normative power than its intrinsic resources can support. It is now taken to define some species of 'good philosophy' by philosophers entirely ignorant of work in the sub-community from which the norm draws its intelligibility. They acknowledge and apply the norm as if it were a convention of discourse (its original *local* function), but only on the authority of those who are believed to have the appropriate expertise. Unfortunately, that expertise presupposes the norm it is employed to justify. Although originally a valid, productive convention of discourse, the norm now operates in a merely conventional way to limit philosophers' ability to appreciate innovative or unconventional work. By these means, philosophers come to apply standards they are incapable of justifying in ways they were not meant to function. The process that transforms valid conventions of discourse into merely conventional justifications for limited philosophical perspectives works in such a way that philosophers remain convinced that they possess rationally warranted normative criteria when in fact they have slipped imperceptibly into what amounts to an arbitrary or biased point of view.

By these means, the larger community sometimes adopts as valid for its sub-communities norms that it does not understand and that may be mutually contradictory once removed from their community of origin. For example, some writers in ethics argue that problems in moral philosophy require resorting to decision theory for their solution, while other moral philosophers reject the thesis that rational choice theories of any kind are useful in solving ethical problems. Philosophers in the first group must know certain works in decision theory to be taken seriously by their colleagues; those in the other are held to a different standard of knowledge. The philosophical community at large recognizes both groups as professional practitioners of moral philosophy. 'Philosophy' acquires common norms that are mutually exclusive, or that, if not contradictory, are nonetheless not susceptible to rational justification by those who employ them.

On this account, it is not in the least surprising that contemporary philosophers assert that they are capable of recognizing good philosophy when they see it. It is also not surprising that they are unable to state and defend criteria of merit that delimit the boundaries of 'good philosophy'. The criteria they understand are derived from local norms in the sub-

communities in which they are participants. Such general criteria as they are familiar with are typically conventions of discourse accepted on the authority of others. As conventions, they not only cannot be justified by most of those who maintain them but typically lack persuasive force outside the community of discourse they partly define. Within that community they seem obvious; outside they appear arbitrary. A rational defense of them that does not beg the question against those challenging their validity would be extraordinarily difficult to conceive.

So described, philosophy has a highly compact structure, possesses highly articulate local norms, and yet lacks collective standards of any real persuasive significance. The structure is such that contradictory norms may be recognized within separate localities. This creates the illusion that the system as a whole is 'open' in that it incorporates everything of value—even contradictory things valued by different localities. However, the ultimate limits of the total community are basically conventional. It contains merely what it happens to contain. The community may by its own lights appear inclusive, but when challenged from without can offer no reasoned case for its own limitations. Its limitations are essentially arbitrary, although mutable. The limits may be extended outwards or drawn closer. In either case, the change will reflect the persuasive power of some participant voice already within the community. If such a voice labors to make something external and alien into part of the community's common property, it is possible that the community will expand. Richard Rorty and Ian Hacking have recently attempted something of this sort regarding the work of Michel Foucault, often described previously as 'not really a philosopher'. That judgment now seems conservative and narrow. The exclusion of the great intellectual traditions of Asia from the realm of 'philosophy' remains, and one can hear these systems of thought dismissed as 'merely religion' by philosophers perfectly ignorant of them. In such circles, philosophers interested in 'oriental philosophy' are themselves suspect.

Another example illustrates how norms within the philosophical community give shape to significant discourse while at the same time operating as arbitrary conventions excluding much that is philosophical from 'philosophy'. In the twentieth century, the philosophy of science has become one of the most prosperous branches of philosophy. Why is this? The usual explanation traces this development in philosophy to the emergence of scientific knowledge as the most powerful single element in modern intellectual culture. Philosophers have persuasively argued that scientific knowledge is paradigmatic of human understanding, and belief that this is so has made the study of science central to much of epistemology. Philosophy of science has become a richly diverse enterprise in contem-

porary philosophy. Its principal themes are topics like the nature of explanation, the process of theory change, the truth-value of scientific theories, and the manner in which scientific research elicits 'rational' understanding. Philosophy of science has influenced metaphysics (witness the debate over 'scientific realism') and profoundly shaped the contemporary theory of rationality. With the possible exception of moral philosophy, it is the branch of the discipline which has had the greatest impact on non-philosophers. It is perhaps the preeminent example of a diverse, open field of philosophical research.

Does philosophy of science so described exhaust the possibilities for philosophical reflection on natural science? Clearly not. Existential philosophers reject the entire enterprise that I have sketched on the ground that it fails in a fundamental way to grasp the significance of scientific culture. In their view, the rise of science is symptomatic of a profound transformation in the meaning of human existence. That scientific modes of thought have become (for many) paradigmatic indicates the degree to which traditional modes of human life and experience have disintegrated, plunging civilization into a nihilistic abyss. The problem of scientific rationality as understood in the philosophy of science is utterly misconceived, according to these thinkers. In many ways, they suggest, the application of scientific understanding to certain kinds of human phenomena is not only undesirable but deeply irrational. Science is not so much a paradigm of rationality as a form of civilizational neurosis.

Owing especially to the influence of Husserl and Heidegger, this sort of 'philosophy of science' has been significant in Europe. In American philosophy, however, work of this sort is not so much rejected as simply ignored. Followers of Kuhn, Popper, and Hempel debate one another about the nature of scientific rationality, and all are prepared to take on a radical nominalist like Feyerabend who challenges the very idea of rational explanation in science, yet none of these philosophers pays the least attention to existentialist critiques of scientific rationality. These, it is typically suggested, belong not to the philosophy of science but to 'existentialism' or 'philosophy of culture', which are of little interest to a philosopher of science.

A similar story could be told about Whiteheadian cosmology. Despite its foundations in modern physics and its explicit claim to being a kind of highly generalized 'philosophy of science', Whitehead's *Process and Reality* is completely ignored by philosophers of science. They have no interest in Whitehead's problems, and make no effort to understand his manner of coping with them. Whitehead and his followers are dismissed as 'metaphysicians', philosophers of no interest to the philosophy of science.

Neither the existentialist critique of scientific culture nor

Whiteheadian cosmology is taken seriously by philosophers of science. The typical philosopher of science knows little if anything about these works or their intellectual antecedents, and dismisses them as unimportant to the understanding of science, that is, to the enterprise called the philosophy of science. 'Serious' philosophy of science is concerned with the sorts of problems I outlined above. Describing other kinds of reflection on science as 'uninteresting' or as not being 'serious' philosophy is a shorthand way of saying that these reflections fall outside a specific community of discourse. Existentialists and process philosophers, in other words, regard as interesting and worth talking about what the community of philosophers of science regards as uninteresting and not worth talking about. This judgment does not have the form of a justification but is offered to justify excluding existentialist and Whiteheadian works from the canon of important philosophical books about science and to justify dismissing their concerns from the agenda of 'the philosophy of science'. In other words, this judgment offers what is merely a convention as if it were a rational justification that explained what counts as 'serious' philosophy. This pseudo-justification derives from and indirectly expresses the highly articulate norms of a philosophical sub-community noted for its rigorous standards of excellence. However, in defining the enterprise rigorously, these norms establish a community of discourse that arbitrarily excludes other forms of reflections on scientific culture, with just as much cause to be called 'philosophical', from the domain of 'philosophy of science'.

When the larger community of contemporary philosophy adopts the norms of the philosophy of science as its own, it automatically pushes Whiteheadian cosmology and existential philosophy of scientific culture to the margins of 'philosophy'. This judgment of their merit will subsequently be offered as authoritative by philosophers as ignorant of Grünbaum and Laudan as they are of Heidegger and Ivor Leclerc. The conventionalization of local norms becomes a device for producing 'authoritative' judgments about what counts as 'good philosophy' based on no acquaintance with the work being judged or simply on a lack of interest in it. That such judgments lack all rational justification is masked by the knowledge that philosophers of science do, in fact, possess rigorous norms that delimit their field of work. What is not understood is that these rigorous standards are irrelevant to the question of whether *Process and Reality* is an important book. Nothing at all about Whitehead follows from the fact that philosophers who are not interested in his problems do not read his book. The claim that only the established problems in philosophy of science are *worth* investigating (which does reflect adversely on Whitehead) is one for which there is no rational justification—other than an appeal to the authority of the community of philosophers of science.

However, since it is precisely that authority which is at issue, this appeal is hopelessly circular.

The conventionalization of norms takes two basic forms. In the first, a locally originated norm extends across a large segment of the philosophical community. However, as a norm is extended more broadly it is interpreted more generally to preserve its relevance to an even wider circle of philosophical conversations. As it becomes more and more a general philosophical convention, it loses its specific content and its power to distinguish significant philosophy from anything else. The more widely the norm is applied, the less it is able to provide the basis for a rational account of philosophical merit.

A primary example of an extended norm is the notion—common in contemporary philosophy—that good philosophy can be measured by the quality of argumentation it employs. Many contemporary philosophers define philosophy in part as the analysis of arguments. This view ignores the persistence of descriptive, declamatory, and evocative discourse in philosophy and the importance often assigned in philosophical knowledge to immediate experience, eidetic and moral intuitions, 'raw' givens and the like. Philosophers—like attorneys and theologians—are much given to argument, but neither arguing or the analysis of arguing is either distinctively philosophical or necessary to the enterprise. The close scrutiny of arguments is characteristic of philosophers, not definitory of them. Nonetheless, this criterion has often been employed to rule phenomenological discourse out of philosophy. 'There is no argument here', it is said.

The second form of conventionalization of norms is the case in which the community at large recognizes as valid for a sub-community a norm originating in that sub-community and thereafter counts only work that satisfies this norm as 'good philosophy' within not only the sub-community, but its domain of interest, broadly defined. In these cases, the norm never achieves general relevance but does acquire a kind of general authority. One knows, say, that philosophers of language are interested in referential theories of meaning, since that is what one vigorous community of philosophers is interested in, and these philosophers describe themselves—reasonably, in view of their interests—as 'philosophers of language'. That other self-styled 'philosophers of language' (followers of Hegel, Heidegger, and Gadamer) conceive linguistic meaning in terms of the self-disclosing of essences and reject the metaphysical premises that make a referential account of meaning intelligible becomes grounds for denying that they are philosophers of language at all. They are, it is suggested, really metaphysicians. In fact, they are philosophers of language who participate in a different community of discourse about language than do philosophers who trace the ancestry of their ideas to figures like

Russell. The conventionalized norm that permits the former group to *define* 'philosophy of language' for the philosophical community as a whole results in an arbitrary division of the field.

There are no general rules or principles of custom that govern when either of these processes of conventionalization operates. The direction of philosophical discourse, the waxing and waning of its sub-communities, is unpredictable. Some new forms of discourse are taken up and their norms adopted into the larger community, while others to all outward appearances equally worthy are ignored or scorned. An influential figure within the established community can 'discover' neglected work lying outside and make it, if not fashionable, at least intriguing; but an equally able exposition of this same new material by a figure outside the main community causes no stir whatsoever. Heidegger is dismissed out of hand on the grounds that his work is so unclear as to be unintelligible, while Davidson's equally difficult writings are labored over energetically. Roderick Chisholm can make some of Husserl's work accessible and worthy of attention, while Robert Sokolowski's extended exposition and development of these same ideas is noted for the most part only by other phenomenologists. Chisholm's advantage is not so much greater philosophical acuity as greater familiarity. A community tends to listen only to familiar voices speaking in their familiar idioms. Yet a member of the family can win a hearing for peculiar notions on occasion. Attempting it too often can alienate one from the community, but the insider has a margin for innovations denied to an outsider, no matter how insightful or brilliant. These sorts of structures, involving personal associations, shared experiences and styles of discourse, a common history and agreed purposes reveal more about the life of the philosophical community and its development than do any of the formal definitions that seek to represent the nature of philosophy.

The community of 'contemporary philosophy' has sufficiently dominated American academic philosophy in recent decades as to be able to represent its on-going discourse as coextensive with 'serious' philosophy. In reality, this community is not as compact as my descriptive model might suggest. There is a tendency for each sub-community to break into still smaller units defined by the work of one or two leading philosophers. The academic community permits so much autonomy, and philosophers of all sorts are so amply eccentric, that the periphery around the core community is crowded. I do not think this openness at the margins undercuts my thesis. The more one penetrates into the center of organized philosophy, the more prevalent become the norms of 'contemporary philosophy' or 'analytic philosophy.' At the center, they enjoy the institutional support

of most of the leading graduate departments and the most widely read journals.

'Contemporary philosophy' is deservedly described as an establishment, but it did not become so by satisfying some independent criteria of merit. Rather, the prevailing criteria of merit arose out of this emerging community, enhanced its sense of purpose, rationalized and structured its growth, and finally gave it the illusion that it was philosophy itself. But it is no more that than is the very different philosophical community centered in Germany. The nature of the standards employed within the establishment betray its nature. They permit local communities to function according to definite rules and standards, but do not equip the community at large to meet the pluralist critique authoritatively. This renders the establishment's hegemony arbitrary, although this charge can only seem paradoxical or false by its lights.

For its part, the pluralist critique is correct in pointing out that the established criteria defining 'good philosophy' are at best conventional and therefore an unsatisfactory basis for excluding other forms of self-styled 'philosophy' from professional preferment. But this critique errs when it implies that no standards of philosophical excellence exist. The standards exist, but they tend to be only local in scope. All philosophical work is not equally good, but authoritative distinctions between philosophical wheat and intellectual chaff can be made only within a sub-community. When broader judgments are attempted, some of their grounds at least will be merely conventional. The task of rendering an intelligible account of what philosophy is, and using that account as a basis for judging purported examples of it, is hopelessly impractical. Yet, if there is anything that seems characteristic of philosophers, it is that they possess deep-seated convictions about the nature of philosophy and opinions about what is worthwhile in it.

V. THE PRACTICE OF PHILOSOPHY AND PHILOSOPHICAL TRUTH

Philosophy is grounded in its own practice. It is not only that philosophical views are developed through reflection and argument. Further, our sense of what it means to be a philosopher, and our standards for evaluating philosophical work, have their genesis in the on-going practice of the community of philosophers. It follows that community practice is intrinsic, not extrinsic to the *nature* of philosophy. By this claim I do not mean to assert some kind of sociological reductionism. To do so would be to imply that logical considerations, the weight of evidence, and rational persuasion lack any autonomous power to shape thought. But I do mean

to suggest that such 'rational' considerations are conditioned, and that their autonomy is limited. The logical ordering of an argument may be as 'objective' a matter as anything can be, but the same cannot be said for evidence, or other considerations advanced in efforts to persuade our interlocutors. The weight of evidence depends on an assessment of its significance, and the various means of persuasion open to us have variable appeals. How evidence is assessed, and what I can be persuaded by depends in part on such factors as the prevailing community standards in my intellectual environment, my individual qualities of character, and my conscious philosophical commitments. These sorts of conditions are sensitive to the activities of others in the philosophical community. That this is so is evident from the failure of any significant philosophical argument to be even generally, not to mention universally persuasive. Unless we are prepared to conclude that all philosophers lack certain elementary intellectual capacities, we are forced to conclude that their assent to, or dissent from, various propositions reflect in part the variable effects of non-logical considerations.

My discussion of how normative principles operate in philosophical discourse is intended to illustrate the consequences of these other factors that vitally affect the development of philosophy. There can be nothing like a *logical* reason for delimiting some branch of philosophy in a certain way. Such limitations always have a practical rather than purely theoretical significance. They mark the boundaries of an active community of philosophers engaged in on-going conversation with one another, argumentative or otherwise. Various factors bind that community together. Some of these factors are straightforwardly philosophical: shared convictions, a common tradition of texts, arguments, analyses, and inspirations. Other factors are in a traditional sense extraphilosophical: common teachers and shared schooling, professional familiarity rooted in meetings and seminars attended together, journals read in common, and the like. It would be absurd to suggest that these so-called extra-philosophical factors have no direct bearing on what philosophers think, that they provide merely the occasions for the operation of the intrinsically philosophical factors. In order to defend this view one would have to show that the sum total of philosophical ideas to which members of the community have been exposed, and which they have reflected upon and assessed, corresponds to the sum total of available and relevant ideas, so that their common interests and shared convictions could be described as being based on purely rational grounds, i.e., as possessing unconditionally rational authority. But of course, none of us is ever in this position. Each of us has accepted a great deal of philosophical lore on the authority of our respective teachers, colleagues, and friends. It would be impractical for

even the most industrious of us to become acquainted with the totality of potentially relevant philosophical work in our own field of interest so that we could claim to have arrived at a well-grounded assessment of its merits and actual significance for the work we are engaged in. We rely on the philosophical community to make such judgments, conscious that although inevitably imperfect, they are also revisable.

It is an interesting question whether we should regard as ideal a state of affairs in which the philosophical community would be so unified, and all philosophical notions so well considered, that the community could offer a single account of 'philosophical truth', a single authoritative evaluation of philosophical merit, and a single account of what philosophy itself is. A consistent pluralist necessarily rejects this formula; for him it describes an anti-utopia. If, as moral philosophers often insist, 'ought' implies 'can', then in this respect at least we should all be pluralists. Whatever its apparent attractions, a philosophical singularity, or as Hegel called it, 'absolute knowledge', is a practical impossibility. No philosopher is capable of such omniscience, although philosophical *hybris* leads some few to claim it for themselves, and many disciples to claim it for their masters. Most of us are content to settle for the poor man's vulgar omniscience: self-glorifying prejudice. If we were more reflective, or more skeptical, we would draw back from such postures in which we make ourselves easy targets for ridicule or mockery.

Philosophers have failed to produce authoritative standards for judging philosophical work not because philosophy lacks standards, but rather because philosophical practice is inherently pluralistic. All philosophical ideals are local. There has never been a significant philosophical notion that has not been regarded with utter skepticism from the point of view of some other significant body of philosophy. The history of philosophy is a history of disagreements, not agreements. It is like the history of the novel or the history of painting—there is always originality, and its appearance generates new standards, appropriate to a new kind of practice. These standards augment, but never displace those of the past. Here we find something like a growth of vision or insight rather than a growth in knowledge, such as we expect in physics. Philosophy is a craft; the best work is not always a model for imitation, but it is always worthy of appreciative regard as a thing of beauty, and even, in its fashion, of truth.

NOTES

1. Drew Hyland reports that two years ago NEH fellowship applications often proposed to investigate connections between 'analytical philosophy' and 'con-

tinental philosophy', and offered elaborate justifications for the interest being expressed in the continental tradition. This past year, the same themes were prominent among applications, but few authors bothered to justify their broader interests.

2. Chicago, Princeton, and Yale Presses are examples of presses with very pluralistic lists, although the philosophy departments at these universities are not, with the exception of Yale, similarly diverse in the variety of philosophical persuasions prominently represented among their faculty. The State University of New York Press has specialized in 'continental' philosophy in the past decade.

3. John Smith, Quentin Lauer, and Joseph Kockelmans were elected to the Eastern Division presidency with the support of the Committee for Pluralism. A proposal to reconstitute the National Board of Officers was put forward in December 1986. President Joel Feinberg, although not himself associated with the pluralist movement, has taken up this proposal and appointed an ad hoc committee to develop it for consideration by the Association.

4. Rorty's own philosophical roots are in the analytic tradition and much of the discussion in his book concerns that tradition. The 'end' of philosophy he champions is, therefore, above all the end of analytic philosophy, i.e., the end of philosophy that aspires to be some sort of rigorous science. As Rorty has noted, of course, other modern philosophers outside the Anglo-American tradition have earlier argued for an 'end' of philosophy, e.g., Marx, Nietzsche, Heidegger, and lately, the deconstructionists.

5. See for example Rorty's 'From Logic to Language to Play', *Proceedings and Addresses of the American Philosophical Association* vol. 59, #5 (June 1986), 747–753. Also, his *Consequences of Pragmatism* (Minneapolis: University of Minnesota Press, 1982).

6. Rorty, Schneewind, and Hacking, editors, *Philosophy in History* (Cambridge and New York: Cambridge University Press, 1984).

7. In November 1980, a letter circulated over the names of W. V. O. Quine, Kurt Baier, and others following the pluralists' first electoral victory. In the interests of maintaining "high professional standards" and avoiding "factional pressures", it urged colleagues to support Adolf Grünbaum for election as divisional president. The letter stated:

The Committee on Pluralism seeks to obtain, through political means, a position of influence which its members have not been able to obtain through their philosophical work. We believe that the Committee favors the suppression of serious scholarly and intellectual standards under the false banner of openmindedness.

In a subsequent newspaper interview (*New York Times*, 6 January 1981) Professor Quine was quoted as remarking that "he did not know their work" when asked if any pluralists had done work of philosophical merit. He did not explain how he came to the conclusions embodied in the letter consistent with this admission.

PART II

PHILOSOPHY: INTERPRETING THE CRISIS

The current self-questioning mood within the philosophical profession is marked by a sweeping skeptical attitude towards the traditional tasks philosophers assigned themselves. By and large, this attitude expresses a loss of faith in the ability to ground, legitimize, or validate the great ideas of the Enlightenment: Reason, Objectivity, and Science. But we have witnessed such skeptical moments many times in the past. So how novel is the present critique?

For Avner Cohen the answer is not metaphilosophical but historical. The recent attacks on foundationalism, the core of the crisis, tie together philosophy and culture. Cohen suggests that the current end-of-philosophy crisis is both a postmodern statement about philosophy and a philosophical statement about our postmodern culture. Along these lines he proposes to interpret Rorty's move from Philosophy to philosophy as an attempt to unmask the *ethos* of philosophy. By the term 'ethos', Cohen means something less than a doctrine or school of thought; it consists of those sentiments that constitute the continuity of philosophy as a literary genre. This ethos was still shared by the founding fathers of analytic philosophy. Hence, the end of analytic philosophy is more than just a transition within philosophy. Rather, it is the very ethos of philosophy that is called into question.

The other component in this equation is the emergence of postmodernism as a new cultural mode. As typical for hermeneutic discourse in general, postmodernism operates on a dual mode: it is both a descriptive account of postmodern changes and a promotion of a postmodernist viewpoint on culture. It describes and promotes a vision of a new post-Philosophical, non-foundationalist, late twentieth-century cultural situation. The demise of foundationalism is not only a disputed thesis among members of the philosophical profession. It is also the cultural climate of a new reality.

Reflecting on the historico-cultural significance of all this, Cohen suggests viewing the crisis in philosophy in the light of the state of late twentieth-century world civilization. Two fundamental facts stand out in this respect. The one has to do with the end of ideology: we live in an age of suspicion toward all totalizing ideologies and belief systems. The second is living under the shadow of the bomb: mankind not only has the potential to annihilate itself many times, but has deliberately made its survival depend on these apocalyptic anxieties. We are forced to face the facts of our fallibility, our contingency.

David Rosenthal reflects on the importance of the history of philosophy for philosophy conceived as a problem-solving enterprise. On the face of it, the taking-history-seriously approach to philosophy raises a difficulty for the problem-solving paradigm. The difficulty is due to the common association of the problem-solving paradigm with Platonic presuppositions. We habitually tend to conceive of problems Platonically, i.e., as

real, objective, fixed, and timeless entities. Given this attitude, one wonders whether the respect philosophers pay to history is more than lip service. Not only do they lack an explicit account of the importance of history for their enterprise, but their implicit Platonism suggests that history could be safely discarded.

On the other hand, the historicists' fascination with the contingency of history leads them to dissolve, together with the perennial objectivity of problems, the very image of philosophy as problem-solving. This is most explicit, Rosenthal points out, in Rorty's version of historicism: "Rorty sees the passing of today's outmoded problems as leading not to new, livelier ones, but to the end of philosophy, conceived of as a problem-solving discipline". Nevertheless, for Rorty's radical historicism to have any force, there must be a way to make distinctions between different discourses, eras, and so on. To make such distinctions, however, is a genuine philosophical move that cannot be avoided. Furthermore, for Rosenthal, the problem-solving image is indispensable for philosophy. To abandon this image would be to abandon philosophy itself, to render philosophy a merely cultural/conversational phenomenon. However, the concrete practice of philosophy grounds and reaffirms the validity of the problem-solving paradigm. This is, in fact, Rosenthal's version of the *tu quoque* argument against Rorty.

So the initial question remains: how to reconcile the unquestionable fact that the history of philosophy is important for philosophy with the no less unquestionable problem-solving character of philosophy? Rosenthal's strategy is to strip the problem-solving paradigm from its Platonic clothes, thereby making it fit for a marriage with history. The implementation of this strategy turns on an application of Davidson's views on translation and charity to our relationship with the past. "We can grasp somebody else's doctrines and arguments only if we can somehow construe them in terms native to our intellectual lives." This principle must be valid not only synchronically but also diachronically. Thus, any history of philosophy—even if it is radically critical of past doctrines—must treat historical figures as contemporaries. But, given the division of opinion among philosophers at any given time about what would count as a 'charitable' interpretation of a philosophical text, it turns out that (a) no uniform and uncontroversial history of philosophy is to be expected; and, more importantly, that (b) in doing 'history of philosophy' one is in fact participating in the contemporary debate and proposing solutions to contemporary problems: "wrestling with the meaning of philosophical texts means, almost invariably, wrestling with substantive philosophical issues of current concern".

Mark Okrent's general strategy consists of wielding yet another version

of the *tu quoque* against Rorty's pragmatism. If pragmatism is defined largely in negative terms (e.g., as a type of anti-essentialism), then what is the philosophical status of the pragmatist thesis itself, in particular its account of language? The dilemma Okrent discerns is the following one: either pragmatism purports to be an objectively true philosophical account of the nature of language, or else it is just a recommendation to avoid the philosophical practice of inquiring about language, knowledge, truth, representation, and the like.

Rorty generally seems to adopt the latter attitude. But its price, as Okrent points out, is high. For in so doing, Rorty has to admit, as he often does, that there is no decisive reason to prefer his metaphilosophical recommendation (i.e., 'edifying conversation') over that of traditional philosophy (i.e., argumentative confrontation). Yet, the fact that Rorty also acknowledges that traditional philosophy has been instrumental in fostering commendable human goals requires that he provide at least some justification for preferring pragmatism. Rorty could have replied, in a historicist vein, that the issue turns out to be whether the *present* conjuncture is such that traditional ways of philosophizing are still useful to mankind. However, such a reply would still imply the possibility of some kind of 'objective' assessment of the present situation, which the pragmatist cannot deliver nor accept. Thus, Okrent concludes, Rorty is trapped in an incoherent position, by his own standards.

Okrent proposes a way out of this dilemma by considering pragmatism a philosophical theory after all. For this purpose, it is necessary to revise Rorty's excessively narrow construal of the philosophical tradition, which accepts without question the self-description of the discipline provided by his Platonic opponents. Instead, Okrent proposes a broader picture of the philosophical enterprise, encompassing both Platonists and anti-Platonists. Okrent's picture restores some measure of *substantial* unity to philosophy as "the field of discourse in which the necessary formal character of discourse itself. . . [is] called into question." Once the tradition of philosophy is construed in this way, it is possible to redefine the niche occupied by pragmatism in that tradition. Though pragmatism rejects the traditional ontological function of philosophical discourse, this need not be understood as a rejection of Philosophy *tout court*. The thrust of pragmatism, in Okrent's interpretation, is to show that philosophy "cease(s) to tell us anything substantial concerning which things are", without ceasing thereby to be philosophical. Pragmatism's main contention is that the test of knowledge is *practical*, i.e., pragmatism offers a "series of reflective comments directed towards our practices for determining if a system counts as a linguistic system". As such, pragmatism is a transcendental

inquiry into language, just as any other properly understood philosophical inquiry.

By setting up a narrowly conceived Platonic tale, however, Okrent seems to make his task too easy. It is not difficult to find in the history of philosophy an alternative to the Platonic ethos, and then proceed to argue that, underlying both this alternative and its Platonic opponents, there is a thematic unity, namely an a priori, though non-ontological, concern with language—the thing he calls "transcendental semantics". By interpreting pragmatism itself as a particular account of the necessary formal conditions on language, he manages to have it both ways: cashing in the advantages of the pragmatist critique of essentialism, while at the same time preserving the significance of the transcendental project. Yet, one may remain skeptical as to the value of such a salvage effort. For Okrent seems to overlook the pragmatist contention that the belief in the 'fundamental', the 'foundational', or the 'transcendental' is, ultimately, an illusion.

Carlin Romano's interest is also to unmask. He calls attention to the tendency of philosophers to describe their arguments as 'justified', their positions as 'legitimate', their claims as 'unwarranted', with a blind eye to the false jurisprudential overtones of that vocabulary. Romano sums up his view as the contention that "current philosophy is 'illegal' because it is 'pre-legal', though it pretends otherwise".

On Romano's view, justification is a legal metaphor that philosophers employ to lend their arguments and positions an air of judicial finality and authority they would otherwise lack. Non-philosophers, he contends, see through this philosophical gambit, recognizing that one philosopher's criteria of 'justification' are often not another's. After discussing the tradition that holds language to be at base metaphorical, and abstractions (such as justification) to be later derivations that retain some measure of their sensuous origins, Romano examines analytical definitions of metaphor and applies them to the notion of justification. He shows that in using of this and other legal metaphors philosophers gladly welcome such characteristics of a legal judgment as finality and the presentation of evidence, but not others such as unchallenged authority. But he sees no reason to be selective in that way.

Romano suggests that the only way to restore philosophy's intellectual prestige is to have it "incorporate some features of a legal system". Citing the work of the late Belgian philosopher Chaim Perelman, he posits the idea of a World Court of Philosophy, and maintains that, if pre-legalism is right, such an institution is not only not preposterous, but highly preferable to the current situation. "Philosophical problems—he writes—require judicial solutions, not just the sound of them."

Marcelo Dascal's attempt to interpret the alleged crisis of philosophy seeks to uncover some of the themes and modes of argumentation common to several 'post-philosophers' or 'postmoderns'. Like other contributors, Dascal too shows the post-philosophers' vulnerability to the *tu quoque* type of argument. Unlike them, however, he argues that the postmoderns should not be unhappy with this fact. For, having rejected the notion that there can be objective canons of knowledge, rationality, validity, legitimacy, etc., they should not be bothered by logical paradoxes. In fact, one of their 'deconstructive' strategies consists of seeking—rather than avoiding—paradox. According to Dascal, what underlies such an indifference to paradox, as well as many of the other techniques of deconstruction employed by post-philosophers, is a conception of language which he dubs "discursive egalitarianism", namely the rejection of all principled differences between kinds of discourse, both the intra- and inter-discursive ones. If all discourses and levels of discourse are on a par, they are all *both* incommensurable and conversationally linkable. Whether one emphasizes incommensurability and discord or conversation and harmony is a matter of temperament and hope. Rorty *hopes* that the latter will prevail; Lyotard and Derrida are rather skeptical about it.

Ultimately, Dascal argues, the post-philosophers' revolt against 'modernity' is a revolt against the arrogance of Reason. What is new in their critique is the awareness of the multiple 'ruses de la Raison'. Criticism itself (viz., 'critical rationalism') can be viewed as one of the ways in which Reason tries to defeat its critics by incorporating their own devices. Dialectics and historicism can be interpreted, similarly, as a *Aufhebung* of Reason through integration of its opponents' categories. In order to avoid such *ruses*, a truly thoroughgoing rebellion against Reason cannot be merely a denial or demolition of classical doctrines; it must be a *suppression* of the very ground on which such doctrines could have been erected. Hence the archeological metaphors of Foucault, implicitly adopted by other post-philosophers, fit more than accidentally the nature of their undertaking.

Dascal concludes by an inquiry into the reasons why each historical wave of rebellion must be more radical than its predecessors. He suggests this is a result of a kind of hysteresis, similar to the one found in magnetism: the fact that each new crisis or revolution lags behind its predecessors makes it mandatory for it to find motives of criticism that are closer to the roots (Lat. *radix*), i.e., more radical. This historical 'law of hysteresis' shows—Dascal contends—that the post-philosophers are right in insisting on the historicization of the 'nature' of philosophy. Yet that law, just like any other historical account, can only show the need for historicization if it is itself correct, i.e., only if it has been *objectively* established—

that is to say, only if it escapes the very historicization it is supposed to legitimate. But why should the post-philosopher care about another familiar paradox?

5

Avner Cohen

THE 'END-OF-PHILOSOPHY': AN ANATOMY OF A CROSS-PURPOSE DEBATE

I. INTRODUCTION

Many are the heralds that nowadays pronounce the coming end of philosophy. They spread their word in many voices, tongues, and accents. Despite their ideological and geographical diversity, they seem to share a common thread. They all invoke the notion that philosophy as we know it, philosophy conceived as a foundationalist enterprise, may have come to its last stop. The philosophical genre has become anachronistic, a legacy of an outdated vision of knowledge and culture. The time has come to bid this genre farewell.[1]

To accept their verdict is more than to express a view about the state of contemporary philosophy; it is a view about culture at large. Implicit in all those 'end-of-philosophy' critiques is the recognition that developments of enormous historical significance are in the making now, both in philosophy and culture, though they are still obscured from sight. They echo the suspicion that late twentieth-century civilization has come to a historical breaking point, to a point of departure from its modernist legacy. The vision that guided the West for at least three centuries, and in some areas even longer, may have ultimately turned out to negate its own roots. Postmodernism is the name of this suspicion. (Lyotard, 85; Wellmer, 85; Kolb, 86; Hassan, 87)

The institution of philosophy was one of the most prominent pillars of the modern order. It articulated the very ideological core—foundationalism—of that order. But as this order now becomes cracked, the special privilege preserved for the institution of philosophy has been undermined

as well. All the recent 'end-of-philosophy' attacks on philosophy can be read as variants on the postmodernist theme of historical discontinuity.

There is, of course, an unavoidable sense of irony and paradox about negative philosophers philosophizing the end of philosophy. First, there is the semantic paradox, the paradox of self-reference, intrinsic to all (philosophical) claims about the impossibility of *philosophy*. And, apart from self-reference, there is the pragmatic paradox about *ending* history, in this case ending the history of philosophy.[2] We have witnessed too many times how philosophers have declared the death of philosophy just to replace it with a new brand of philosophy—of course, philosophy of their own liking. The history of philosophy, one might say, is nothing but the eternal recurrence of the call, 'Philosophy is Dead, Long Live Philosophy!' One cannot but agree with Belting (in his discussion of the 'end-of-art') that always, somehow, "things nevertheless [will be] carried on." (Belting, 1987, xi) As long as humanity lasts, there will always be something humans will call 'philosophy'.

Nevertheless, to rebuff the postmodernist call for the 'end-of-philosophy' by irony and paradox alone is not enough. After all, the assurance that 'things nevertheless [will be] carried on' is no more than restating a truism about the human condition. Such a truism begs, even obscures, the real significance of the challenge posed by the postmodernist critics: (1) whether modern philosophy shares an ethos of a historically single, distinct, and continuous literary genre; (2) whether philosophy can (and will) continue to keep this ethos of philosophy as 'natural kind'. The postmodernist critiques of philosophy respond with YES to the first question and NO to the second.

In articulating their answers, regardless of their diversion, they bring the postmodernist turn *ad extremum*. They extend the postmodernist call for *radical historicization* to the realm of philosophy, a realm that has always been notoriously hostile to such a move.[3] To fully understand the radical nature of the historicist turn in philosophy, consider the polarity between magic and logic. Most of us, modernists as we are, tend to be historicists as far as magic is concerned. This historicism is the legacy of the nineteenth-century developmental view of culture and mentality. We take it that magic once dominated much of human experience, but, over time, the emergence of new cultural-cognitive modes superseded the belief in magic. In our time, at least within the 'public realm', one can hardly make an appeal to magic as a way to explain, predict, or control natural or social phenomena.[4] Modernity has historicized and anthropologized the magic mode; as far as the 'public realm' is considered it has led to the 'end-of-magic'. But logic, surely, is something utterly different. It represents the opposite pole as far as historicization is concerned. We most

naturally think of logic as fixed, timeless, and ahistorical. Though the human interest in the study of logic, like all human interests, has a history of its own, the laws of logic in themselves are not, and cannot be, subject to historicization. The notion that logic can be historicized is preposterous, just as talking about the 'end-of-logic' sounds like gibberish.[5]

Is philosophy more like logic or more like magic? Can we render philosophy, like magic, an object of (radical) historicization,[6] or, conversely, would the historicist move to be preposterous as the call to historicize logic? These questions, I suggest, are at the crux of the current 'end-of-philosophy' debate. It is the issue of radical historicization that constitutes the big divide between the contemporary critics and the defenders of the institution of philosophy. For the postmodernist critics, the thesis of radical historicization implies the demise of the ethos of philosophy, the end of philosophy as a name for a generic enterprise. For the defenders of philosophy, in *contra*, the postmodernist attempt to deconstruct philosophy, like all forms of total skepticism, is no more than an indication of intellectual bankruptcy, a gross (logical) misunderstanding of the limits of the skeptical assault itself.

To appreciate the radical nature of the postmodernist critique one must confront it with the grand ethos of philosophy. Ever since Plato's quarrel with the poets, philosophy's self-image has been built on the notion that philosophy is more than just opinion (*doxa*). In associating itself with genuine knowledge (*episteme*), philosophy places itself in the realm of the perennial. One can speculate, following Nietzsche, that this Platonic sentiment—the hope to escape the cave of obscurity—constitutes the core of the craving for philosophy.[7] By virtue of its contact with the eternal, with ahistorical *logos*, with the matrix of rationality, the enterprise of philosophy becomes a mission radically different from anything else humans can do.[8] Knowledge, Truth, Reason are the links binding humans with the sublime; philosophy is the enterprise that makes it possible for humans to be in touch with the God's-eye view.

It is this grand ethos of philosophy, in particular its foundationalist-modernist version, that has been unmasked, deconstructed and ultimately historicized by all postmodernist critics. Like the great skeptics of the past, from Sextus to Nietzsche, the postmodernists also attempt to expose the self-deceptive character of this ethos. Though they fully acknowledge that this ethos played a crucial role in the formation of Western civilization, the time has come to recognize that it 'has outlived its usefulness'.

Richard Rorty is the writer most associated, certainly in America, with the renewed call for the 'end-of-philosophy'. He has been recognized as the American voice of postmodernity, regardless of his own resent-

ment, or at least ambivalence, about the rhetorics associated with (European) postmodernity (the stress on 'crisis', 'historical break', 'end-of-history' and the like). If anything, Rorty's *Philosophy and the Mirror of Nature (PMN)* and his subsequent *Consequences of Pragmatism (COP)* highlight the explicit issues in the debate about the future of philosophy more than any other single writer's work.

On one level, almost all the particulars of Rorty's critique are not new at all. His critique of foundationalism relies explicitly on previous internal criticisms of the 'dogmas' of analytic philosophy, criticisms made by some of the most distinguished heroes of the tradition, such as Quine, Sellars, and Davidson. On another level, however, Rorty's critique is extremely original, provocative, and comprehensive. Rorty unifies and transcends elements from those internal critiques into an external assault on the very self-image of modern philosophy. For Rorty, foundationalism is the ideological core of the modern institution of philosophy—its *raison d'être*—and it is that core that is now declared intellectually bankrupt.

My reading of the postmodernist revolt will be focused here almost exclusively on Rorty's prism. My interest is to highlight some of the communicative peculiarities of the debate about philosophy between the pragmatical postmodernists (e.g., Rorty) and the faithful of the tradition. The debate is strikingly characterized, I argue, by a communicative impasse between the two sides. I will attempt to trace the sources of this impasse to a fundamental disagreement about the nature of philosophy, a disagreement about what I take to be the ethos of philosophy—the grand ethos of *philosophia perennis*. This disagreement cannot be resolved in either side's favor by appeal to some abstract metaphilosophical principle, procedure or method (just as the abstract debate between dogmatism and skepticism cannot be settled by logic and argument). The institution of philosophy cannot be the judge of its own case, despite its traditional pretensions as an activity uniquely capable of self justification. Yet it is important to recognize that the impasse between the two sides is not symmetrical. The impasse can be broken by a therapeutic persuasion to move outside the traditional realm of philosophy.

II. Rorty's Project: Unmasking the Philosophical Ethos

Rorty repeatedly identifies his overall objective with Dewey's call "to overcome the [philosophical] tradition". Yet precisely what he means by this phrase, and how much ground the term 'tradition' is supposed to cover, is really difficult to say. Moreover, by treating the 'tradition' as a 'natural kind' of sorts, as Rorty at times appears to do, he undermines his own

strong anti-essentialist stance in regard to the history of philosophy, "the view that philosophy is not the sort of thing that *has* an historical essence or mission". (*COP*, 220) Rorty's ambivalence is underscored by the noticeable differences in terminology, scope, and emphasis between *PMN* and *COP*.

One possible clue to use in resolving this ambiguity may be found in the last part of *PMN* where Rorty develops the distinction between 'epistemology' and 'hermeneutics', while explicitly identifying the former with the tradition of philosophy, saying that its time has come to be overcome. By the term 'epistemology', Rorty refers to the intellectual enterprise built "on the assumption that all contributions to a given discourse are commensurable". (*PMN*, 316) The basic assumption of epistemology is "that to be rational, to be fully human, to do what we ought, we need to find an agreement with other human beings. To construct an epistemology is to find the maximum amount of common ground with others." (*PMN*, 316) The enterprise of epistemology, for Rorty, is by nature both foundational and representative. For it is only via the notion of knowledge built upon privileged representations, i.e., the apodictic foundations of knowledge, that one can reach the desired vision of objective and rational agreement based on commensuration in the first place. Foundations, then, are the elementary building blocks of the common ground believed to be indispensable for rational agreement.

Epistemology, then, is the general presumption that makes the enterprise of *modern* philosophy possible. If modern philosophy is, for Rorty, "the attempt to underwrite or debunk claims to knowledge made by science, morality, art or religion", it does the job only by claiming to have a "special understanding of the nature of knowledge and the mind". (*PMN*, 3) Epistemology and philosophy of mind are the two indispensable components of the foundationalist project of modern philosophy. In order for a philosophical belief to be recognized as knowledge, it must (1) mirror the real foundations of knowledge 'out there', and (2) those foundations must be capable of being grasped and represented by the human mind. Once again, philosophy *must* be foundational and representative.[9]

It is clear that in *PMN* the attack on the philosophical tradition is virtually an attack on 'modern philosophy'. Not surprisingly, Descartes and Kant are the two major figures in the historicist narrative that Rorty develops. Descartes, for Rorty, is the founder of the marriage between epistemology and philosophy of mind, possibly the most critical nexus for the formation of modern philosophy. Kant, for Rorty, is the modern thinker who identifies the idea of 'epistemologically-centered philosophy' with a distinct academic subject matter (*Fach*). Kant's transcendental revolution provides the ideological *raison d'être* for the establishment of modern phi-

losophy as a well-defined institution. Though philosophy's objects of inquiry stand apart and pure from science, philosophy is indispensable for science, and, in a sense, higher.

While scientific discourse concerns representations about the world, epistemological discourse concerns representations about representations. In this way modern philosophy becomes 'a general theory of representation'. The novelty of Kant's project, according to Rorty, is the separation of the epistemological question of representation from both Cartesian metaphysics and Locke's psychologism. After Kant epistemology is declared the distinct legitimate object of inquiry appropriate for critical philosophy. (*PMN*, 392)

The close association that Rorty sees between the rise of 'epistemologically-centered philosophy' and the cultural vision of modernity can be presented from another perspective. It has often been claimed, most recently by Habermas, that the core of the modernist vision of culture is its division into three distinct and autonomous spheres: science, morality, and art. Each of these spheres has its own discourse (Habermas, 1986). Rorty adds an important aspect to this view of modernity as he stresses the second-order, foundationalist, function of the institution of philosophy. The implicit mission of the institution of philosophy is to serve as a central legitimizing institution for all the spheres of culture.[10] Furthermore, this threefold division of culture is in itself a *philosophical* one; that is, it relies on some epistemological and ontological claims about the essences of these spheres.

A somewhat different meaning of the term 'the philosophical tradition' is suggested in the introduction to *COP*. Here the 'end-of-philosophy' issue becomes explicitly the issue of the possibility of 'post-Philosophical culture'. The 'epistemology versus hermeneutics' distinction of *PMN* is replaced now by the 'Philosophy versus philosophy' distinction (and the 'Platonism versus pragmatism' distinction). By substituting "epistemology" for "Philosophy", Rorty significantly widens the extension of his critique. The term "tradition" now encompasses virtually *all* the history of philosophy, not only modern philosophy. It unites, as Rorty puts it, "the gods and the giants, Plato with Democritus, Kant with Mill, Husserl with Russell". (*COP*, xvi) Consequently, the chief target of Rorty's assault is no longer Descartes or Kant, but Plato. Platonism is presented in *COP* as the most general feature of Western philosophy.

Rorty seems to be aware, of course, of his idiosyncratic usage of the term 'Platonism'. It is used not as the name of any specific set of philosophical doctrines attributed to Plato, but rather as the name of "that literary genre we call 'philosophy'". (*COP*, xiv) The unifying thread of that literary genre is the attempt to isolate and capture the real nature or es-

sence of the True, or the Good, or the Rational. "The history of the attempts to do so, and of criticisms of such attempts is, roughly, coextensive with the history of that literary genre we call 'philosophy'—a genre founded by Plato." (*COP*, xvi)

There is, of course, something inescapably ironic about Rorty declaring Platonism to be the essence of the genre called Philosophy. Rorty, who uses the historicist stance in order to deny that philosophy has anything like an ahistorical essence, seems to describe the historical continuity of the philosophical genre as capturing an historical essence. In invoking the generic name 'Philosophy' as his primary target, Rorty appears to do one of the two: either he offers another essentialist metaphilosophical theory about the nature of philosophy or its history, or he makes some crude empirical generalizations about the history of philosophy. To Rorty, however, none of these interpretations is too complementary: the former stance is in tension with his anti-essentialism, while the latter is historically awkward. And anyway, either interpretation is too 'philosophical'.

In order to find a way out of this uncomfortable dilemma I suggest interpreting 'Philosophy' as neither a reference to a real historical tradition, nor as a reference to a metaphilosophical thesis about the nature of the history of philosophy. Instead, 'Philosophy' is Rorty's way of naming the ethos of philosophy. By the term 'ethos' I have in mind the implicit set of presuppositions, sentiments, self-images, hopes, and anxieties that together form the collective *raison d'être* about the ultimate significance of the enterprise in the eyes of its practitioners. The ethos relates closely to what the members conceive as the deep cause behind the enterprise— which makes it meaningful to its practitioners. It provides its members with a coherent sense of social identity and mission. It is the ethos of the group that binds all the great dead philosophers as members of one and the same intellectual enterprise. But one should be careful not to confuse the ethos of a group with its actual history. Rather, ethos is the means by which the history of the group is grasped as constituting a sense of continuity between past and present generations of participants.[11] The ethos is the myth that forms the sense of solidarity among the members of that group. No group can sustain a common cause without forming its ethos. Thus in order to deconstruct philosophy (conceived as a foundationalist enterprise) one must first construe its ethos, its *raison d'être*.

Once Rorty's project is understood in this way, namely as an attempt to unmask the ethos of philosophy, the differences between *PMN* and *COP* become a matter of emphasis and terminology, not a matter of internal inconsistency. In *PMN* the focus is on the formation of modern philosophy, the rise of philosophy as a distinct social institution. Epistemology, I suggested, is simply the name that Rorty calls the ethos of modern phi-

losophy. This ethos lies in the Enlightenment view that what is common to humans, i.e., Reason, can be reduced to an explicit and neutral matrix of rationality, a matrix which all human conversations must obey in order to be regarded as 'rational'. To be engaged in epistemological inquiry means, then, to search for this ahistorical and abstract matrix of rationality. Such a matrix *must* be foundational in order to do its commensurable job; hence, the ethos of modern philosophy is inherently foundational.

Once the ethos is unmasked (through holistic, anti-foundationalist, and pragmatist arguments) the philosophical enterprise is seen quite differently. Epistemology is seen now as no more than an expression of *hope* about the human condition.[12] To assume the existence of common ground, Rorty points out, is to maintain the hope that "rational agreement can be reached on what would settle the issue on every point when statements seem to conflict". (*PMN*, 316) Epistemology, hence, is the enterprise built on the desire to make the hope something more solid than just hope.

Hermeneutics, in Rorty's special (and somewhat idiosyncratic) sense, is the intellectual enterprise that stands in diametrical opposition to epistemology.[13] Hermeneutics, Rorty stresses, "is not 'another way of knowing'—'understanding' as opposed to (predictive) 'explanation'. It is better seen as another way of coping". (*PMN*, 356) Against the epistemologists' emphasis on the notion of 'inquiry' as the embodiment of the philosophical task, hermeneutics proposes the notion of 'conversation'. The difference between the two is significant: the former is philosophical, i.e., directed toward finding the ultimate common ground, while the latter is 'post-philosophical', i.e., abandons altogether the notion of ultimate common ground, but is still interested in the question of how to search for enlightenment without the commitment to foundationalism.[14]

The difference between 'inquiry' and 'conversation', says Rorty, is largely a manifestation of a *sociological* difference, i.e., a difference in the social cohesion and solidarity of the group of inquirers. This point is highlighted by an appeal to Oakeshott's distinction between *universitas* and *societas* as two distinct types of social solidarities. (*PMN*, 318) The participants in an inquiry are socially united in the sense of *universitas*, that is, a social unity gained by "mutual interests in achieving a common end". (*PMN*, 318) In scientific inquiry the common end of the participants is to find the ultimate true theories about the world. The participants in conversation, on the other hand, are socially united in the sense of *societas*, that is, a unity achieved by a sense of past solidarity or civility, "rather by common goal, much less by common ground". (*PMN*, 318)

Conversation, then, is *not* a 'successor project' within the tradition of epistemology, but rather the recognition of how futile that entire tradition

is. Though central elements in Rorty's attack on epistemology, such as the use of Quine's holism or Sellars's 'myth of the given', are clearly borrowed from the epistemological discourse, their role in Rorty's scheme is *not* epistemological, but deconstructive. Their function is to *unmask* the notion of epistemology as the ethos of the ahistorical inquiry into all meaningful inquiries. Hermeneutics, then, is what would remain of philosophy once its epistemological core is abandoned.[15]

Each of these modes is tied to a radically different image of the role of the philosopher in culture. Epistemology represents the foundationalist image of the role of philosophy in culture. According to this image, the philosopher is "a kind of cultural overseer who knows everyone's common ground—the Platonic philosopher-king who knows what everyone else is really doing whether *they* know it or not, because he knows about the ultimate context [the Forms, the Mind, Language] within which they are doing it". (*PMN*, 317–18) Contrary to this, hermeneutics presents a non-foundationalist, non-professional image of the philosopher, the philosopher as a cultural commentator.

Interpreted in this way, the call to bring an end to the foundationalist era is more than just a call for deep revisions within the house of philosophy; rather, it is a call to abandon that type of housing environment in order to live differently. Foundationalism, for Rorty, is more than just one philosophical view, or a particular style of philosophizing; it is the ideological core of the very idea of modern philosophy. This idea, Rorty stresses, still dominates the contemporary scene in philosophy. (*PMN*, 392)[16] Philosophy is still presented, both to its own new students as well as to outsiders, in highly foundationalist terms: as a second-order normative inquiry about inquiry.

From the broader perspective of *COP*, the overall architecture of Rorty's entire critical project can be depicted as encapsulating three distinct layers of philosophical 'traditions'. The core is the tradition of analytic philosophy (founded by Frege, Russell, Carnap), which belongs to the broader tradition of modern philosophy (founded by Descartes, Locke, and Kant), which its ethos links itself with the historically continuous Western tradition called 'Philosophy' (founded by Plato). These three layers of traditions can be graphically seen as composing a sort of Chinese box. In *PMN* much of the critique is directed at the first two layers, the agenda of analytic philosophy as the contemporary embodiment of the philosophical tradition—Epistemology. Nevertheless, Rorty keeps stressing that his almost exclusive focus on the analytic tradition as the embodiment of the foundationalist genre is a product of the contingency of his own intellectual biography. An equally strong mutant of the same post-Kantian, foundationalist, ethos—Epistemology—can be found in

Husserl's purist notion of philosophy as well. Rorty sees no significant difference, as far as the postmodernist project of unmasking epistemology is concerned, between the logical positivists' and the phenomenologists' notions of what 'professional philosophy' is all about. Both Carnap's logical positivism and Husserl's phenomenology are, for Rorty, variants of the same modernist picture of philosophy as the ultimate matrix for assessing all forms of inquiry. (*PMN*, 166–69, 269, 382)

To sum up, the issue of the 'end-of-philosophy' is, for Rorty, the issue of the ethos of philosophy, or in Rorty's own term the issue of 'Philosophy'. While the tradition of Philosophy is the expression of the view that 'human beings were entitled to self-respect only because they had one foot beyond space and time', postmodernist pragmatism is the call to recognize that we have reached the historical point when we should give up this quasi-religious longing for the eternal.[17] If the ethos of philosophy is aimed towards guarding and preserving this longing, postmodernism means a farewell to this longing. While from within the ethos there is literally no way to step outside philosophy (or metaphysics, or logic, or reason) since it is ubiquitous, for the postmodernist it is human *language* and *culture*, not Philosophy, that is ubiquitous.

III. THE PHILOSOPHICAL OBJECTIONS: *PHILOSOPHIA PERENNIS*

The postmodernist critique of philosophy, especially Rorty's, has stirred a very strong counter-reaction from within the philosophical community.[18] This is not surprising. Members of professional guilds and participants in institutional practices feel obliged to defend their collective *raison d'être* under fire. Many of the objections that the postmodernist critiques have evoked have to do with the sense of deep anxiety that those critiques have triggered among philosophers. For reasons to be further explored below, the counter-reaction looks more like procedural dismissals and a priori objections than well-worked-out arguments. Not surprisingly, once again, the postmodernist critiques represent for many philosophers the ultimate intellectual heresy. Such an attitude can be discerned, I think, not only among hard-nosed analytic epistemologists, but also among softer, more historically-oriented philosophers. The objections to the end-of-philosophy critiques contain elements of both sociological (i.e., factual) denial of the crisis and ideological (metaphilosophical) dismissal of the postmodernist critiques.

On the sociological front, the counter-critics have pointed out that they just don't 'see' the sociological indicators that a sobering crisis threatens to bring the discipline to its end. They concede that philosophy is

more pluralistic nowadays than it was some thirty years ago, and certainly the golden days of doctrinal unity in philosophy under the flag of 'analysis' are gone. They may even agree with the spirit of Rorty's descriptive assessment that analytic philosophy no longer carries much substantial unity, having instead "only a stylistic and sociological unity".[19] Granting this, however, is not to factually grant that a disciplinary-institutional crisis threatens to bring philosophy to an end.

Indeed, the disciplinary divisiveness that we witness within contemporary philosophy is not in principle different from the state of the other disciplines within the humanities and the social sciences. (Mandt, the present volume) On the contrary, one can argue that philosophy as a discipline is as alive and healthy as it has ever been. (Castañeda, the present volume) In no other period in its history has the institution of philosophy been so securely professionalized and well-entrenched within the general academic setting. Not only does one 'see' no life-threatening disciplinary crisis, but in America today the institution of philosophy is enjoying a golden era of pluralism of a kind it has never experienced before. "All topics are available, all its applications are legitimate, all methods are feasible, all interdisciplinary connections are accessible." (Castañeda, the present volume) The fact that some philosophers insist on talking and writing about the end-of-philosophy seems only to demonstrate Castañeda's point about the healthy liveliness of the profession. This is another great irony, one among many, about the 'end-of-philosophy' debate: only a well-grounded and secure institution of philosophy could summon such resources to explore seriously the rumors about its own death. To paraphrase Mark Twain's reaction to the rumors about his death, one can say that all the reports about the death of philosophy are, at least, 'gross exaggerations'.

Much more interesting than the factual denial of the 'news' about the 'end-of-philosophy', however, are the ideological dismissals of the issue. In a way, it is the ideological issue that determines the sociological issue: whether the current philosophical scene should be described in terms of a disciplinary identity crisis, or in terms of gay prosperity. The trust of the ideological dismissals is shared, in one way or another, by most practitioners within the institution of philosophy. I will present here only two basic versions of the ideological objection. While the first dismisses the very notion of the 'end-of-philosophy' as incoherent and self-defeating, the latter points out that there is virtually nothing new in the present skeptical wave and no amount of skepticism can stop the human need to philosophize. Let me elaborate on these themes briefly.

I will begin with the first dismissal, the dismissal from incoherence. According to this objection, all the 'end-of-philosophy' genre suffers, in-

deed *must* suffer, from the same chronic philosophical fault: its very logi-
cal structure makes them self-defeating. The very radical project of dis-
solving or deconstructing philosophy is logically incoherent, *ergo*,
impossible. The philosophical reasoning behind this objection is, I think,
a version of the transcendental argument against wholesale skepticism.
The objection has the following structure. The very idea of Philosophy—
like its closest all-encompassing siblings such as Metaphysics, Rationality,
Logic, Epistemology, Language, and Conceptual Scheme—is not, and
cannot be, a proper semantic object for wholesale skeptical onslaught.
(Davidson, 73) The totalizing, all-encompassing nature of these norma-
tive concepts paralyzes the very possibility of carrying out a meaningful
and comprehensive skeptical argument. In order for the argument to
make sense at all, it must rely on the very normative notions it aims to
negate. The more totally one doubts, the more the skeptical argument it-
self becomes impossible. This argument, as indicated earlier, is a version
of the transcendental objections to the meaningfulness of all-encompass-
ing skepticism.[20] An unlimited skeptical argument, as both Sextus and
Hume well recognized, can never get off the ground.[21] It is bound to end
up in a morass of self-referential paradoxes.

Let me rehearse the dismissal from incoherence from a slightly differ-
ent angle. The 'facts' of history, sociology, or culture are, in themselves,
too impotent to yield a genuine *normative* (i.e., philosophical) conclusion
about the impossibility of the philosophical enterprise. Only by con-
verting those facts into some kind of normative-philosophical position—
call it perspectivism (Nietzsche), historicism (Dilthey), sociology of
knowledge (Mannheim), pragmatism (James and Dewey) or what have
you—is one able to reach the sufficient normative potency to construct a
comprehensive critique of philosophy. But here comes the paradox. As the
critical enterprise becomes a 'philosophical' one, it also becomes self-de-
feating. So, like it or not, even in rebelling against the tradition, you still
must subscribe to it. *Tu quoque.*

This dismissal often seems to bear moral overtones. Not only are all
forms of radical skepticism equally untenable on logical grounds, they are
also deceptive. Deceptive because 'end-of-philosophy' thinkers always
need to assert some form of 'magic loophole' in order to allow their own
critiques to be exempted from their own excessive destruction. Only with
the aid of such a loophole are they saved to do what they cannot help but
do anyway, *philosophize* the end-of-philosophy. Take Sextus's classical
skepticism, or Nietzsche's perspectivism, or Wittgenstein's language game
theory, or Rorty's pragmatism: behind each of these critiques of philoso-
phy one finds a genuine philosophical mind-set after all. There is no way
to step out of philosophy. The love-hate relationship these thinkers have

with philosophy demonstrates that anti-philosophy is a philosophical species after all. *Tu quoque* again.

This has also been the ultimate judgment of the history of philosophy. After all is said and done by the negative philosophers, the same tradition they so vehemently reject retroactively embraces them as its *own* children, naughty perhaps, but still the legitimate children of philosophy. They are granted full admission to the eternal pantheon of the 'Great Dead Philosophers', being classified as a distinct philosophical mind-set—skepticism. Skepticism, for this attitude, is the mirror image of dogmatism, and just as perennial. For some philosophers (e.g., Barry Stroud), the deep significance of philosophical skepticism lies precisely in its ability to demonstrate perennial insights about the strangeness of the human predicament. (Stroud, 1984)

Once the anti-philosopher is presented as no more than the skeptical voice of the perennial philosophical battle-like dialogue between dogmatism and skepticism, there is, indeed, nothing philosophically unique about the present cycle in this saga. For this saga will go on for ever no matter what. To put this differently, once skepticism is presented as a merely epistemological issue, something to which human history and culture are philosophically irrelevant, then, by definition, there cannot be anything 'philosophically significant' about the present 'end-of-philosophy' movement.

Viewed in this way, the alleged 'end' of analytic philosophy—a sociological description very few would dispute nowadays (Rajchman, 85)—means nothing like the *end* of the entire Western genre of philosophy; rather, it is a transition *within* that perennial genre. Once again, philosophy (or epistemology, or metaphysics) is not the kind of thing that truly can be ended. Hence, for a philosopher like Stroud, the deep significance of philosophy has nothing to do with culture. Looking at philosophy *sub specie aeternitatis*, one sees absolutely no reason to suppose that the fate of current post-analytic rebellion against the tradition will be significantly different from similar skeptical rebellions of the past. All the skeptical attempts to liquidate philosophy, just like all the attempts to establish its foundations once and for all, are bound to fail for the same deep reason: the urge to philosophize in the broad sense, that is, the urge either to do or undo philosophy, is irresistible. Hence, to talk about the 'end-of-philosophy' is to forget the most essential thing about philosophy, *philosophia perennis*.

IV. CAN THE IMPASSE BE BROKEN?

At this point it becomes clear that the debate is characterized by a com-

municative impasse between the two sides. The ideological objections to the postmodernist critiques, as I pointed out, are a priori dismissals of the very legitimacy of the 'end-of-philosophy' notion. While the first objection considers the notion of bringing philosophy to an end as semantically faulty and self-referentially paradoxical, the second objection views the notion that the history of philosophy may have an end as presenting a pragmatic paradox. Each of these dismissals, in itself, reflects aspects of the all-powerful ethos of *philosophia perennis*. There is simply no way to step outside philosophy.

For the postmodernist critic, however, here lies the real problem. For him, the intrinsic flaw in all these (and similar) objections is that they simply *beg* the very question that the postmodernist critique raises: the question of Philosophy itself. The fact is, he claims, that the postmodernist critique is not adequately answered, but is rather dismissed either as incoherent or as another kind of philosophy. All the objections are made from *within* the Philosophical mode, i.e., they presuppose that there exists an upper level discourse—universal, neutral, and ubiquitous—called 'Philosophy'. Consequently, these objections fail to acknowledge, let alone to address, the major cultural-historicist point of Rorty's critique, namely, the claim that society can exist, even prosper, without the need to appeal to Philosophy as a way to ground our political, moral and intellectual values and practices; not only that a 'post-Philosophical' era is possible, but that we seem to be moving towards it anyway. For the Rortyian postmodernist, this is not a theoretical-philosophical claim; it is a statement that reflects the historical conditions of our emerging postmodernist culture.

I do think the postmodernist is justified in his grievances that he is dismissed by the ethos without sympathetic hearing. Nevertheless, to understand the significance of the impasse one must recognize that those dismissals are actually inevitable from the perspective of the ethos. There is no way, for those who share the ethos, to make sense of the call to bring philosophy to its end. Implicit in their objection is the powerful sentiment, a deep Platonic-Kantian theme, of the necessity and ubiquity of philosophy. Indeed, for those who maintain the ethos, the very application to philosophy of the concept of 'institution' is awkward, even misleading. Philosophy is *not* a social institution in the common sociological sense. Rather, it is a by-product of the constitution of *thought*, an essential residue of the self-reflective nature of thought itself. The institutional features of philosophy as a discipline are external, hence irrelevant, to its true praxis. Granted this view, the application of radical historicization to philosophy does not make sense. The idea that philosophy is an institution that can be ended, at some specific historical point, is utterly incoher-

ent and senseless. In a sense, procedural dismissals are the only response available for those who maintain the ethos.

It is also the prevalence of the ethos that leads the faithful to consider the postmodernist critiques of philosophy as no more than variants of the philosophical genre called 'skepticism', while skepticism itself is conceived of as a mirror image of dogmatism, i.e., negative dogmatism. Here is the source of the charge of *tu quoque*. No matter how loudly the postmodernist expresses his reluctance to be part of the epistemological game, he would be viewed as an epistemologist anyway: a philosopher who promotes certain negative epistemological theses. For the epistemologist, it is virtually impossible to see anything discursive that can exist outside the space of epistemology. Since epistemology is indispensable and ubiquitous, there is no other space to go to. A post-philosophical space simply does not exist.

Is there a 'rational' way to break this impasse if there is no agreed-upon procedure for resolving it? Again, to look for a 'rational' way would beg the very question we ask, for it is the question of rationality and discourse that divides the two camps. As we have earlier noted, Rorty's notions of 'inquiry' and 'conversation' involve a set of incommensurable assumptions as to the nature of meaningful discourse, and the standards of rationality that make it possible. Though there is an impasse over rationality between 'inquiry' and 'conversation', it is not a symmetrical one. This is so because their communicative predicaments are quite different.

For the Philosopher, as we saw, there is simply no way to do philosophy without also being engaged in Philosophy. This is so because "to be rational is to find the proper set of terms into which all the contributions should be translated if agreement is to become possible". (*PMN*, 318) For the philosopher, *all* discourses *must* be epistemological in order to be considered rational. Epistemology is the home of rationality. Conversation, from the viewpoint of epistemology, is no more than "implicit inquiry". (*PMN*, 318) The postmodernist-pragmatist, however, is in an entirely different predicament. Having altogether lost faith in the epistemological project of constructing a neutral matrix of rationality ('the common ground'), he no longer has either the hope, or the interest, to form such a matrix. For him, epistemology is no more than just 'routine conversation', a conversation about those topics for which it is easy to form a consensus on how to resolve disputes.

Now we can see the asymmetry in communication between the two sides. The postmodernist is much more sensitive to the defensive anxiety embedded in the opponent's position, and recognizes the enormous psychological and cultural force behind his opponent's need to preserve the ethos of Philosophy. For this reason, the postmodernist wants to demon-

strate to his opponent that it is possible to be a philosopher, yet without being a Philosopher; that "one can be a philosopher precisely by being anti-Philosophical". (*COP*, xvii) His strategy to break the conceptual impasse is based not on procedural dismissals, as his opponent does, but rather on a *therapeutic* understanding of the Platonist mind set. This is the Nietzschean project of unmasking, stripping Philosophy from its grand ethos. Rorty, like Sextus-Empiricus or Wittgenstein, treats the unmasking project as a therapeutic process, a process of gaining self-consciousness about one's own identity and history. The postmodernist is fully aware, as were all of the great skeptics of the past, that skeptical arguments alone—skepticism viewed as a negative philosophical thesis—cannot break the impasse by themselves.[22] Skepticism, as the philosophical combatant of dogmatism, leads only to further impasses and paradoxes. But it is through the pragmatics of unmasking, if successful, that one learns it is possible to philosophize without subscribing to Philosophy.

This therapeutic method captures, I think, the core of Rorty's project of unmasking Philosophy. But unlike Wittgenstein's or Wisdom's methods of 'therapeutic positivism', Rorty offers something quite different: what one might call 'therapeutic historicism'. His therapeutic practice is built upon an historicist narrative of the rise of modern philosophy as a new cultural mode. One can reconstruct Rorty's therapeutic approach as a process consisting of a series of therapeutic layers. Each layer is designed to enhance the effect of the earlier one.

The first layer is a straightforward philosophical-skeptical layer. It amounts to a series of skeptical arguments against foundationalism and representationalism. It makes use of the analytic style in order to undermine the very foundationalist image of analytic philosophy. This layer is based on "the holistic, antifoundationalist, pragmatist treatments of knowledge and meaning which we find in Dewey, Wittgenstein, Quine, Sellars and Davidson". (*PMN*, 317) Rorty uses these arguments to debunk the analytic philosophy version of the notion that Philosophy is, or could be, the mirror of nature. But this layer, of course, is not enough. Philosophical skepticism alone, as skeptics know all too well, has its own inherent limits. (Cohen 1984)

So we come to the second layer, one designed to provide credibility to the skeptical arguments. Its role is largely psychological, i.e., to create a sense of distance, a feeling of suspicion, about the foundationalist hope. As the stock of anti-foundationalist arguments accumulates weight, one naturally becomes more tuned in to Rorty's historical suggestion that the two and a half millenia of attempts to do Philosophy "support the suspicion that there is no interesting work to be done in this area". (*COP*, xiv) It should be clear, however, that this is no more than a sense of suspicion,

not a 'proof' of the impossibility of the enterprise. The suspicion results not from the epistemic weight of inductive evidence, but rather from the psychological process of losing faith.

The third layer of unmasking has to do with better appreciating the nature of the impasse between the Philosopher and the pragmatist. Rorty sees the issue as the choice between two notions of philosophy:

> *The issue is one about whether philosophy should try to find natural starting points which are distinct from cultural traditions, or whether all philosophy should do is compare and contrast cultural traditions.* This is, once again, the issue of whether philosophy should be Philosophy. (*COP*, xxxvii, italics in original).

Once the issue is formulated in these terms, it is clear that the impasse cannot be settled by an appeal to philosophical procedures. There can be no agreeable *philosophical* procedure to resolve the issue of philosophy within philosophy itself; any attempt to do so would beg the question. This situation is, indeed, a mirror image of the impasse in the classical debate between the skeptic and the dogmatist. (Cohen 1984) As the great skeptics discovered long ago, the therapeutic move is well suited to accomplish the real skeptical goals—to relieve us from the flight to certainty and objectivity. Indeed, the only way to break the philosophical impasse is by explaining—in a non-philosophical fashion—the powerful roots of the Philosophical ethos. But unlike Sextus's (or Nietzsche's or Wittgenstein's) attempts to unmask philosophy in psychological or linguistic terms, Rorty attempts to do the job using cultural-historical terms.

The fourth layer, then, is a genealogical investigation of the historical-cultural circumstances that led to the rise of philosophy in various eras. Much of Rorty's strategy in *PMN* can be understood as an attempt to sketch a preliminary narrative of the rise of modern philosophy as part of the phenomenon of modernity at large. At this point the therapeutic process is designed to relax the philosopher's anxiety about losing the ethos. The stress on the distinction between 'Philosophy' and 'philosophy' may do the job. Only once this distinction is drawn Rorty can explicitly call to bring Philosophy to its end, saying we should stop "asking questions about the nature of certain normative notions (e.g., "truth", "rationality", "goodness") in the hope of better obeying such norms". (*COP*, xv) This call, however, should not be confused with the call for the end of philosophy, nor an expression of total discontinuity with our philosophical past. That kind of anxiety is simply unwarranted. For, of course, there will always be something humans will call 'philosophy'.

In its uncapitalized form the notion of philosophy is not a generic name for a subject matter, or method, but rather (rephrasing Sellars) the name for the attempt "to see how things, in the broadest possible sense,

hang together". This notion of philosophy does not require a special space for philosophy, but philosophy is an integral part of the culture and history. Sellars's notion of philosophy is just a precursor of the postmodernist notion of philosophy as cultural commentary, "seeing how all the various vocabularies of all the various epochs and cultures hang together". (*COP*, xxxviii)

V. Postmodernism and Radical Historicization

As the therapeutic process reaches its finale it is worthwhile to reflect on the question I presented in the introduction: "Is philosophy more like magic or more like logic?" This question, I suggested, constitutes the great divide separating the two sides of the 'end-of-philosophy' debate. Not surprisingly, the question mirrors the communicative impasse that dominates the entire debate: it begs the real issue—i.e., whether philosophy must be Philosophy—that divides the two sides. Each side maintains his own notion of what philosophy is or ought to be.

For the traditionalist philosopher, the issue here is a conceptual one: whether the call to historicize philosophy can make more sense than the call to historicize logic. That philosopher's initial answer, prior to the therapeutic process, was NO. The call to historicize philosophy is, for him, just as preposterious as the call to historicize logic. The question, for him, is a straightforward Platonic one, i.e., a question about the essence of 'logic', 'magic', and 'philosophy'. Viewed from the Platonic perspective, the affinity between 'philosophy' and 'logic' is self evident: if Philosophy is the enterprise that discovers and deciphers the structure of Reason, formal logic is the core of philosophy. Magic, viewed from this perspective, is at odds with the belief in rationality, hence, a proper object for historicization. To historicize magic is just another way to be positivistic about it, a way to explain it away.

On the postmodernist side of the divide, however, the issue is quite different. The postmodernist may well agree with the positivist's endorsement of historicization in the context of magic. But the reasons behind the postmodernist endorsing of historicization are not positivistic at all. Unlike the positivist, the postmodernist does not want to limit historicism to magic, or religion, or metaphysics, but instead wants radical historicism all the way. Let me further highlight this difference.

The historicism of the positivist is a distinctly modernist attitude. For the modernist, historicization is a fair approach to deal with 'the irrational' or 'the primitive'. Historicism, however, is not an appropriate way to explain 'the rational', for the rational does not need further explana-

tion. For positivists, from Comte to Reichenbach, the fascination with the project of the end-of-philosophy was closely tied to their faith in the idea of modernity as rationally progressive. Their project of bringing philosophy to its end falls within the broader modernist project of 'unmasking' the 'non-modern' modes, i.e., those modes of thought that from the viewpoint of modernity look anachronistic. Consider some of the classical works of modernist thinkers in the human sciences—Lévy-Bruhl on the history of mentality, or Frazer on magic and primitive thinking, or Freud on the history of religion, or Spencer on the evolution of thought. In all of them we find a distinct post-Hegelian attempt to historicize some 'nonrational' or 'primitive' aspects of the human psyche. Central to all these attempts to unmask the 'non-modern' is the Enlightenment faith in progress as something to be rationally unfolded through history. Yet intrinsic to this modernist attitude is the Platonic sentiment that philosophical 'Reason' is something to be found, not to be created, and that it is not an appropriate object for historicization.

The postmodernist abandons this hope altogether. He rejects the positivist attempt to use *limited* historicization, that is, to apply historicization only to the realm of the irrational, while keeping the normative notion of philosophical Reason intact—and aim at *radical* historicization. As far as historicism is concerned, philosophy is not that different from magic, religion or metaphysics. The question of whether philosophy is more like magic than logic is, from the postmodernist perspective, an historical-cultural issue, not a conceptual one. It is the issue of whether we can historicize philosophy, just as our modernist forerunners historicized magic a century ago. Not surprisingly, once again, the postmodernist's answer is unequivocally YES.

To sum up, though the communicative impasse cannot be settled on the basis of philosophical Reason—for it is the existence and the legitimacy of philosophical Reason that divides the two sides—it appears that there are other cultural means outside Philosophy. For the postmodernist, it is the very function of the therapeutic process, a process of gaining a sense of historicity, that gives credibility to the pragmatist/postmodernist critique of philosophy. For the postmodernist, as we just saw, the dialectical history of foundationalism is deeply ingrained within the same 'negative dialectics' that leads from modernity to postmodernity. Just as metaphysics lost its claim to be the seat of philosophical Reason to positivism and analytic philosophy, the latter is now losing its status as late-twentieth-century thought struggles with the Platonic demon of philosophical Reason. Not only is the postmodernist skeptical about the possibility of finding philosophical Reason, but it is not clear whether the institution of

science any longer needs to have foundationalist support from philosophical Reason.

VI. BEYOND THE ETHOS

Does the call to bring Philosophy to its end also entail the end of philosophizing? Can the high culture of learning survive without having some philosophy on its side? And if not, how will the 'philosophy of the future' look? How can one teach the history of philosophy when that heading itself may have become *passé*? In general, what vision of the future of philosophy can be offered for a 'post-Philosophical' era?

Such questions, and others of the kind, have been constantly hanging over the debate as philosophy is increasingly forced to face the question of its own liquidation. Such questions leave both sides of the divide with the utmost anxiety, the anxiety over the future of philosophy. For the traditional philosophers, it is the anxiety of losing something dear and indispensable, something they believe it is impossible for humans to lose. For the critics, it is the anxiety of ambivalence, the anxiety of the desire 'to have and to have not', the anxiety of being damned with it and damned without it. It is this anxiety that makes the exchange at cross-purposes so apparent.

I deliberately left the issue of 'the future of philosophy' to the very end, to be addressed after we had gone through the therapeutic process. Indeed, the whole point of that process is to find ways to come to terms with this anxiety, to relax it. Remember that the philosophers' apprehension was born out of the very call to liquidate philosophy. Since, for philosophers, all philosophizing should be compatible with the ethos (that is, Philosophy in Rorty's terms), the call to bring philosophy to its end is nothing than the call to end all philosophizing. Guided by that ethos, philosophers find such a call outrageous in tone, and self-defeating in content. The need to philosophize, they point out, is not something that can be ended, liquidated or abolished. *Philosophia perennis* is a deep reflection of the human capacity to be self reflective; it is that capacity that makes philosophizing indispensable for humans. As long as there are humans, philosophizing cannot go away.

This objection from the ethos was made before the therapeutic process started. It is the task of the therapeutic process to demonstrate that that anxiety is unwarranted. The call to liquidate philosophy as a modern foundationalist genre is not a threat to the indispensability of philosophizing. Such a call is not directed against the primordial human need to philosophize, but rather against a specific ethos—Philosophy—which

tells us what true philosophizing necessarily should look like. It is this ethos that identifies philosophizing in the most general sense with a way of asking Philosophical questions, questions about ahistorical properties to be adequately answered by the construction of some ahistorical Reason. The call to liquidate philosophy is directed against the notion of philosophy as a well-defined subject matter with its distinct problems and methods, that stands in a Platonic realm, outside, and prior to, history, language, and culture.

Though the history of philosophy has certainly tended to associate philosophizing and Philosophy into one literary genre, there is nevertheless nothing that makes this association a matter of deep necessity rather than a matter of historical contingency, except, of course, the fact that the ethos of philosophy just says so. But the ethos cannot be the ultimate judge of its own case, even when it invokes a full metaphysics for this purpose. The important thing to realize is that the ethos vision of philosophizing, no matter how dominant it happens to be, is still only *a* way of philosophizing. Once culture loses its faith in the ethos, there are still other ways to philosophize.

In the case of Rorty we noticed how already the therapeutic process itself is meant to diffuse the tension. Rorty separates the need to philosophize from the ethos by making the distinction between 'Philosophy' and 'philosophy'. The former associates the philosophical mission with the goal of rational inquiry, while the latter associates philosophizing with the idea of the ongoing conversation of mankind. Another way to explicate the difference is by distinguishing between philosophy as 'fundamental' and philosophy as 'foundational'. In everyday use we treat these terms as interchangeably synonymous, and certainly they do overlap most of times, yet the terms are quite different. As to philosophy, one can say that philosophizing is dealing with the fundamentals, as the ethos *rightly* tells us, yet without claiming that in doing so it must be foundationalist.

The prevalence of the ethos through history has caused us to believe that for philosophy to be fundamental it must also be foundationalist. Ever since Plato this ethos has been at the core of the philosopher's self-image. It is in philosophizing that we can transcend our flesh and blood mortality to share a divine sense of immortality. Philosophy allows us to get in touch with the sphere of the eternal—Truth, Knowledge, Reason.

For modernity, the institution of philosophy meant the promise that secular culture can rest on true and secure rational foundations. Though Laplace declared, on behalf of the spirit of the Enlightenment, that he had no need to presume the existence of God as a postulate in order for the institution of science to work, it was the job of foundationalist philosophy to provide, both for science and morality, a secular replacement of reli-

gion. Despite its thin secular cloth, modernity was not confident enough in itself to abandon its metaphysical or epistemological assurance. For modernity, the fear of nihilism was always seen as waiting behind its thin intellectual gates.

Analytic philosophy can be read, as Rorty reads it, as the latest modernist outburst within this historical narrative of modernity—indeed, quite a 'minimalist' one, like all the other products of late modernity—to provide quasi-religious assurances to culture. But once the last minimalist stage is exhausted, it may well be the case that one can no longer make an appeal to this modernist ethos.

Postmodernism, as a call for a new philosophical genre, is a defiance of the grand Platonic ethos. It sees culture itself as the ultimate and ubiquitous starting point, not Philosophy. It is a view of culture as something that has no foundations other than itself. Postmodernity is the historical condition of culture where culture comes to terms with its ubiquity, where no ahistorical and transcultural assurances—metaphysical or otherwise—are sought to contain our self-esteem. It is the realization that in order to ask fundamental (i.e., philosophical) questions one must be involved in both history and culture. The ethos has become impossible to maintain, not because of the discovery of a new skeptical counterargument (this, indeed, would be self-defeating), but because it has lost its cultural vitality, its historical relevance. To say that philosophy is more like magic than like logic, as postmodernists say, is not at all to deny the indispensability of philosophizing, but simply to acknowledge that philosophy no longer has to be Philosophy. It is the admission that the present culture of learning—and most importantly science—no longer needs a distinct and higher institution (or discourse) of legitimization. (Lyotard, 84; Redner, 86)

Now, how radical is that move? Should we call it an 'end' or just a 'turn'? (Baynes, 87) Here, too, we are stuck in the business of converging perspectives. In relation to the perspective of the grand ethos, the postmodernist negation seems total. To abandon the ethos is to abandon the subject matter of philosophy. For the purpose of rhetoric many of the postmodernists, especially the French, adopt this perspective in order to boost the element of radical discontinuity in their attack on the tradition. But as we converge into the new perspective of postmodernity as a historical-cultural category, not a philosophical category, we have to realize that from the perspective of 'the ongoing conversation of mankind' this must be just another turn. For as long as humanity itself exists, there will be only turns, no final ends.

As to the anxiety about the loss of philosophy as a subject matter, that 'danger' too is probably unwarranted, and certainly premature. Rorty, un-

like some of the European postmodernists, explicitly dismisses this danger:

> Whichever happens, however, there is no danger of philosophy's "coming to an end." Religion did not come to an end in the Enlightenment, nor Painting in Impressionism. Even if the period from Plato to Nietzsche is encapsulated and "distanced" in the way Heidegger suggests, and even if twentieth-century philosophy comes to seem a stage of awkward transitional backing and filling (as sixteenth-century philosophy now seems to us), there will be something called "philosophy" on the other side of the transition. (*PMN*, 394)

One way to think about the appropriateness of the term 'end-of-philosophy' is by comparing it to a previous prelude within that narrative, the 'end of metaphysics'. Though most of our scientific and philosophical concepts and principles originated in what should appropriately be called metaphysical thinking, metaphysics as a distinct genre of producing knowledge claims is virtually extinct. In the last three centuries, as the forces of modernity emerged, metaphysics lost its distinct place in culture. In particular, the formation of science as a distinct institution claiming to be the sole embodiment of modern knowledge made the divorce between culture and metaphysics a matter of historical inevitability. As philosophy found itself endangered by the rise of the institution of science, it had to redefine itself by "going epistemological". (Redner, 86, especially chapter 2) Both science and epistemology began to look for a mutual coexistence through cooperation.

The disappearance of metaphysics was not the logical result of the emergence of new skeptical arguments that proved the impossibility of metaphysics, but rather the aftermath of a complex historical-cultural process. This is not to deny, of course, that thinkers, from Bacon and Locke to Hume and Kant, developed all types of epistemological and linguistic arguments against metaphysics. Rather, these skeptical arguments, historically understood, were largely articulations of a new cultural landscape which put metaphysics at odds with the new vision of scientific knowledge. By the nineteenth century, with the emergence of various brands of positivism as the new anti-metaphysical movement, metaphysics became a bad word, a reference to reactionary and prejudiced thinking.

Now, does the disappearance from the surface of Western culture of metaphysics as a *distinct* mode mean that the human need for metaphysics is no longer there? Of course not. The longing for metaphysics has not ceased even in a culture that has turned its back on metaphysics as a distinct subject-matter. Though we no longer live in an era where metaphysics is used as a generic name for a common field of inquiry, we can still trace plenty of metaphysical residues in all quarters of culture. Dialecti-

cally, most of those residues can now be found in those areas that once claimed to be the ultimate replacement of metaphysics—science and philosophy. In this generation metaphysics got the most revengeful rehabilitation as it became the main interest of *late* analytic philosophy, the analytic philosophy that turns its back on its own ideological parent—logical-positivism. Metaphysics has made a spectacular comeback under the most ironic heading of 'analytical metaphysics'. But this comeback only seems to highlight the identity crisis of late analytic philosophy, as it realizes the need to withdraw from its own modernist heritage.

Can we make an enlightened analogy from the fate of metaphysics to the fate of philosophy itself? Yes and No. Yes, for just as the longing for metaphysics has not ceased, it is utterly inconceivable that the human need for self-reflection, broadly understood, will one day vanish. As in the case of metaphysics, there will always be an heir to the subject matter we call 'philosophy'. No, for in the case of philosophy as an institution it has a much better chance than metaphysics to preserve its vitality as a subject matter. Unlike metaphysics which by the late nineteenth century had hardly any institutional base on which to preserve itself as a distinct academic field, philosophy in the late twentieth century has a very solid institutional basis. (Castañeda, 88; Mandt, 88) Given this enormous institutional base it is utterly inconceivable, even under the worst kind of identity crisis, how such a sociological infrastructure could be damaged to the point of disappearance.

But, there is one final postmodernist factor to be accounted for. Though late-twentieth-century postmodernists may well agree that the need to philosophize is indispensable for humans—*philosophia perennis*—this is not enough to ensure its future existence as a human enterprise. As children of the nuclear age we are aware that the future of the human enterprise is fragile and uncertain. Nuclear deterrence is supposed to be the ultimate guarantee for our global future security, yet inherent human fallibility has the potential, indeed for the first time in human history, to lead to omnicide. No one can be certain any more about the future existence of philosophy, just as no one can be certain about the future existence of our world-civilization. The eventuality of omnicide is present with us as an inherent ingredient of the postmodernist condition. It is this possibility of omnicide that makes the postmodernist moment so historically unique.

NOTES

1. It is not possible here to provide a complete bibliography of the 'end-of-

philosophy' theme in contemporary philosophy. To compose such a list would be a vast enterprise, in itself beyond the scope of this paper. At any rate, there is no question that the call to bring philosophy to its end is one of the most prevalent themes in twentieth-century philosophy. It is a central theme in the thought of the two most influential philosophers in this century, Wittgenstein and Heidegger. In the post-war years Theodor Adorno made in the most forceful way the claim that "the problem of the liquidation of philosophy" is symptomatic of the predicament of our time as a central cultural issue of our time. (Adorno, 1973) In the last decade the theme of the 'end-of-philosophy' has penetrated into almost all philosophical communities. Contemporary French thought, in its post-structuralist and post-modernist versions, has repeatedly alluded to this theme. Jacques Derrida, for example, declares that the question(s) of the death of philosophy "should be the only question(s) today capable of founding the community of those who are still called philosophers". (Derrida, 1978, 79–80) Another French postmodernist, Jacques François Lyotard, defines the "postmodern condition" as "incredulous towards meta-narratives", and he considers philosophy as the paradigm case of meta-narrative. (Lyotard, 1984) Among contemporary English-speaking philosophers two major thinkers have distinguished themselves as the voices of the postmodernist revolt: Richard Rorty in his critique of the institution of philosophy at large (Rorty, 1979, 1982) and Paul Feyerabend in his critique of the idea of Reason (Feyerabend, 1975, 1987). Other major late analytic philosophers, such as Putnam, Margolis, Hacking, and others, have taken somewhat a more modified version of the historicist turn. Harry Redner has recently provided an intriguing historical-cultural narrative of the 'end-of-philosophy' crisis (Redner, 1986, 1987). As an indication of the prevalence of the theme, in addition to the present volume, there are at least four recent collections in English devoted to the postmodernist theme of the 'end-of-philosophy' (MaCarthy et al, 1987; Rajchman and West, 1985; Silverman and Ihde, 1985; Hollinger, 1985).

2. I owe this distinction to Marcelo Dascal (Dascal, the present volume).

3. By the phrase 'radical historicization' I mean something almost interchangeable with the current use of the term 'historicism' (but not in Popper's sense, or the way we commonly understand Hegel's rational historicist system). Crudely speaking, I have in mind the view that considers the formation of our conceptual vocabulary not as a reflection of some intrinsic epistemological necessities, but rather as the result of some historical contingencies along our way. See also note 6.

4. I think that the press revelations about the Reagans and astrology are compatible with this claim. The controversy was not about Nancy Reagan's personal interest in astrology; it became an embarrassing public issue as it became known that the Office of the President of the United States used astrological services in order to plan Presidential schedules.

5. To historicize logic was, of course, Hegel's grand vision. As an undergraduate, one of my first anthropological lessons in entering into philosophy was the clear sense of disdain that analytic philosophers have towards Hegel, in particular his *Logic*. Likewise, I recall the highly apologetic tone with which Hegel's scholars protected him: Hegel's *Logic* has nothing to do with symbolic logic.

6. I refer to the postmodernist call as *radical* historicization for, unlike the historicism of the nineteenth century, the current one lacks any teleological, rationalist or progressive presuppositions about the direction of history.

7. Richard Rorty refers to this as "*the* philosophical urge". (Rorty, 1979, 179). He stresses that this craving is just a way of expressing hope.

8. This emotion is beautifully expressed in Descartes's *Discourse* II.

9. This is the central claim in *Philosophy and the Mirror of Nature.* "To know is to represent accurately what is outside the mind; so to understand the possibility and nature of knowledge is to understand the way in which the mind is able to construct such representations." (p. 3)

10. When Rorty claims that "philosophy's central concern is to be a general theory of representation, a theory which will divide culture up into areas which represent reality well, those which represent it less well, and those which do not represent it at all" (Rorty, 1979, 3), it is clear that by philosophy he means modern philosophy.

11. The very first sentence of *PMN* indicates that the object of Rorty's unmasking efforts is philosophy's self-image. "Philosophers usually think of their discipline as one which discusses perennial, eternal problems—problems which arise as soon as one reflects." (Rorty, 1979, 3)

12. In *PMN* Rorty sees to talk about the search after "common ground" (i.e., epistemology) as the essence of the philosophical enterprise. He does not use the term "essence", but it sounds like that. He says: "The history of philosophy is the story of the attempts to look for this common ground, It might be found beyond and outside the soul in the realm of Being or the Forms as Plato suggested, or perhaps inside the mind as many seventeenth-century philosophers insisted, or alternatively within the autonomous sphere of language as many twentieth-century analytic philosophers suggested." (Rorty, 1979, 3)

13. It should be noted that 'hermeneutics', as Rorty uses the term, is quite different from the standard use of the term, especially in reference to the alleged special features of the human sciences. Hermeneutics, for Rorty, is not a method of interpretation for it is not a method at all; it is not limited to the context of 'understanding' human artifacts, for it rejects this distinction as 'epistemological'. Hermeneutics, for Rorty, is simply a way to cope with the diversity of human phenomena, an expression of the hope that we can continue in the conversation for the sake of enlightenment (but 'enlightenment', it should be noted, is not defined as, say, 'the growth of knowledge', or 'better approximation of the truth').

14. "Hermeneutics sees the relations between various discourses as those of strands in a possible conversation, a conversation which presupposes no disciplinary matrix which unites the speakers, but where the hope of agreement is never lost so long as the conversation lasts. This hope is not a hope for the discovery of antecedently existing human ground, but *simply* hope for agreement, . . . For hermeneutics, to be rational is to be willing to refrain from epistemology." (Rorty, 1979, 318)

15. Nevertheless, the end of epistemology as a subject-matter would not be necessarily the end of epistemology as a discourse. After all, epistemology, from the perspective of hermeneutics, is just a *type* of a conversation, namely a 'routine conversation' that deals with the 'familiar', with the apparently 'commensurable'.

16. "Our post-Kantian sense that epistemology or some successor subject is at the center of philosophy is a reflection of the fact that professional philosopher's self-image depends upon his professional preoccupations with the image of the Mirror of Nature." (Rorty, 1979, 392)

17. The pragmatist does *not* "invoke a theory about the nature of reality or knowledge or man which says that 'there is not such a thing' as Truth or Goodness. Nor do they have a 'relativistic' or 'subjectivist' theory of truth or Goodness. They would simply like to change the subject. . . . [P]ragmatists keep trying to find ways

of making antiphilosophical points in nonphilosophical language." (Rorty, 1979, 392)

18. The reaction to Rorty's 'end-of-philosophy' theme is vast and still growing. There is no way to provide here a comprehensive list of that literature. The following are just fragmentary samples: Hacking, 80; Hiley, 88; Kim, 80; Levi, 81; MacIntyre, 82; Skinner, 81; Young, 84. In this volume the papers by Castañeda, Dascal, Okrent, Putnam, and Rosenthal are additional contributions to that literature.

19. As Rorty (1982, 216–17) puts it, "most philosophers [in America] are more or less 'analytic,' but there is no agreed-upon interuniversity paradigm of philosophical work, nor any agreed-upon list of 'central problems.'

20. For a discussion of whether transcendental arguments can really 'stop' skepticism, see Stroud, 84.

21. For the development of this theme in the history of skepticism, see Avner Cohen, *Doubt, Anxiety and Salvation: A Study of Metaphilosophical and Psychological Themes in the History of Scepticism*. Unpublished Ph.D. dissertation (University of Chicago, 1981).

22. This is a recurrent theme in the history of skepticism. Ever since the third century A.D. when Sextus Empiricus introduced Phyrronian skepticism as a kind of therapeutic method designed to unmask the makeup of philosophical dogmatism, the point of the anti-philosopher's complaint against philosophy has hardly been properly understood. (Cohen, 1984; Hiley, 88) Kierkegaard may have been the first modern thinker to be aware of the philosophical significance of the problem of cross-purpose communication. (Cohen, 82) Skeptically-oriented thinkers have always insisted, like Rorty, that their point is *post-philosophical* (i.e., cultural and therapeutic), not Philosophical: culture would be better off by replacing the Philosophical notion of 'Truth by Correspondence' by the post-philosophical notion of 'living by appearances'. Then, as now, their proposals have gotten a bad name, usually for the same Platonic mixture of hope and anxiety.

BIBLIOGRAPHY

Adorno, W. Theodor. 1973. *Negative Dialectics*. Translated by E. B. Ashton. New York: The Continuum Press.

Baynes, Kenneth, et al., eds. 1987. *After Philosophy*. Cambridge: M.I.T. Press.

Belting, Hans. 1987. *The End of the History of Art?*. Translated by Christopher S. Wood. Chicago: University of Chicago Press (originally published in German in 1983).

Bernstein, Richard J., ed. 1985. *Habermas and Modernity*. Cambridge: M.I.T. Press.

Burnyeat, M. F. 1984. 'The Sceptic in his Place and Time.' In Richard Rorty, et al. (eds) *Philosophy in History*. Cambridge: Cambridge University Press.

Castañeda, Hector-Neri. 'Philosophy as Science and as Worldview.' In the present volume.

Cohen, Avner. 1982. 'Kierkegaard as a Psychologist of Philosophy.' *The Journal of the British Society of Phenomenology* (Vol. 13, 103–119).

_____. 1984. 'Sextus Empiricus: Classical Scepticism as a Therapy.' *Philosophical Forum* (Vol. 15, 405–424).

Dascal, Marcelo. 1988. 'Reflections on Postmodernity.' In the present volume.
Davidson, Donald. 1985. 'On the Very Idea of a Conceptual Scheme.' In John Rajchman and Cornel West (eds.) *Post-Analytic Philosophy*. New York: Columbia University Press.
Derrida, Jacques. 1978. *Writing and Difference*. Translated by Allan Bass. Chicago: University of Chicago Press.
Feyerabend, Paul, 1975. *Against Method*. London: New Left Books.
———. 1988. *Farewell to Reason*. London: Verso Press.
Habermas, Jurgen. 1975. *Legitimation Crisis*. Translated by Thomas McCarthy (German edition: *Legitimationsprobleme im Spatkapitalismus*, 1973). Boston: Beacon Press.
———. 1987. *The Philosophical Discourse of Modernity*. Translated by Frederick Lawrence. (German edition: *Der Philosophische Diskurs der Moderne: Zwölf Vorlesungen*). Cambridge: The M.I.T. Press.
Hacking, Ian. 1980. 'Is the End in Sight for Epistemology?' *Journal of Philosophy* (Vol. 77, 579–588).
Hassan, Ihab. 1987. *The Postmodern Turn*. Ohio: Ohio State University Press.
Hiley, David R. 1988. *Philosophy in Question*. Chicago: The University of Chicago Press.
Hollinger, Robert, ed. 1985. *Hermeneutics and Praxis*. Notre Dame: University of Notre Dame Press.
Kim, Jaegwon. 1980. 'Rorty on the Possibility of Philosophy.' *Journal of Philosophy* (Vol. 77, 588–597).
Kolb, David. 1986. *The Critique of Pure Modernity*. Chicago: University of Chicago Press.
Levi, Isaac. 1981. 'Escape from Boredom: Edification According to Rorty.' *Canadian Journal of Philosophy* (Vol. 11, 589–601).
Lyotard, Jean-François. 1984. *The Postmodern Condition: a Report on Knowledge*. Translated from French by Geoff Bennington and Brian Massuni. Minneapolis: University of Minnesota Press.
MacIntyre, Alasdair. 1982. 'Philosophy, the 'Other' Disciplines, and their Histories.' *Soundings* (Vol. 65, 127–145).
Mandt, A. J. 'The Inevitability of Pluralism: Philosophical Practice and Philosophical Excellence.' In the present volume.
Rajchman, John. 1985. 'Philosophy in America.' In John Rajchman and Cornel West (eds.) *Post-Analytic Philosophy*. New York: Columbia University Press.
Rajchman, John and West, Cornel, eds. 1985. *Post-Analytic Philosophy*. New York: Columbia University Press.
Redner, Harry. 1986. *The Ends of Philosophy*. Totowa: Rowman & Allanheld.
———. 1987. *The Ends of Science*. Boulder: Westview Press.
Rorty, Richard. 1979. *Philosophy and the Mirror of Nature*. Princeton: Princeton University Press.
———. 1982. *Consequences of Pragmatism*. Minneapolis: University of Minnesota Press.
———. 1985a. "Habermas and Lyotard on Postmodernity." In Richard Bernstein ed. *Habermas and Modernity*.
Silverman, Hugh J. and Ihde, Don (eds). 1985. *Hermeneutics & Deconstruction*. Albany: State University of New York Press.
Skinner, Quentin. 1981. 'The End of Philosophy?' *New York Review of Books* (19 March).

Stroud, Barry. 1984. *The Significance of Philosophical Scepticism*. Oxford: Oxford University Press.
Wellmer, Albrecht. 1985. 'On the Dialectic of Modernism and Postmodernism.' *Praxis International* (4, 337–362).
Young, James. 1984. 'Pragmatism and the Fate of Philosophy.' *Dialogue* (Vol. 23, 683–686).

6

David M. Rosenthal

PHILOSOPHY AND ITS HISTORY

It is widely recognized that the history of philosophy is strikingly important to the field of philosophy. The history of philosophy virtually always plays a role in philosophical training, and frequently figures quite prominently in it. Moreover, many whose intellectual interests are primarily philosophical devote themselves to studying the history of philosophy. And philosophical issues whose point is not at all historical are often cast in terms of discussions drawn from the history of philosophy.

Though it is indisputable that the history of philosophy is important to philosophy, it is far less clear why that should be so. The difficulty is that it is also generally agreed that philosophy is fundamentally a search for solutions to particular problems. Philosophical activity is not restricted just to the solving of problems, but the attempt to solve a certain range of problems is that main mark that distinguishes philosophical work from other forms of intellectual activity. Just what problems fall within this range is not easy to specify in a way that is at once accurate and informative. But we recognize such problems fairly readily, partly by way of family resemblances, and partly because philosophical problems usually involve relatively abstract issues that other, more easily defined disciplines typically ignore.

Most philosophers today operate with roughly this conception of their field. This is evident both in their actual work and in the judgments they make about its success and failure. Indeed, this view of philosophy has dominated the writings of virtually all those past authors whose work we regard as paradigmatically philosophical.

It typically goes unnoticed, however, that this conception of philosophy is uncommonly hard to square with the strong and abiding interest philosophers have in the history of their field. The views of past philosophers may sometimes be helpful in current efforts to solve philosophical problems, by suggesting strategies for solving them or by pointing up pit-

falls and fallacies to avoid. But such benefits hardly seem proportionate to the central importance to philosophy of its own history. Why, if philosophy is mainly the solving of problems, would the history of such efforts be a well-established part of the field, and such a central part of philosophical training? Why wouldn't past successes simply be seen as part of our current philosophical knowledge, rather than as a reason to study the past works themselves? Why, moreover, do so many with distinctively philosophical interests study those past works, rather than devote themselves directly to the problems that define the field? Indeed, why should the history of philosophy be studied, as it is, almost exclusively by those whose training and interests are philosophical, rather than historical? Satisfactory answers to these quandaries are not readily forthcoming if philosophy is essentially a problem-solving activity.

One response to this difficulty would be to contest the apparent data that seem to lead to it. Thus one might insist that, despite appearances, the history of philosophy is not actually all that important to philosophical work. Or one might, instead, deny that philosophy is a discipline whose main goal is to solve problems. Both the problem-solving conception of philosophy and the importance of its history seem well established. But perhaps a coherent view demands that we deny one or the other.

There is another, more elaborate way in which emphasizing the history of philosophy can lead to doubts about the problem-solving paradigm. Historicists from R. G. Collingwood to Alasdair MacIntyre have forcefully urged that philosophical problems arise in particular intellectual contexts, which give those problems whatever point they have. If one presses hard on the idea that philosophical problems are in this way creatures of their historical contexts, such problems may no longer seem to have any independent standing as serious intellectual concerns. The problem-solving paradigm would come to seem like just a self-serving piece of mythology philosophers promulgate in order to keep their field alive. Such uncompromising historicism can thus undermine the idea that the real goal of philosophy is to solve problems. It is roughly this challenge to the traditional conception of philosophy that Richard Rorty has developed, most impressively in *Philosophy and the Mirror of Nature*, but also in *Consequences of Pragmatism* and other recent writings.[1]

My principal goal in what follows is to explain the importance to philosophy of its history, given that philosophy is at bottom a problem-solving discipline. Before taking up that task, however, I confront the challenge to the problem-solving picture posed by extreme historicism of the sort Rorty advances. In section I, I set out Rorty's historicist argument against the view that philosophy is devoted to the solving of problems. I

then show in section II that such historicism does not undermine the problem-solving picture of philosophy, and that Rorty's historicism and the alternative picture he gives of philosophy rely on a double standard that affects his historicist accounts. In section III, then, I turn to the general significance to philosophy of its history. And I take up the usual explanations of the importance to philosophy of its history, and argue that they are inadequate. In section IV I conclude by arguing that the history of philosophy has special importance to philosophy because understanding philosophical views and arriving at the truth about philosophical issues necessarily go hand in hand. The history of philosophy has distinctively philosophical importance because we must confront, and think through, philosophical issues in order to interpret any other person's philosophical position, and thus to interpret any philosophical position from the past.

I. Rorty's Eliminativist Historicism

It is sometimes held that philosophy is defined by a set of distinctive problems that are eternal and perennial. Such problems would inevitably command the attention of philosophers in every era, unless and until they are decisively solved. As Rorty notes, this view is widely presupposed in standard texts on the history of philosophy.[2] Rorty sees this kind of history as reflecting the idea, dominant in such texts, "that 'philosophy' is the name of a natural kind—the name of a discipline which, in all ages and places, has managed to dig down to the same deep fundamental questions" (p. 63).

But such standard texts are not the main source of the idea that philosophy addresses perennial problems. Rather, that idea derives its force principally from the way philosophers themselves typically discuss their philosophical predecessors. It is natural to represent one's predecessors in terms of the issues that animate one's own work and dominate current discussion. So previous philosophers come across as having posed and addressed the very problems that are central to those current debates.

This way with our predecessors is hardly peculiar to the present day. Kant and Aristotle gave such accounts of their philosophical forebears, accounts that were so impressive, systematic, and illuminating that they have served as models for successive generations. Even Hegel, who notoriously saw philosophical thought as having systematically evolved, tacitly read current issues into the past. For he depicted previous philosophers as having posed questions whose true meaning we can grasp only in terms of the subsequent problems. Earlier problems are, in effect, dialectically in-

complete versions of the truer questions that Hegel himself addressed, and can be fully and correctly understood only in terms of them. I argue in later sections that this way of representing one's predecessors is both natural and fruitful, and indeed to a great extent inevitable. But whatever the case about that, so describing one's intellectual ancestors plainly fosters the impression that they shared with us a concern with problems that are perennial.

But we should be cautious about what we conclude from this practice of representing past philosophers as having addressed problems of current concern. That practice may more reflect the way we represent others' views than any eternal character of the problems addressed. Moreover, there are compelling reasons to reject the idea of perennial philosophical problems. The problems philosophers in different eras address typically resemble one another in many ways, but they are seldom exactly the same. As many from Dewey to Rorty have urged, these problems arise in the context of particular intellectual and social situations, and at various stages in the acquisition of relevant knowledge. These contexts are crucial for understanding the intellectual hold the philosophical problems of the day exert on us; to that extent, these contexts partly define just what those problems are. To view problems apart from context inevitably results in distortion. This distortion is often evident in the accounts philosophers give of their predecessors. It is most dramatic when contemporaneous accounts of previous philosophers diverge in ways that reflect philosophical differences between those giving the accounts.

To this extent, it is quite plausible to adopt a historicist view about philosophical problems. Indeed, even within a particular era, problems may be less similar than they appear at first sight, in part because of divergence of relevant intellectual context. But this much historicism in no way threatens the problem-solving paradigm of philosophy. Indeed, it would be surprising, on that view of philosophical activity, if the problems did not shift and evolve. Efforts to solve problems will presumably sometimes yield definite results—occasionally decisive solutions, perhaps more often refinements in formulations and clarifications of presuppositions. When such progress occurs, however modestly, the problems we address will change. If, with Russell, we see philosophical problems as truly perennial, we shall have to deny, as he was led to, that such problems are susceptible to any sort of solution at all.[3]

If philosophical problems are motivated in part by concerns specific to the intellectual or social context in which they arise, a shift in context will very likely induce a corresponding shift in the problems addressed. This change might occur even when the earlier problems are not thought to have been satisfactorily solved. When concerns that led us to pose certain

questions no longer capture our attention, the problems themselves will come to seem artificial and unmotivated. If those problems continue to receive attention, debates about competing solutions will seem pointless and idle, and the proposed solutions mere intellectual exercises. Such philosophical work will no longer reflect our desire to learn something new or deepen our understanding of things.

It is Rorty's contention that exactly this situation obtains today. The problems about mind, knowledge, and meaning that have dominated, and even defined modern philosophy derive, he argues, from seventeenth- and eighteenth-century concerns that no longer have any hold on us. Philosophical discussion about these topics now have that artifactual air typical of attempts to solve pointless problems. Rather than continue to emulate the efforts of past thinkers to find satisfactory solutions, Rorty concludes we should simply stop addressing those problems at all. Parts One and Two of *PMN* advance this view in detail.

If Rorty is right that the problems central to modern philosophy have become idle, we might expect those problems eventually to be reformulated, or even replaced by new questions that better reflect the concerns of the day. Such shifts have occurred before, and it is natural to suppose that occasionally they will again.

It is here, however, that Rorty's historicism is most radical. If one notices that the scholasticisms of one period repeatedly give way to problems newly formulated by a later generation, one may eventually come to see all such problems as transitory cultural phenomena, and thus question the value of trying to solve them. And if philosophical concerns pass only when problems come to seem pointless, and not because we find convincing solutions, one may well doubt whether such solutions are possible. Accordingly, Rorty sees the passing of today's outmoded problems as leading not to new, livelier ones, but to the end of philosophy, conceived of as a problem-solving discipline. His eliminativist exhortations extend beyond the present concerns of philosophy to the problem-solving picture of philosophy itself. Two eliminativist paths are possible. We can come to think of philosophy in non-problem-solving terms, as he recommends in Part Three of *PMN* or, equivalently, we can abandon philosophy altogether and enter a "post-Philosophical culture", as he foresees in *Consequences of Pragmatism* (xxxvii–xliv). Like Marx, Rorty hopes that by becoming aware of the pattern that has so far governed our passage from one historical stage to the next, we shall at last become able to break free of that pattern.[4]

Its revolutionary aims notwithstanding, Rorty's historicist stance has a fair measure of intuitive appeal. Philosophers disagree dramatically about central issues. Despite the central role of reasoning in philosophical

activity, these disagreements are rarely resolved by rational argument. Indeed, it is striking how seldom argument leads anybody actually to change sides in a debate. Disagreements that seem impervious to argument occur in all fields when issues of overarching theoretical significance arise. But such disagreements seem virtually epidemic in philosophy. It is hard to imagine how we could make sense of "those astounding differences of philosophic belief that", as John Dewey noted, often "startle the beginner and become the plaything of the expert".[5] Such disagreements, moreover, occur at all levels of abstraction, leaving little common ground for disputants to fall back on. These considerations make it inviting to hold, with Rorty, that the issues themselves must be pointless and idle. Describing the issues historically heightens that intuition. To see an issue as a part of our historical past is, to some extent, automatically to see it as lacking genuine current concern.[6]

But such general considerations are by themselves hardly compelling. Philosophical discussions add little to our knowledge or understanding if we measure such progress by whether the adherents of one position are converted to another. But from the perspective of a particular school, whose members adhere to a position that remains reasonably stable, such discussions often lead to substantial advances in our command over the relevant issues. Nor is philosophy unlike other fields in this respect. Rival research programs typically seem relatively sterile to one another, no matter what the field. The ability to represent an issue as merely historical, moreover, is hardly a reliable guide to its cognitive status. Historicizing an issue that still arouses active concern is little more than an oblique way of wishing it didn't.

But Rorty does not rest his case on such considerations. Rather, he devotes much of *PMN* to extended accounts of contemporary philosophical discussions of mind, knowledge, and language, and the historical backgrounds that led to them, in order to show that the issues these discussions turn on are, after all, idle. It will suffice to consider his treatment, in Part One, of the mind-body problem, since the other two cases follow the same pattern of argument.

II. The Self-Defeating Double Standard

On Rorty's account, we can understand the modern mind-body problem only if we see that there are at least two ways of talking about things on which no such problem arises. One involves the concept of mind Rorty believes we had before Descartes. Prior to Descartes, Rorty holds, 'mind' meant pretty much the same as 'reason'. On this conception, the modern

mind-body problem cannot get going, since that problem rests on puzzles about consciousness, incorrigibility, and transparency, and these puzzles do not arise in connection with reasoning. This pre-Cartesian conception of mind gave rise instead to the Aristotelian problem of how concrete bodily creatures can grasp universals (38–51). Descartes, however, led us to apply 'mental' to perceiving and feeling, as well as reasoning. But the only thing these three have in common is that we know about them incorrigibly (47–63). We thus came to think of the mind as that with respect to which "there is no distinction between appearance and reality", whereas for everything nonmental how something appears can diverge from how it really is (55). According to Rorty, we owe the modern mind-body problem to a decision by Descartes to use the word 'mental' in this new, extended way.[7]

The other way of talking that avoids the modern mind-body problem is that of the mythical Antipodeans Rorty describes, who operate not with a concept of mind different from ours, but with no such concept at all (72). Rorty argues, on the whole quite persuasively, that the Antipodeans can describe and explain things just as well as we can. They seem to diverge from us only in being unable to grasp the mind-body problem that Terran explorers try to explain to them.

If that mind-body problem derives just from Descartes's innovative application of the term 'mental', Rorty is right to see that problem as artifactual. And if the Antipodeans' only conceptual shortcoming is their inability to enter into our mind-body debates, we will be right to regard those debates with suspicion.

There are many places in Rorty's historical account that are open to scholarly challenge. Indeed, he explicitly concedes as much (e.g., p. 51, fn. 21 and p. 53, fn. 23). But his principal aim is to historicize the main problems of modern philosophy—to see them as creatures of a particular cultural development rather than as independent intellectual quandaries. For this purpose, scholarly accuracy is arguably less important than a measure of general plausibility.

But even given his historicist aims, Rorty's story often lacks plausibility. As he insists, pre-Cartesians had relatively little interest in the mind-body problem as we know it. But interest did not arise because of any redefinition of our concepts. However pre-Cartesians may have used such terms as *nous* and 'mens', they plainly often grouped thinking and perceiving together. Indeed, Aristotle himself insists that thinking and reasoning actually involve perceptual imagination (e.g., *de Anima* III 7 431b2 and III 8 432a5–14), a view which before Descartes was widely endorsed. And despite his broad sense of *psuche*, he connects no other faculties in this strong way.

Moreover, there is a more widely accepted and more convincing account of how the mind-body problem came to exert its hold on us. Post-Galilean science aims at explanation by means of laws expressed with mathematical precision. Such laws are thought to provide the key to understanding the nature of the physical reality thus explained. Since the quality of colors and sounds intuitively resist such treatment, we ordinarily explain those qualities as actually mental qualities caused by physical processes that are themselves describable in mathematical terms. Once relocated in the mind, such qualities no longer threaten the sovereignty of mathematically formulated laws in the physical realm. Thinking too seems to defy description in terms of mathematically precise laws.[8] Because thinking and perceiving thus resist inclusion within modern mathematical physics, how these phenomena fit with the rest of nature automatically becomes starkly problematic.[9]

This explanation undermines Rorty's suggestion that the mind-body problem arose from a relatively arbitrary terminological innovation, rather than from well-motivated intellectual concerns. Moreover, these concerns continue to be pressing today. A reduction of all natural phenomena to those of mathematical physics seems even more likely today than it did in the seventeenth century, but the brute qualitative character of color and sound seems as unyielding as ever to such treatment. Perhaps that is why physicists and neurologists often regard the mind-body problem as far more intractable than philosophers.[10]

On Rorty's account, Descartes so redescribed things that thought and perception came to be seen as at bottom the same kind of phenomenon. The reclassification was, according to Rorty, so novel and so unnatural that it called for some special explanation. Only the incorrigibility both phenomena putatively share would do, and that came to define the new concept of mind. The mind-body problem is basically the problem of how states that are incorrigibly known can fit with the rest of nature. The Antipodeans believe nothing is known incorrigibly, and that is why they lack any concept of mind. On this story, the mind-body problem is of course pointless. How can one take seriously a puzzle that turns solely on an avoidable reclassification of things or an arbitrary definition of terms?

On theories of mind inspired by Descartes, mental states are incorrigibly known, and nothing else is. But it hardly follows, even on those theories, that the mental is by definition incorrigible. There is considerable controversy about whether mind is incorrigibly known at all, and if so, what that incorrigibility amounts to. If it were definitionally incorrigible, such controversy would be literally incoherent. Cartesians and their opponents differ here about the correct theory of mind, not about their definitions of 'mental'. Nor can Rorty's historicism make it plausible to define

mind in terms of incorrigibility. How we explain our classifying thought and perception together hinges on the position we take about the mind-body problem.[11]

Part of what leads Rorty to see incorrigibility as defining the mind-body problem is a peculiar asymmetry about the solutions people put forth. If one follows Descartes about the incorrigibility of the mental, mind will be a singularity in nature, and its relation to the rest of reality will be problematic. By contrast, if one denies incorrigibility, there may seem to be no problem about the mind-body relation. So it may be tempting to insist that the mind-body problem arises only on the assumption that mental states are actually incorrigible.

If so, nobody could rationally hope to solve the mind-body problem. Because they deny incorrigibility, materialists reject a presupposition of the problem itself. Cartesians capture the presupposition, but by doing so definitionally assign the mind an irretrievably problematic status. On this picture, the mind-body problem is plainly idle and spurious.

But this line of reasoning conflates what it is for us to have a problem with what it is for something to be problematic. The mind-body problem is the problem of explaining how the mental fits in with nonmental reality. All this problem presupposes is a tenable distinction between what is mental and what is not, and that we have not yet satisfactorily articulated the relations between them. That problem may very well exist regardless of whether the relation between the two turns out to be problematic. Problems exist relative to our state of knowledge; their existence implies only that we have more to learn, not that the relevant phenomena are themselves somehow problematic. Accordingly, the mind-body problem in no way presupposes that mind is incorrigible.

The Cartesian theory of mind has dominated philosophical discussion since the seventeenth century. And Rorty sensibly insists that any distinction between conceptual and factual components of what we say will inevitably be arbitrary (e.g., 169). So perhaps he is entitled to redescribe certain central claims of our dominant theory as though they are features of our very concept of mind. Insofar as we define mind in terms of the Cartesian theory, the mind-body problem will indeed presuppose incorrigibility. We thus end up construing the mind-body problem in terms of the dominant theory advanced to solve that problem, in effect understanding, as Collingwood urged we must, the problem in terms of the solution given it.[12]

Redescribing theoretical doctrines as conceptual connections is innocuous as long as we treat the two types of description as interchangeable.[13] So Rorty's claim that the mind-body problem presupposes incorrigibility is unobjectionable if all it means is that our dominant theory asserts such

incorrigibility. But having traded theory in for concept, Rorty goes on to avail himself of the putative privileged character of conceptual connections. Rorty sees the Antipodean denial of incorrigibility as indicating that they have no concept of mind. But if all it meant to say that mind is definitionally incorrigible is that the dominant philosophical theory says it is, the Antipodean denial must count as a coherent alternative solution to the mind-body problem, rather than an avoidance or rejection of it. We have no more reason to think the Antipodeans lack a concept of mind because they regard nothing as incorrigibly reportable than that we now lack a concept of species because we no longer believe that biological kinds are immutable.

This point emerges especially vividly in connection with W. V. Quine's well-known remarks about prelogical peoples. Suppose we translated a language in such a way that some sentences that native speakers generally assent to got rendered as simple, explicit contradictions, say, of the form 'p & ~p'. This, Quine convincingly argues, would count overwhelmingly against the correctness of that translation. What evidence could ever convince us to accept this absurd result? "[P]re-logicality," Quine concludes, "is a trait injected by bad translators."[14]

Rorty's Antipodean story invites much the same challenge. The Antipodeans' conceptual resources largely match ours. Indeed, they describe their own behavior and ours along pretty much the same lines we ourselves would use. They diverge from us, Rorty holds, only in denying that reports of anything are every incorrigible. Rorty believes this denial shows they lack a concept of mind. Why doesn't that conclusion simply show that Rorty has mistranslated his own Antipodeans? What evidence could a translator confronting such people invoke that would sustain this strange consequence? Is it even intelligible to us that a people should describe their own behavior much as we do, but lack any concept of mind? Rorty's description rests on his having transformed the Cartesian doctrine that mental events are incorrigibly reportable into a conceptual truth. This transformation is not only gratuitous; it is unmotivated relative to the task of accurately translating the Antipodeans' remarks into our terms. It thus closes off the natural way of understanding them: they count as mental just those things which we do, but deny the Cartesian theory that reports of them are incorrigible.

Rorty contends we cannot correctly so describe the Antipodeans. Rather, we must resist attributing to them any philosophical view whatever, even materialism in its eliminativist form (118–19; cf. 114–25). If we ever became like the Antipodeans—if, that is, "we could ever just drop the whole cluster of images which Antipodeans do not share with us," that

would not entitle us "to infer that [materialism] had triumphed..."
(123).

Rorty's reason for this is that he believes materialism cannot triumph,
since 'mental' and 'physical' are incompatible terms (121). This pro-
nouncement about 'mental' and 'physical' is surprising, since Rorty has at
that point just repudiated the essentialism about "the terms 'sensation',
'mental', and the like'", which he concedes underlay his own earlier argu-
ments against standard materialism (120, fn. 24). But in any case 'mental'
and 'physical' are not incompatible. Rather, we contrast the mental with
the physical because we use 'physical' idiomatically as a variable term of
contrast. The physical is, depending on context, whatever is not mental,
or not distinctively chemical, or not living. We contrast physical versions
of things with computer simulations, even though, considered on their
own, these very simulations are of course paradigmatically physical. In
each case, 'physical' applies to phenomena at lower levels of organization
than the one we are focusing on. The mental-physical contrast seems to
have special significance only because no well-defined level of organiza-
tion exists higher than the mental.[15] But this use of 'physical' to mark
contrasts in no case implies anything about the nature of the phenomena
under consideration.[16]

Rorty's double standard on these issues emerges even more clearly in
connection with his discussion of incommensurability, which is central to
the historicist picture he advances. Rorty sees intellectual revolutions of
the sort Descartes provoked as giving rise to discussions incommensura-
ble with those of the previous era. Pre-Cartesian views are not commensu-
rable with our own, nor are ours with the Antipodeans'. Similarly, today's
philosophical work would be incommensurable with intellectual activity
in the "post-Philosophical culture" Rorty envisages (365–73).

Rorty borrows much here from the well-known work of Thomas S.
Kuhn.[17] But Rorty insists it is a mistake to follow Kuhn and others in
construing incommensurability as a matter of whether the discussions
under consideration are mutually translatable. For he endorses Donald
Davidson's convincing critique of the notion of alternative conceptual
schemes (259–73). As Davidson argues, we can make sense of somebody's
having a particular conceptual scheme at all only to the extent to which
we can render that scheme within our own. But a scheme translatable into
our terms cannot qualify as an alternative to our scheme.[18]

Because of these difficulties about the notion of alternative conceptual
schemes, Rorty transforms incommensurability from a thesis about
meanings of terms into a thesis about people's beliefs. "To say that parties
to a controversy 'use terms in different ways'," he writes, "seems to me an
unenlightening way of describing the fact that they cannot find a way of

agreeing on what would settle the issue" (316, fn. 1). Rather, we should say discussions are commensurable if they can "be brought under a set of rules which would tell us how rational agreement can be reached on what would settle the issue on every point where statements seem to conflict" (316).

But, as already indicated, when Rorty describes actual cases of incommensurability, he reverts to meanings of terms. Descartes brought about an intellectual revolution "by verbal maneuvers which reshuffled the deck slightly" (58). And, in general, "no [intellectual] can succeed which employs a vocabulary commensurable with the old, and thus none can succeed by employing arguments which make unequivocal use of terms shared with the traditional wisdom" (58, fn. 28). Moreover, just as equivocal terminology affects the interface between pre- and post-Cartesian discourse, issues of translatability separate us from Rorty's Antipodeans. The reason they have difficulty grasping our mind-body problem is that "they had so much trouble translating the [Terran] background reading necessary to appreciate the problem" (73).

It is not surprising that Rorty falls back on meanings of terms to describe cases of incommensurability. If incommensurability were just the inability of disputants to agree on rational means for settling their differences, it would not be a rare occurrence characteristic of intellectual revolutions but a constant fact of intellectual life. Rorty adapts Kuhn's distinction between normal and abnormal science in an effort to sustain the connection between incommensurability, so construed, and intellectual revolutions.

> [N]ormal discourse is that which is conducted within an agreed-upon set of conventions about what counts as a relevant contribution, what counts as answering a question, what counts as having a good argument for that answer or a good criticism of it. Abnormal discourse is what happens when someone joins in the discourse who is ignorant of these conventions or who sets them aside (320).

So understood, however, normal discourse is hardly typical of intellectual exchanges within a particular period. Rather, it occurs only between those who hold essentially similar views. Discourse between contemporary Cartesians and materialists is affected by this kind of incommensurability no less than discourse between pre- and post-Cartesians or between the Antipodeans and us. Incommensurability so construed is simply the commonplace noted above that the arguments of opponents seldom lead philosophers to change their minds.

For Rorty's historicist picture to have any force, the break between pre- and post-Cartesians and between the Antipodeans and ourselves must be substantially greater than the distance that separates contemporaries with

opposing views. This is highly implausible if we measure these distances by reference to the beliefs held by each group; contemporary philosophers often disagree just as heartily as do those on different sides of intellectual revolutions. These revolutions will seem special only if described in terms of translatability or equivocal terminology. Once again Rorty's argument trades on seeing things in terms of meanings rather than beliefs.

If we cannot make clear sense of the idea that others differ from us conceptually,[19] historicist contrasts will be hard to sustain. All disagreement will then be just a matter of divergent beliefs. What divides us from our contemporaries will be the same sort of thing as what divides us from our predecessors. Even more important, we shall have to construe others, of whatever era, in the terms we use to formulate our own beliefs. It is thus unavoidable that we treat our differences with our intellectual ancestors in just the way we treat contemporary disagreements.

Rorty's avowed goal is to get us to stop trying to solve philosophical problems. But it is difficult to make clear sense of this goal in a way that retains its radical air, and also keeps it from collapsing into the traditional aims of philosophical activity. Philosophers typically propound solutions to problems. And nobody continues to work on problems they believe have been solved. So we might try to make sense of Rorty's radical program by noting that he, unlike traditional thinkers, wants us to put these problems behind us not because we think we have solved them, but simply because we have lost interest in them.

But this will not do. As indicated above, Rorty sometimes seems to urge jettisoning a problem because no solution is possible. To show this is not literally to solve the problem. But this move figures centrally in traditional work. Locke and Kant, among others, made familiar the idea that knowledge may have certain limits, and some problems no solution. Rorty also seeks to undermine problems by challenging their presuppositions, but this too is a traditional technique, again widely associated with Kant.

Occasionally Rorty appeals to considerations that have no distinctively intellectual standing.[20] These appeals plainly differ from traditional methods for resolving problems. But *PMN* also contains a rich tapestry of argument. So occasional nonintellectual appeals will not suffice to differentiate Rorty's approach. Rorty would doubtless insist that his arguments are meant not to resolve problems but to show only how insubstantial they are and how little hinges on what solution one gives. But this kind of critique still falls within the range philosophers traditionally embrace.

Perhaps what makes Rorty's approach radical is the attitude he hopes to engender, rather than the methods he employs. We should regard philosophical problems, he urges, not as issues of serious concern, but as his-

torical curiosities. Our interest in them should be the kind we have in historical events: how they arose, what sustained them, and why they declined. The right attitude will be that of the detached outsider, not that of the insider for whom those problems have force. We should end up with the sense that those problems never had any real bite.

But any satisfactory resolution of a problem will have that effect. Once a problem has been satisfactorily resolved, we adopt an outsider's attitude towards it. Once we know our way around the relevant issues, those problems no longer evoke a sense of mystery. As Nelson Goodman observes, when we try "in philosophy to make the obscure obvious . . . the reward of success is banality. An answer, once found, is obvious."[21]

Intellectual activity, like everything else, has its fashions. Interests can shift because something else catches our fancy, or just because something no longer holds our attention. But it is not easy to produce a clear case of a problem we have abandoned despite our still regarding it as unresolved. Even when no decisive resolution has won general acceptance, we normally drop a problem only when it has yielded sufficiently for us to understand the issues reasonably well. When a problem is prematurely dropped its demise is typically short-lived; it will attract the attention of subsequent generations. Because unresolved problems have a way of being rediscovered, Rorty's revolutionary shift, in which philosophy no longer focuses on solving problems, is unlikely to occur until the main problems of philosophy are satisfactorily resolved.

III. WHY STUDY THE HISTORY OF PHILOSOPHY?

One sure way to kill a cultural movement is to write its history. Rendering an idea, movement, or cause historical defuses its energy and mutes its impact. To be sure, tracing the historical development of a flagging cultural movement can revitalize it. Knowing the history of a movement can highlight connections with present concerns, thereby kindling new interest in it. But more often the history of a movement serves as a kind of epitaph. Seeing events as belonging to history induces a kind of detachment and a sense of having moved beyond them. Historicist descriptions can thus be useful for trying to alter the course of cultural or intellectual activity. Moreover, this effect is in general wholly independent of any theoretical bias or issue of interpretation that may color the historical account one offers. A historical perspective about philosophical problems is thus ideally suited to the rhetorical needs of Rorty's radical metaphilosophical picture.

Historicist arguments are not likely, however, to help much in circum-

venting active debate about issues of current concern. We are all understandably reluctant to see ourselves as belonging to an era whose time has past. So participants in contemporary debate can hardly be expected to yield more readily to the historicist's suggestion that their work is outmoded or idle than to the arguments of their opponents. And the natural desire to make recognizable contributions will lead most to be cautious about disregarding the debates of the day. Descartes, possibly the most successful philosophical revolutionary ever, took great care to cast things in terms of debates then current.

Moreover, historicism is unlikely to achieve anything we could not accomplish equally well by standard, nonhistoricist means. As section II illustrates, success in historicizing an issue generally relies obliquely on considerations and arguments that are more effective when brought to bear directly on the issue at hand. Describing issues in historicist terms is therefore typically idle; historicist arguments can generally be readily reconstrued as direct, ahistorical arguments about the merits of the case.

The natural reluctance to see one's work as outmoded provides a powerful incentive to construe the arguments of historicists ahistorically. But there is another reason for such reconstrual that is less open to a charge of self-interest. We typically succeed better in understanding others if we assume, as far as possible, that they are addressing issues and talking in terms that are familiar to us from our own thought. Historicist efforts to influence the direction of intellectual activity trades on evoking a sense of discontinuity between different intellectual styles or movements. Our natural desire to understand others conflicts with that picture, since understanding implies bridging such apparent discontinuities.

This tendency to reconstrue historicist arguments in ahistoricist terms reflects a deep-seated attitude philosophers have toward the history of their field. Histories of philosophy typically portray past philosophers as though they were contemporaries, whose work is animated by much the same issues and interests as our own. Such histories tend to abstract from, or ignore, the details of historical context—often even from the intellectual climate of an era—and to construe the writings of past philosophers solely in terms of the issues addressed.

Because most history of philosophy is written by philosophers rather than historians, it may be unsurprising that the resulting histories are relatively ahistorical in orientation. But here again there is an intellectually more respectable reason for our ahistorical tendencies. A certain distance inevitably separates the historian from the historical subject. This is due in part to the historian's desire for objectivity, which may suggest striving for a neutral viewpoint, or at least a viewpoint independent of the historical subject's. But this distance arises also from the tendency of history to

focus on the unusual and striking. Historical explanation adds little to our understanding if the events explained seem mundane to us. We need such explanation only when an event or movement is not immediately intelligible. Only in these cases will the historian's appeal to antecedent influences and surrounding circumstances help us understand why the event occurred, or why somebody held an idea.

But understanding why somebody thought something is not the same as understanding the thought itself. And distinctively historical explanation seldom helps much in understanding past ideas themselves, as opposed to why they were held. Indeed, historical discussions often seem almost to assume that the idea in question may not, in its own terms, be wholly explicable, and so often try instead to explain only why somebody would have thought such a thing.

To understand the thought itself, by contrast, requires that one be able to imagine having that thought oneself. If we have no good idea of what reasons a person would give for thinking something, and how those reasons would fit with beliefs of ours about related matters, we will have little grasp of what that thought is. If our goal is understanding the ideas others have had, rather than why they held them, we will try as much as possible to see those ideas in terms of our own. This is so even when we discover important discontinuities that separate us from past thinkers. We can understand such discontinuities by reference to how we, today, think about the issues in question.

Needless to say, the ahistorical and historical approaches to understanding complement, rather than compete with each other. We often need explanation by reference to antecedent circumstances; only thus could we account, e.g., for the nearly universal concern among seventeenth-century thinkers with the impact of the new science on old, commonsense ways of describing things. But antecedent events are unlikely to do much to explain why Descartes, Spinoza, Leibniz, or Locke held the particular doctrines they did. Here we must try to understand the thoughts ahistorically, in terms of the considerations one can rationally adduce in support of those views, and thus by reference to our own conceptions of what counts as a rational consideration. The understanding of our intellectual past must unavoidably be partly 'Whiggish', in that we must use our own thought as the main reference point in terms of which we find the past intelligible. This consideration will figure later in this section, and centrally in the argument in section IV.

This circumstance is not unique to philosophy, but applies equally to the history of the natural sciences and mathematics. We inevitably must understand past scientific theories and mathematical reasoning in terms of the best thought available today. Accordingly, the history of such fields,

like that of philosophy, is typically pursued not by historians, but by those with the relevant specialist's training.

But philosophy is quite different from the sciences and mathematics in respect of the relationship each field has to its history. Unlike the history of philosophy, the histories of mathematics and the sciences are not integral parts of those disciplines. Mathematicians and scientists do, in the course of their training, acquire some, often anecdotal, historical knowledge of discoveries in their fields. But the systematic study of that history does not figure in standard professional training in those fields, and studying the work of past mathematicians and scientists rarely has much impact on current research.

By contrast, as noted at the outset, the history of philosophy is one of the major areas of study included in virtually all philosophical training. This has been so even when the dominant school or tradition has conceived of philosophical knowledge on the model of knowledge in mathematics or the sciences. By this standard, the history of philosophy is not regarded as independent of the study of philosophy itself, nor even as a mere adjunct to it, but is seen instead as important, even integral, to philosophical work itself.

In this respect, philosophy is more like the humanistic disciplines than the sciences. Whatever one's interests in literature, music, or the arts, training in these fields invariably includes a grounding in the history of such work. Indeed, much of what we study in these areas, as in philosophy, is the great work of the past. Not only is the history of humanistic fields central to the fields themselves, as it is in philosophy; the study of this history is often pursued in a somewhat similar spirit. The main impetus behind studying these great past works is frequently their ahistorical value as works of literature, music, and art, and not their position in the historical context that produced them.

Philosophy thus shares important features with both the sciences and the humanities. Because the history of philosophy counts as an integral part of philosophy itself, philosophy thus far resembles the humanistic disciplines. But like the sciences, the guiding aim of philosophy is arriving at the truth about particular matters. This is not to say that the humanities have no interest in truth; but truth is only one among many goals in humanistic studies. The dominant aim there is rather understanding—understanding the great works of literature, music, and art, and understanding what makes them great. Philosophy, mathematics, and the sciences, by contrast, formulate specific problems to solve, and issues we want settled. Our goal is to arrive at true answers to specific questions. Philosophy does, of course, also aim at understanding; indeed, many would characterize philosophy primarily in terms of that goal. Still, all would agree that

the goal of philosophy is not, in the first instance, to understand the great works of philosophy, but to understand how things are. Philosophical understanding is understanding the nature of things, not the meanings of texts.[22]

This dual character of philosophy—resembling the sciences in some ways and the humanities in others—is reflected in traditional, widely held views about the field. Since Aristotle, philosophers as diverse as Descartes, Hume, Kant, and Hegel have classified philosophy as a kind of theoretical knowledge, like mathematics and the natural sciences. But since Plato the complex and ambiguous kinship philosophy has to literature has also loomed large, a kinship reflected in the prevailing contemporary classification of philosophy with the humanities. Rorty's views can thus be seen as an effort to resolve the tensions inherent in this dual character by undermining the comparison with science. Success would thus yield exactly the result Rorty envisages: a humanistic model for philosophy, unencumbered by the strictures imposed by a search after truth. The arguments in section II against Rorty's revolutionary goals in effect restored that balance, by appealing to the ineliminable interest philosophers have in discovering and understanding the truth about things.

These considerations again point to the question raised at the outset: why, if philosophy is essentially a problem-solving discipline, is the history of philosophy so important to philosophical work? There are a number of standard answers that are given to this question, some of which may seem to help in explaining this apparently anomalous concern of philosophy with its own history. But these standard explanations all raise difficult questions in turn. And none seems able to explain why the history of philosophy should actually count as an integral part of philosophy, rather than merely an occasionally useful adjunct. The rest of this section will try to show this by briefly surveying these standard explanations.[23]

It is sometimes said that the history of philosophy is important to philosophy because the works of the past great philosophers can be a source of idea useful for current work. Past philosophical work can be suggestive about how to formulate or solve present problems. Aristotle's influence is often evident, e.g., in the work of J. L. Austin. But salutary as such input can be, ideas for solutions, arguments, and formulations come from many sources. Austin arguably derived at least as much from the law and philology as from Aristotle. Moreover, such successful direct fertilization by historical sources occurs relatively rarely, not nearly often enough to explain why we see the history of philosophy as an area of philosophical study on a par, say, with ethics or epistemology.

The history of philosophy sometimes seems almost to be a history of

philosophical mistakes, suggesting that its value may lie in presenting us with a catalogue of errors to avoid. But philosophical mistakes occur too often to need the history of philosophy as a source for study. And, other things being equal, it is more fruitful to hone one's critical abilities on the work of one's contemporaries. This explanation again suggests the history of philosophy should be a mere adjunct to philosophy, rather than an actual part.

There is also an unsettling obliqueness about studying past philosophical works either for the moves they suggest we might make or the errors they hold up to avoid. What counts as a good philosophical argument and what counts as a philosophical mistake are both controversial issues. So whatever aid we get from past works must be transported to fit current needs, and then reevaluated in that context. Other things being equal, it would seem better to avoid having thus to transpose and reevaluate, and just judge errors and arguments on their own, as they arise in contemporary discussion.

Perhaps, however, the importance of the history of philosophy has more to do with the perspective it gives us about issues than with any specific, direct contribution it makes to the solving of contemporary problems. A representative sample of past philosophical thought will encompass a far greater diversity of viewpoint and style of argument than one can encounter in contemporary work. This diversity can be useful in giving an appreciation of how dramatically philosophical positions can diverge, how parochial contemporary thought often is, and what unexamined assumptions may underlie our own work. It can suggest how problems might yield to points of view quite different from anything now in fashion, or that we might try approaching issues in radically different ways.[24]

This kind of explanation has more air of plausibility than does the appeal to specific contributions historical works might make to current research. But concrete examples of this kind of benefit are not easy to find. Many contemporaries have derived much from studying the work of some particular historical figure—P. F. Strawson from Kant, Stuart Hampshire from Spinoza, Roderick M. Chisholm from Brentano, Zeno Vendler from Descartes. But these are all cases in which a contemporary view meshes especially happily with the work of some past philosopher, rather than cases in which studying the past has broadened our perspective. Nor, in any case, does the usefulness of studying some particular figure explain the value of the history of philosophy generally.

Perhaps, therefore, we somehow profit from the history of philosophy because of the extraordinarily high quality of much past work. The works of the great figures on whom we concentrate are penetrating, systematic,

comprehensive, subtle, and thorough, on a scale probably never today equalled. Reading these authors doubtless produces a better sense than we could otherwise get of what it is for philosophical work to have these qualities, and to have them to such an astoundingly high degree.

But the astonishingly high quality of such historical works occurs in the service of theories nobody would now accept, and in connection with issues and problems that are now formulated in rather different terms, when they are addressed at all. We do not now cast issues about ontology or the mind-body problem, e.g., in terms of conceptions of substance such as those that dominated philosophical thought from Aristotle to Berkeley. One can adjust for these differences to make the insights of past thinkers more useful for our own thinking. But it is unclear that the adjusted results will exhibit the same outstanding qualities as the originals. And if they did, why would we not be better off producing our own original works, with as much quality as we can give them, rather than translations of past thought into current idiom?

Indeed, most of the explanations just surveyed seem more apt as reasons for the study of the history of a field by those in literature, music, and the arts than by those in philosophy. Since a primary aim in humanistic studies is to cultivate an appreciation and understanding of works of literature, music, and art, it makes sense to study the best available even if they do not conform to current taste. These goals make it natural, moreover, to study past works to gain perspective about the possible diversity of humanistic work and about what it is that makes some works good. Finally, the great writers, artists, and composers of the past generally had great technical skill. And even though artistic technique evolves, studying past technique does much in developing one's own.

Studying the history of philosophy can, of course, yield similar benefits. And the sense that these benefits are important for philosophy doubtless helps explain its now traditional classification among the humanities. But these considerations simply underscore the need to explain that sense of importance. When cultivation of taste and understanding of value are paramount, the history of a discipline is indispensable. But these are not the central goals of philosophy. The problem remains of why the study of largely unacceptable theories should be considered crucial to a field whose main aim is to arrive at the truth about certain issues. It is worth noting that this problem arises however one conceives of truth. In particular, the distinction between truth as a relation words bear to extralinguistic reality and truth as warranted assertability, on which Rorty heavily relies (e.g., *PMN*, ch. VI, esp. pp. 261–62, and *Consequences of Pragmatism*, Introduction, sec. 3), is irrelevant here. Whether we aim at corre-

spondence with the facts or warranted assertability, it will be equally unclear why we should study largely unacceptable theories.

It may seem that a problem exists about the importance to philosophy of its history only on a rather narrow conception of the nature of philosophy. If philosophical problems are all technical in character, then the analogy with mathematics and the sciences is apt, and it is doubtful whether the history of philosophy could significantly further philosophical progress. But there are areas of philosophy, such as ethics and aesthetics, whose problems resist precise, technical solutions. Perhaps if we give these fields their due, and avoid thinking of philosophical progress in solely technical terms, the importance to philosophy of its history will no longer seem problematic.

But work in ethics and aesthetics aims at accurate formulations of issues and solutions of problems no less than does research in epistemology or philosophy of language. So the history of philosophy should be no more important for any of these subfields than for any others. The issue is not whether we conceive of the problems in these areas in technical terms, but whether the primary aim of such research is to solve certain problems. If so, it is on the face of things unclear why studying unacceptable solutions proffered by past great philosophers will help. The difficulty arises in all areas of philosophical work, no matter how technical. Indeed, many philosophers who work primarily in philosophy of mathematics or mathematical logic study the histories of those fields in a way that a physicist or mathematician would be unlikely to.

From time to time scientists and mathematicians turn to the history of a particular problem to learn what earlier researchers had to say about it. But this occasional practice reveals little about the importance to philosophy of its history. For one thing, the analogy with the history of mathematics and the sciences only suggests a way the history of a field can function as a useful adjunct to that field, and not as an integral part. Moreover, this is not the way philosophy seems actually to profit from its history. One seldom hears that somebody doing contemporary research on the mind-body problem learned something specific and useful from Descartes or Locke that was not independently available in the contemporary literature. Indeed, it would be striking if contemporaries could learn much that way, given the large, and stubborn issues of interpretation that continue to affect our reading of most major past philosophers.

Lawrence H. Powers has given the analogy to the history of science a novel and ingenious turn. A scientific theory must successfully explain relevant scientific experiments performed in the past. Similarly, Powers urges, a philosophical position must explain why past philosophical arguments on the topic in question seemed convincing to those who advanced

them.[25] Scientific experiments, of course, must be replicable; so their having occurred in the past is incidental to the scientist's aims and procedures. But Powers insists that an ahistorical account of past philosophical arguments will not do. A philosophical theory must "explain why these arguments appeared cogent to" past philosophers, and this "will involve us in assessing the dialectical situation prevailing at that time" (11).

When philosophers study the history of philosophy, they do indeed seem largely concerned to explain why past arguments and positions seemed compelling to those in the past who advanced them. But when philosophers pursue their distinctively philosophical interests, why should they care why past philosophers found something convincing? That may well be historically interesting. But the distinctively philosophical question about past arguments and views is whether they are convincing to us. Powers's answer in effect appeals to "a dialectical rule according to which philosophers cannot simply ignore but must try to explain the arguments of their opponents" (8). But it is not clear why this rule should apply to historical figures. Philosophers invariably have opponents enough among their contemporaries without borrowing from the past. And the spirit of that dialectical rule can hardly be satisfied with opponents who cannot answer back. In any case, our problem was to explain the importance to philosophy of its history. We cannot do that unless we can explain why Powers's dialectical rule applies to opponents of the past as well as the present.

Perhaps the most widespread explanation of the importance to philosophy of its history is that we can understand the problems that define contemporary discussion only if we understand its historical background. The problems each generation addresses often derive from the work of the preceding generation. And philosophical issues are frequently put in terms of theories and debates that figure prominently in the philosophical tradition.[26] But past philosophical discussions typically differ markedly in style and substance from those of today. And philosophical issues and arguments are highly sensitive to details of exposition. So, while traditional terms and theories may sometimes enhance our understanding of present problems, there is a substantial danger that those traditional discussions will often instead distort those problems.[27] We could guard against this undesired result only by having a firm, independent grasp of the character of the problems and issues now addressed. But then illumination from the past would be an idle adornment. In any case, an understanding of past thought could not be necessary to grasp current problems. Since understanding the past unavoidably means putting it in terms now current, we must understand traditional terms and theories by reference to today's thought, rather than the other way around. This need to

construe the past in today's terms has provided one of the main arguments against standard explanations of the importance to philosophy of its history. In the concluding section, this very need to construe others' words will give us the key to why the history of philosophy actually does figure so centrally in philosophy.

IV. Understanding Philosophy and Its History

Understanding somebody else's doctrines or arguments is never an automatic, effortless matter. Grasping another's meaning, whether that person is a contemporary or a predecessor, always involves both word-by-word translation of the other's statements and the charitable attribution to the other of as much correctness as those words will bear. Sometimes we must strike an uneasy balance between these two processes. We adjust readings of individual words if we can get a lot more truth or validity from the resulting sentences and arguments. Such adjustment occurs even when interlocutors share a language. One must sometimes depart from homophonic translation of words to make sense of what somebody is saying. We must sometimes take the other person to use words in ways we would not ourselves if we are to be able to see the other person's statements and inferences as even intelligible, much less correct.[28]

As noted above, the need to attribute views and inferences charitably is a major factor in the ahistorical character of the history of philosophy written by philosophers. Understanding another requires that we render that person's statements in words we ourselves might use. We can grasp somebody else's doctrines and arguments only if we can to some extent construe them in terms native to our own intellectual lives. Any history of philosophy that aims at such understanding must thus treat historical figures to some degree as contemporaries.

But interpretations of past philosophical texts depend on current philosophical discussion in ways that go beyond the mere need to understand those texts in terms native to current debate. As just noted, we must also balance the result of word-for-word translation against the demands of reasonably charitable attribution of views and arguments. But here problems arise, since what counts as charitable will often itself be a matter of philosophical controversy.

This is easiest to see when our aim is charitable attribution in its strongest form. Charity then means that we try, as often as possible, to construe the other person's arguments as valid and claims as true. But there is often heated controversy in philosophy about what is true, and even about what follows from what. So it will often be controversial

whether a reading of a philosophical text is, in this strong sense, charitable.

Charity, however, may mean only that one can make fair sense of the text in question, and not also that it is philosophically sound. This more modest charity requires not that we render arguments as valid and statements as true, but just that we see reasons for advancing those arguments and views—reasons that it is credible to hold, and that the author in question might actually have held. Something makes sense if, roughly, we understand why somebody would have said it.

This form of charity is plainly the least we can ask for. We may sometimes be unable to achieve it, but we cannot aim for less. But there is even less agreement in philosophy about what counts as a credible reason for something than there is about what is true or valid. So it will often be a matter of considerable philosophical controversy whether a particular of a text is charitable in even this minimal way. We cannot, in general, hope to settle whether something counts as a charitable interpretation without first settling whatever philosophical questions are at issue in the interpretation we are considering.

There is an intimate tie between the need to construe charitably and Davidson's compelling claim that we can make sense of another conceptual scheme only within our own. Davidson often expresses this connection by saying that understanding others implies construing most of their beliefs as true. "Charity is forced upon us; whether we like it or not, if we want to understand others, we must count them right in most matters."[29] This is a modified form of strong charity. Construing others as mostly agreeing with us is only slightly weaker than always so construing them as to maximize agreement.[30] Davidson's caution concerning how much agreement understanding presupposes may seem to cause difficulties. Agreement "in most matters" is unhelpfully vague, telling us only that we must balance strong charity against other considerations.

Davidson tends to cast his view in terms of agreement on truth values because he seeks to understand meaning and belief by applying to natural languages a Tarski-style theory of truth.[31] But sometimes he puts his point not in terms of such agreement, but as a "methodological presumption of rationality.... We weaken the intelligibility of attributions of thoughts of any kind to the extent that we fail to uncover a consistent pattern of beliefs."[32] Once we bracket Davidson's appeal to theories of truth, understanding presupposes rationality rather than actual agreement. And a methodological presumption of rationality conforms closely to the minimal form of charity just described. However we may explicate rationality, understanding others requires us to attribute to them reasonable views

and arguments. Other things being equal, the more reasonable we succeed in making them, the more fully we will understand them.

Examples of how our interpretations hinge on philosophically controversial issues are easy to come by. Jaakko Hintikka's performative account of the *cogito*, e.g., will be persuasive only to one convinced that Hintikka's notion of existential inconsistency does the work he claims for it.[33] This has by no means commanded universal assent. Similarly, one will find plausible Alan Gerwith's and Harry G. Frankfurt's explanation of why Meditation III is not circular in the way Arnauld charged roughly to the degree one finds convincing the reasoning they attribute to Descartes. Gewirth and Frankfurt claim that the argument in Meditation III for the divine guarantee is meant only to show that no challenge to the reliability of reasoning which itself relies on reasoning can be coherent.[34] Only if that argument strikes one as having *prima facie* plausibility will that interpretation of Descartes seem compelling. Similarly, one's views about the mind-body problem will undoubtedly influence how credible one finds Thomas Slakey's view that Aristotle was a mind-body physicalist, or W. F. R. Hardie's and Jonathan Barnes's arguments that he instead held a modified form of dualism.[35] Again, one's positions on various contemporary issues about modality will very likely affect how one tries to interpret Aristotle on potentiality and actuality, or on the sea battle. Other examples abound, many of which, being less dramatic are less readily noticed.

The foregoing considerations explain why such dramatic diversity exists in how philosophers interpret their predecessors' work. We must exercise minimal charity when we construe a text, and in the case of a philosophical text what counts as charitable hinges in part on substantive issues about which opinion is markedly divided. Such division of opinion unavoidably results in corresponding controversy about the interpretation of texts.

These factors also help us understand an odd phenomenon that is otherwise difficult to explain. There is a striking prevalence of misunderstanding among philosophers who hold opposing views. This can occur even among those whose philosophical acumen is otherwise the greatest, and it occurs in contemporary debate no less than in exchanges such as those between Locke and Leibniz, or Descartes and the authors of the various Objections. Since what counts as a charitable ascription hinges in part on points of philosophical controversy, we are especially prone to misconstrue those with whom we have substantial disagreements. When disagreements are sufficiently stark, the pronouncements of another may actually seem incapable of being construed in a way that is even minimally charitable. Thus the familiar temptation arises to which philosophers sometimes succumb simply to regard as unintelligible remarks of

those with whom they sharply differ, remarks that others often find quite comprehensible.

We often use the doctrines and arguments of the great figures of the past as reference points in putting forth our own position. This is entirely natural. Invoking our shared intellectual heritage is frequently effective for expository purposes. And the issues that divide us from our contemporaries often seem so immediate and so intractable that these past figures may be the only useful common ground available to us.

However natural this expository practice is, it has important presuppositions that are seldom noticed. Using past thinkers as reference points can be useful only if we see those thinkers as sharing with us a common set of terms, views, and interests. Thus invoking past thinkers, however, is just an expository device; our main interest is in issues we must be able to articulate independently of the views of others, past or present. So we must in effect construe the past writers we invoke in terms of those issues. Only thus can this expository practice help convey our views, rather than distort them.

Finally, to be at all useful, this construal of past thinkers in terms of our own interests must remain tacit. There is little expository value in putting our own points in terms of past writings if we then explicitly construe those writings by reference to contemporary discussion that we independently understand. Invoking past views and arguments can be expositorily useful in addressing issues of current concern only because our construing past thinkers in our terms is typically so effortless, and so often goes unnoticed.

Thus invoking past figures will sometimes mean seeing them as siding with us against our contemporaries in ways that are tendentious and controversial, with respect to the issues we want to discuss. This is to be expected. If current debate divides us so starkly that we must look to past discussions to find shared terms, our interpretations of those discussions will very likely reflect that current divergence of position. Because our construing past thinkers in our terms must remain tacit, disagreements about those thinkers will tend to look like misreadings of readily accessible texts, rather than disagreements about philosophically controversial issues of current concern.

The need to understand past authors in terms of our own thinking does not at all imply that contemporary fashions of thought are superior to those of the past. Indeed, one's own thinking might be recognizably more akin to that of some past era than to any views now current.[36] But no matter how much one's views resemble those of some past time, or how much one identifies with discussions then prevalent, one must still understand others ultimately in terms of one's own thinking, even others for

which one has a special affinity. We have access to another's thought only insofar as we can put it in terms we independently understand. And to the extent that we interact with our contemporaries, our thinking will inevitably be cast in terms native to current discussion.[37]

It might seem that however great the vagaries of charitable attribution may be, they surely could not issue in such a wide range of interpretations found acceptable by different philosophers. Everybody, after all, must operate largely within the constraints set by homophonic translation when we construe those with whom we share a language, or constraints set by established lexicons in other cases. The words we use cannot mean just anything, and the possibility of communicating with our peers presupposes standards embodied in homophony and in standard lexicons.[38]

Homophony and traditional lexicography map others' words into our own. When communication is unproblematic, these mappings yield strong constraints; we can then count on others using words pretty much as we do. Fluency and the impression of mutual comprehension provide operational ways to tell when this situation prevails. But when substantial issues divide philosophers, ready understanding is frequently impaired, and important terms are often used in discernibly different ways. Here received lexicons, and even homophony, help a lot less than usual. We are then trying to construe people who are using words as we ourselves never would.

It is sometimes said that the historian should present the past objectively, from a neutral, unbiased perspective. And it might seem that construing the words of others in terms of our own thinking impairs such neutral objectivity.[39] But such construal is unavoidable; what somebody says is intelligible only if we can represent it in terms we independently grasp. And in any case, such construing need not threaten neutrality or objectivity. The more adequate our own thinking is to the relevant issues, the more unbiased and objective our reports of others' views will be. Absolute objectivity and neutrality in such reports are of course unattainable. But that is true even in the sciences; complete objectivity and neutrality are ideals we can approach, not goals we can reach.

In his important and influential 'Meaning and Understanding in the History of Ideas',[40] Quentin Skinner has penetratingly discussed the question of proper methodology in intellectual history. Skinner takes to task both the view that "the *context* 'of religious, political, and economic factors'. . . determines the meaning of any given text," and the opposing "orthodoxy" that "the autonomy of the *text* itself [is] the sole necessary key to its own meaning" (3, emphasis original). Both these views, he maintains, go wrong "in the assumptions they make about the conditions necessary for the understanding of utterances" (4). "The understanding of

texts," he argues, "presupposes the grasp both of what they were intended to mean, and how this meaning was intended to be taken" (48). Thus "the appropriate methodology [for the history of ideas] is . . . concerned in this way with the recovery of intentions" (49).

Skinner envisages this recovery of intentions as "part of [a] linguistic enterprise" in which we first "delineate the whole range of communications which could have been conventionally performed on the given occasion by . . . the given utterance, and, next, to trace the relations between the given utterance and this wider *linguistic* context as a means of decoding the actual intention of the given writer" (49). But in philosophy, both past and present, misunderstandings among contemporaries are virtually epidemic. Conventional patterns will therefore help little in such a recovery of intentions. And there is little to go on when we "trace the relations between the given utterance and this wider *linguistic* context" except our desire to make the text intelligible. This means simply relying on minimal charity in attributing beliefs and inferences to the author.

The central role of charitable attribution in construing past philosophical writings points the way to a satisfactory and revealing solution to our problem about the importance to philosophy of its history. When we charitably interpret a philosophical text, we must have sufficient command over the philosophical issues an earlier author raises for us to judge what construals would actually be charitable. Some of these issues will by now have become settled. But many will not. And there will be unsolved problems the author did not address explicitly which are intimately tied to those the author did. And there are invariably some of these unsolved problems we must in some way sort out in order to tell what readings of the author's text make reasonable sense. Wrestling with the meaning of philosophical texts means, almost invariably, wrestling with substantive philosophical issues of current concern.

There is thus no conflict between conceiving of philosophy as a problem-solving activity and assigning a central and integral role within the field to the history of philosophy. One cannot do philosophical justice to the history of philosophy without actually doing philosophical work on problems that are the subject of current controversy. When philosophers do such historical work, their style often minimizes the role of that philosophical work. But it is unavoidable in reconstructing what construals of historical texts could possibly make philosophical sense.

The study of past philosophical texts is in a way, therefore, a somewhat oblique way to approach philosophical problems. But this obliqueness is not the kind stigmatized in the foregoing section as unhelpful. It is not that we are trying to solve the problems obliquely, by bringing to bear the insights, techniques, or proposals of past philosophers. Rather, we must

directly come to terms with contemporary issues and problems in the very course of trying to understand past philosophical views. The indirectness affects only the way the problems arise; we must try to solve them in just the way we would if they had arisen independently of the study of any philosophical text.

This oblique approach to philosophical problems can be extremely beneficial. Formulating philosophical problems is notoriously difficult. Their abstractness makes them elusive, and they often seem virtually inseparable from the tangle of issues in which they arise. Trying to make reasonable philosophical sense of an important text provides a useful scaffold from which to work on central problems, problems which ineluctably arise in trying to construe that text. The task of interpretation helps structure the problems one addresses, and may allow them to arise in more manageable ways.

Accordingly, approaching philosophical problems thus indirectly has some of the advantages of critically commenting on the views and arguments of a contemporary. But interpreting past works affords far more flexibility in the problems one discusses, and how one discusses them. In commenting on one's peers, the works one discusses largely defines the problem one can sensibly take up. In philosophical exegesis of past works, by contrast, one will address whatever problems are useful in arriving at an accurate and charitable construal of the work at hand.

These observations help make sense of a number of Collingwood's otherwise difficult pronouncements. The historian's aim, he insisted, is to understand past actions from the agent's point of view. This means understanding the thought processes that issued in those actions.[41] In the special case of studying what somebody wrote, we must "discover what the person who wrote those words meant by them," which "means discovering the thought. . . which he expressed by them" (282–83). Since understanding words and deeds means understanding the thoughts they expressed, "[a]ll history is the history of thought" (215; cp. 305). Hyperbole aside, there is nothing difficult here.

But Collingwood goes on to maintain that "the historian can discern the thoughts he is trying to discover" only "by rethinking them in his own mind" (215; cp. 283, 304). This may seem puzzling. How can one rethink a past thought without already knowing what that thought was? And in any case, how could one find out such a thing? But if our goal is understanding, rethinking is an effective, and indeed an unavoidable procedure. Rethinking means simply trying to think through what would make tolerable sense for somebody in the relevant position—somebody who wrote those words or performed those deeds. This fits well with Collingwood's apparently extravagant remark that "[t]he fact that we can identify

[a philosopher's] problem is proof that he has solved it" (*Autobiography*, p. 70). On the present suggestion, this means just that we can only identify the problem by reference to what the proffered solution would actually solve.[42] The supposition that the solution works is merely a fairly strong form of charity in construing the text.[43]

Collingwood insists, moreover, that one could not "discove[r] (for example) 'what Plato thought' without inquiring 'whether it is true'" (*Idea of History*, 300). "What is required, if I am to know Plato's philosophy, is both to re-think it in my own mind and also to think other things in the light of which I can judge it" (305). Again, Collingwood evidently has charitable attribution in mind. We must attribute to Plato, say, views that make the best philosophical sense we can manage of the words he wrote. We must examine interpretive hypotheses to see both how well they fit the text and how much philosophical sense they make. Philosophical criticism is an integral part of philosophical exegesis; interpretation and evaluation proceed hand in hand.[44]

It might seem that much simpler, less arcane explanations are available of the importance to philosophy of its own history, explanations that would circumvent difficult issues about charitable attribution and the like. After all, the subject matter of the history of philosophy is undeniably in part philosophical; studying past views about philosophical problems means studying those problems. And the skills involved in interpreting philosophical writing are, at least, akin, to those involved in actually solving philosophical problems.

But neither explanation is convincing. Interpreting texts and solving philosophical problems are quite diverse activities, which typically appeal to different temperaments, demand different talents and training, and satisfy different interests. Exegesis calls for careful scholarship, solving philosophical problems for abstract, conceptual work. Even when the text deals with philosophical problems, these activities remain quite different. Nor does studying past views about philosophical problems always, or even often, proceed in a way that would engage philosophical interests, as the large number of philosophically sterile histories of philosophy attests. And, in any case, we have no access to what problems a text may have addressed independent of our rendering that text in our own philosophical terms. What arouses lively, keen philosophical interest in studying past views is the challenge of making good philosophical sense of the text at hand. Typically we can meet this challenge only if we address certain problems independently of the views we are studying. Exegesis is not similar to philosophical activity, even when it is about such activity. But because charitable attribution implies a fair amount of philosophical knowledge, successful exegesis requires philosophical activity.

This hypothesis helps explain a number of points noted in the section III. For example, studying the history of philosophy is generally a more fertile source of philosophical ideas than other areas precisely because making philosophical sense of a text forces one to confront pivotal philosophical issues. Such study can give us perspective that is philosophically beneficial because the demands of charitable attribution put yesterday's outmoded theories and problems in the context of today's pending issues. The quality of a past philosopher's work matters more to us than how correct that philosopher's theories and solutions were because we generally profit more from having to confront philosophical problems that arise in trying to understand the work than from the past philosopher's views themselves.

Most important, we can do justice both to the problem-solving character of philosophical activity and to the preoccupation philosophers have with the history of their field. In particular, we can explain why philosophy shares that preoccupation with the characteristically humanistic disciplines. History is central in the humanities because our main goal there is to uncover the significance of specific works. It is useful in philosophy because uncovering the significance of great works provides a fruitful way to work on actual problems.

Without an explanation of the importance of history that preserves philosophy's problem-solving character, there is some appeal to Rorty's contention that philosophy is not a search after truth, but merely a cultural phenomenon on a par with literature and the arts. The present explanation undercuts that appeal. Nor will Rorty's actual historicist arguments carry much weight. If we must understand past philosophers in terms of philosophical issues that occupy us today, the shifts of concern and context that divide us from our predecessors can hardly sustain skepticism about the value of continuing to work on philosophical problems.

Our goal, when we study the philosophical work of a contemporary, is relatively straightforward. We must in the first instance understand that work, but our main interest is to learn from it and evaluate it critically. When we read a past philosophical work, however, understanding is no longer a mere preliminary concern. The problems, context, and theories of the past differ so markedly from our own that understanding normally becomes our main goal in the study of past works.

There is an air of paradox here. The goal of philosophical work is not the understanding of others' views, but to develop and defend the most satisfactory view one can. The foregoing solution is that we understand another's views only when we grasp the issues involved well enough to tell what a charitable interpretation would be of that person's words. This is, in effect, a special case of the general point that understanding implies

knowing. We understand something, whether a substantive issue or the views of another, only when we know our way reasonably well around the topic under consideration.[45]

NOTES

1. *Philosophy and the Mirror of Nature* (Princeton: Princeton University Press, 1979 [henceforth *PMN*; unless otherwise indicated, references to Rorty are to this work]; *Consequences of Pragmatism* (Minneapolis: University of Minnesota Press, 1982). Of particular interest also are 'Realism and Reference', *The Monist*, LIX, 3 (July 1976): 321–340 and 'The Historiography of Philosophy: Four Genres', in *Philosophy in History*, edited by Richard Rorty, J. B. Schneewind, and Quentin Skinner (Cambridge: Cambridge University Press, 1984): 49–75. Virtually all the essays in this collection are of interest for the present topic.

2. See 'The Historiography of Philosophy', sec. III: "Doxography."

3. Bertrand Russell, *The Problems of Philosophy* (London: Oxford University Press, 1912), 155–57, and *A History of Western Philosophy* (New York: Simon and Schuster, 1945), xiii–xiv. Russell's conviction that philosophical problems are perennial is vividly expressed by his remarkable contention in *A Critical Exposition of the Philosophy of Leibniz* (London: George Allen & Unwin Ltd., 1900) that

the philosophies of the past belong to one or other of a few great types—types which in our own day are perpetually recurring—[and] we may learn, from examining the greatest representative of any type, what the grounds are for such a philosophy (xii).

Thus

a purely philosophical attitude towards previous philosophers . . . seek[s] simply to discover [without regard to dates or influences] what are the great types of possible philosophies (xi–xii).

4. This eliminativism is not new with Rorty. As Jonathan Rée observes, the eighteenth-century philosophes largely adopted the attitude Rorty recommends toward philosophical issues. "They took the apparent separateness of philosophy and ordinary ideas as reasons for denigrating or ridiculing philosophy." Thus

Adam Smith drew the conclusion that systems of philosophy were matters of taste and that people could not 'reasonably be much interested about them'; and in general the philosophes decided that traditional philosophy ought to be abandoned ("Philosophy and the History of Philosophy," in Jonathan Rée, Michael Ayers, and Adam Westoby, *Philosophy and its Past* [Hassocks: The Harvester Press, 1978], p. 7).

Ian Hacking seeks to undercut the problem-solving paradigm in a nonrevolutionary way, by suggesting that it is a parochial view that originated in the early twentieth century ('Five Parables', in *Philosophy in History*: 103–124, p. 110). But writings from Plato and Aristotle to Descartes, Hume, and Kant seem to provide an abundance of manifest counterexamples to this claim.

5. *Experience and Nature*, 2nd edition (New York: W. W. Norton, 1929), 30.

6. It is important to distinguish between seeing something as belonging to our history and seeing it in the context of historical developments and changes. Bringing historical perspective or context to bear can enhance our understanding

of things, without at all suggesting any lack of live, current concern in the issues in question. Historical discussion can even revive interest in some topic. But when an issue still excites current interest, its history is thus far incomplete. So when we describe an issue solely in historical terms, and solely as a part of our past, we describe it as devoid of current concern.

7. For a different view about Descartes's terminological innovations and its consequences see Gareth B. Matthews, 'Consciousness and Life', *Philosophy* 52, 199 (January 1977): 26.

8. Nonetheless, it is striking that Descartes's conception of thought actually suggests a mathematical model: we know the mind better than the body because, like mathematical objects, mental states are transparent to intellectual scrutiny.

9. Rorty's discussion of knowledge and language in Part Two of *PMN* leads him to conclude that we should stop seeing science as the sole source of objective truth about things (see pp. 372-78). Despite his questioning the authoritative status of science, this line of reasoning concurs with the standard explanation just sketched in linking the central problems of modern philosophy to the claims of modern science to provide a standard of objectivity.

10. See, e.g., Eccles in Karl R. Popper and John C. Eccles, *The Self and its Brain* (London: Routledge & Kegan Paul, 1977). Popper and Eccles give a useful sample of quotations to this effect from Wilder Penfield, Erwin Schrödinger, Charles Sherrington, and Eugene P. Wigner.

11. On these points see my 'Keeping Matter in Mind', *Midwest Studies in Philosophy* V (1980), 295–322.

12. See Collingwood's striking contention that "we only know what the problem was [that somebody addressed] by arguing back from the solution". *An Autobiography* (London: Oxford University Press, 1939), 70.

13. Insofar as a problem provides the conceptual character of an issue and a solution is a theory, Collingwood seems to recognize this equivalence. Thus he stresses that reasoning from solution to problem cannot be done apart from reasoning from problem to solution, and that the two are interdependent. As observed in note 12, we can determine what problem somebody meant to address only by reference to the solution. But also, "you cannot find out what a man means by simply studying his spoken or written statements. . . . [Y]ou must also know what the question was (a question in his own mind, and presumed by him to be in yours) to which the thing he has said or written was meant as an answer" (p. 31; cp. pp. 55 and 71).

14. 'Carnap and Logical Truth', in *Way of Paradox and Other Essays*, revised and enlarged edition (Cambridge: Harvard University Press, 1975): 107–133, p. 109.

15. Though see Tyler Burge's 'Individualism and the Mental', *Midwest Studies in Philosophy* IV (1979): 73–121 for a penetrating and compelling challenge to the idea that the mental has such special status.

16. On these points, see my 'Keeping Matter in Mind'.

17. *The Structure of Scientific Revolutions*, Second Edition, Enlarged (Chicago: The University of Chicago Press, 1970), and *The Essential Tension* (Chicago: The University of Chicago Press, 1977).

18. See Davidson's 'On the Very Idea of a Conceptual Scheme', reprinted in his *Inquiries into Truth and Interpretation* (Oxford: Oxford University Press, 1984), 183–198. See also, in that collection, Davidson's 'Radical Interpretation', 'Thought and Talk', and 'Belief and the Basis of Meaning'. Cp. Ree's similar argument:

The idea that if one system of thought breaks with another there cannot be any comparison between them is self-defeating. A discontinuity only exists when one system differs from or conflicts with another, and this presupposes that they can be compared ('Philosophy and the History of Philosophy', p. 15; cp. p. 30).

Davidson's claim does not, of course, apply to the intrapersonal case. Each of us presumably thinks about things in many ways that resist translation into the others. For the purposes of Davidson's point, the different ways one person thinks about things are all parts of a single conceptual scheme. It is only another's way of thinking that I must somehow be able to translate into my own for it to be intelligible to me.

19. Except, perhaps, insofar as those we seek to understand may turn out to lack some of our conceptual resources. Difficulties about alternative conceptual schemes therefore do not prevent us from Rorty's account of the Antipodeans as diverging from us conceptually, since, if he is right that they lack a concept of mind, they will have weaker conceptual resources than ours.

20. E.g., 122: "It would better at this point to abandon argument and fall back on sarcasm."

21. *The Structure of Appearance*, second edition (Indianapolis: Bobbs-Merrill, 1966), xix.

22. The analogy of philosophy with the sciences, in respect of their dominating concern for getting at the way things are, is thus independent of any view, such as that of the logical empiricists or the seventeenth-century rationalists, which models philosophical procedures on that of the sciences.

23. In addition to items specifically cited, recent discussions of this problem occur among the contributions to a special issue of *Synthese* (67, 1 [April 1986]), entitled *The Role of History in and for Philosophy*; a special issue of *The Monist* (53, 4 [October 1969]), entitled *Philosophy and the History of Philosophy* (see especially Lewis White Beck's introduction and bibliography); and *Philosophy, its History and Historiography*, edited by A. J. Holland (Dordrecht: D. Reidel Publishing Co., 1985), Part I: 'Conceptions of Philosophy's History.' I have also greatly benefited on these and related topics from Michael Frede, 'The Historiography of Philosophy', manuscript.

24. Edwin Curley has forcefully advanced an explanation along these lines in 'Dialogues with the Dead', *Synthese* 67, 1 (April 1986: 33–49).

25. 'On Philosophy and its History', *Philosophical Studies* 50, 1 (July 1986): 1–38, pp. 9–11.

26. See, e.g., Lesley Cohen, "Doing Philosophy is Doing its History," *Synthese* 67, 1 (April 1986): 51-55.

27. It is arguable that Rorty's historical account has just such a distorting effect on contemporary issues and problems.

28. This difficulty is a matter of how to construe the words of another in respect of the propositional content those words express. So it persists even if we concentrate on that content, in abstraction from the complete mental context in which the other person's that content was held.

29. 'On the Very Idea', p. 197. See also, e.g., 'Radical Interpretation':

If we cannot find a way to interpret the utterances and other behaviour of a creature as revealing a set of beliefs largely consistent and true by our own standards, we have no reason to count that creature as rational, as having beliefs, or as saying anything (137).

and 'Thought and Talk':

A theory of interpretation cannot be correct that makes a man assent to very many false sentences: it must generally be the case that a sentence is true when a speaker holds it to be (169).

30. See, e.g., 'Thought and Talk', p. 169 for some remarks on when other factors may lead us to suspend such charity. On the general need for charity, see Quine, 'Carnap and Logical Truth', and *Word and Object* (Cambridge: M.I.T. Press, 1960), sec. 13; on some limits to such charity, see *Philosophy of Logic* (Englewood Cliffs: Prentice-Hall, Inc., 1970), chapter 6.

31. See 'Radical Interpretation', 'Belief and the Basis of Meaning', and especially essays 2 through 5 in *Inquiries into Truth and Interpretation*.

32. 'Thought and Talk', p. 159. See also, e.g., 'Belief and the Basis of Meaning':

Making sense of the utterances and behaviour of others, even their most aberrant behaviour, requires us to find a great deal of reason and truth in them. To see too much unreason on the part of others is simply to undermine our ability to see what it is they are so unreasonable about (153).

33. '*Cogito, Ergo Sum*: Inference or Performance?', *The Philosophical Review*, LXXI, 1 (January 1962): 3–32; '*Cogito, Ergo Sum* as an Inference and a Performance', *The Philosophical Review*, LXXII, 4 (October 1963): 487–496.

34. Gewirth, 'The Cartesian Circle', *The Philosophical Review*, L, 4 (July 1941): 368–395 and 'The Cartesian Circle Reconsidered', *The Journal of Philosophy*, LXVII, 19 (October 8, 1970): 668–685; Frankfurt, 'Descartes' Validation of Reason', *American Philosophical Quarterly*, II, 2 (April 1965): 149–156.

35. Slakey, 'Aristotle on Sense Perception', *The Philosophical Review*, LXX, 4 (October 1961): 470–484; Hardie, 'Concepts of Consciousness in Aristotle', *Mind*, LXXXV, 3 (July 1976): 388–411 and *Aristotle's Ethical Theory*, 2nd edition (Oxford: Oxford University Press, 1980): 83–93; and Barnes, 'Aristotle's Concept of Mind', *Proceedings of the Aristotelian Society*, LXXII (1971/2): 101–114.

36. On this possibility, see especially Frede, 'The Historiography of Philosophy', p. 37 and sec. 7, and 'The Sceptic's Two Kinds of Assent', in *Philosophy in History*, edited by Richard Rorty, J. B. Schneewind, and Quentin Skinner (Cambridge: Cambridge University Press, 1984): 255–278, reprinted in Frede's *Essays in Ancient Philosophy* (Minneapolis: University of Minnesota Press, 1987): 201–222, pp. 221–22.

37. Leo Strauss is therefore mistaken to urge that, in order to remain open to the possibility "that the thought of the past is superior to the thought of the present day," we must "abandon the attempt to understand the past from the point of view of the present" ('On Collingwood's Philosophy of History', *The Review of Metaphysics* V, 4 [June 1952]: 559–586, p. 576).

38. On Quine's theses of indeterminacy of translation and inscrutability of reference, equally good translations can differ about truth values of the same sentences and extensions of the same predicates (*Word and Object*, chapter 2, and *Ontological Relativity and Other Essays* [New York: Columbia University Press, 1969], chapters 1 and 2). But if such variations do occur, they would be irrelevant to the present argument, since by hypothesis they are empirically undetectable.

39. Powers believes this threat arises specifically because, to explain why a past philosopher advanced an argument we see as invalid, we must generally appeal to some equivocation that that philosopher was unaware of. But one cannot resolve, or even take note of such equivocation without adopting a philosophical position, since, as Powers rightly observes, "in philosophy, questions about ambi-

guity are very controversial. One philosopher's distinctions are another's pseudodistinctions" ('On Philosophy and its History', 31).

Powers argues, however, that neutrality can be rescued. Successful communication does not demand disclosure of these equivocations, much less their resolution (28–35); so a requirement of "absolute clarity. . . [is] unreasonable" (28). This is implausible. If I report a statement without noting its ambiguity, my report is correspondingly ambiguous. Moreover, fallacies of equivocation are hardly the main occasion for interpreting the words of others. An argument may strike us as invalid not because it equivocates, but because it uses terms differently from the way we do. Misunderstandings among contemporaries and variant readings of past writings alike testify to the general need for interpreting others' words.

40. *History and Theory* VIII (1969): 3–53; see also Skinner's numerous related articles, usefully cited in his *The Foundations of Modern Political Thought: The Renaissance* (2 vols.), vol. I (Cambridge: Cambridge University Press, 1978), 285–86.

41. *The Idea of History* (Oxford: Oxford University Press, 1946), e.g., pp. 214 and 283).

42. As quoted in note 12: "we only know what the problem was by arguing back from the solution" (*Autobiography*, p. 70).

43. Skinner therefore seems mistaken in arguing that it is simply a conceptual confusion that leads Collingwood to advance this claim ('Meaning and Understanding', p. 51).

44. Thus, "the distinction between the 'historical' question 'what was So-and-so's theory on such and such a matter?' and the 'philosophical' question 'was he right?'" is "fallacious" (*Autobiography*, p. 68). Similar claims are advanced by Ree:

> The attempt to exclude history from philosophy, and philosophy from history, is not so much impractical as theoretically impossible. Ascribing a belief to someone involves making some sense of it by articulating it into one's own language and concepts" ('Philosophy and the History of Philosophy,' p. 30; cp. Ree's Davidsonian remark, quoted in note 18)

and by John Dunn:

> [T]he connection between an adequate philosophical account of the notions held by an individual in the past and an adequate historical account of these notions is an intimate one; both historical specificity and philosophical delicacy are more likely to be attained if they are pursued together. . ." ('The Identity of the History of Ideas', *Philosophy* XLIII, 164 [April 1968]: 85–103, p. 86)

See also Skinner's acknowledgement of general indebtedness on these matters to Collingwood (*Foundations*, vol. I, x, note 2).

45. I am grateful to Eileen Abrahams, and especially to Michael Frede for useful and probing comments on an earlier version of this paper.

7

Mark Okrent

THE METAPHILOSOPHICAL
CONSEQUENCES OF PRAGMATISM

I. A Recent Account of the History of Philosophy

Let us consider a certain story about the history of philosophy and the evolution and nature of contemporary philosophy. The story begins with Sellars's 'bland' definition of philosophy: "seeing how things, in the largest sense of the term, hang together, in the largest sense of the term".[1] Well, what is it to see how 'things hang together'? According to our story, since Plato this question has tended to be answered with what Rorty calls "the archetypical philosophical fantasy . . . of cutting through all description, all representation, to a state of consciousness which, *per impossibile*, combines the best features of inarticulate confrontation with the best features of linguistic formulation."[2] To 'cut through all representation', according to this story, has been traditionally thought to involve the ability to describe things in terms which are ideally suited to describe things as they 'really are'. This 'fantasy' thus involves two sides, a certain picture of what is to be seen and a certain picture of what it is to correctly see. First, what is to be described, things as they really are, has been taken to be things 'in themselves', that is, things as they are apart from their being affected or referred to by any human agency or cognition. Second, for terms to be ideally suited to describing things as they really are means that those terms are capable of giving us a description of things which mirrors, without distortion, those things in themselves. Such terms are nature's own terms because they refer to those types of entities which 'really do' exist and ascribe the kinds of properties to those entities which they 'really do' possess.

So far, the philosophical fantasy gives us a general picture of knowledge and being, but it doesn't provide a determinate conception of a special discipline, which is both distinct from other types of knowledge and

is philosophical. According to Sellars's definition interpreted in terms of Plato's fantasy, all descriptions which show us how things really hang together are philosophical. At best, philosophy *per se* might be distinguished from, for example, biology, by its greater scope. Given that ideally any type of thing can become the object of a special science, philosophy would be either the union of all such special sciences or, perhaps, a super science which treats the relations among all of the special sciences.

But, according to the tale we have been telling, something extraordinary began to happen in the seventeenth century which determined a dominant modern conception of philosophy which is different from either of these alternatives. The birth of modern physics marked the rise of a discipline which was so successful at knowing its class of things, things which are capable of motion and rest, that, given Plato's fantasy, it became difficult to doubt that the language and method of physics was the long hoped for 'Nature's Own Vocabulary'. At this point a new question arose. Among the things which are are human beings, and among the things which human beings do is 'understand' things. If physical science supplies us with the language of nature, then it should be possible to give a scientific account of how it is that science itself occurs. What is required is a science of science, or of knowledge: a new role became open to philosophy; the role of providing a scientific account of knowledge itself. Philosophy became epistemology.

According to our story, philosophers so conceived quickly broke into several groups. One group began to ask what it was about the successful sciences, and in particular physics, which made them successful. This led to a formal inquiry into the nature of representation in general, of what it is for mind or language to mirror the world at all. From this group ultimately emerged those, like Dummett, who see philosophy as concerned with meaning, or with the relation between words and the world, and hope to give a general formal account of the nature of all word-world semantic connections. A second group kept in the forefront of their work the notion that physical science is the language of nature and thus emphasized the hope that it would become possible to give a physicalistic account of science, knowledge, and representation. From this group there ultimately emerged those, such as Quine, who want to 'naturalize' epistemology.

Our story of how contemporary philosophy evolved is not quite finished, however. In the nineteenth century a new element was added. After a long gap, the special sciences which treat human beings and what they do began to develop and change. It began to appear as if the various vocabularies with which human beings speak about the world, and in particular the language of physics, were radically contingent and admitted historical and sociological explanations. In addition to epistemological

questions concerning the justification of talk about the world there were a whole range of genealogical questions concerning the origin and adoption of such talk. The first fruit of this development were the great nineteenth-century systematizers, Marx and Hegel. But an even more important consequence arose when this emphasis on the historicity of knowledge was combined with a development in the specifically philosophical study of language and representation. This is the move which Rorty labels 'pragmatism'.

According to our story, pragmatism, as it first developed at the end of the nineteenth century, undercuts the foundations of Plato's fantasy by denying that understanding or knowing something consists in picturing how things are in themselves. As such, it is a position which is similar to Kant's, and which depends upon Kant's Copernican Revolution. Pragmatism differs from Kant, however, in at least three important respects; it does not make Kant's sharp distinction between the matter and form of cognition, it dispenses with the notion of the thing in itself entirely, and it replaces Kant's emphasis on the activity of transcendental synthesis with an emphasis on real, overt, activity.

For pragmatism, the philosophical task of understanding how things hang together can no longer be thought to consist in correctly modeling or picturing how things are in themselves, or in the epistemological variant of discovering the form of representation itself by examining the structure of the uniquely adequate example of accurate representation, physical science. That this philosophical self-understanding is in error follows from the pragmatic view of language. The essentials of the pragmatic view of language can be expressed in five propositions. The first three are taken directly from Rorty, the last two are implicit in much of his work.

> "If there is one thing we have learned about concepts in recent decades it is that (1) to have a concept is to be able to use a word, (2) that to have a mastery of concepts is to be able to use a language, and (3) that languages are created rather than discovered",[3] (4) that languages are created in order to help us reach various goals and to realize various purposes, and (5) that languages are intersubjective tools whose use is regulated by social procedures which determine the conditions when it is appropriate to use particular terms or to assent to particular assertions.

If this view is correct, then to think or to talk about the world should be understood as more like a practical activity than like mirroring an independent object. For a claim to be true is more like an activity being successfully performed than like a picture picturing what it pictures.[4] If this is the case, then it is also wrong to think that (1) there is anything distinctive about physical science which makes it better at describing how things 'really are' (it isn't better at doing this, it is merely highly successful at achieving the ends for which it is designed) and (2) that there is a special

structure of representation, or method, which physical science embodies, and which captures the nature of knowledge itself.

The tale we have been telling says that seen from this perspective philosophy as epistemology loses its possibility and its point. Philosophy becomes just one more way in which human beings cope with the world, and the language of philosophy just one more tool which is more or less successful in helping us reach the ends for which it is designed. Given the diversity of vocabularies and self-ascribed tasks of those who have called themselves, and been called, philosophers, it would be better to say that philosophy is just the variety of things which people who are called philosophers do and the modes of discourse which they engage in in doing these things. If there is any unity to philosophy it is merely the institutional unity provided by the fact that there are intersubjective procedures which serve to determine who is to count as a philosopher and what is to count as philosophy. This final point is supposed to follow from the general pragmatic understanding of concepts applied to the concept of 'philosophy'.

This story of the nature and history of philosophy should be familiar. It is roughly the story which Rorty has been telling for approximately the last decade. I find much of this story quite persuasive. In this paper I want to focus on one aspect of this story, the conception of language and representation which is expressed in the five propositions which I isolated above. I don't mean to ask the question here of whether this account is true. Rather, I merely intend to ask concerning the status of this view of language: what sort of view is it, how would we know if it were true, what sort of evidence is relevant to deciding if it is true? It is my contention that if we seriously raise these issues we will see that the metaphilosophical conclusions which Rorty draws from pragmatism are not quite correct, even if we grant the truth of pragmatism. We will see that philosophy has not only an institutional unity, but also a unity which is provided by a specific problem, the problem of how to give a formal account of representation as such, the problem of what I will call 'transcendental semantics'. We will also see, however, that Rorty's answer to this problem makes that question far less important for other disciplines, or even for the question of how things in the largest sense hang together in the largest sense, than it traditionally has been thought to be.

II. Philosophy of Language and Metaphilosophy

Before we can do any of this, however, we must examine more carefully the inference which was drawn above from the pragmatic conception of lan-

guage to the metaphilosophical conclusion that contemporary philosophy has merely an institutional unity. As stated above, this inference is plainly invalid. To see that it is invalid consider the example of the concept of addition.[5] Let us assume for the sake of the example that there is something right about the pragmatic conception of language which Rorty proposes. In that case, that some particular operation counts as an act of addition 'depends', in some ultimate sense, upon the fact that a group of human beings are disposed to assent to the assertion 'That's addition' or 'She's adding', or something like that, about that operation. Similarly, that a particular addition is correctly performed, 'depends upon' the acceptance of that answer by some human group.[6] The force of the word 'depend' here is that the only ultimate criterion for determining that some act properly counts as (correct) addition is the linguistic practice of some community; there is nothing about acts themselves which some acts possess and others don't which naturally divides acts of addition from the others, and which can be used to justify treating some acts as additions. The reason for this is that, as Kripke points out, every novel addition problem admits of a wide variety of responses which are perfectly consistent with all former practices of addition. And, because of this, the 'rule' for addition, 'proceed in the same way that you have proceeded in the past while adding', which presumably gives us the meaning of 'to add', is indeterminate among a wide range of potential responses.[7] It's just that some assertions that an act is an addition are acceptable to our sisters and brothers and others aren't and that some answers to addition problems are acceptable and others aren't. That a certain addition is correctly performed, then, rests upon the criterial and justificatory 'foundation' of the social acceptability of the response to the problem which has been set. That there is a uniquely correct answer to the problem depends upon the fact that only that answer is socially acceptable.

This doesn't imply, however, that the practices which determine whether or not an act is a correctly performed addition are totally arbitrary or entirely unconstrained. In fact, there are two sorts of constraints on such practices. First, some social practices, if followed, lead, as a matter of contingent fact, to the success and survival of those who engage in them. On Darwinian grounds such practices tend to survive, others don't, so the usefulness of a style of asserting provides a constraint on that style. Second, it is also the case that some linguistic practices are so ordered that, contingently, it is socially proper to assent to a particular assertion or to perform an operation in a certain way if and only if some initial condition, a condition which can be described in some way semantically unrelated to 'the conditions under which it is socially appropriate to do or say x', is present. There are such regularities governing the practice of addi-

tion and discourse using the word 'addition', for example. We can provide rather good algorithms for what does and what does not count as correct answers to addition problems. These algorithms are so good, in fact, that we can use them to program computers in such a way that we are tempted to treat the computer's responses as definitive standards of correctness. And this is the case regardless of the supposed fact that the ultimate criterion for correctness remains our acceptance. In cases like this it seems uncontroversial to say that there is a certain 'unity' to the activity of addition, or that all acts of addition share something in common, the unity or condition expressed in the rule given by the algorithm. The fact that the criterion for whether that rule or algorithm has been fulfilled in any given case is once again social practice is beside the point if we can cash in our assent to its fulfillment in purely mechanical terms.

There is thus no direct way to go from the pragmatic conception of language to the metaphilosophical claim that philosophy "has only a stylistic and sociological unity".[8] As Wittgenstein pointed out, there are certainly some words, such as 'game', for which it is impossible to state necessary and sufficient conditions for appropriate use. At most, various games display a 'family resemblance'. The pragmatic conception of language allows for such cases by specifying that it is social practice which ultimately determines correct usage, rather than any immanent feature of the situation in which it is correct to use a word. As we have just seen, however, it doesn't follow from this conception that every word is like 'game' in lacking independently statable conditions of correct use. The word 'philosophy', may be more like 'addition' than it is like 'game', in which case there is a perfectly straightforward sense in which there is more than 'stylistic and sociological unity' to philosophy.

It is nevertheless clear that those who wish to argue in favor of a merely institutional identity of philosophy do use the pragmatic view of language as *a* premise in their arguments. We soon see what role this view plays in Rorty's metaphilosophy if we recall the notion of philosophy which he is arguing against, namely philosophy as epistemology. It is this epistemological concept of philosophy which the recent pragmatic developments in philosophy of language have supposedly rendered at least implausible, and perhaps incoherent.

According to the Rortyan story, that there can be a science of science presupposes that there is some real difference between science, or real knowledge, paradigmatically conceived as natural science, and other pseudo-disciplines. Given Plato's fantasy, this difference is supposed to be that physical science correctly mirrors the world, while pseudo-science fails to do so. So philosophy as epistemology is that field which inquires into the nature and possibility of correct representation of the world, that

is, into what it is about science which allows it to be true representation and into how, in general, such representation is possible. The results of these inquiries conducted by philosophy are that science provides a 'neutral matrix' of representational language and that such a use of a neutral scheme is able to correctly mirror the world insofar as such use adequately expresses the nature of reason, mind, or language themselves, and thus adequately embodies the form of representation itself. That is, philosophy as epistemology discovers that "... the 'mind' or 'reason' has a nature of its own, that discovery of this nature will give us a 'method', and that following that method will enable us to penetrate beneath appearances and see nature 'in its own terms'."[9] The supposed structure of natural scientific discourse and method, is supposed to supply us with a standard for judging what is rational and a consistent application of rationality will result in real knowledge, a true representation of the world.

But if the pragmatic conception of language is correct, then there is no secret to the success of natural science to be discovered. There are two reasons for this. First, science is not true in virtue of correctly mirroring the world, so there is no secret to its ability to do so. It is merely a highly successful technology which has proved to be greatly helpful in achieving a certain rather restricted class of ends having to do with prediction and control. Second, the mind or representation or language have no nature in themselves; the 'right' way to discuss these intentional phenomena is just the way which proves to be useful for dealing with whatever problems we happen to have. So, if philosophy is the field whose unity is supposed to be provided by the attempt to give an account of how science can correctly mirror the world and in the process of doing so attempts to uncover the real form or essence of mind and representation, then philosophy ceases to have a unified subject matter. At most it might have a peculiar style of dealing with whatever questions happen to arise and an institutional matrix which certifies who is to count as a philosopher and what is to count as an act of philosophizing. The modern notion of philosophy as epistemology would have supplied a unified rule or decision procedure for determining and justifying what is philosophy , but it turned out not to be viable. So, the pragmatic argument concludes, 'philosophy' is more like 'game' than 'addition' after all.

There are two serious problems with this reconstruction of a Rortyan argument for connecting pragmatism with metaphilosophy. First, it completely accepts the epistemologist's own self-conception of what it is that they are up to. This argument thus presupposes that because on this account there is nothing in common between analytic philosophy and say Hegel or Heidegger there is in fact nothing in common between them. But just because the epistemological account of the unity of philosophy turns

out to be erroneous it does not follow that there is no unity to philosophy; presumably the collapse of the epistemological definition of 'philosophy' leaves open the question of whether philosophy has some other unity.

Second, there is an odd sort of self-contradiction in the structure of the argument linking pragmatism with Rorty's metaphilosophy. The reason that there can be no science of science is that the pragmatic analysis of language shows us that there is no 'secret' to correct representation and that there is no form or nature to intentionality itself which can be used to discover the necessary structure of scientific knowledge of the world. There is no secret because on the pragmatic account language doesn't mirror, truth isn't correct mirroring, and there is no essence or form of mind because which things are, and what they are, depends upon how the world is dealt with in language. As Rorty puts it, "...pragmatism...is simply anti-essentialism applied to notions like 'truth', 'knowledge', 'language', 'morality', and similar objects of philosophical theorizing."[10] But this anti-essentialism leads directly to a second objection to Rorty's discussion of philosophy. What is the pragmatist account of language if not an account of what it is to be a language? It is only because all language is supposed to have the pragmatic character detailed in the five propositions discussed above that we have grounds for throwing out the Platonic fantasy. But isn't this pragmatic conception itself supposed to show us what it is to represent, even if it doesn't provide us with a neutral linguistic matrix within all meaningful language or provide a foundation for the pretensions of natural science? And doesn't this amount to an attempt to detail a view in regard to the essence of language, an essence which on Rorty's grounds language is not supposed to possess?

We will deal with the first issue, the possibility of alternative unities for philosophy, through dealing with the second set of questions. What kind of claims are the pragmatic assertions in regard to language, and how do they help to justify the rejection of the constellation of notions connected with Plato's fantasy? And how can they do so without in that very act reconstituting that fantasy?

III. Relativism and the Problem of Philosophical Presuppositions

It is clear that the second problem which I pointed to above arises out of a variation in a common philosophical move. Rorty's metaphilosophy seems to be based upon a kind of relativism, and, as is well known, relativism is a self-defeating doctrine. What is not immediately apparent is the

type of relativism Rorty is being accused of, or at exactly which point relativism is supposed to enter into Rorty's account.

In general, relativism is the doctrine that the truth of a proposition is a relational predicate with one more place than it is usually thought to have. On the standard correspondence view of truth, to say that an assertion is true is to assert a relation among that statement, the language in which that assertion appears, the context of utterance, and the way the world is. Since the relations among the assertion, the context of its utterance, and its language just serve to fix which proposition a given assertion signifies, the truth of a proposition is a function solely of the way things are. A view of truth is relativistic, on the other hand, if it claims that the truth of a proposition involves a relation among that proposition, the way the things specified in the proposition are, and some third factor, e.g., the set of social practices the asserter engages in or the social utility of the proposition if taken to be true. The key element in relativism, then, and the aspect which gets it in trouble, is the claim that one and the same proposition can be both true and false, even if there is no change in the state of affairs referred to in the proposition, because the truth of the proposition varies as a function of some other, apparently extraneous, factor. Any view which asserts that the *meaning* of an assertion is a function of some such apparently extraneous factor, and for that reason holds that truth is 'relative' to that factor, may be relativist in regard to meaning, but is in no crucial sense relativist in regard to truth. In this case, two *apparently* identical assertions can differ in truth value depending on utility, etc., but because *meaning* is seen as varying as a function of that factor, it is not one and the same proposition which is true and false, but rather two different propositions.

Now, as Rorty quite correctly points out, there is nothing in the pragmatic view of language which implies relativism in any vicious sense in regard to what might be called 'first order' propositions. For pragmatism, the language which is being spoken determines the domain of objects which is being referred to and constitutes the members of that domain as objects. Because of this, two assertions which appear to be similar, but which function within different realms of discourse or 'vocabularies', can differ in truth value, but they can do so only insofar as they in fact refer to different objects and have different meanings. Within a given vocabulary whether or not an assertion is true is wholly objective; it is determined solely by the way the world is, that is, by the specific facts concerning the objects of the discourse in which the assertion has a meaning. This is for Rorty the proper way to interpret what is correct about the correspondence view of truth. The world doesn't come prearranged into objects with natures which it is our business as truth seekers to picture accurately,

but given a language and a view of the world, objects do have determinate characters about which we can be objectively right or wrong:

> Given a language and a view of what the world is like, one can, to be sure, pair off bits of language with bits of what one takes the world to be in such a way that the sentences one believes true have internal structures isomorphic to relations between things in the world. When we rap out routine undeliberated reports like 'This is water', 'That's red', 'That's ugly', 'That's immoral', our short categorical sentences can easily be thought of as pictures, or as symbols which fit together to make a map. Such reports do indeed pair little bits of language with little bits of the world.[11]

For pragmatism, given a language or vocabulary, it is just false to say that any belief or assertion is as good as any other.

Yet, pragmatism *is* relativistic at a 'higher' level. For, it seems possible to raise the question concerning which vocabulary is the correct one. This is precisely the question which epistemology has traditionally asked. This question is composed of three related but distinct questions. First, is language such that there is some one vocabulary which is 'true', i.e., uniquely capable of giving us the world as it really is, and if so, which language is it? Second, is there some way the world is in itself which grounds the uniquely proper way in which beings should be interpreted and which demands a certain privileged vocabulary for its depiction? Third, how can we know which vocabulary we should adopt? The major metaphilosophical consequences of the pragmatic view of language are that no *language* is true non-relativistically, that this is correlated with a negative answer to the second question, and that there is no non-circular way to answer the third question which does not presuppose some concrete end to be obtained through the use of language. Pragmatism in regard to language implies a negative answer to the question of whether the world in itself uniquely determines our ultimate choice of vocabulary because for pragmatism it is not the role of language to correctly picture the world, but to help us actively deal with it. And to deal with the world is to interact with it for some determinate end or purpose. So the 'correct' vocabulary varies as a function of the end to be attained and the ability of a linguistic practice to help us attain that end. The philosophical attempt to ground some theory or vocabulary non-pragmatically as the uniquely required language of nature is just so much wasted effort.

> James and Dewey are, to be sure, metaphilosophical relativists, in a certain limited sense. Namely: they think there is no way to choose, and no point in choosing, between incompatible philosophical theories of the typical Platonic or Kantian type. Such theories are attempts to ground some element of our practices on something external to those practices. Pragmatists think that any such philosophical grounding is . . . pretty much as good or as bad as the practice it purports to ground.[12]

There is nothing which 'supports' our practices, linguistic or otherwise, for philosophy to discover. The question of which language is true, in the sense of corresponding to the world, is irrelevant to the choice of a vocabulary, and the language of action is more appropriate to the discussion of language choice than the language of knowledge or theory.

What, then, is the status of the claims which comprise linguistic pragmatism? It is precisely at this point that the basic problem emerges for pragmatism and Rorty's metaphilosophy. There appear to be two alternatives. Maybe the pragmatic view of language stands as a first order theory about its domain of objects, language and linguistic acts, within a well defined set of linguistic practices in which the theory can be judged to be true or false. The only possible such vocabulary would be the metaphysical philosophical language out of which pragmatism arises and which it confronts. Pragmatism seems to be a view in regard to what it is for a proposition to be true, and thus a view in regard to the 'nature' of language and knowledge. But if Rorty's view of pragmatism is right, there is no unity of philosophical discourse and the vocabulary in which pragmatic claims are stated is not well defined; the 'objects' which that language sets up, 'truth', 'knowledge', 'mind', 'language', etc., which are supposed within philosophy to regulate the truth of philosophical discourse, have no natures which by themselves are capable of determining the truth values of philosophical assertions.

This leaves us with the second alternative. Considered on its own grounds, pragmatism is a recommendation in regard to a way of speaking. It suggests that there is no point in searching for the essence of truth, mind, language, etc., and thus no point to the traditional philosophical game. Pragmatism is the application of the philosophical position of anti-essentialism to the objects of philosophical discourse themselves. But, then, given Rorty's rejection of the first alternative pragmatism itself must be seen as a recommendation in regard to a practice of speaking concerning language, knowledge, and being themselves. If that linguistic practice which constitutes pragmatism is itself to be justified it must be justified pragmatically, i.e., in relation to some end which it helps to realize, and for it to be 'true' can only mean that to speak in a pragmatic way serves some such worthwhile end.

The conflict between traditional philosophy and Rorty's pragmatism, then, is as much over what it would be for one of these views to be true or commendable as it is an argument concerning which view is true or commendable. For the consistent Rortyan pragmatist, the metaphilosophical attempt to ground a kind of philosophical discourse must be seen as as much a question of whether a certain practice of doing philosophy is 'good' or 'bad' as is the analogous attempt to ground other theoretical

vocabularies. For the traditional philosopher it is the nature of being, knowledge, and especially language which determines whether it is correct to look for 'nature's own vocabulary'. But insofar as a pragmatist tries to base his metaphilosophy upon an analysis of 'what language is', it seems that he is implicitly contradicting his own pragmatism.

Rorty himself frequently says that he knows of no argument which necessitates the adoption of the pragmatic view. As we have just seen, however, for there to be no conclusive theoretical consideration in favor of pragmatism does not imply that there are no considerations which could weigh in its favor. There are reasons which are relevant, the same sort of considerations which are relevant for deciding other practical issues. Such reasons can be of two sorts. If opponents agree as to the end to be obtained, then the question of which tool or method is to be preferred is the instrumental question of which is most likely to bring about that end. Any consideration relevant to deciding that issue is also a reason for adopting some tool or method of action. If there is disagreement concerning ends, then the practical relations among those ends, and others which the opponents may have, become relevant, as does what Dewey calls the empirical question of whether an end, if obtained, would prove satisfactory, as well as satisfying, desirable as well as desired.[13]

If it is assumed that linguistic pragmatism is correct, then given Rorty's metaphilosophy we have reason to think it correct only if there are some value considerations which speak in its favor. Now, if Rorty were willing to break with the whole constellation of purposes, practices, values, and forms of life which constitute what we call Western Civilization, and in particular with its discursive core in those practices and modes of thought which are typical of inquiry and science, then the second sort of value consideration which we mentioned above would become relevant. But Rorty is not willing to do so. In fact, he expresses anxiety that "the *practical* question of whether the notion of 'conversation' *can* substitute for that of 'reason'"[14] may be answerable only negatively. And this in turn leads to the anxiety that the pragmatic vocabulary will turn out to be insufficient to motivate the attempt to preserve the cardinal virtues of Western Civilization, virtues the preservation of which he clearly takes to be a principal end. So Rorty agrees with his metaphilosophical opponents in regard to the ends of philosophical discourse: motivating a certain style of inquiry and preserving certain civic and intellectual virtues which are related to that form of inquiry. He also recognizes, however, that by and large the traditional philosophical vocabulary has done an excellent job of meeting these objectives and that pragmatism might be incapable of doing so.

> For better or worse, the Platonic and Kantian vocabularies are the ones in which Europe has described and praised the Socratic virtues. It is not clear that we know how to describe these virtues without those vocabularies.[15]

He does not seem to realize, however, that on his own grounds, in admitting this much he is also admitting that there is no reason to prefer the pragmatic view of language to the traditional one. If Rorty's form of linguistic pragmatism is true, it is false. If the questions of metaphilosophy and of which vocabulary to adopt in discussing language, truth, and being are practical questions, then if one accepts our own culture the practical considerations weigh against pragmatism. Nor should we think that Rorty could appeal to the inductive evidence supplied by the historical failure of philosophy to discover the essence of truth, etc., as he sometimes attempts to do. By our own lights it is better to believe that philosophy in the old sense is possible, that is, continue to attempt to do philosophy in the traditional manner, regardless of whether it is possible to come to philosophical knowledge, than it is to speak pragmatically at the cost of abandoning the Socratic virtues. As Plato has Socrates say in the Meno:

> ...one thing I am ready to fight for as long as I can, in word and act—that is, that we shall be better, braver, and more active men if we believe it right to look for what we don't know than if we believe there is no point in looking because what we don't know we can never discover.[16]

Rorty, on his own grounds, should only agree.

In Rorty's form, pragmatism is thus a self-defeating doctrine insofar as it continues to uphold the traditional values of Western Civilization. The only possible grounds, under these circumstances, for adopting the pragmatic view of language is for it to be true non-relatively to value considerations, for it to tell us something about what language, knowledge, and being are. But how can pragmatism claim this while remaining pragmatic, in regard to language? In the next section we turn to this issue.

IV. Pragmatism and Transcendental Semantics

The problem with the status of pragmatism arises out of a dilemma. On pragmatism's own grounds that a given assertion is justified means either that there is a well-established practice of linguistic usage which licenses the assertion, or, when it comes to assertions of the appropriateness of entire sets of such practices, justification depends upon the considerations which give us reason to believe that a particular way of speaking is better (for the ends of human life) than others. Now, Rorty is fond of saying that pragmatism itself does not involve a theory but merely the negative claim that there can not be such theories. Nevertheless, he is willing

to assert, and must be willing to assert if pragmatism is to have any content, propositions such as "to have a concept is to be able to use a word" and "languages are created rather than discovered". The dilemma emerges for pragmatism when it is asked, 'What is the status of the assertions which compose pragmatism itself?'. Either pragmatism is a claim within an already defined language game about well constituted objects or it is a suggestion concerning how to speak, about which practices to adopt. But it is part of the point of pragmatism as Rorty understands it that it does not want to be a new contribution to traditional metaphysical-epistemological philosophy, but rather its end. So the assertion of pragmatic principles isn't merely a move within philosophy, justified by the canons of ordinary philosophical argument. On the other hand, there is a notable lack of pragmatic, value based arguments favoring pragmatism. Aside from the rather inflated early twentieth-century rhetoric of Dewey and James lauding the virtues of America and technology, and Rorty's own more tentative efforts, there is little which could count as attempts at a value based justification of philosophical pragmatism. It seems more plausible to read the history of Western Civilization as many realists do, as the long struggle, and tenuous victory, of rationality against the irrational forces ranged against it, forces which now are given inadvertent support by pragmatism itself, which takes value considerations to be relevant to theory choice rather than thinking that that choice is constrained by the world itself.

Is this dilemma a fair one and are the alternatives offered exhaustive? It is the contention of this section that pragmatism is in fact a move *within* the traditional philosophical game, but that this game is misdescribed when it is taken as the epistemological attempt to ground science or any particular way of speaking. Rather, philosophy is better seen as the attempt to discover formal necessary conditions on the use of our words 'language', 'mind', 'truth', etc. So understood, pragmatism is a philosophical position which happens to imply that philosophy has few if any epistemological or ontological consequences. And, as a philosophical position, pragmatism must be justified, if it is to be justified, according to the usual canons of philosophical debate, according to which value considerations are of very secondary importance.

In order to see the sense in which pragmatism is simply a rather ordinary kind of philosophical view, let us consider some of the ways in which philosophers have attempted to argue in favor of linguistic pragmatism. Perhaps we can discover the status of pragmatic assertions if we discover the range of evidence which has been thought relevant to their justification. The considerations and arguments which have actually been advanced in favor of pragmatic style positions, whether by Quine, the late

Wittgenstein, Davidson, Dewey, Nietzsche, or the early Heidegger tend to begin in the same way.[17] They all start with a question of the form: 'What is someone doing when they say something intelligible?' or 'Under what conditions would one be warranted in saying that someone was speaking a language?' or 'How could we know that someone meant something by an action or that some action had semantic content?' In all of these cases what is called into question is the use of our word 'language', or, alternatively, the use of our words 'understanding' or 'meaningful' or 'intelligible' when applied to linguistic performances.

Consider, for example, a Quinean or Davidsonian argument in favor of the principle of charity, a principle which Rorty considers crucial to pragmatism insofar as it can be used to show that the Kantian split of experience or language into formal and material parts is an error.[18] The base step of the argument involves noting that at least part of what it is to recognize that what another group is doing in using a language is to assign linguistic meaning and semantic content to their various performances. But the only way this can be done is if we can discover that there are conditions under which various 'assertions' are assented to by the members of the group. If we couldn't do this, we would have no reason to think that they were speaking a language. The argument proceeds in two steps. First, given holistic considerations concerning the way in which linguistic connections among various assertions can affect assertibility, one can in general only assign such conditions for a whole structure of assertions at once. In general, we have reason to believe that a particular performance type has a particular semantic content only insofar as we have reason to believe that it is part of a system of performances which themselves have identifiable semantic content, that is, that there are conditions under which they are acceptable and conditions under which they are disallowed. Second, for us to recognize such a correlation between assent and conditions for assent, it is necessary that we be capable of recognizing the regularity of conditions governing the linguistic usage of the others. We are entitled to assert that the sentence 'Gavagai.', has a meaning, specifically the meaning expressed by our sentence 'Lo, a rabbit.', only if the aliens genuinely assent to 'Gavagai.', in general, only when there really is a rabbit present. That is, we are entitled to assign the semantic content of 'Lo, a rabbit.' to 'Gavagai.' only if we would consider most of the aliens uses of 'Gavagai.' true. Combining this result with holism we reach the conclusion that in order for us to have reason to think that what an alien group is doing is using language most of what they utter must be interpretable as (on our lights). And, if we assume that others are speaking a language we also must assume that most of what they say is true. This is the principle of charity.

This is a rather 'high level' argument in that it presupposes a variety of necessary conditions on something being recognizable as a language, conditions which, for example, point towards holism and the need to see what our interlocutor is doing as being done for the purpose of imparting the truth. This argument merely adds another condition to a list which Quine and Davidson already acknowledge. It shows us conditions which must be fulfilled if we are to be warranted in saying that something is a language. These conditions are necessary formal conditions on what it is to be a language, or alternatively, necessary features of the use of our word 'language'. Much of modern philosophy is composed of similar claims concerning 'truth', 'knowledge', etc., and there are reasonably well defined practices for justifying such assertions. In general the arguments advanced in favor of these assertions are, like those given here, in form quite similar to the kinds of arguments Kant gave for his positions concerning the necessary conditions on the possibility of experience. In short, this argument, and others similar to it, are transcendental arguments concerning the necessary conditions for the possibility of languages.[19]

As far as I can tell, all of the arguments which have been advanced in favor of the five propositions which constitute linguistic pragmatism, including Nietzsche's, Heidegger's, and Rorty's own, have been transcendental in form. It is typically argued that it is only correct to call something a language if certain conditions are met, most notably, if it is possible to assign semantic content to utterances. But, it is argued, we can assign semantic content to the actions of an agent only if we can assign understanding of something as something to that agent, which in turn we can only do if it is possible to assign purpose to that behavior. The pragmatist then argues that this indicates that it is appropriate to see language as a tool, from which, together with some other premises, it is supposed to follow that to have a concept is knowing how to use a word, and so on.

Before we look at the implications of this account of the arguments in favor of pragmatism for the dilemma we forced upon Rorty, and thus advance to a consideration of the status of pragmatism itself, it is necessary to deal with two possible objections to this account itself. First, doesn't this account of pragmatism's argument structure contradict pragmatism's own account of what it is to have a concept? Second, why should this enterprise of examining the conditions of appropriate use of *our* word 'language' have more than parochial interest?

The answer to the first question is straightforward. The properly pragmatic position that the ultimate criterion for the correct application of a word is social practice does not imply that no words have necessary conditions for their correct use which can be stated independently of a mere reiteration of that practice. The pragmatic position tells us what is in-

volved in a word or assertion being used correctly, the conditions tell us when the word is used correctly. Now, perhaps contrary to what Wittgenstein thought, the practice of most of Rorty's heroes indicates that the pragmatists in general have treated the words 'language', 'truth', 'representation' etc., as if they are rather more like 'addition' than like 'game'. That is, the pragmatists' actual philosophical practice implicitly commits them to the view that there are necessary conditions on the use of the philosophically crucial words, conditions which can be uncovered by transcendental argument. To be sure, a pragmatist must be a nominalist; but this need not imply that there are no features the absence of which would as a matter of fact make it improper to call some thing an x.

There are two sorts of answers to the second objection concerning the importance of pragmatism if true: the first response has to do with the practical consequences of pragmatism, the second with the scope of pragmatism as a philosophical position. First, the cluster of notions composed of 'language', 'understanding', 'knowledge', etc. is an especially central one in our language. On the one hand, only those beings who are capable of using language, or of understanding, are appropriate candidates for being treated as 'one of us', as persons in the full moral, social, and psychological sense. So, since the use of the terms of philosophical inquiry is closely tied to our primary moral notions, an adequate account of these terms should be helpful in actual moral disputes. On the other hand, the semantic vocabulary is the basic conceptual instrument of reflection concerning what it is we are doing when we know or speak truly. An improved discussion of what is involved in using a language can thus have important immediate consequences on our self-conceptions as knowers and persons and indirect consequences for our practices as investigators.

The second reason for the importance of pragmatism has to do with the way in which the words philosophy deals with actually function. They, so to say, transcend their original context of use. To count as using a language, beings must act in such a way that their acts can be interpreted as having semantic content, as making assertions which can be true and false. But if pragmatism is right, this can only happen if the behavior of a group of beings is regulated in such a way that some actions are allowed and others rejected; that is, if those beings themselves treat each other as if what they were doing had semantic content, i.e., treat each other as having a language in our sense. So whether or not we can identify a specific element in an alien language which translates as our word 'language' (or 'truth', etc.) we know, a priori, that, if it does have a language, the group will interact as if it had the concepts of truth, language, etc. available to them, e.g., they will distinguish the true from the false and the linguistic from the non-linguistic. So in discovering the conditions for the appropri-

ate use of our words 'language' etc., we are also discovering the structure of all possible languages.

What, then, is the status of pragmatism? Is it a recommendation to adopt a new way of speaking about the objects of philosophical concern or is it a theory about those objects which presupposes an already given way of talking? As it turns out, all attempts to justify pragmatism have had one of two forms. Either it is argued that there are pragmatic grounds on which to adopt pragmatism or pragmatism is defended on transcendental grounds as expressing certain necessary conditions on the use of the words 'language', 'truth', etc. But we have seen that the first alternative is precluded by the inherent weakness of the purely pragmatic considerations favoring pragmatism itself. This suggests that whatever grounds there are for accepting pragmatism must arise within the already established philosophical vocabulary. And, as a matter of fact, insofar as pragmatism in regard to language has been defended, it has been defended on philosophical, and in particular, transcendental grounds. Given the failure of pragmatic justifications for pragmatism it seems clear that, on its own grounds, if pragmatism is true it is true as a philosophical theory and, given the actual way in which it has been defended, pragmatism is best seen as comprised of transcendental claims concerning necessary conditions on language, truth, and semantic content. As such, it consists in a series of reflective comments directed towards our practices for determining if a system counts as a linguistic system, or if a being understands what is going on, or if someone is speaking truly. It presupposes both an already established object language, the ordinary language in which we call and treat utterances as true and false, and call what we thereby do 'speaking a language', and a rather well developed set of procedures for talking about that language: the procedures included in the historical practice of philosophizing.

Given the way in which pragmatism is in fact justified, and the ways in which it can not be justified, it seems clear that, on its own grounds, if it is to stand any chance of being true, it must be treated as a philosophical position after all, rather than a recommendation that we stop doing philosophy in the traditional sense. But if this is the case, we are left with two puzzles. First, if pragmatism is a philosophical position which presupposes the tradition of philosophical argumentation, how can it be a radical displacement and rejection of that tradition and practice, as it has always taken itself to be? Second, how should we describe that tradition of philosophizing which pragmatism arises out of? What is philosophy anyway, such that pragmatism is both a philosophical position and an alteration in the way in which philosophy understands itself?

V. The Unity of Philosophy

The Rortyan story which we told at the beginning of this paper has a number of crucial aspects. Perhaps the most central is the claim that traditional philosophy can be defined by a particular answer to the question regarding truth. Philosophy, in the grand old sense, is seen as the practice which attempts to further determine what is involved in a claim, intuition, representation, sentence, or other intentional element being true, when it is presupposed that such truth ultimately consists in a correspondence between that representation and what is entirely independent of human agency.[20] The various traditional preoccupations of philosophy are seen to arise out of this primary task. Because there is only truth where there is correspondence with the real, it is important to know what the reality of the real, its being, consists in: hence metaphysics. Because representations are that which are true and false, it is important to know what it is to be a representation: hence philosophy of mind and philosophy of language. With the rise of physical science in the seventeenth century, it was taken as certain that physics comprised a privileged domain of certain truth and philosophy became concentrated on questions concerning the nature and possibility of scientific knowledge: hence the rise to preeminence of classical modern epistemology.

Pragmatists such as Rorty reject the primary notion of truth upon which this entire development and practice is supposed to be based. For Rorty, the key move is the rejection of the traditional picture of language as a system of pictures. As the picture we have been describing is taken to be definitive of philosophy, pragmatism's rejection of these central notions of truth and being is thus taken to represent the end of philosophy as a unified endeavor. All that remains is the institutional matrix which was historically established for the practice of philosophy and certain styles of dealing with arguments which initially arose as tools for dealing with philosophical issues. The issues themselves which gave unity to the practices and a point to their exercise are simply in the process of disappearing. In Rorty's well-worked analogy, philosophy is well on the way to becoming like theology.

What this story and its presupposed definition of philosophy fail to recognize, however, is that there has always been an alternative tradition *within* what has generally been called philosophy. What are we to make of figures such as the Sophists or the Pyrrhonian Sceptics, who reject the Platonic ideas concerning truth, knowledge, and being? What, too, are we to make of those embarrassments to analytic philosophy departments, the historicists and German Idealists of the nineteenth century? If such figures are to be considered philosophers, and I see no alternative to ordi-

nary usage in doing so, then 'philosophy' is a rather broader term than our story would admit. It includes all those enterprises which take a stand on what it is 'to be true', or what it is to know or to be a language, regardless of whether that stand accepts the Platonic fantasy or not. In short, philosophy is the field of discourse in which the necessary formal character of discourse itself, and with it semantic content, meaning, truth, and knowledge, are called into question. It is the discipline which is concerned to discover necessary features and concomitants of systems which have semantic content. As such, it may be characterized as 'transcendental semantics'. So understood, pragmatism fits rather well into the traditional discipline of philosophy. Instead of being seen as the rejection of philosophy, as Rorty tends to see it, pragmatism should be seen as a philosophical movement which uses philosophical procedures and modes of argument to make philosophical points which attack one of the dominant traditions within philosophy, the tradition which is characterized by acceptance of the Platonic fantasy.

Why, then, do pragmatists such as Rorty persist in seeing pragmatism as the end of philosophy as a coherent, unified whole? I would suggest that in an odd way they have accepted too much from their philosophical opponents. In particular, their definition of philosophy has simply accepted the Platonic-Kantian position on the nature of philosophy. For traditional Platonic thought, the ultimate point of philosophy has been to determine the nature of reality itself. The modern form of this enterprise has been to determine the character of what is by determining the essential necessary character of what can be known. This in turn is determined through an analysis of knowledge itself. Perhaps the clearest statement of this strategy, which is common to neo-Kantians and positivists, phenomenologists and analysts, is contained in Kant's Highest Principle of Synthetic Judgment, where he says that the necessary conditions on the possibility of experience are also the necessary conditions on the possibility of the objects of experience. So this sort of philosophy is structured as the attempt to determine what kinds of things there are, and what it is for them to be, by analyzing the nature and structure of knowledge, representation, or language. In other words, this kind of modern philosophical argument has contained two stages. First, one engages in a transcendental investigation of the necessary conditions on language, etc., so as to give a formal account of what it is to be a language. Second, this account is used to set a priori constraints on the objects of knowledge and thus, ultimately, on what can be. Philosophical epistemology serves an ontological end.

This strategy evolved to the point, however, that finally in the late twentieth century the distinctive ontological function of philosophy dissolved. If what is is what can be known, and what is knowable are the

objects which the sciences assert to exist, then what exists is just that which can be known to be by science. For pragmatism, if knowledge and language have a form, it is merely the form which they acquire in virtue of operating within the context of human practical activity, so pragmatism asserts that the test of a science is ultimately a practical one. Science determines ontology, and practice is the test, and point, of science. In other words, the transcendental analysis of language and knowledge in its pragmatic incarnation provides constraints on the objects known which are so loose and general that for pragmatism the formal analysis of language ceases to play a distinctively ontological role. Philosophy ceases to tell us anything substantial concerning which things are or about which categories are the appropriate ones for understanding reality; it merely suggests that practical criteria are the only ones relevant to deciding these issues. If in order to fulfill some purpose it is necessary to talk about persons as beings who possess intentional states, then persons have intentional states. But this should not be taken to mean that there is something about human beings which eludes physical description. There may be other purposes for which the language of physics is just what we need for dealing with humans.

But if philosophy is defined by its ontological function, pragmatism ceases to be a philosophy, or if one accepts pragmatism, philosophy ceases to have any point; its primary function is entirely usurped by the sciences. Once again, however, the crux of the argument which leads to this conclusion is the assumption that the function of philosophy is and must be the Platonic function of providing a neutral matrix, an a priori form, which is applicable to the knowledge of anything which is because it mirrors the necessary formal structure of being. But if we give up the notion that transcendental semantics must have this ontological point in order to be philosophical, in other words if we give up the Platonic self understanding of philosophy, we also give up the notion that transcendental semantics without substantive ontological implications must be non-philosophical.

I think that it would be possible to show that much of contemporary philosophy, as well as much of the history of philosophy, has the unity I have suggested, the unity of being concerned with what I have called transcendental semantics. To actually show this in detail would require at least an additional paper; but it is at least plausible to see contemporary philosophy, in all of its diversity, as unified by a common interest in what it is to be a language, for a system to have semantic content, and for there to be acts which are 'true'. And this, I would argue, is just the unity philosophy has had since Plato.

NOTES

1. W. Sellars, 'Philosophy and the Scientific Image of Man' in *Science, Perception, and Reality* (London: Routledge and Kegan Paul, 1963), 1.

2. Richard Rorty, 'Method, Social Science, and Social Hope' in *The Consequences of Pragmatism* (Minneapolis: University of Minnesota Press, 1982), 194.

3. R. Rorty, 'Philosophy in America Today' in *The Consequences of Pragmatism*, 222.

4. This metaphor needs to be fleshed out. In particular, pragmatism needs to give an account of the general notion of the 'success' of an action.

5 cf. Saul Kripke, *Wittgenstein on Rules and Private Language* (Cambridge: Harvard University Press, 1982).

6. In fact, the practical linguistic criteria here need to be far more complex than these simplified examples would suggest. As the proponents of this view recognize, it is a whole inferential net of assertions, and the conditions of their acceptance, which is relevant to the propriety of any given use of an assertion.

7. Kripke, 8, ff.

8. Rorty, op. cit., 217.

9. Rorty, 'Method, Social Science, and Social Hope' in *The Consequences of Pragmatism*, 192.

10. Rorty, 'Pragmatism, Relativism, and Irrationalism' in *The Consequences of Pragmatism*, 162.

11. Ibid., 162.

12. Ibid., 167.

13. cf. John Dewey, *The Quest for Certainty* (New York: Capricorn Books, 1960), 254ff.

14. Rorty, op. cit., 172.

15. Ibid., 172.

16. Plato, *The Meno*, translated by W. K. C. Guthrie in E. Hamilton and H. Cairns, eds. *The Collected Dialogues of Plato* (Princeton: Princeton University Press, 1961), 371, 86 b.

17. I argue this claim in detail for Heidegger in my book, *Heidegger's Pragmatism: Understanding, Being, and the Critique of Metaphysics* (Ithaca: Cornell University Press, 1988).

18. The version given here is a generalization of specific formulations of the argument which appear throughout the writings of Quine and Davidson. In particular, cf., Quine, *Word and Object* (Cambridge: The M.I.T. Press, 1960), chapter 2 and Davidson, 'Radical Interpretation' in *Inquiries into Truth and Interpretation* (Oxford: Clarendon Press, 1984), 125–140.

19. Notice that in general this type of argument is inadequate to discover sufficient conditions for something being a language, etc. Also, it is significant to note that there are crucial differences in regard to the status of the conclusions to this type of argument among those who attempt to use them. Whether such claims are analytic, or synthetic a priori, or merely ordinary scientific synthetic a posteriori judgments is a source of important disagreement among twentieth-century philosophers. I treat this issue at length in 'Relativism, Context, and Truth,' *Monist* 67 (July 1984), 341–358 and in chapter 8 of *Heidegger's Pragmatism*.

20. cf. Rorty, *The Consequences of Pragmatism*, xxvi.

8

Carlin Romano
THE ILLEGALITY OF PHILOSOPHY

I. INTRODUCTION

Philosophers talk about justifying all sorts of things: knowledge claims, religious beliefs, aesthetic judgments, moral principles, scientific theories and political systems. It is hard to read through a philosophical text without being told that someone should have justified P, might have justified P, didn't justify P, or couldn't justify P. We hear the same intellectual serenade in the titles of serious theoretical books: C. Behan McCullagh's *Justifying Historical Descriptions*, for instance, or *The Justification of Induction*, edited by R. W. Swinburne. Yet we hear very little discussion of justification in its own right.[1]

The silence invites attention for a time-honored philosophical reason—an unexamined concept is not worth using, and certainly not overconfidently. Very often, a philosopher implies that we all know what would count as a justification in one context or another. This occurs frequently in the formulation 'By failing to show that X, Y fails to show that Z.' Yet often, when we encounter such a phrase as readers, we think to ourselves that we don't share the writer's judgment about the importance of X for Z, that we're being taken for granted in regard to what evidence matters for establishing a claim. If it's true that nothing marks debate in philosophy so much as its lack of finality, a key reason for the unsettled atmosphere is not that philosophers fail to justify their views by presenting reasons or evidence that meet their *own* criteria for a justification, but that others don't agree that meeting those criteria suffice for a justification.

In the sphere of jurisprudence and political philosophy, this state of affairs persists in an especially powerful form. Even in the U.S., where argument largely takes place within a narrow domain of democratic theory, disagreement reigns. Posner argues his wealth maximization, Nozick

his ahistorical historical libertarianism, Rawls his neo-Kantian egalitarianism. Yet while all pretend that persuasion of others who disagree is their aim, a key presumption behind the way we describe well-known philosophers is that they're unlikely to be persuaded out of their stands. We confidently speak of Derrida as a deconstructionist, or Quine as a believer in ontological relativity, partly because we know from experience that such thinkers are unlikely to accept the arguments of their critics tomorrow, next year or ever.

Disagreement about what constitutes a justification thus keeps the philosophical engines grinding as much as any other cause. Understanding justification is not just useful for understanding philosophy, but also for successfully practicing it. For if a crisis attends contemporary philosophy, it's not something new that can be blamed directly on the work of Derrida or Richard Rorty, but something old that these two thinkers, among others, have successfully returned to the spotlight—the embarrassing fact that philosophy, as a discipline, refuses to take 'Yes' for an answer. It remains a field that declines to agree on a set of ground rules, widely enough accepted to be authoritative, that would allow genuine answers to its dilemmas to emerge and be passed along to the rest of the culture.

What philosophy needs to escape its crisis, therefore, is a greater appreciation of the role played by decision, rather than discovery, in intellectual life. A first step toward that is to understand 'justification', a term, I submit, that operates as a key tool in a conceptual vocabulary exerting enormous influence over philosophical and critical discourse—the vocabulary of jurisprudential metaphors frequently used to describe arguments, positions, conclusions and the like. It is a key term, but not the only one, for when we refer to a 'legitimate' point of view, or a 'warranted' position, or an 'illicit' influence, we are also engaging in this kind of talk.

I stretch a bit in describing such terms as jurisprudential metaphors, for whether they are is a controversial matter.[2] What is plainly true is that they are at least arguably metaphors, and that may well be enough to make some larger points. One is that philosophers, in innocently or calculatedly using such metaphors to grade rational argument, appeal in an inappropriate way to both the force and objectivity of legal finality. After all, no existing social structure in the intellectual world 'warrants' the claim that one's argument has been justified. No legal structure of intellectual authority exists in the philosophical world—neither the A.P.A. nor the World Congress of Philosophy can rule on the justification of induction. Yet that has not stopped philosophers from claiming to justify moral principles, aesthetic judgments (interesting word, that last) and so on.

Some of the questions raised in asserting justification as a legal metaphor are extraordinarily thorny. For example:

1) What is a metaphor? How can we tell whether 'justified', when used to describe argument, is one? Does choice of metaphor determine how we evaluate the intellectual payoff of philosophy or jurisprudence? Could we employ any synonyms or replacements for our jurisprudential metaphors (e.g., 'licensed') without assuming other commitments?

2) If 'justification' is a metaphor, is it a persuasive metaphor? Speakers use metaphors to call attention to the similarities between things, events, experiences or processes. Presumably, the use of jurisprudential metaphors to describe arguments comes from a desire to call attention to similarities between arguments and the legal process. But not all similarities. Who determines which should be left in, and which left out?

3) If justification is not a metaphor, what is its 'literal' meaning?

4) How far do parallels between philosophic and legal decisions go? Isn't every step toward a juridicial model of philosophy—the notion of hierarchies of judicial authority, of an audience that needs to be persuaded—a step away from traditional notions of philosophy and truth as standing apart from conventions of the moment? If not, should there be a World Court of Philosophy to resolve philosophical disputes? Is that preposterous?

In this essay, to make the issues manageable, I generally restrict my attention to one jurisprudential word—justification—and its cognates. Here, then, are the essay's main claims:

1) While there is no agreed-upon single criterion that determines, regardless of context, what counts as a metaphor, there is virtually no word or language that is not *originally* metaphorical. So the problem in identifying most metaphors is not asking whether they ever entered the category, but whether they ever exited it, and became, in the familiar phrase, dead metaphors.

 'Justification', I argue, has never passed into the dead metaphor category in a first-order sense, though it has in a second-order sense. That is, it has not been given an exact, concrete, behavioral meaning, applicable to specific cases, although it has gained a secondary sense of 'enough reasons have been supplied for some challenge to a claim to be dropped.'

2) Because 'justification' has gained no concrete sense, the idea that one can justify a position or argument in social theory has no lit-

eral meaning, and no easy test (Who must give us a challenge? For how long? For what reason?).

3) Talk of justification in philosophy is a metaphorical attempt to lend an air of legal authority and finality, a sense of 'right answers', to matters for which there exists no legal authority or finality.

4) The need for that air of authority is a symptom of Cartesianism's long dominance in modern Western philosophy, of what Dewey called "the quest for certainty."

5) Cartesianism's endurance partly rests on the split that took place in Western philosophy between rhetoric and philosophy. An understanding of the rhetorical origins and nature of philosophy, such as that evidenced by the late Belgian philosopher Chaim Perelman, suggests an alternate, juridical model of philosophy that can live up to its jurisprudential pretensions.

Taken together, these theses cohere into what I call 'prelegalism'—the view that current philosophy is illegal because it is prelegal, though it pretends otherwise. This view helps explain a commonplace about contemporary intellectual discourse willfully ignored by many professional philosophers in America—the lack of interest shown by both the media and many intellectuals outside professional philosophy in the discipline's logic-chopping debates. When justification makes its typical metaphorical transference from the jurisprudential area to that of philosophical argument, one resemblance that goes along is an idea of final, authoritative answers. Many non-philosophers would stop this immigrant at the border.

Prelegalism implies philosophers need not only the tools of the logician to answer philosophical questions, but those of the jurisprud, the rhetorician, the political theorist, the journalist. It also forces us to look differently at philosophy. Paul De Man wrote in his essay, 'The Epistemology of Metaphor', that it appears "philosophy either has to give up its own constituitive claim to rigor in order to come to terms with the figurality of its language or that it has to free itself from figuration altogether."[3] Where does a philosophy that abandons its claim to rigor and absolutes head? Into conversation and the history of ideas à la Rorty? Into oblivion?

Nietzsche asserted that truth is the solidification of old metaphors. Better to say, regarding justification, that understanding how old metaphors solidify brings us the closest we can come to truth. In this vein, the beliefs of a couple of great philosophers coalesce into insight. Husserl, who would have preferred to call philosophy archeology if the term hadn't already been coopted, taught us something about investigating the origins and uses of concepts, and Foucault partly fulfilled his legacy. Wittgenstein demonstrated how easy it is to be imprisoned by a picture. Prelegalism suggests that those who seek knockdown justifications of positions on the

ultimate questions are prisoners of a picture for a very specific reason: failure to pay attention to the legal metaphors that characterize their holy grail. Understanding that point could free philosophers to argue more effectively with one another.

Before turning to a more considered look at metaphor, an observation and admission are in order. First, if the view I offer is correct, philosophers of law are especially guilty of intellectual bad faith. For jurispruds, when freed by philosophy from the normal constraints placed on legal argument by precedents, restatements, statutes, uniform codes, and so on, have tended to borrow from the vocabulary of jurisprudential metaphor as blindly as anyone else. Of all philosophers who hear intellectuals talk of 'justifying' this and that, one would expect legal theorists in particular to blow the whistle on the false jurisprudential framework. Instead, one detects an air of delight among them that their own discourse has been kicked upstairs to what seems a more spacious, open-minded courtroom. Dworkin, Hart, Raz—all attempt to justify positions within philosophy of law. It resembles the old confidence scam in which one is tricked into buying a second-rate version of something one already owns.

Second, prelegalism presumes that what has counted for good philosophical argument under the dominance of analytic philosophy—an avoidance of irrelevant historical information, an announcement of axioms or principles with precise, stipulative meanings, a syllogistic segue to the finish line—keeps us from seeing things as they are. It holds that a more Wittgensteinian approach—describing actual conceptual situations in the hope of persuading readers to conclude, 'Yes, this is how things are'—is required. Such acknowledgment, I believe, is all one can seek in philosophical argument, though who agrees and how many do is of some consequence.

II. METAPHOR

Historically, there has been wide agreement that language is at root metaphorical, and that philosophical language is no different. Rousseau argued that man's "first expressions were tropes",[4] modern analysts such as Nelson Goodman recognize that metaphor still "permeates all discourse",[5] and continental theorists such as Derrida agree ("Abstract notions always hide a sensory figure").[6] Fontanier, the great French theorist of tropes, began his work *Figures of Discourse* by pointing out that even so abstract an idea as 'idea' had grown from the Greek *eido*, 'to see'.[7]

Closer to our own thesis, the verb 'to judge' is a metaphor that originally meant (and perhaps still does) to act like a legal judge. The *Oxford*

English Dictionary states that in the fourteenth century,[8] justification referred to the actual administrative rendering of justice by a legal system. That marked a metaphorical doubling back, of sorts, to the origins of justice itself. In his study *The Greek Concept of Justice*, Eric Havelock points out that only with Plato did the Greek word for justice aim to indicate something beyond a concrete set of circumstances and relationships—indicate, that is, a concept. Before that, in *The Iliad*, it "is a procedure, not a principle or any set of principles—it is particular, not general, in its references."[9]

Most daunting of all for those seeking an Archimedean point from which to analyze metaphor is the fact that even the words 'metaphor' and 'figure' are metaphors. Derrida, in *White Mythology*, actually mocks Aristotle's famous definition: "Metaphor consists in giving the thing a name that belongs to something else; the transference being either from genus to species, or from species to genus, or from species to species, or on grounds of analogy." He points out how, in the original, every word of the definition is a metaphor.[10] The situation seems to be as Paul Ricoeur acknowledges early in his study, *The Rule of Metaphor*: "There is no non-metaphorical standpoint from which one could look upon metaphor."[11]

Of all the philosophical writers on metaphor, Nietzsche probably draws the strongest conclusions from this state of affairs. "Tropes," he writes, "are not something that can be added or abstracted from language at will—they are its truest nature."[12] He argues that there is "no real knowing apart from metaphor",[13] by which he means that we experience reality through metaphors, and our notion of literal meaning simply reflects the ossification of language as figures of speech lose their vitality. He emphasizes in *The Genealogy of Morals* how metaphor tends to extend its sway, to bring wider ranges of experience under its wing. He goes so far as to say that "the drive toward the formation of metaphor is the fundamental human drive." For him, literal and figurative meaning are not stable categories, but historical ones determined by their social context.

The Nietzchean big picture of metaphor's role in language and culture lends support to the view of justification as part of a metaphorical scheme. In *White Mythology*, for instance, Derrida takes it for granted that the evolution of abstractions is always a case of going from the physical and sensible to the abstract. He is critical, like Nietzsche, of the automatic distinction of the sensory and non-sensory in Western thought, believing that it shows a lack of self-consciousness in thinkers about the roots of their language. He sneers at the search for definition: "The recourse to a metaphor in order to give the idea of metaphor: this is what prohibits a definition . . . ".[14] Further, he realizes that a key question in

looking at a supposed "abstraction" is whether the memory of its sensory origin remains in its usage.

So far, the thesis proposed for 'justification' fits with what seems a typical biography for abstractions. A word (in its various forms), originally referring to actual sensuous, concrete matters—in the case of justification, say, forms of behavior in regard to debts, or in regard to resolution of disputes in a system of ordered authority—is extended to a new realm of argument. The physical sense of judicial wheels turning, of victorious litigants feeling safe in their claims and disappointed ones withdrawing their own, allows one to grasp, in some way, the effects of a justified argument.

Further, the Nietzschean claim that one can know *only* metaphorically seems accurate in regard to justification. We do not have, on the tips of our tongues, a 'literal' alternative meaning of what 'justifying' an argument means. To some, it is presenting reasons. To others, presenting compelling reasons. To still others, presenting a foundationalist argument whose premises, inferences and conclusions can't be denied. But leaving aside the rampant metaphors here (no 'compelling' reason ever physically forced a seminar participant to give in when he didn't want to), we're left with *candidates* for a literal meaning—not an elected official. So the person who would argue that justification is not a metaphor in regard to an argument has a problem—no first-order literal meaning to fall back on.

In recent years, contemporary philosophers have picked up on Nietzsche's big picture view of metaphor. Paul Ricoeur argues in *The Rule of Metaphor* that looking at metaphor simply on the word or sentence level, however useful, does not provide a full picture of how metaphor structures our conceptual systems. George Lakoff and Mark Johnson, in their groundbreaking book, *Metaphors We Live By*, explicate a related position in great detail.

Lakoff and Johnson assert that "our ordinary conceptual system is fundamentally metaphorical in nature."[15] They note that "metaphor is principally a way of conceiving one thing in terms of another, and its primary function is understanding."[16] Rejecting the view that metaphor is just a matter of language, they argue that, "on the contrary, human *thought processes* are largely metaphorical."[17]

They make their claim in part by analyzing clusters of sentences that indicate typical "metaphors we live by". One germane to the position taken in this essay is that "ARGUMENT IS WAR". The authors observe, "What may at first appear to be random, isolated metaphorical expressions turn out to be not random at all. Rather, they are part of whole metaphorical systems that together serve the complex purpose of characterizing the concept of an argument in all its aspects."[18] Lakoff and Johnson

give the following examples as part of the "ARGUMENT IS WAR" cluster:

> Your claims are *indefensible.*
> He *attacked every weak point* in my argument.
> His criticisms were *right on target.*
> I *demolished* his argument.
> I've never *won* an argument with him.
> He *shot down* all my arguments.[19]

Convincing or not in its particulars, the Johnson/Lakoff approach highlights how a metaphorical language game can clue one to the actual meaning of concepts. Put in their terms, the slogan for prelegalism might be, JUSTIFICATION IS A LEGAL PROCESS WITH A VERDICT. Yet in ARGUMENT IS WAR, we also see one of the most troubling aspects of metaphorical characterization at work—the way some resemblances make the trip from the original metaphorical setting and others do not. In ARGUMENT IS WAR, the sense of winning and losing, or using strategy, makes the trip. The use of physical force and prisoners of war does not. Similarly, in the metaphorical extension of justification to philosophical argument, we watch such legal characteristics as presenting reasons and arguments, and considering evidence, making the trip, but not constituted authority, rules of evidence or working presumptions.

Johnson and Lakoff recognize that in all areas of life, we find attempts to express anything that is abstract, or a matter of process or behavior, through concrete metaphors. It is typical in a conceptual system, they write, that "events and actions are conceptualized metaphorically as objects, activities as substances, states as containers."[20] Elsewhere, they observe that "we typically conceptualize the nonphysical *in terms of* the physical."

What the examination of metaphor suggests in regard to whether justification is an illicit metaphor when applied to argument, is the appropriateness of placing the burden of proof on whoever would maintain for it a literal sense. If, as we have seen, a) figurative uses come first, b) justification is inevitably figurative, and c) metaphor structures our whole way of thinking, then it plainly behooves philosophers to explain the metaphor of justification. Yet philosophers have shunned this task.

To understand why requires some study of the 'small picture' examination of metaphor in the philosophical tradition—the effort to analytically define it. Johnson has succinctly described the dominant view of metaphor in the Western philosophical tradition: "an elliptical simile useful for stylistic, rhetorical and didactic purposes, but which can be translated onto a literal paraphrase without any loss of cognitive content."[21] The origins and consequences of that view can be summarized.

Although Plato exulted in the use of metaphor, his hostility to poets betokened a fear of how metaphor could mislead. It was Aristotle, however, who first conceptualized metaphor by defining it. In doing so, he bequeathed it a legacy.

First, Aristotle placed metaphoric action at the level of words, a decision that is coming to be questioned only in this century. Second, he began the tradition of seeing metaphor as a deviation from literal usage, and established the great divide between the figurative and the literal. Third, Aristotle suggested that metaphors are more or less like similes, and always involve some set of ulterior resemblances.

Aristotle gave metaphor and rhetoric an important place in persuasive argument. Metaphors could be good or bad, provide insight or create obscurity, and Aristotle discussed some criteria for assessing their value. But he did plant a seed of fear in philosophers that presaged metaphor's overt decline amongst them. Even though he appreciated apt metaphors for the "charm and distinction" they might bring to prose, he warned against using them in definitions because "a metaphorical definition is always obscure."[22]

Over the long period extending from Aristotle to modern Western philosophy, Aristotle's suggestion of metaphor as but a kind of simile took strong hold. Both metaphor and rhetoric were demoted to categories of ornamentation and style, and a firm distinction between literal and figurative language arose.

By Hobbes's time, the philosopher could say that "metaphors, and senseless ambiguous words, are like ignes fatui; and reasoning upon them is wandering amongst innumerable absurdities." On this view, truth and our conceptual system are literal, and a metaphor always calls for a literal paraphrase. Thus Locke warned that "all the artificial and figurative application of words eloquence hath invented, are for nothing else but to insinuate wrong ideas, move the passions, and thereby mislead the judgment; and so indeed are perfect cheat. . . ." And Berkeley advised that "a philosopher should abstain from metaphor."[23]

Roughly the same view persisted through the heyday of logical positivism in this century. Only as logical positivism started to pick itself apart did a more respectful view of metaphor resurface. A key document in the revival was an essay by analytic philosopher Max Black, 'Metaphor' (1955). In it, he set forth three traditional views of metaphor that still largely order the debate.

The 'substitution' theory argues that a metaphor of the form 'A is B' ('Bob is a gorilla') presents some intended literal meaning of the form 'A is C' ('Bob is fierce').

The 'comparison' theory, probably the most widely held, interprets the

'A is B' metaphor as an elliptical simile that really asserts 'A *is like* B' in the following respects. Here, the reader or listener must ferret out the relevant respects. 'Bob is a gorilla' may call attention to Bob's fierceness, strength, speech habits, tree-swinging abilities or all these characteristics.

Last and probably least, the 'interaction' theory suggests that the 'system of associated commonplaces' of A and B somehow merge to *create* a distinct metaphorical meaning that no literal paraphrase can express.

Black's setting out of these views did not suddenly turn philosophers into tropemongers. With the views on the table, though, it is possible to understand some of the reasons why philosophers have overtly snubbed metaphor while tolerating it in words like 'justification'.

First, metaphors seem to flaunt philosophical etiquette by inviting the reader to take his eye off the ball—the arguments and the evidence. When the latter flop in an effort to prove, say, that some government procedure is too complicated to maintain, what flimsier (yet more effective) way to persuade the uninformed than by calling it "a kind of Rube Goldberg thing", as Ronald Reagan once dubbed the federal budget process. When we want to reassure people worried about food, clothing, and housing, what handier item to pull out than "a safety net"? Philosophers may accept the comparison or substitution view and yet conclude that—in these cases—the pairings of metaphor and literal meaning have not been done with sufficient rigor to make the metaphors reliable carriers. So when it comes to metaphors, philosophers have usually preferred similes, which announce shared characteristics with 'like' or 'as'.

They favor similes because similes are, according to a widely-held view, trivially true. Similes, that is, make only the weak claim that 'A is somehow like B'. But everything can be said to be like everything else in *some* regard. Therefore, similes return disputes to the arena of argument—we haggle over the particular regards. On the other hand, most metaphors can be seen as false if taken literally—or, better, lexicographically. It may be true that 'Bob is like a gorilla,' but he isn't a gorilla—not unless he's a gorilla named Bob. That causes a problem for philosophers fond of metaphor: How can literally false statements help us on the way to truth? It also causes a problem for the comparison theory above—if metaphors are really paraphrasable as similes, how can they be true in one form and false in the other?

The above should make clear that current metaphor theory is far from settled. A knockdown account of the justification-metaphor problem would require a definition of metaphor and theory of meaning that satisfied all objections. Both tasks, of course, have frustrated philosophers for centuries. On the view suggested here, however, solving such matters could only occur through decisions in an ordered, authoritative judicial

structure. Philosophical problems require judicial solutions, not just the sound of them.

Here, in completing our consideration of metaphor and its link to justification, it's important to point out a major source of philosophical hostility to metaphor—intolerance of ambiguity. It may be easy to understand, for instance, Indira Gandhi's complaint that "You can't shake hands with a closed fist", but what did journalist Richard Reeves mean when he called politics "sex in a hula hoop"? If, philosophers complain, we can't figure metaphors out (an interesting idiom, that), we can't test their truth. For the scientific philosopher who seeks a world as neatly ordered as a supermarket shelf, with each item bearing its individual price in truth conditions, criteria, verifiability tests or what have you, metaphor simply keeps philosophy and science from going truth-shopping. With such a troublemaker lurking in the aisles, only literal language can trundle the facts home.

One virtue of a judicial solution to these problems would be greater clarity in use of metaphors, so that one could have them on the shelves without sacrificing lucidity. To do that, however, we must clarify the big fish, the 'constitutive metaphors' so central to the intellectual enterprise that they can neither be given up nor acknowledged too directly. Computer metaphors, we know, have been indispensable in the theoretical vocabulary of modern cognitive psychology. But we've seen little such acknowledgment of similarly powerful metaphors in philosophy.

Justification is such a constitutive metaphor—one even more influential, I think, than foundationalism. True, we talk in philosophy of 'foundationalist' theories with not much concern for the rather severe difference between buildings and strung-together claims. But the foundationalist metaphor seems almost harmless—most philosophers recognize that what is important is the relation of the strung-together set of linguistic claims as premises and conclusions, and we have an independent standard of success or failure for a syllogism regardless of whether any sounds of building collapse are heard.

The situation is different with justification. Although we sometimes use 'justify' as though it meant only the presentation of reasons in order to convince, we recognize a difference between *trying to justify* a position and justifying it. That's because of the so-called 'further question' challenge—given that X has presented all the reasons he thinks necessary to justify Y, it still makes sense to ask, 'But has he justified Y?'

Understanding this helps one to reply, apropos justification, to Derrida's concern about whether a word carries in it the memory of its original figurative sense. 'Justification' still implies a decision, or state of mind, on the part of the audience to whom the justification is presented.

It still implies an interpersonal judgment. That's why, when one of us wants to make the point that we have acted on a decidedly personal view of justification, it is more natural to say, 'I thought it was justified' rather than simply 'It was justified'. We can imagine a geometric proof, left in an archive, with no one around, and still consider it a proof. We can't understand a justification nestled away there, posited by no one and understood by no one, and consider it a justification. Some audience response is implied.

That is what makes the failure of our philosophers to address 'justification' *writ large* so significant. It is not a matter of choosing among candidates for an analytical definition of metaphor. For we've been denied on all fronts. We haven't been told what the forensic sense of justification is on the substitution view (e.g., '*X* is justified' means '*X* is supported by reasons mostly unchallenged by the Harvard philosophy department'), or the comparison view (e.g., '*X* is justified in that it has gone through the following justification procedure—opposing parties have presented evidence, testimony has been taken, and both sides have recognized the authority of the judge'), or on the interaction view (e.g., '*X* is justified in that evidence was presented, but only for one side of the proposition').

The result is an impasse. In the section that follows, I conclude by suggesting why philosophical argument has come to it. The escape route, I think, is an ancient road bypassed by philosophy for too long—a discipline called rhetoric, resurfaced under the knowing eye of the law.

III. JUSTIFICATION AND RHETORIC

Let's suppose, then, that no clear, widely-accepted first-order literal meaning of justification exists to tell us exactly what argument must be made, in what manner, to which people, with what behavioral result, for a philosophical position to be considered justified. At best, on this view, 'justify' has a loose second-order sense of 'to persuade through the presentation of reasons'.

So we must assume that, depending on which of the basic theories of metaphor one adopts—substitution, comparison, or interaction—use of the justification metaphor implies a) some single resemblance between a judgment's justification in a legal system and in the critical argument at hand, b) several resemblances, or c) an entirely new way of looking at a judgment that somehow evokes the qualities of a legal system.

Consider then some typical features of a legal system—recognized authority, ability to back up judgments by force, ability to end further claims on an issue by issuing judgment, provision of a forum in which operating

claimants can present their best arguments. Do you know any philosophical arguments that possess these attributes?

If not, it seems only one way exists to salvage the language of justification in philosophy—to let metaphor be metaphor and have philosophy incorporate some features of a legal system. The notion is less preposterous than it appears if one accepts a story about Western philosophy best told by the late Belgian philosopher Chaim Perelman.[24]

Perelman started out as a logical empiricist.[25] In his first book, *The Idea of Justice and the Problem of Argument* (1963), he didn't give rhetoric a tumble and sought impersonal truth. He distinguished particular theories of substantive justice from the principle of formal justice—the notion that persons in the same category must be treated equally. Unlike Rawls and Nozick, and like David Miller and Michael Walzer, Perelman accepted justice as a 'confused concept' that breaks down inconsistently depending on whether one favors needs, deserts, or entitlements as its foundation. He accepts the Humean principle that one can't deduce an 'ought' from an 'is', and agreed that one can rationally calculate the means to an end, but not choice between ultimate values. All standard period stuff.

But instead of folding his axiological tent, as many analysts did, Perelman sought intellectual escape from a conclusion that clashed with the process of argument exemplified by the law: infinitely orderly, a kind of institutionalized controversy, yet not reducible to formal logic. Eventually, Perelman decided to take a 'Fregean' turn. Noting that Frege had shed fresh light on logic by examining the actual reasoning of mathematicians, Perelman examined the actual reasoning used by sophisticated humanists—judges, politicians, journalists—when they attempt to make 'a value or a rule prevail'. The result was *The New Rhetoric* (1958), written with L. Olbrechts-Tyteca.[26]

Perelman's research surprised him. Returning to Aristotle, he discovered that rhetoric had suffered a wrong and carried the stigma ever since. Aristotle had distinguished between analytical argument (reasoning about the necessary) and dialectical argument (reasoning about the probable). The influential Renaissance logician Petrus Ramus merged the two kinds of reasoning in his *Dialectics*, assigning to rhetoric the study of the art of speaking well and various tropes and mannerisms of oratorical delivery. By that move, Perelman believed, Ramus triggered the whole misguided divorce of rhetoric and philosophy.

Perelman argues that Aristotle recognized rhetoric as a practical discipline aimed at persuading an audience to action and discussed it in relation to both dialectic and analytical reasoning. Dialectic, Aristotle held, provides techniques by which to argue one's way to truth. The premises

consist of generally accepted opinion (as contrasted to the premises of analytical or demonstrative reasoning, which are true or ultimate). Rhetoric instructs in how to manage a debate of various views where the decision is left to the audience. Perelman admits that Aristotle showed some condescension and probably contributed to Ramus's confusion, but he maintains that Aristotle ultimately accepted rhetoric as a branch of dialectic distinguishable only by the questions it examines and the audience to which it's addressed. He didn't rule rhetoric out of rationality's ballpark.

Ramus, in effect, did. As a result, philosophical tradition lost a bulwark against the 'quest for certainty' and demonstrative realism that swept into philosophy with Descartes's emphasis on deductive reasoning, geometry, and mathematical models. Since then, waves of pragmatism and Wittgensteinianism haven't wiped out the Cartesian notions that make the joining of philosophy and law seem so counterintuitive. As Descartes wrote, "Whenever two men come to opposite decisions about the same matter, one of them at least must certainly be in the wrong."

Perelman sees things differently. In the Treatise's "new rhetoric," Perelman treats rhetoric as complementary to formal logic, just as argumentation complements demonstrative proof. He posits that all argument involves the adherence of specific minds to specific theses, and that argument always seeks to change an existing state of affairs by winning adherence or greater adherence to one's beliefs. Because Perelman looks to a juridicial model of truth rather than a mathematical one, he does not assume, like Descartes, that only one side can be right (or justified) in a dispute. He cites, for instance, the Talmudic notion that divergent biblical interpretations can be equally reasonable.

In a crucial philosophical move—one only possible because of his investigation of Western philosophy's history—Perelman rejects the conventional wisdom that the reasonable is intellectually inferior to the rational. On the contrary, he believes that the modern notion of rationality devolves from the reasonable, and only bad intellectual history has left things cockeyed. What characterizes philosophical justification for Perelman, as opposed to street-corner casuistry, is the sort of audience whose adherence one seeks. In philosophy, one appeals to a 'universal audience', roughly the broadest class of open-minded, astute people capable of following extended argument. The quality of the argument, in Perelman's radical view, comes from the quality of the audience that adheres to it. Thus, much as Hume took the man of good taste to be the proper standard of taste, Perelman takes the strong adhesion of a wise and acute audience as the proper standard of truth. Rational argument and its criteria of

success, therefore, cannot be described in the abstract. It always involves reference to a real, up-to-the-minute audience.

Perelman's Fregean move, I think, is a healthy one for philosophy, a turn that might lead modern philosophers away from their real crisis—irrelevance in the eyes of other intellectuals. Although Perelman himself does not add a tropish turn, his reading of Western philosophy suggests why jurisprudential metaphors have achieved the prominence they now enjoy in the philosopher's vocabulary. Modern analytic philosophers, in particular, find themselves under incompatible pressures. On the one hand, there is Cartesian pressure to slouch toward objectively right answers—toward truth. On the other, there are the notorious problems that continue in devising any objection-proof theory of truth or meaning—a situation that has led philosophers such as Rorty to view analytic philosophy as a project that self-destructed. Jurisprudential metaphors in this situation serve as wonderful euphemisms. Even though they lack the smell of the courtroom, the give and take of everyday argument and its sensitivity to authority and expedience, enough *resemblance* comes through to hint—every time a philosopher says that 'We are now justified in holding P'—that some court in the intellectual world has issued an opinion and passed judgment.

Why not, then, a World Court of Philosophy? Recall some of our objections to the present state of jurisprudential metaphors in philosophy. We saw in the section on metaphor that the 'abstract' sense of justification comes after the concrete sense, and must—in the absence of a lexicographically-fixed literal sense—trade on it for its meaning. When we return to the earlier sense of justification as the functioning of a legal system, a language user has no trouble in making clear what the term means—he can almost do it ostensively (stand pointing to a courtroom in action from day to day). But the user of justification in regard to argument has no ostensive way out. At best, he might appeal to a social practice that resembled the courtroom justification—perhaps philosophers nodding at the claims of a speaker at a symposium, then going home and ripping up all articles opposing his views and never making those claims again. But this does not happen.

Further, a World Court of Philosophy, with rules of evidence and procedure, could give force and content to the notion of justification in argument. It would give a concrete answer to 'Whose adherence under what circumstances counts as a justification?' Perelman's argument for a delimitation of the audience that must be persuaded for philosophical justification to take place is exactly the legal model. Courts would not work if we didn't know who had to be persuaded—the judge, jury, or whomever. But somehow we expect philosophy to work without it. A World Court of Phi-

losophy might restore respect for philosophers, just as the World Chess Championship stirs respect for grandmasters.

In the end, it is hard to free ourselves of the picture that demands philosophical truth and justification to be something beyond every human structure or social institution. After all, can't one pose the 'further question' objection to prelegalism? To wit, even if you could clarify justification, make plain its metaphorical origins, set up a World Court of Philosophy and start issuing rulings on induction, justice, and so forth, wouldn't it still make sense to ask, 'But what justifies that whole set-up?'

Two answers emerge to this objection—one purely linguistic, the other both social and linguistic. The purely linguistic answer is that the potential regress of justification cannot appropriately take place once philosophy assumes a juridicial model. A justification that became *actual* justification—that returned to its home in a legal process—would need no further justification. It would *be* justification, by dint of both etymological pedigree and stipulative decision. Dissenters would bear the burden of coming up with a new name for exactly what they sought in regard to a theory.

The social and linguistic answer, in part, is that the will to ask further questions gradually flags when a culture begins to suspect that doing so is fruitless. At one time, when Platonism ran strong, any particular judgment on an abstraction like Beauty might have been followed by, 'But what is the form of Beauty? What is Beauty itself?'

After a century of debunking CAPITALIZED ABSTRACT IDEAS, however, it is a simple fact about Western secular culture that we do not ask these questions with the frequency we did. Philosophical theories do affect the meanings and uses of words, and philosophical relativism and nominalism have especially done so in the twentieth century. Nowadays, when the art critic opines, '*X* is beautiful', we retort at best, 'But what do *you* mean by Beauty?'

In short, the meanings of words can change in the light of understanding certain facts about society, and, as they do, the practices formed around those words can change too. Understanding the use of jurisprudential metaphors in philosophy and other critical fields could lead to changes in the way philosophy is done. Perhaps, with a juridicial model in philosophy, we would begin to talk of positions being 'licensed' rather than 'justified'. The result, I submit, would be a gain of meaning, not a loss.

Various philosophers facing the post-analytic age have suggested new models of how philosophy might function, most notably Richard Rorty with his salon of conversation. I—sketchily—am suggesting the courtroom.

NOTES

1. Titles deceive in this regard. For instance, the recent volume, *Justification: Nomos XXVIII* (New York University Press, 1986), edited by J. Roland Pennock and John W. Chapman, suggests a direct look, but immediately leaps into sections on justification in ethics, law and politics. It contains not a single attempt at 'meta' justification theory.

2. Book-length theories of metaphor continue to appear apace, making any article-length account of them necessarily cursory. While a growing consensus holds that metaphor is too complex to be analyzed wholly on the level of words (as opposed to sentences or conceptions or world views), approaches remain diverse in both nomenclature and premises. Among the most thorough new investigations are Samuel R. Levin, *Metaphoric Worlds* (Yale University Press, 1988), Robert J. Fogelin, *Figuratively Speaking* (Yale University Press, 1988), Ellen Winner, *The Point of Words* (Harvard University Press, 1988), Eva Feder Kittay, *Metaphor* (Oxford University Press, 1987), Janet Martin Soskice, *Metaphor and Religious Language* (Oxford University Press, 1985), Liselotte Gumpel, *Metaphor Reexamined* (Indiana University Press, 1985) and Earl MacCormac, *A Cognitive Theory of Metaphor* (MIT Press, 1985).

3. P. 11, Paul de Man, *The Epistemology of Metaphor*, in *On Metaphor*, edited by Sheldon Sacks (University of Chicago Press, 1981).

4. Chapter 3, *Essay on the Origin of Languages*, quoted on p. 15, Mark Johnson, "Introduction: Metaphor in the Philosophical Tradition," in *Philosophical Perspectives on Metaphor*, edited by Mark Johnson (University of Minnesota Press, 1981).

5. P. 130, Johnson, *Philosophical Perspectives on Metaphor* (a selection from Goodman's *Languages of Art*).

6. P. 210, Jacques Derrida, *Margins of Philosophy* (University of Chicago Press, 1982).

7. P. 254, *Margins of Philosophy*.

8. *Oxford English Dictionary*, Vol. V, p. 643. The OED is a rich source on the linguistic peregrinations of the word and its roots. We have had in English justifiable, justificial, justificator (one who justifies) and other variants. The OED's very first definition of 'justify' is "to administer justice to; to try as a judge, to judge; to have jurisdiction over, rule, control, keep in order, to do justice to . . ." To show how close the sense I discuss has been, one can consider the OED's definition 6:

6) To show or maintain the justice or reasonableness of (an action, claim, etc.); to adduce adequate ground for; to defend as right or proper . . .

b) To make right, proper or reasonable; to furnish adequate grounds for . . .

c) To render lawful or legitimate . . . **1725** POPE, *Odyss* . . . "Till public nuptials justify the bride."

Then there is Berkeley, very much attending to the legal sense of the process: "He justified the notion to be innocent."

9. P. 137, Eric Havelock, *The Greek Concept of Justice* (Harvard University Press, 1978).

10. P. 252–253, *Margins of Philosophy*.

11. P. 18, Paul Ricoeur, *The Rule of Metaphor* (University of Toronto Press, 1977).

12. P. 71, Paul Cantor, 'Friedrich Nietzsche: the Use and Abuse of Metaphor', in *Metaphor: Problems and Perspectives*, edited by David S. Miall (Humanities Press, 1982).

13. Ibid, p. 72.

14. P. 253, Derrida.

15. P. 3, George Lakoff and Mark Johnson, *Metaphors We Live By* (University of Chicago Press, 1980). Both men have continued to elaborate upon their work, Lakoff in *Women, Fire and Dangerous Things: What Categories Reveal About the Mind* (University of Chicago Press, 1987) and *More Than Cool Reason: A Field Guide to Poetic Metaphor* (co-authored with Mark Turner, University of Chicago Press, 1989), and Johnson in *The Body in the Mind: The Bodily Basis of Meaning, Imagination, and Reason* (University of Chicago Press, 1987).

16. P. 36, Lakoff and Johnson.

17. P. 6, Lakoff and Johnson.

18. P. 105, Lakoff and Johnson.

19. P. 59, Lakoff and Johnson.

20. P. 30, Lakoff and Johnson.

21. P. 4, Johnson.

22. P. 6, Johnson (from *Topics*, 139B).

23. P. 13, Johnson.

24. Although Perelman died in 1983, others besides his disciples have continued the call for a revival of rhetoric. A major recent contribution to the history of relations between rhetoric and philosophy is Brian Vickers, *In Defence of Rhetoric* (Oxford University Press, 1988), which provides richer pedagogic detail than Perelman's account.

25. See Chaim Perelman, *The Realm of Rhetoric* (University of Notre Dame Press, 1982), which distills some of the key claims and intellectual journeys described in *The New Rhetoric* (University of Notre Dame Press, 1969).

26. The thumbnail account of Perelman's general theory is based on the two books above, and Chaim Perelman, *The New Rhetoric and the Humanities* (D. Reidel, 1979), Chaim Perelman, *Justice, Law and Argument* (D. Reidel, 1980), and Chaim Perelman, *Justice* (Random House, 1967). The most comprehensive secondary work on Perelman in English is *Practical Reason in Human Affairs: Studies in Honor of Chaim Perelman*, edited by James L. Golden and Joseph J. Pilotta (D. Reidel, 1986).

9

Marcelo Dascal

REFLECTIONS ON
THE 'CRISIS OF MODERNITY'

> ...*la négation universelle équivaut à*
> *l'absence de négation. Nier est un acte:*
> *tout acte doit s'insérer dans le temps et*
> *s'éxercer sur un contenu particulier.*
> —Jean-Paul Sartre[1]

I. INTRODUCTION

One of the recurrent themes of the current self-questioning of philosophy is its challenging the legacy of what is customarily called 'modern philosophy'—the tradition of philosophizing whose founding heroes are Descartes and his contemporaries. An ever-increasing number of voices join the choir of those who, like Richard Rorty, denounce the illusions and mistakes upon which that tradition was built. They tend to demand not the correction of such mistakes, but rather the abandonment *tout court* of that tradition as a whole: its questions, methods, goals, concerns and vocabulary. Unlike Whitehead—who described the seventeenth century as a model of intellectual achievement and as an inexhaustible source of inspiration and fruitful ideas—the current critics of modernity consider that, at best, 'modernity' has exhausted its resources and must be declared irreversibly dead. To attempt to remain faithful to any of its components would—in their view—amount to trying to pursue a 'research programme' that has become, in Lakatos's terminology, 'degenerative'. Accordingly, they recommend a radical shift to a totally new state of affairs, to a 'postmodern'—sometimes also called 'post-philosophical'—condition.

The criticism of 'modernity' is neither exclusive to philosophy nor an absolute novelty in philosophy itself. Our century has seen 'modernist' and 'postmodernist' rebellions in the arts, many of which were inspired by the work of 'anti-modern' philosophers like Nietzsche. But at least part of the current anti-modern attitude strikes one by its uncompromising radicality—and in that fact may reside its novelty. My purpose in this essay is to highlight some central characteristics of this particular brand

of criticism. I will confine myself, as far as possible, to those philosophers (should one say ex- or post-philosophers?)—e.g. Derrida, Foucault, Lyotard, Rorty—who consider the new condition not as involving a transformation (even a radical one) of philosophy as it has been practised up to now, but simply as its end. Were it not for the fact that the phrase 'diagnosis of our time' (so fashionable a few decades ago) has itself become an object of suspicion due to the work of the 'post-philosophers', I would have dared to suggest that some of the main characteristics of this kind of radical criticism are symptoms of a broader syndrome of our times...

II. THE SEARCH OF PARADOX

For philosophical reflection, paradox has always been a sign of danger, an obstacle to overcome. Recall the centuries of attempts to solve Zeno's paradoxes, the medieval efforts to overcome the liar's paradox, Frege's despair when faced with Russell's semantic paradoxes. Post-philosophy, however, seems to be rather unimpressed by paradoxes of any kind. In a sense, it seems even eager to produce paradox, in order to achieve its desired shock effect.[2]

A first paradoxical effect is what might be called the 'remodernization' of modernity through its 'postmodern' critique. The very effort to uproot 'modernity' has the paradoxical consequence that, instead of simply decaying naturally and disappearing under the dust of the archives, modernity suddenly is brought back to our attention. It is thus rendered again pertinent to current discussion, and its detailed scrutiny may well lead to the rediscovery and rehabilitation of at least part of its legacy. This paradox is similar to the so-called pragmatic paradoxes characteristic of injunctions of the type: "I *must* do my best to forget *X*!". Such injunctions are not only impossible to comply with. They also yield a result that is at odds with their explicitly expressed goal: by trying very hard to forget, one ends up by remembering. For that reason, one may suspect that in fact the desire they actually express is the opposite one: remembering, not forgetting. Similarly, one might think that, instead of really wishing to get rid of modernity, the postmodern movement wants, in fact, to inherit and pursue, in some way, 'modernity'. In a sense to be clarified later on (sections 7 and 8), post-philosophers might be charged with seeking to implement the policy—condemned by the Old Testament—of murdering *and* inheriting.

This is not the only paradoxical aspect of the recent radical criticism of modernity. Such a criticism denounces, among other things, the traditional notion of objective truth as correspondence, *adaequatio intellectus*

ad rem, which it takes to be one of the basic assumptions of modernity. Yet, once such a concept is *totally* abandoned, how can anybody determine whether the image of modernity so harshly criticized by the postmoderns is more than just a fruit of their fertile imagination? In fact, this very question becomes senseless, within their framework. To be sure, some postmoderns propose pragmatist or other surrogate theories of 'truth' and 'objectivity'. Still, the common denominator of such theories is the rejection of the idea that the correctness of any hypothesis can be assessed by an appeal to the 'facts of the matter' to which the hypothesis refers. But, if there are no historical or other 'facts of the matter' capable of supporting this or that image, if all interpretations of the texts are equally plausible, clearly it does not make any sense to talk about a more accurate historiography, which would be able to establish the correctness of the description of the object of the critique, and thus contribute to assessing the critique itself. In fact, the very idea of a 'correct' or 'better' historiography is anathema for the postmoderns, for it is one of the illusions of modernity itself. Consequently, an appeal to this notion cannot be of any use either to support or to refute the critics of modernity. Clearly, it is not in historiography that they are interested, but in promoting a certain *interpretation of* the history of philosophy, whose accuracy is largely irrelevant for their purposes.

This irrefutability in principle—which would be a matter of concern for others—does not disturb the postmoderns in the least, since they do not purport to offer a 'scientific' analysis of the historical phenomenon. At most, they are engaged in a hermeneutical exercise. They aren't disturbed either by the possibility that, once the notions of truth and verisimilitude are suppressed, the modernity of which they are trying to escape may be just a product of their fantasy, a straw man created for their own deconstructive purposes. For the value of such a construct (of any construct, as a matter of fact) is—on the postmodern/pragmatist view—a function not of its serving as a true description of something, but only of its being able to serve 'our purposes'. And 'our purposes', in turn, are not—and cannot be—those grandiose, typically 'modern' goals such as 'contributing to the progress in the discovery of truth', 'understanding historical processes', and so on. They are rather, more modestly, "edifying" contributions to the "ongoing conversation of mankind" (Rorty), effective local blows within an unending power struggle (Foucault), partial, unpretentious narratives (Lyotard). And what can be more edifying than a narrative where an imaginary enemy, laboriously combatted, is finally defeated? Especially if the enemy is presented as a Goliath—an all-powerful and dominant tradition—and those that fight him are a modest bunch of Davids, metaphysically and epistemologically self-depauperized?

III. Tu Quoque

One of the most powerful strategies of philosophical argument (though sometimes used abusively or trivially) is the so-called *tu quoque*. It combines logical and *ad hominem* features in order to show the absurdity of a philosophical position. We may discern two main variants of this strategy: (a) 'You are doing precisely what you say it is impossible to do', and (b) 'You are not doing what you say should be done'.

In any of these versions, the *tu quoque* is efficient against those who are sensitive to paradox and contradiction, and thus feel compelled to take precautions against its potentially devastating effects. Thus, to the (academic) skeptic who claims that we know nothing, one may point out that he contradicts himself, since he professes to know at least that very generalization. For that reason, his Pyrrhonic successor will take all sorts of precautions in order not to affirm anything—a fact that suggests that he respects at least the principle of contradiction. Similarly, to the critical rationalist who sees in rational criticism the principle that grounds every belief, it can be pointed out that rational criticism is unable to ground itself. Sensitive to this, he may unwillingly admit a single exception to the universal applicability of his principle, granting that its own acceptance is an act of faith.

It is not hard to apply the *tu quoque* to several versions of 'post-philosophy '. To a Lyotard who denies the possibility of any 'grand narrative' which would be able to account for the general characteristics of all discourse, one might object that this very denial *is* a grand narrative accounting for at least one (crucial) characteristic of present-day discourse. To a Foucault who analyzes all discourse on sexuality—be it permissive, 'scientific', or repressive—as part and parcel of the mechanisms of power which, through the creation of 'sexuality' as an object of discourse, aim at new forms of domination, one might say that his own *Histoire de la Sexualité* inserts itself in that very discursive game he condemns. Facing a Derrida who systematically practices 'deconstruction', one might employ his own weapons to deconstruct the method of systematic deconstruction. To a Rorty that glorifies holism and the elimination of barriers between all domains of culture, one might remind the parochialism and ethnocentrism implicit in his discussion of social, political, philosophical, and cultural issues from a point of view that is strictly (and avowedly) Western and Northern-Hemispheric.

The fact, however, is that these 'post-philosophers' are likely to be indifferent to this strategy of argumentation. This is not merely a psychological fact. Their positions contain defense mechanisms which make them resilient to the *tu quoque* and similar objections (e.g. *petitio principii*). My

narrative may look grand, but it is partial and limited—would probably be Lyotard's reply. It does not claim to have any superiority, to stem from a dominant or global viewpoint, over and above all other narratives. It is a language game just like the others, not a 'meta-game' containing the rules of all language games—which is precisely the kind of grand meta-narrative whose existence and possibility are denied. My discourse—Foucault might say—indeed belongs to the power game; it expresses my own way of exerting the power of discourse, as against the other ways; the fact that it is *mine* does not confer upon it any superiority, objectivity, or precedence over the others: "I don't try to universalize what I say" (Foucault 1986:101); my archeological investigations, which disclose the presuppositions of certain forms of discourse, do not acquire a 'grounding' role just because they dig 'deeper'; they are only other forms of *fighting* against power structures, not of *judging* them.

There is no point, therefore, in escaping or rejecting the *tu quoque*. Were the critic's discourse to try to escape the *tu quoque*, it would thereby falsify itself. By not attempting to escape, but rather by admitting and even seeking it, the critic's discourse, paradoxically, confirms itself. Rather, it illustrates or shows the illusoriness of both the notions of 'confirmation' and 'disconfirmation'. By doing—or welcoming those who do—with my own discourse what I claim should be done with all discourse, I do not 'confirm' my principle. I merely show how to place it alongside all other 'principles', without privileging it as an 'exception'.

IV. Discursive Egalitarianism

The strategy that allows for such a *tour de force* is what I would call a 'flattening' of (philosophical) discourse. It is a move toward a discursive egalitarianism of sorts, whose manifestations are multiple. In Wittgensteinian terms, it consists in the thesis that all language games co-exist at the same level, side by side, without there being any possibility of providing a general theory of language games or of granting a more basic status to one of them vis-à-vis the others. In particular, the game known as 'epistemology', which was thought to provide criteria for the grounding of knowledge claims, is—in case we insist on continuing to play it—to be 'naturalized' (following Quine's suggestion, previously made by Piaget, Ortega y Gasset, and presumably even Hume); thereby epistemology becomes co-lateral with all scientific discourse and loses the grounding function that modernity traditionally assigned to it—a fact that, according to Rorty, simply means that epistemology ceases to exist as such.[3] Philosophy, as conceived by modernity, i.e. either as epistemology or as 'general

metaphysics' (the science of being in general—as it is still defined in the general classification of the sciences proposed by D'Alembert in his *Discours Preliminaire* for the *Encyclopédie*), becomes at best a language game like any other, without the self-assigned right to be the supervisor, coordinator, or arbiter of the legitimacy of all other forms of discourse.[4]

Within each language game, a similar flattening occurs. First, the classical distinctions which establish hierarchies within a form of discourse are suppressed: analytic versus synthetic; literal versus figurative; observational versus theoretical vocabulary; and so on. In this way, the possibility of discovering a universal basic core of beliefs or concepts (to be described as 'logical', 'analytic', 'synthetic a priori', 'protocol sentences', etc.), shared by all practitioners of the same language game and, eventually, by all language games, is ruled out. Thus, the intra- and inter-discursive flattenings support each other: should there exist a privileged core of beliefs or concepts, they (and the way they serve to 'ground' the rest of our knowledge) might be viewed as the proper domain of investigation for epistemology.

Second, the distinction between object-language and meta-language is itself restricted, if not totally eliminated. Neither of these levels of language can be considered independent of the other. There is both a top-down and a bottom-up essential interaction between them, the result being an inextricable interpenetration which renders their separation practically impossible. Thus, a theory (object-level) is formulated and defended with arguments and terms borrowed from the methodological level (meta-level); a victorious paradigm establishes simultaneously a new theory and the types of problems, arguments, research programmes, and solutions to be regarded as legitimate thereafter. The ascension to the meta-level is of no help in solving conflicts which cannot be solved at the object-level, since, as pointed out by Scheffler when commenting upon a remark by Kuhn,

> paradigm differences are inevitably reflected upward, in criterial differences at the second level (For to accept a paradigm is to accept not only theory and methods, but also governing standards or criteria which serve to justify the paradigm as against its rivals).[5]

Third, discourse flattens out in so far as one insists—as do Derrida and some hermeneuticists—on the priority of the "text as such", denying any constitutive role or otherwise privileged position (as far as the text is concerned) to such 'extraneous' factors as the text's alleged 'meaning', its author's communicative intentions, etc. Here too intra- and inter-discursive flattening support each other, e.g. in the form of Derrida's conception of culture (and its history as well) as nothing more than a web of 'inter-tex-

tual' relations, rather than as, say, the relations between the 'ideas', 'intentions', 'emotions', etc. expressed in the culture's textual products.

The common theme of all these forms of flattening is the suppression of barriers, distinctions, demarcations, etc.—in short, an uncompromising espousal of 'holism'. Rorty (1979:302ff.) places Davidson in his pantheon of heroes on account of the latter's alleged definitive establishment of holism in semantics. According to Rorty, Davidson's decisive contribution was the destruction of the scheme/content distinction. That is, the rejection of the idea that it is possible to separate questions about the truth of propositions from questions about their meaning. With the fall of such a distinction, the idea that there are 'alternative conceptual schemes' (possibly employed by speakers of languages very remote from Indo-European, as suggested by Whorf), radically different from 'ours', also falls— for it amounts to assuming that there may exist another language, 'true but not translatable' into our language. Such a language would have the same 'content' (since it is, ex hypothesi, true), but a radically different structuration of meanings or 'conceptual scheme' (see Davidson 1974). Such theses derive from Davidson's attempt to apply Tarski's formal method to the semantics of natural language, an attempt that, as Davidson himself acknowledges, led him to adopt "a certain holistic view of meaning". This is the view that the characterization of the meaning of a linguistic expression refers us back necessarily to the totality of the language, since the meaning of an expression depends upon the meanings of its components and vice versa:

> If sentences depend for their meaning on their structure, and we understand the meaning of each item in the structure only as an abstraction from the totality of sentences in which it features, then we can give the meaning of any sentence (or word) only by giving the meaning of every sentence (and word) in the language. Frege said that only in the context of a sentence does a word have meaning; in the same vein he might have added that only in the context of the language does a sentence (and therefore a word) have meaning (Davidson 1967:22).

Holism, conceptual and semantic, does indeed block the possibility of appealing to an 'external' criterion—be it of meaning or of truth. We have at our disposal only the concept of 'true in L', while the meaning of the expressions of L is, in turn, completely spelled out by means of a recursive definition of 'true in L'. There is no need to throw away the ladder, since there is no place to climb to nor to exit to, not even to throw the ladder into. There are no alternative conceptual schemes because if there were any, we could never come to know that.

This enclosure 'within' the (only) possible scheme or system, produced by the flattening effect of holism, is felt as a prison by anyone who—like Derrida, for one—yearns for a "changement de terrain" through a "trem-

blement radical" (Derrida 1986:150f.). The solutions he proposes seem to be desperate attempts to escape that prison which, having no walls, cannot be escaped. For the alternatives he envisages are either to "get out" of philosophy and/or of the West, "throwing" oneself in the arms of other disciplines and/or of the Third World (would this mean abandoning discourse altogether and engaging in political action?), or else to speak the different languages simultaneously (wouldn't this amount to embracing cacophony, i.e. noncommunicative 'speech'?).

It is necessary to insist, however, that mono-conceptual flattening holism does not imply a denial of the diversity of language games, nor is it incompatible with the incommensurability thesis, at least as it is understood by Rorty. On the latter's interpretation, Davidson is not opposed to Kuhn, i.e. Rorty's post-philosophy, which insists on holistic mono-conceptualism, is not necessarily distinct (in this respect) from Lyotard's, which stresses the plurality and incommensurability of language games and the impossibility of Grand Narratives.[6]

Rorty tries to accommodate incommensurability and holism through his hermeneutic notion of 'conversation'. For him, 'commensurability' is the basic presupposition of traditional epistemology (i.e. of all 'modern' philosophy), and as such it should be uncompromisingly rejected: "By 'commensurable' I mean able to be brought under a set of rules which will tell us how rational agreement can be reached on what would settle the issue on every point where statements seem to conflict (Rorty 1979:316)." To deny commensurability, in this sense, means to deny the existence of a rational and universal decision procedure for conflicts (of ideas). The existence of 'scientific revolutions', in Kuhn's sense, proves that, at least for *some* conflicts (of ideas) there is no rational decision procedure. Only during 'normal' periods are there such procedures. The language game called 'epistemology', therefore, would be playable only during such periods. Since, however, each paradigm possesses its own set of rules, incommensurable with the others, there is no single Epistemology, but several epistemologies. That is to say, classical Epistemology, with its essential universalistic pretentions, simply has its 'production line' discontinued.

According to Rorty, the lack of universal rules for the rational resolution of conflicts does not preclude the possibility that the different, incommensurable discourses, contribute to a joint conversation, provided the latter is conceived hermeneutically, rather than epistemologically:

> Hermeneutics sees the relations between various discourses as those of strands in a possible conversation, a conversation which presupposes no disciplinary matrix which unites the speakers, but where the hope of agreement is never lost so long as the conversation lasts. This hope is not a hope for the discovery of antecedently existing common ground, but *simply* hope for agreement . . . For hermeneutics, to be rational is . . . to be willing to pick up

the jargon of the interlocutor rather than translating it into one's own (Rorty 1979:318).[7]

What is the basis for such a hope? Why desire agreement? To these questions, Rorty does not reply, nor does he have to, on his anti-foundationalist principles. The hope simply expresses his optimistic (perhaps American?) temperament, his trust in the invisible hand which somehow will manage to harmonize the conflicting tendencies. In the absence of any foundation, another, less optimistic temperament such as Nietzsche's might employ—with equal justification (or lack thereof)—the rhetoric of war instead of that of hope for universal harmony. That kind of temperament might argue, in contradistinction to Rorty, that to be rational is to strive by all possible means to amplify the sphere of one's will to power. If we take the Nietzschean option, however, incommensurability will reign, since there can hardly be any hope for agreement amongst irreducibly opposed wills. In Rorty's terminology, such a situation is equivalent to ceasing to be rational. Furthermore, given the flattening of discourse, 'rhetoric' cannot be significantly distinguished from 'content', so that a choice of rhetoric, though 'merely' a matter of temperament, is also at the 'heart' of the matter.

If rationality is nothing more than a hope, and irrationality a lack of such a hope, both equally unjustifiable in terms of more basic principles, neither has anything to do with the classical concept of Reason. It is against this concept that all versions of 'post-philosophy'—optimistic as well as pessimistic, pacific as well as belligerent—ultimately rebel most radically. It is the arrogance of 'modern' Reason that must, by all means, be flattened out.

V. THE ARROGANCE OF REASON

The picture of an arrogant Reason, able to ground everything including itself (Rorty), able to engender a meta-narrative which legitimizes all discourses (Lyotard), able to divest itself from all prejudices and act as an impartial and objective judge (Gadamer)—in short, the image projected onto classical reason by its postmodern critics—is not, after all, totally unjustified. Suffice it to recall a Galilei who describes himself as the discoverer of the code in which the great book of nature is written, a Descartes confident of the power of his understanding's 'natural light' to find the founding certainty capable of overcoming all skeptical doubt, a Leibniz working towards the formulation of the commensurability rules that would constitute an absolute "judge of every controversy", or a Kant (1784:54) summarizing the essence of the Enlightenment with the maxim

"Sapere aude!", in order to remind ourselves of a modernity absolutely confident in the unlimited power of (its) Reason.

Historically, it is such an over-confidence in the power of Reason that justified, for modernity, the complete rupture with the 'Ancients'. In the twelfth century Bernard de Chartres's claim that his contemporaries, though being dwarfs (if compared to the intellectual giants of Antiquity), could see farther than the Ancients by climbing on their shoulders, was certainly a daring and presumably unusual claim. But in 1668, Perrault expresses no more than the then current opinion, when he transforms the Ancients into dwarfs and the Moderns into giants—those that performed "a prodigious progress in the arts and sciences in the last fifty or sixty years":

> I contend that we have today a more perfect knowledge of all arts and all sciences than ever before... it suffices to read the journals of France and England, and to browse through the beautiful works of the academies of these two great kingdoms to convince oneself that since twenty or thirty years there have been more discoveries in the science of natural things than in the whole of the learned antiquity.[8]

Hence, it is not without reason that Ortega y Gasset, much before the current critics, characterized "modern sensibility" as centered around a single virtue—pure intellectual perfection:

> Descartes's physics and philosophy were the first manifestation of a new state of mind, which a century later was to spread to all forms of life and dominate the living-room, the stage, and the public square. By letting the features of this state of mind converge, we can draw the specifically "modern" sensibility. Suspicion and despise for whatever is spontaneous and immediate. Enthusiasm for every rational construction. The Cartesian, "modern" man, is unsympathetic towards the past, because in the past things were not done *more geometrico*... the Cartesian man is sensitive only to one virtue: pure intellectual perfection (Ortega y Gasset 1923:29–30).

It is the exercise of this intellectual perfection that ensures, for the "modern sensibility", the possibility of resolving oppositions and conflicts of all kinds: subject versus object, intellect versus the senses, reason versus faith, theory versus praxis, monism versus dualism, individual versus society, determinism versus freedom, analytic versus synthetic, and so on. The method of rational argumentation always permits one to take a fully justified stand in favor of one of the alternatives, or to devise concepts that will somehow reconcile them, or else—as a last resource—to declare (in equally well-justified terms) that the issue lies 'beyond the boundaries of reason'.

The men and women of 1790, absolutely confident in their Reason, "did not content themselves with legislating for themselves: they not only declared the nullity of the past and of the present, but also suppressed

future history, establishing how 'every' political institution should be"—says Ortega y Gasset. "Today"—he continues—"such an attitude seems to us excessively arrogant . . . We begin to suspect that history, life, neither can nor 'should' be ruled by principles, like mathematical books" (1923:31).

History, Life. These are apparently irreducible principles, which therefore seem to contest the up to then uncontested supremacy of Reason. Yet Reason pulls yet another trick to overcome such an apparently insuperable opposition. Its name is 'dialectical synthesis'. Due to the possibility (and, according to Hegel, the necessity) of synthesis, the opposition between thesis and antithesis is overcome—in the proper sense of the word (*Aufheben*), i.e. in the sense of being moved upwards, into a superior level. But 'superior' in what, if not in rationality? The Great Synthesis, apex of Hegelian synthesizing Reason is no other than the Great Historical Narrative, the History of the Progress of Spirit. In the hands of dialectics, history, far from being irreducible to Reason, is thus tamed. To reject Grand Narratives implies, henceforth, to reject History with capital 'H' as well.

What about Life? Ortega himself, who declares that we cannot any longer accept the dilemma opposing the absolutist rationalism which saves reason by annihilating life to the relativism which saves life by evaporating reason (Ortega y Gasset 1923:31), and characterizes the new sensibility of the now (i.e. in 1923) beginning era by its refusal of that dilemma, ends up by proposing a *synthesis*—the so-called 'ratio-vitalism'—which ultimately rejects the irreducibly distinct nature of his 'vital principle'.

And these are not the only examples, for it is not easy to resist the charms of dialectical Reason. Consider for instance Karl Mannheim—unduly forgotten for several decades. As a critic of traditional epistemology, Mannheim (1936) proposed to replace it by the "sociology of knowledge". This discipline would reveal the inexorable contextual dependency of the forms of thought of each epoch, a fact that renders them incommensurable with those of other periods. Even within each period, there are contradictory tendencies between 'conservation' and 'change'. The former idealize the past and value stability; they engender what Mannheim calls 'ideologies' which distort reality. The latter engender 'utopias', not less distortive, in so far as they supervalue the future and the agents of change. Between these two poles, however, a 'realist' *synthesis* (within the context of the time) is possible, argues Mannheim. It would synthesize the contradictory tendencies, and yield a 'totalizing perspective' able to neutralize the unilateral distortions of each of those tendencies. The social agent capable of this feat is, according to Mannheim, the *intelligentsia*,

viewed by him as relatively uncompromised and neutral (compare this with the intellectual elite typical of the aristocratism of the last works of Ortega y Gasset). Regardless of other doubts concerning Mannheim's optimism, one may ask by what means the *intelligentsia* would be able to perform the task he assigns to it, if not once more through the good services of the old fox, Reason?[9]

Even a rather radical conception of the 'hermeneutic circle' (rather, 'hermeneutic spiral') such as Gadamer's takes up faithfully the Hegelian categories, when it conceives of progress as a continuous series of *syntheses* (ultimately rational) of the initially antithetical perspectives:

> We are continually shaping a common perspective when we speak a common language and so are active participants in the communality of our experience of the world. Experiences of resistance or opposition bear witness to this, for example, in discussion. Discussion bears fruit when a common language is found. Then the participants part from one another as changed beings. The individual perspectives with which they entered upon discussion have been transformed, and so they are transformed themselves. This, then, is a kind of progress—not the progress proper to research in regard to which one cannot fall behind but a progress that always must be renewed in the effort of our living (Gadamer 1981:110-11).

No wonder that what upsets most the post-philosophers is the 'patience' of Reason, i.e. its ability to absorb and exploit in its own benefit even what seems to be the most irreducible form of opposition (cf. Derrida 1986:129, 151).

VI. THE IMPOSSIBILITY OF DIALECTICS

If modernity, then, is characterized by the imperialism of Reason, which is even able to absorb its apparent antithesis by means of synthesis, postmodernity, in its relentless battle against the imperialism of its archenemy, must reject not only some of the dilemmas of modernity, but *all* of them. For such dilemmas not only arise out of oppositions engendered by Reason itself. They are also opportunities for its exercise and consequent upgrading, through an ever-improving mechanism of auto-correcting synthesis. The very notions of opposition and dilemma are based on Reason's overarching principle of noncontradiction, and must therefore be dissolved together with the particular dilemmas and oppositions they engender. Accordingly, Rorty often employs the strategy of attacking not this or that position, but attempting to challenge oppositions and contrasts. For example, he argues that Kuhn's mistake was to allow for a replacement of realism by idealism, whereas what he should have done was to suppress the alternative altogether (Rorty 1979:325). Once generalized as the basic

strategy to combat the legacy of modernity, one can see the deep signifi-
cance—for those who hold it—of holism as well as of the fragmentation
of discourses, of the inconclusive conversation amongst incommen-
surables as well as of the incommensurability of the language games.
Nietzsche's perspectivism—not Ortega's—with its dissolution of all oppo-
sitions into mere gradations of the will to power, is the one that both an-
nounces and articulates the major theme of postmodernity.

For the reasons above, the truly radical critique of modernity cannot
rest content with mere denial. Denial, just as affirmation, presupposes
truth and falsity, admitting therefore a cleavage in the space of infinite
gradations.[10] Where there is either incommensurability or holism, there is
no denial or negation, no antithesis, and therefore no synthesis. Hence, to
deconstruct is not to deny—which is a rational/intellectual activity. To
deconstruct—in the postmodern sense, which goes beyond Heidegger—is
to act, contraposing one power to another, opposing one discourse to an-
other, employing thereby a 'force' which cannot be just the force of Rea-
son. To reach an agreement via an edifying conversation, on the other
hand, is not to convince or to be convinced by an appeal to Reason, but
rather the result of a composition of the forces operating in a certain con-
juncture, where the supposed force of reasons and arguments is at most
one—presumably quite marginal—component.

To deconstruct is not to demolish either. It is to suppress the grounds
of the affirmation and of the negation as well. For it amounts to a dilution
of the oppositions upon which both are necessarily based (recall Spinoza's
dictum: *omnis affirmatio est negatio*). In this way, not only is it no longer
necessary (nor possible) to deny or to affirm anything; it is also unneces-
sary to attempt, later on, to synthesize the opposites. If one insists in com-
paring it to demolition, deconstruction is no doubt a peculiar kind of
demolition, much more radical and perfect than the current technique of
implosion. For, in deconstruction, one suppresses the underground foun-
dations of the building, in such a way that it is swallowed into the ground
without leaving any traces. The flattened landscape left after deconstruc-
tion is completely different from the one left after any usual form of ra-
tional critique. The latter, by demolishing a thesis, makes room for an
alternative theory. Recall, for example, that for Popper a successful refuta-
tion of a theory requires the suggestion of an alternative theory which is
able to successfully replace its predecessor. One demolishes a building to
build another in its stead. The open space resulting from the demolition
remains vacant, usable and waiting to be used. Deconstruction, however,
purports to avoid precisely that. Were another theory to replace the one
deconstructed, that would be a sure sign of deconstruction's failure. There
is no question of making room for an alternative conception of philoso-

phy, for an alternative epistemology, or for an alternative *tout court*. Says Rorty:

> I am *not* putting hermeneutics forward as a "successor subject" to epistemology, as an activity which fills the cultural vacancy once filled by epistemologically centered philosophy. . . . On the contrary, hermeneutics is an expression of hope that the cultural space left by the demise of epistemology will *not* be filled (Rorty 1979:315).

One understands, then, that in order to achieve a suppression such that not even a vacant space is left, deconstruction must 'demolish from underneath', i.e. that its natural vocation be 'archeological', to use Foucault's apt term. Unlike Hegel, Foucault does not consider contradictions as opportunities to exercise our ability to disclose a 'secret principle' underlying them or a privileged point of view from which they can be ultimately defused. To assume this would be to play 'the grand game of contradictions', which consists in suppressing a contradiction locally only to restore it at a higher, more encompassing level, thus transforming 'contradiction' into the most general, abstract, and uniform principle of explanation. Instead, Foucault's 'archeological analysis' seeks to identify and describe different kinds of contradictions and their functions in a non-reductive spirit. What emerges from this analysis is a 'space of multiple dissensions', not unifiable—hence not ruled—by any single 'principle of contradiction', be it classical or dialectical. The identified kinds of contradictions themselves should not be understood as organizing principles which lie 'beyond' (neither 'above' nor 'below') the concreteness of discourse: they only serve to remind us that our discursive space—which is all that matters—is not smooth, grounded, or well-organized, but rather "multiply rough" (cf. Foucault 1969, chapter 4.3).

The 'flattening' of discourse desired by post-philosophers need not, therefore, lead to a flat landscape. But its effect is the same, regardless of whether it suppresses contradictions and oppositions or indefinitely multiples them. Either way, its ultimate aim is to leave no possibility whatsoever of a new 'synthesis', of a new trick pulled on us by Reason, not even a dialectical one.

VII. Déjà Vu

I have attempted to stress the radical character of the current crisis of 'modernity'. Yet, a feeling of *déjà vu* emanates from this very same radicality. How many modernisms and postmodernisms have already appeared and disappeared in the present century's art? Doesn't the theme of the end of 'traditional' philosophy and metaphysics recur in Nietzche, the

Vienna Circle, 'ordinary language philosophy', Sartre's *Critique de la Raison Dialectique*, and many other thinkers and schools of this century? And hasn't, after all, 'modern' Reason itself conquered its dominant position—so we are told by most historians of philosophy—through a not less radical act of total and uncompromising rejection of the Scholastic tradition? And later on—according to the same historical narratives—didn't it consolidate that position by Kant's equally radical 'Copernican revolution', followed by dialectics, historicism, positivism—each involving a heavy load of purported (or real) radicality vis-à-vis its predecessors? It would then seem that, far from announcing a rupture, the current critique inserts itself nicely in the Great Critical Tradition which in fact is the real essence of 'modern' (and why not earlier, perennial?) philosophizing.

Rorty himself, when he could still be located in the rank and file of the analytic tradition, has provided an excellent description of this Great Critical Tradition. In his introduction to what I take to be still the best collection of metaphilosophical texts produced by analytic philosophy, *The Linguistic Turn*, Rorty reflects upon the philosophical revolutions of the past, and observes that they always arose out of a questioning of the implicit presuppositions of preceding doctrines. Aware of this fact, "every philosophical rebel [of the past] has tried to be 'presuppositionless', but none has succeeded" (Rorty 1967:1). Nevertheless—he pursues—that does not mean that philosophy makes no "progress", or else that it expresses only arbitrary opinions, for:

> Uncovering the presuppositions of those who think they have none is one of the principal means by which philosophers find new issues to debate. If this is not progress, it is at least change, and to understand such changes is to understand why philosophy, though fated to fail in its quest for knowledge, is nevertheless not 'a matter of opinion' (Rorty 1967:2).

The acknowledgment of the impossibility of elaborating philosophical doctrines or methods which are free of any presuppositions (and hence capable of resisting the critical rebellion of future generations), leads Rorty to a justified pessimism regarding the analytic (and also phenomenological) ideal of transforming philosophy into a 'strict science', thanks to the linguistic (or phenomenological) method. But such a pessimism, which is in fact based on a fallibilism shared by both philosophy and science, need not lead to the abandonment of philosophy, as it does not lead to the abandonment of science. It suffices to adopt a more 'realist' view of the nature of philosophizing, its potentialities as well as its limitations, a view based on an analysis of the historical mutations the exercise of this activity suffered. Of course, we should not fall back into the ingenuity of believing that such a 'nature' corresponds to some eternal, fixed, and well-defined essence. But it is no less important to recall that, precisely for that

very same reason, we cannot speak about the extinction of philosophy. Significantly, Rorty concludes his introduction to *The Linguistic Turn* with a quotation from Hampshire which stresses the *continuity*—an essentially critical one—of philosophical activity throughout time:

> If we have no final insight into the essence of man and of the mind, we have no final insight into the essence of philosophy, which is one of men's recognisable activities: recognisable, both through the continuity of its own development, each phase beginning as a partial contradiction of its predecessor, and also by some continuity in its gradually changing relation to other inquiries, each with their own internal development (Hampshire 1960:243; quoted in Rorty 1967:39).

Couldn't one say, in the light of Rorty's and Hampshire's insightful description, that philosophy—perhaps unlike science—*cannot* be 'normal' in Kuhn's sense? For, its nature being essentially 'critical', in the radical sense of seeking to disclose and criticize the presuppositions upon which it rests, it is in a state of 'permanent crisis', even in its system-building phases (a close inquiry into the great philosophical systems would easily detect their polemical underpinnings).

Let us ask, with Rorty, what kind of future might be expected by philosophy were the (critical) program of analytic philosophy to succeed, i.e. were all traditional philosophical problems to be satisfactorily dissolved. From the six possible scenarios he discusses (Rorty 1967:34–36), only one (namely, the replacement of the linguistic by the phenomenological method) is compatible with the pessimism mentioned above. As for the rest, only *one*—the one associated with the name of Wittgenstein—proclaims the end of philosophy:

> It might be that we would end up by answering the question 'Has philosophy come to an end?' with a resounding 'Yes', and that we would come to look upon a post-philosophical culture as just as possible, and just as desirable, as a post-religious culture. We might come to see philosophy as a cultural disease which has been cured, just as many contemporary writers (notably Freudians) see religion as a cultural disease of which men are gradually being cured. The wisecrack that philosophers had worked themselves out of a job would then seem as silly a sneer as a similar charge leveled at doctors who, through a breakthrough in preventive medicine, had made therapy obsolete. Our desire for a *Weltanschauung* would now be satisfied by the arts, the sciences, or both (Rorty 1967:34).

If this is only *one* of the possibilities, why ask already at this point the question about the future of philosophy in terms of the notion of a 'post-philosophy', as does Rorty (1967:34): "Is a 'post-philosophical' culture really conceivable?". And why, a decade later, opt for this as the only viable alternative? In 1967 the critique of traditional philosophy left a gap which two rival conceptions (in English-speaking countries) of *philoso-*

phy—those of Austin and Strawson—were considered capable of filling (as acknowledged by Rorty himself). What happened between 1967 and 1979? Why did disenchantment—to use Weber's term—grow so deep as to lead to a radicalization of the critique of modernity to the point of making the gap itself disappear, i.e. to the point of ruling out *any possible replacement* of the traditional ways of philosophizing? Why the 'partial contradictions of their predecessors' by means of which Hampshire describes both continuity and change as essential characteristics of the philosophical activity throughout time must now make room for a 'total rejection', which purports to be, as we have seen, much more destructive than even a 'total contradiction'?

VIII. CAN ONE EXPLAIN THE 'CRISIS'?

Clearly, questions such as the ones above cannot be answered by invoking facts about the intellectual biography of Rorty and the other post-philosophers, for such an answer could not explain the quick dissemination of these ideas in the 1980s, especially in Anglo-Saxon philosophical communities. On the other hand, the attempt to provide a more satisfactory answer, be it through a broader historical perspective on the history of philosophy or by reference to extra-philosophical social (or other) facts, runs the risk of being pigeonholed as a 'Grand Narrative', a genre post-philosophers abhor. In spite of the risks, I think the exercise is worthwhile.

We might, for instance, narrate the story as follows. 'Modern', a word derived from Lat. *modo* = present, current. But the destiny of every present is to become past; the Moderns of yesterday are the Ancients of today, and those of today will be the Ancients of tomorrow.[11] The only question is the duration of the process, for duration is presumably the indicator of the depth and extensiveness of the changes instituted by each new Modernity. If the changes are relatively shallow and quickly superseded by other changes, we would certainly speak of fashion (Fr. *mode*—a word possibly derived from the same root). Otherwise, we might speak of rupture, paradigm shift, revolution, the appearance of a new *episteme*, etc.

Rudolf Eucken, a philosopher of the turn of the century,[12] proposed a way to distinguish between these two kinds of 'modernity'—the shallow and the genuine. The former can be entirely explained in terms of man's psychological (and perhaps biological) drive for constant change. It has to do with the capriciousness and arbitrariness of human desire and pleasure (*blossmenschlichen Lust und Laune*). The latter, on the other hand, has to do with 'spiritual necessity' (*geistige Notwendigkeit*). The former affects only the surface. "The same wind that brings it"—says Eucken—"quickly

takes it away" (Eucken 1909:280). The swift oscillations from one pole to the other produced by this kind of change engender only fatigue and disenchantment: "Sad is the life of the men and times which is commanded by this kind of modernity!" (Eucken 1909:280). The other is completely different. It affects the depths of human life, and yields, instead of fatigue, new creative forces. It has to do with the 'turn' (*Wendung*) of world-historical life, and has a deep 'truth content'. Hence its irresistible 'necessity', which shakes even the most remote corners of our life, and against which entrenched opinions (*Meinungen*) and egoistic interests lose all force. The genuinely modern has as its enemy not only the ancient, but also the shallow modern. But its strength, derived from its deep truth, is such that it ensures its victory over its enemies. "Our time" (i.e. the turn of the century)—he concludes—is doubtless one of those moments in history where genuine modernity emerges.

The weaknesses of Eucken's account notwithstanding, it suggests a number of questions that we certainly would like to ask about our own times and the current crisis in philosophy: Is our time also a historical moment of emergence of deep and significant change? Are post-philosophy or post-modernity expressions of such a change? Are they 'genuine' or 'shallow' forms of novelty? If the former, what is the 'historical necessity' to which they correspond?

At this point, our account—so it seems—must appeal to observations about the socio-politico-cultural situation of our planet. Possible candidates might be: cultural relativism (what is common between the West and Iranian fundamentalism?); unsurmountable economic stratification (the Third World external debt as a permanent rather than transitory phenomenon); mega-urbanization as a dissociative rather than unificatory process; multiplication of nation-states and regional conflicts based on narrow, sectarian interests; inability of science and technology to overcome poverty and suffering; etc. Such facts would in turn justify the widespread skepticism towards all the traditional as well as new global ideologies. And they would correlate with the incommensurability and fragmentation of discourses, transformed—as we have seen—in a key principle by some of the postmoderns. The historical necessity of the post-philosophical critique would, then, stem from its correspondence to and expression of those deep changes in the socio-politico-cultural sphere. The authenticity and depth of the 'crisis' of philosophy and the genuineness of the changes advocated by the post-philosophers would, on this account, be a direct function of the seriousness of the crisis of our times.

As it stands, the account is still obviously defective, and not only by the post-philosophers' own standards. For one thing, it seems to take for

granted key components of one of the ideologies that are supposed to be outmoded, namely the naïve interpretation of the Marxian doctrine of the determination of the (cultural) 'super-structure' by the (socio-economical) 'infra-structure'. For another, its list of socio-political-cultural facts is extremely selective. One might as well mention a series of phenomena that point not towards fragmentation and relativism, but to the opposite direction: the homogenization of the world through the means of communication and technology, the expansion of the capitalist system which has transformed the world into a single 'world-system', the constant breaking of traditional disciplinary barriers and the increasing popularity of new inter-disciplinary approaches, etc. In the light of such a selectivity, one might ask whether the postmodern emphasis upon pluralism and fragmentation does not indicate that, in Mannheim's terms, the postmodern critique is either an 'ideology' (tending to mask the reality of the homogenization of the world) or a 'utopia' (expressing the desire that homogenization give way to pluralism), rather than a 'realist' expression of the current situation.

But it is by the post-philosophers' own standards that the above account is most defective. The post-philosophical and postmodern reaction to our answers, as well as to our questions, would certainly disqualify both. It would presumably point out that we are trying to apply distinctions and categories whose inapplicability and inadequacy is precisely what is at stake. Together with the old modernity—be it that of the seventeenth century or of the turn of this century—we should have abandoned *also* its theory of change, and we should refrain from proposing any replacement to it. The flattening of discourse forbids the acceptance of such distinctions as that between 'shallow' and 'deep', between 'apparent' and 'genuine'. Nor can we appeal to such things as the idea of a 'truth content', the Grand Narrative category of a 'spiritual necessity', or an illusory 'objective' description of socio-politico-cultural facts allegedly correlated with philosophical or anti-philosophical views.

Still, disregarding the self-referential application of their own standards, we crave to understand the 'logic', if not the causes, of the seeming necessity with which the post-philosophical critique radicalizes itself. An interesting model for that logic can be partly found in the magnetic phenomenon of the hysteresis. An electrical current magnetizes a ferromagnetic material by inducing an homogeneous orientation of its molecules. When the current is off, the material is demagnetized. Yet, a residue of magnetization remains, so that the next magnetization requires less energy, since it begins upon partially oriented molecules. Conversely, if one wishes to invert the direction of the magnetic field generated, *more* energy

is required, since, in addition to the amount needed to generate the field, one has to eliminate the residual (opposed) orientation too.

Analogously, when Heidegger 'returns' to the Greeks, he is performing a gesture which is similar, in some respects, to the Renaissance's rediscovery of classical Antiquity. But his gesture is also a gesture of rejection of the 'moderns', who in turn had rejected some fundamental Renaissance concepts. A divorced man, after all, is not a bachelor and each revolution—as pointed out by Hume—sets up a precedent. Generally speaking, a new wave of criticism against a certain tradition both builds upon earlier waves (which explains its aroma of *déjà vu*) and faces more opposition caused by the tradition's reaction to earlier criticism (which explains the need to be more 'radical'). Each round of historical change confronts opponents which are likely to reappear in subsequent rounds (this corresponds in magnetism to the polarity of orientations). Yet, similarity is not identity. Simply to repeat the moves of its predecessor would be fatal for a new wave of criticism, because the opponent has, in the meantime, learned to defend itself against that move.

Within this general scheme, specific features of the radical character of the post-philosophical critique might perhaps be explained by additional assumptions. Suppose we divide the great philosophical parties or orientations of all times into 'constructionists' and 'deconstructionists'. The problem of the former is to avoid being 'naïve' after each deconstructionist attack. They are allowed to climb over the shoulders of their predecessors, but only over that part that has remained immune to earlier criticism. The problem of the latter is twofold: (a) their critique must confront ever stronger constructions, so that it must be both more energetic and deep (i.e. aimed at the very foundations of all such constructions), to have any lasting effect; (b) they must be careful not to erect deconstructionism into a construction, which would be self-defeating. Driven by its inner logic, each of the parties fulfills its role. The deconstructionist is compelled to 'flatten' the landscape, not in order to prepare it for new building, but to prevent any such thing from occurring. Instead of placing himself *above* or *on* its opponent's constructions, he digs deeper and deeper to *under*mine any possible foundation. The constructionist, undeterred by this challenge, pursues his ant-like vocation and somehow manages to produce his constructions, with or without deeper (why not higher?) foundations.

But can either of them succeed once and forever? The achievement of the deconstructionist program requires in fact not only a 'spatial flattening', but also a reversion (indeed, suppression) of time. Archeology should bring us back to a primeval ground, unpolluted by any constructions. It would liberate us not by resolving our conflicts and contradictions, but by

letting us return to a point where the binding force of institutions, norms, theories and other sources of such contradictions simply did not exist.[13] The three-hundred-years episode in Western history called 'Philosophy' would be thereby erased, and we would happily return to the unprofessionalized, commonsensical, naïve, natural, and healthy embedding of our 'philosophical' concerns within our ('cultural') life as a whole. Yet, this utopia (or 'ideology', in Mannheim's terms) is impossible to achieve precisely because of the hysteresis effect just discussed.[14] The final achievement of the constructionist program, on the other hand, would require the equally utopian *actual* finding of lasting foundations. The outcome—in all likelihood—is that no party will win. Rather, both are likely to go on playing their polar but complementary roles in a game that encompasses all of their possible moves, and out of which, consequently, they cannot step.

By post-philosophy's own standards, each one of the above sketched meta-narratives is certainly inadequate. Once flattened out, all modernities as well as their corresponding 'post-', are equivalent; all are equally profound or shallow; all are nothing more than fashions and nothing less than archeological ruptures; all contribute their part to a conversation that they all know cannot really take place. Still, one cannot but wonder what might be the next position we will find ourselves occupying soon in the flux and reflux of ever more radical deconstructions/constructions. No matter what this position turns out to be, I can hardly conceive that it will be a position not included in the game whose name—we can now disclose it—is "The Great Critical Tradition of Philosophy'. But then, isn't this, after all, the last, winning, card played by Reason?

NOTES

1. In Mallarmé (1952:10).
2. Such a search for paradox is not characteristic only of present-day 'post-philosophy'. Before it, the plastic arts (e.g., dadaism) and the so-called theater of the absurd have pursued paradox systematically and persistently. In literature and philosophy, Camus's and Sartre's work announce many of the themes of post-philosophy. In its most extreme form, the ultimate paradox faced by a writer is that of 'discovering' that silence is the only way of avoiding misrepresentation, a paradox that ultimately leads to suicide as its only possible outcome: "Suicide, symbolic or actual, becomes the consummation of the avant-garde. We know the fate of Sade behind prison walls. Lautréamont vanishes at the age of twenty-four, and Rimbaud ceases to write after nineteen. Jarry wills his death; Vaché, Rigaut, Crével, Artaud kill themselves; Cravan disappears in the Caribbean" (Hassan 1982:79). The symbolic killing of philosophy by post-philosophers, though per-

haps less dramatic, bears some similarity to this. In other areas, paradox is used as a technique for problem-solving. Thus, in psychotherapy certain practitioners employ 'paradox' as a key element. An example—used by the Italian school—consists in *prescribing* to a family or an individual that come to treatment 'No change in behavior'. This creates the paradoxical situation that the patient, who came to the therapist because he or she feels the need to change, is confronted with the instruction not to change. Of course, the 'same' behavior is no longer the same, since it now is to be performed not spontaneously but by prescription, and the therapeutic effect is achieved precisely through this shift. (I am indebted to Varda Dascal for this illustration.) This modification, under new conditions, of what appears to be 'the same' parallels the analysis of each new wave of radical criticism as analogous to the hysteresis cycle of ferromagnetic materials (see section 7 below).

 3. According to Lyotard, no science—hence not even "epistemology naturalized"—can legitimize any language game (not even its own game): "Science plays its own game; it is incapable of legitimating the other language games. The game of prescription, for example, escapes it. But above all it is incapable of legitimating itself" (Lyotard 1986:86).

 4. The expressions "Platzanweiser" (Habermas 1986:299), "Cultural Overseer" (Rorty 1979:317) and "Discours Metaprescriptif" (Lyotard 1986:88) all refer to this impossible role that traditional philosophy had allegedly attributed to itself.

 5. Scheffler (1967:84), quoted by Rorty (1979:326).

 6. Rorty points out that "It is important for the argument of this book to separate sharply these two notions [untranslatable and incommensurable]" (Rorty 1979:302n), and later on he distinguishes between "commensurable" and "assigning the same meaning to terms" (p. 316n). See also the quotation below, where he mentions the possibility of "picking up the jargon of the interlocutor", regardless of the fact that all jargons are, ultimately (for him), incommensurable.

 7. Note that what appears to be essentially the same phenomenon ('picking up the jargon of the interlocutor' = 'defending the point of view of the other even if it be opposed to one's own view') is described by Rorty as opposed to 'translation', whereas another champion of hermeneutics, Gadamer, identifies that phenomenon with true and deep translation: "translation . . . is higher because it allows the foreign to become one's own, not by destroying it critically or reproducing it uncritically, but by explicating it within one's own horizon with one's own concepts and thus giving it new validity. Translation allows what is foreign and what is one's own to merge in a new form by defending the point of the other even if it be opposed to one's own view" (Gadamer 1976:94). Is this a mere problem of translation or do indeed Gadamer's and Rorty's 'hermeneutics' differ significantly from each other? I suppose that the reason why Rorty rejects here 'translation' is his fidelity to Davidson's thesis that there is only one conceptual scheme. I wonder, however, how *this* is compatible with there being different 'jargons' to be 'picked up'.

 8. *Parallele des Anciens et des Modernes*, quoted in Eucken (1909: 276n). The translation is mine, as are all ensuing translations, unless otherwise specified in the bibliography.

 9. The Peruvian writer Mario Vargas Llosa, in a conference in Lisbon (May 31, 1987), illustrates nicely Mannheim's analysis. He adopts the posture of a 'neutral' intellectual, observing as it were from nowhere the current scene. From that privileged position, he feels safe to condemn as utopias all ideologies that seek a radical change in social structure, *even* in the Third World.

10. To be sure, the post-philosopher rejects this strong notion of denial, together with his rejection of the strong notion of truth, both remnants of the very tradition he wants to destroy. Yet, if it is in terms of his own weaker notion of denial (in a pragmatist vein, something like 'not useful/relevant for our purposes') that the critique of modernity and classical Reason is to be understood, then its alleged radicality and the extremism of the consequences drawn from it is thereby completely undermined.

11. The 'modern' is identified by Paul de Man as "the innovative element, the perpetual moment of crisis in [the literature of] every period" (Hassan 1982:302n).

12. Eucken was perhaps justly forgotten, in spite of his Nobel Prize in Literature (1908). His views may have been instrumental in shaping Nazi ideology later on, as can be gathered even from the brief exposition below.

13. In a short story that beautifully thematizes the effects of the reversal of time, obligations, contracts, etc. are 'cancelled' precisely because one returns to a point in time *before* they were established (Carpentier 1979). My discussion of demolition and deconstruction above is also inspired in this story.

14. On the historical, hence non-'naïve' nature of 'common-sense', as well as of philosophical appeals to common-sense, see Dascal (1984).

REFERENCES

Baynes, Kenneth, James Bohman, and Thomas McCarthy (eds.). 1986. *After Philosophy: End or Transformation?*. Cambridge, Massachusetts: MIT Press.
Carpentier, Alejo. 1979. Viaje a la semilla. In *Cuentos Completos*. Barcelona: Bruguera, 65–93.
Davidson, Donald. 1967. 'Truth and Meaning'. In Davidson 1984:17–36.
_____. 1974. 'On the Very Idea of a Conceptual Scheme'. In Davidson 1984:183–198.
_____.1984. *Inquiries into Truth and Interpretation*. Oxford: Clarendon Press.
Dascal, Marcelo. 1984. 'Philosophy, Common-sense, and Science'. In J. Gracia, E. Rabossi, E. Villanueva and M. Dascal (eds.), *Philosophical Analysis in Latin America*. Dordrecht: Reidel, 285–312.
Derrida, Jacques. 1986. 'The Ends of Man'. In Baynes et al. (eds.), 125–158. (Given first as a paper to a colloquium on the topic "Philosophy and Anthropology" in New York, October 1968; published in 1972 as 'Les fins de l'homme', in *Marges de la Philosophie*, Paris: Minuit.)
Eucken, Rudolf. 1909. *Geistige Stromungen der Gegenwart*. Leipzig: Veit & Comp.
Foucault, Michel. 1969. *L'Archéologie du Savoir*. Paris: Gallimard.
_____. 1986. Questions of method: an Interview with Michel Foucault. In Baynes et al. (eds.), 100–117. (First published in M. Perrot [ed.], *L'Impossible Prison: Recherches sur le Système Pénitentiaire au 19ème Siècle*. Paris: Seuil, 1980.)
Gadamer, Hans-Georg. 1976. *Philosophical Hermeneutics*. Translated and edited by D. E. Linge. Berkeley: University of California Press.
_____. 1981. *Reason in the Age of Science*. Translated by F. G. Lawrence. Cambridge, Massachusetts: MIT Press.

Habermas, Jürgen. 1986. Philosophy as Stand-in and Interpreter. In Baynes et al. (eds.), 296–315. (First published in 1983 in *Moralbewustsein und kommunikatives Handelns*, Frankfurt: Suhrkamp.)

Hassan, Ihab. 1982. *The Dismemberment of Orpheus: Toward a Postmodern Literature*. 2nd ed. Madison, Wisconsin: The University of Wisconsin Press.

Kant, Immanuel. 1784. 'An answer to the Question: "What is Enlightenment?"'. In *Kant's Political Writings*, ed. by Hans Reiss. Cambridge: Cambridge University Press (1977), 54–60.

Lyotard, Jean-François. 1986. The postmodern condition. In Baynes et al. (eds.), 73–94 (extracts from his *La Condition Postmoderne: Rapport sur le Savoir*. Paris: Minuit, 1982).

Mallarmé, Stéphane. 1952. *Poésies*. (Preface by Jean-Paul Sartre). Paris: Gallimard.

Mannheim, Karl. 1936. *Ideology and Utopia*. London: Routledge and Kegan Paul (Translated from the German [1929] by Edward Shils).

Ortega y Gasset, José. 1923. *El Tema de Nuestro Tiempo*. Madrid: Revista de Occidente. Quoted according to the 12th edition, 1956.

Rorty, Richard. 1979. *Philosophy and the Mirror of Nature*. Princeton: Princeton University Press.

⸻ (ed.). 1967. *The Linguistic Turn: Recent Essays in Philosophical Method*. Chicago: The University of Chicago Press.

PART III

PHILOSOPHY:
WHAT NEXT?

In the second part, in the course of the exploration of the meanders, dead-ends, and new avenues opened by the recent self-criticism of philosophy, the anxiety about the future of philosophy never ceased to cast its shadow. Is it possible to accept *part* of the post-philosophical sweeping criticism of the tradition and still go on philosophizing, albeit in a modified way? Or must one accept that criticism *en bloc*, including its demand for philosophy's self-dissolution? Is there any way to admit the compelling evidence that shows the bankruptcy of foundationalism, epistemology, representationalism, Reason—in short, Philosophy—and still believe that something much like it can and should survive? Can philosophy gather a new strength from its courageous acknowledgment of that bankruptcy, in order to become more radical and at the same time more modest and careful than before? Can it dare to admit its own death only to resurrect, fertilized by the ashes of its burned-out tradition?

The essays contained in this part address these questions by spelling out specific agendas for the philosophy of the future. While one of the authors (Joseph Margolis) considers the prospects for the future from a point of view that might be described as *internal* to philosophy, even though the solution he proposes appeals to a radical historicization of the philosophical activity, the other contributors bring into the discussion, in addition to history, other dimensions—political, sociological—that are usually considered *external* to the concerns of philosophy: Amelie O. Rorty thematizes 'exteriority' as a value, Nancy Fraser and Linda Nicholson warn against a possible transformation of exteriority into a separate essence, and Harry Redner urges that we address the pressing ethical problems of our times without resorting to Ethics.

Joseph Margolis addresses the issue of the future of philosophy by contrasting the 'self-correcting' and the 'self-eliminating' trends in contemporary philosophy. The former is entirely justified by the cumulative force of the arguments adduced both by recent Anglo-American and continental philosophy. The latter is an unwarranted consequence that those unduly enamored with deconstruction draw from the former. Margolis argues that both Quine and Heidegger, while denouncing the 'dogmas' of traditional philosophy, do not go on to disallow philosophy as such. On the contrary, both thinkers pursue (constructive) philosophical enterprises, purged—so they believe—from the denounced mistakes. Furthermore, neither Quine nor Heidegger were radical enough in completely avoiding those mistakes. For the true force of their self-correcting drive was the insight that there cannot be privileges of any sort granted to any type or level of inquiry. That is, "that (any and all would-be) transcendental, phenomenological, pragmatist, or second-order legitimating arguments of the 'apparent' accomplishments of science . . . *cannot themselves be privileged as against, or as conceptually segregated from, first-order in-*

quiries." And yet Quine inconsistently privileged extensionalism, while Heidegger—no less inconsistently—privileged the analysis of *Dasein.*

The reason why Quine (and Heidegger) came close to inconsistency lies in the fact that first-order inquiries (e.g., science) *need* to be legitimized, in so far as they are successful cognitive achievements. That is to say, epistemology or metaphysics have a *function* which they must discharge. Quine's 'naturalized epistemology' is a move in that direction. Yet, what Quine failed to recognize is that, once naturalized, epistemology's status and fate cannot be different in principle from those of any first-order inquiry. In particular, it cannot escape history. The temptation to maintain a privileged status for the second-order inquiry, though stemming from a genuine need, amounts to a betrayal of the achievement of Quine's 'Two Dogmas'. On the other hand, however, simply suppressing epistemology or metaphysics, as suggested by Rorty, reveals an insensitivity to the necessary function of second-order inquiry. It also indicates a misreading of the whole philosophical tradition in terms of a Platonic formula that can be easily put aside, without ever coming to grips with the 'exceptions', i.e. those philosophers (like Quine and Heidegger) who criticize the Platonic formula, but still pursue second-order inquiries.

According to Margolis, then, the real question philosophy now faces is how to become fully radicalized in its endorsement of the elimination of the distinction between first- and second-order pursuits, while at the same time letting the latter fulfill their necessary role vis-à-vis the former. In other words, the problem is how philosophy can live with and make sense of the fact that "first- and second-order questions regarding (the foundations of) science or knowledge are methodologically inseparable but functionally distinct from one another". Margolis's hope, which brings him close to hermeneutics, is that the solution lies in the full exploitation of the historicity of the philosophical enterprise at all its levels.

Amelie O. Rorty's contribution is described by her as a "day dream but practical proposal for picaresque philosophical exploits". Her humorous tone is no mere stylistic fancy; it vividly illustrates the content of her proposal. The new Socratic turn she urges is an invitation to engage in public inquiry, philosophy in the *agora.* In so doing, she suggests, one will rediscover the wealth of ways in which the philosophical imagination can be put to work, engaged in the natural pleasures of inquiry described by Hume. Philosophers will thereby be in a position to ask really important, useful, and serious questions.

Such questions will not, on the face of it, be technical philosophical questions. They will be addressed to architects, bureaucrats, industrialists, educators, planners, politicians—in short, to anyone engaged in any human practice. The Socratic philosopher might be hired as an 'intern' in

non-philosophical organizations and institutions, with the task of asking relatively well-informed but innocent, difficult questions. For example, in schools of architecture, Sophia might ask: 'how does the definition of space affect the interactions among those who use them. Should there be a distinction between public, domestic and private spaces?. . . What activities and modes of life should be visible and what enclosed?. . . Where should basic scientific research take place?' It might be objected that architects, like thoughtful practitioners in any field, do not need the intrusive philosopher in order to ask these questions. Amelie Rorty's reply is that the informed but marginal stance of philosophers vis-à-vis the practice they examine is what places them in "a position to question and to make explicit whatever complexities exist" in those practices. For "often outsiders are in the best position to see practices clearly and to raise basic questions about them". Not only that: being relatively marginal to the practice of "professional" philosophy, the Socratic questioners will also be able to effectively question philosophy's own practice. For this purpose, the more marginal, the better. Hence, Sophia, who has not "until recently been [a] guild-philosopher", is particularly privileged to see presumption and absurdity.

Amelie Rorty argues for her proposal by responding to several possible objections. But her essay is not only programmatic. By actually offering a long list of examples of the questions the Socratic philosopher might ask in different contexts, she performs the philosophical turn she propounds. In addition to that, she descends to the practical level of suggesting ways to implement her proposal, something philosophers rarely do. Her contribution also evokes and exemplifies other recurrent themes in this book: the ubiquitousness of philosophy, the freedom of constraints necessary for its proper exercise, and its ability to participate in a Socratic, edifying and non-pretentious conversation with human beings engaged in any kind of activity. And all this, with no trace of the gloomy agonistic picture of the 'end of philosophy'.

Nancy Fraser and Linda Nicholson propose the notion of 'postmodern feminism' as their example for post-Philosophical discourse. As committed to both postmodernism and feminism, they observe that no happy marriage between these two contemporary modes exist at the present time. In fact, there is a theoretical and political distance, if not actual tension, between these forms of criticism. To enable such a marriage, the authors criticize elements of both. While endorsing the essentials of the postmodernist attack on the notion of a totalizing metanarrative, they also point out the shortcomings of postmodernism (in Lyotard's version) as a platform for social criticism. Postmodernism is excessively concerned with its negative critique of the institution of philosophy to be able to

produce an effective (i.e., normative) notion of global social criticism. The rejection of *all* totalizing metanarratives allows only for 'smallish, localized narratives'. Consequently, current postmodernism cannot acknowledge the legitimacy of feminism as a broad-based social critique. As a large-scale historically oriented narrative and social analysis of dominance and subordination, feminism is, for Lyotard, just another case of an illegitimate metanarrative. Like Marxism, feminism is thus rejected as too Philosophical, too foundationalist.

There is, though, a grain of truth in the postmodernist dismissal of feminism. The problem with most versions of feminism, Fraser and Nicholson maintain, is that it has indeed been too foundationalist and essentialist. Biology, or gender identity, or the 'domestic sphere' were said to be the sole and universal cause of women's oppression. Theory in the early days of feminism "was understood as the search for the one key factor which would explain sexism cross-culturally". No doubt, such an attitude was also politically effective, for it helped to provide first-generation feminists an ideological fervor in their combat against sexism.

A constructive marriage between postmodernism and feminism has begun to take place since the early eighties. Many feminist theorists have abandoned the notion of a grand social theory, though "vestiges of essentialism have continued to plague feminist scholarship". At the same time, the practice of internal feminist politics in recent years has tended to work against its construal as a grand metanarrative. All kinds of minority groups within feminism have unmasked the earlier narratives as culturally biased. Feminism itself has become fragmentary and pluralistic. It is such a historical dialectics that opens the door for a better link between feminism and postmodernism, which can be beneficial for both sides. For postmodernism, feminism is a way to question its too apolitical notion of social criticism. For feminism, postmodernism is a reminder of the theoretical defects of ahistorical, essentialist theories. Once consummated, the marriage would yield a postmodern-feminism which should be "pragmatic and fallibilistic", a socially and theoretically effective practice, unhampered by unnecessary Philosophical commitments.

Harry Redner proposes to take Rorty's cultural turn a step further. While Rorty focuses on the genealogy of 'epistemologically-centered philosophy', Redner inquires "how the discourse called Ethics arose and how it differentiated itself from those that came to be called Law, Politics, and Economics, which originally were so closely related to it." For Redner, such a genealogical investigation should start with the raw material of the history of moral sentiments as a social phenomenon, not from the history of the philosophical subject-matter called Ethics. Redner strongly rejects the ahistorical attitude commonly found within Ethics, which treats the

'ethical' as a natural kind. It is this view that seems to underlie the way moral philosophers debate Aristotle and Kant, Aquinas and Hume, as if these thinkers take part in the same perennial discussion. For Redner, on the contrary, "[Adam] Smith and Aristotle are talking about different things in the sense in which Smith and Kant are not; the latter can meaningfully disagree, the former cannot". Hence, Redner's reconstructed project of the genealogy of ethics incorporates the history of ethics into the history of culture at large. But, unlike MacIntyre, Redner has no longing to revive Aristotelianism. If history is to be taken seriously, he maintains, one must realize that such a project is no longer viable.

Redner's narrative of the moral history of the West is centered on two notions: moralization and de-moralization. Moralization is a feature of modernity, closely related to rationalization in Weber's sense. "It is concerned with the interiorization of conscience and the formation of psychological subjectivity . . . the quality and refinement of character and social life which need serve no utilitarian practical purpose. The historical outcome of the long process of moralization is the formation of the European moral individual as a subjective and freely autonomous being". Kant, the thinker who rationalized and formalized Lutheran ethics, is a crucial point in such a narrative, for he is the one who postulated the categorical "and thereby for the first time clearly formulated a purely moral 'ought' as distinct from every other". De-moralization is the post-Enlightenment radical response to the Enlightenment's process of moralization. It can be seen as another example of what Adorno calls the 'dialectic of the Enlightenment'. De-moralization's indifference to the autonomy of morality is manifested when institutional procedures, technological devices of control, legal routines, and the like overwhelm individual moral decisions. If Kant is the philosopher of moralization, Nietzsche is the philosopher of de-moralization.

Redner's project of reconstructing the genealogy of morality is a philosophical—not a Philosophical—one. It is meant to suggest ways for rethinking ethics in the unethical condition that typifies our times. Redner calls for an updating of Weber's notion of the 'ethic of responsibility' to meet the pressing problems of our time: "the problematic relation of Man and Nature due to the ecological crisis; the problematic nature of humankind itself, due to the possibility of nuclear annihilation; and the problematic status of the individual . . . due, partly, to the prevalent de-moralization". For Redner these issues should constitute our new philosophical agenda, at least up to the close of the twentieth century.

10

Joseph Margolis

RADICAL PHILOSOPHY AND RADICAL HISTORY

I

The clever demon of philosophy nowhere betrays itself more nakedly than in its self-destructive moments. From time to time, a deliberately self-defeating zeal positively becomes the fashion of the age: our own may prove to be one of the most completely thus captivated. Certainly, at the present time, in both the Anglo-American and continental philosophical camps, there are very strong, sustained, convinced, even rather evangelical exposés of the utter futility of the most distinguished—almost canonical—achievements of the profession. Naturally, the conversion required of those who accept the new tidings is bound to be of two extreme sorts: renunciation of the entire pointless labor or uncompromising adherence to the new and exclusive instruction. Equally naturally, the professional company divides itself in both directions, sometimes, paradoxically, even within the same effort; some retire, or imagine they actually advance, to restore the endangered tradition—again, sometimes, in a smoothly single effort; and some even take heart enough to try to reunite the complex continuities and discontinuities that, on the original challenge, had seemed quite impossible to bring together coherently.

The rejection of philosophy at its most clever presents itself as a philosophical triumph: as a minimal but irresistibly compelling discovery that does not itself violate the constraints of ordinary reason but brings us instead to the very brink of the theorizing disorder by which established philosophy has always wrongly supposed it could penetrate the central puzzles of its own tradition and making. That rejection, then, is *not* the fatigue of skepticism or the bleaker satisfactions of nihilism and irrationalism and the like. No, it is offered rather in the spirit of a tidier sense of

rational scruples than more than two thousand years of flawed philosophy ever managed to sniff.

For the contemporary reader, there is no more familiar diagnosis of the philosopher's disease than Wittgenstein's:

> philosophical problems arise [Wittgenstein says] when language goes on holi-
> day [*wenn die Sprache* feiert]; our [philosophical] considerations could not be
> scientific ones. . . . We must do away with all *explanation*, and description
> alone must take its place. And this description gets its light, that is to say its
> purpose—from the philosophical problems. These are, of course, not empiri-
> cal problems; they are solved, rather, by looking into the workings of our lan-
> guage, and that in such a way as to make us recognize those workings: *in de-
> spite of* an urge to misunderstand them. The problems are solved, not by
> giving new information, but by arranging what we have always known. Philos-
> ophy is a battle against the bewitchment [*gegen der Verhexung*] of our intelli-
> gence by means of language.[1]

Yet, though there can be little doubt that he did expose in a most arresting way any number of philosophical blunders, it is not clear that, in spite of his own opinion, Wittgenstein was not—by his own effort—actually advancing the cause of legitimate philosophical theorizing; furthermore, it is certainly clear that he never explicitly said *what* the salient, perhaps even universalizable, conceptual blunder was that philosophy could not escape if it persisted in pursuing its characteristic inquiries.

Other philosophers brushed more sparingly with the same therapeutic zeal (but perhaps just as daringly) have shown us how to disqualify this or that large undertaking—meaning by their restraint to redirect us toward the licit inquiries that *remain*. Heidegger, for example, however Delphic his words, discounts the pretension of metaphysics, without discounting metaphysics (which, he thinks, we cannot escape), by the following economical pronouncement:

> That which bears such a name [perdurance, *Austrag*] directs our thinking to
> the realm which the key words of metaphysics—Being and beings, the ground
> and what is grounded—are no longer adequate to utter. For what these words
> name, what the manner of thinking that is guided by them represents,
> originates as that which differs by virtue of the difference. The origin of the
> difference can no longer be thought of within the scope of metaphysics.[2]

Heidegger's point—very possibly the same (though with an additional 'difference' of course) pressed in Jacques Derrida's notorious essay, 'Différance', also intended to delimit the illegitimate pretensions of Western philosophy[3]—is that the systematic categories of metaphysics, the systematized *differences* that can be articulated as between different metaphysical accounts, fail and must utterly fail to grasp the originating condition (what 'perdurance' in a sense itself signifies) that makes metaphysics possible: the *difference* between that 'first', originating condition (Being,

the 'ground' of beings) and *every* metaphysical system (every system of categorized beings or *differences*). The ultimate problem of philosophy, Heidegger appears to be saying, rests with understanding how the uttered (and inevitably transient, however apt) conceptual schemata of beings arise (and perdure) because of our original (or 'originary') relationship with Being itself—which is unutterably or ineffably 'different' from all such differences, incapable, that is, of being captured by any such conceptual structures. Heidegger's complaint, very simply put, is that the whole of Western philosophy has misled itself into thinking that it has somehow discovered, or progressively approximated, the actual, the universal, the timeless structures of Being—of reality—present or presented or construed as a transparently accessible and unchanging presence [*Anwesenheit*] to human cognition.[4] Being *is* revealed, Heidegger insists (though only symbiotically to apt respondents, to *Dasein*), in some contingently, unpredictably, inexhaustibly, partially, variably, historically and praxically grounded ways; but we cannot possibly know *what* the relationship is between the one and the other, except that the 'appearance' of the latter *is* the manifestation of the former to human inquirers. What are 'revealed' as the structures of beings are impossible to suppose are the actual structures of Being: the originary 'difference' between Being and beings is not the same as the difference between different beings. This is certainly essential to what Heidegger intends in his phenomenological correction of science and metaphysics. Philosophy, then, has a therapeutic function (quite different from Wittgenstein's) in uncovering the full import of the pervasive error of metaphysics and in *correcting* our work accordingly so that we may *continue* (in the spirit of the new philosophical piety—since dialectic and debate are no longer apt in the old sense.)

 In the Anglo-American tradition, the self-corrective impulse of philosophy is noticeably less florid but just as insistent: so much so, in fact, that it is normally impossible to segregate its triumphant diagnosis of prevailing conceptual disorder and error from the *more promising* possibilities of conceptual surgery that it recommends. There is, in that tradition, perhaps no more successful exemplar of the self-corrective but *not* self-disqualifying undertaking of philosophy than that offered in W. V. Quine's 'Two Dogmas of Empiricism'. It is, actually, an oversimplification to construe Quine's achievement here as subverting the most fundamental conceptual axioms of the continuous tradition of scientific empiricism spanning at least the work of Hume and Rudolf Carnap.[5] It does do that of course. But, more pertinently, in doing so, it signals the characteristic drive of contemporary analytic philosophy to radicalize itself as far as possible, by abandoning, step by step, for the sake of conceptual economy, every doctrinal fixity on which the most sanguine programs it itself favors

may thereupon still be reasonably pursued. This is the reason Quine *remains* a 'Carnapian' in spite of, or rather because of, his defeat of Carnap's assumption of a principled distinction between the analytic and the synthetic *and* of Carnap's strongly verificationist (anti-holistic) assumption that factual statements may be 'confirmed or infirmed' one by one. This is also the significance of Quine's concluding that "The two dogmas [these two dogmas] are, indeed, at root identical."[6]

Once grant the argument, it follows with breathtaking swiftness that foundationalism of every sort is ruled out (empiricist, rationalist—*and* transcendental and phenomenological, though Quine does not directly discuss such extensions[7]); that we are committed to a scientific holism even more radical than Duhem's, since to privilege the testing of scientific statements by way of "the tribunal of sense experience not individually but only as a corporate body"[8] still risks (in a cognitively decisive sense) *both* dogmas; and that we cannot escape subscribing both to "the indeterminacy of translation" and "the inscrutability of reference," since we cannot exit from our own contingent practices of inquiry.[9] In fact, on Quine's view—predictably, after the fact of his own analysis—"indeterminacy of translation . . . cuts across extension and intension alike."[10]

But having accomplished all that, how is it that Quine continues—apparently believing the effort capable of legitimation—to pursue the ulterior Carnapian program of extensionalism? How in fact does Quine construe the very question of legitimation under the extraordinarily spare conditions he has left us with? He never says. For, *to* answer would be to reintroduce doctrines (perhaps not dogmas) more congruent with the conceptual commitments he has already rejected: a more generous view, perhaps, about the analytic/synthetic distinction, a more sanguine reading of the realism of science, a greater assurance about the real *minima* of reference, a certain confidence about the realism of attributes. Here, we must content ourselves with a handful of very small clues. The whole drive, of course, of *Word and Object* is to pursue an extensionalist objective (*with respect to sentences*) as uncompromisingly as possible. Yet Quine is candid enough to say: "I do not disallow failure of substitutivity [with regard to identity], but only take it as evidence of non-referential position; nor do I envisage shifts of reference under opaque construction";[11] again, although the law of extensionality readily fits "constructions on sentences . . . limited to quantification and truth functions," we are (Quine admits) always confronted with "surviving idioms [of natural languages] of an extraneous sort—indicator words, intensional abstracts, or whatever—[which can be allowed to] remain buried in larger wholes [because those artifactual constructions] behave *for the nonce* as unanalyzed general terms."[12] But Quine *never* attempts to show *how* to construe refer-

ence, the use of attributes, belief contexts, and the like, *within the very process of living inquiry, of science itself,* as functionally manageable within the boundaries of his own severe extensionalism.

There is good reason to believe that Quine could not, *and* that the very effort would have threatened the large achievement so neatly concentrated in the 'Two Dogmas'. For once we turn from the analysis of *sentences* to the analysis of *cognitive claims* or surmises or the like (which distinction is, in a way, already adumbrated in the difference between Quine's and Duhem's holism[13]), we can no longer postpone (with Quine) "for the nonce" the intrusions of intensionality *or* the question of the second-order legitimation (transcendental or phenomenological or pragmatist or whatnot) *of* the first-order programs (extensional replacement, for example) that we take ourselves to be reasonable in favoring. There you have both the strength and weakness of Quine's undertaking: it *means* to address the achievements of science, rendering its sentences as extensional as possible; but it does not (and cannot) do so by addressing those actual *achievements,* that is, the actual practices of inquiring men. The result is simply that, in Quine's hands, *extensionalism is only an attractive first-order dogma*—never threatened by the exposure of Carnap's dogmas, but then, also, never supported or confirmed by it or by any other (first- or second-order) conceptual maneuver that Quine offers.

In fact, by one of those marvellous ironies of honest work, Quine himself draws attention to the fatal difficulty.

> But may we not [he asks rhetorically] still aspire to the discovery of some fundamental set of general terms on the basis of which all traits and states of everything could in principle be formulated? No; we can prove that *openness* is unavoidable, as long anyway as the sentences of a theory are included as objects in the universe of the theory.[14]

We cannot ever have grounds for claiming to know what, "at *each stage* [each finite segment, so to say] in the supplementation of an open stock of general terms," new terms will be true of; in fact, says Quine, "The very meaningfulness of quantification would seem to presuppose some notion as to what objects are to count as values of variables."[15] But when he chides the partisans of attributes over classes, because (as he says), although "classes are identical when their members are identical . . . attributes, I have often complained, have no clear principle of individuation,"[16] Quine fails to acknowledge the force of distinguishing (as we have already noted) between mere sentences and cognitive claims. If he had, he would have remembered that he himself insists (correctly) that "classes, like attributes, are abstract and immaterial, and that classes, like attributes, are epiphrastic. You specify a class not by its members but by its membership condition, its open sentence."[17] That is, in *cognitive*

terms; one specifies classes intensionally. But then, Quine could not seriously have gone on to propose that, by the strategy of "exhaustion of lexicon, . . . attributes come out identical if exactly the same things *have* them. In this event, attributes are extensional; we might as well read 'has' as membership, and call attributes classes. . . ."[18] For, for one thing, *if* (as Quine acknowledges) inquiry is radically openended, there is and can be no cognitively relevant "exhaustion of lexicon": the point could have been put praxically or in historicist terms. Secondly, if we cannot suppose we can achieve the required exhaustion, we require *in the interim* (at least), that is, in real-time terms, a conception of identity of attributes that is *not* construed extensionally. Quine nowhere addresses the matter; and that difficulty is the implacable *pons asinorum* of Donald Davidson's attempted application of Tarski's Convention T to natural languages.[19] Thirdly, if the foregoing difficulties obtain, then the provisional success of *any* extensional treatment of *any* cognitively pertinent achievement cannot but be subordinate, in principle, to what we consensually concede to be the then-reliable core of our science. This is the closest Quine comes to an explicit acknowledgement of the philosophical import of the connection between science and its history.

Quine's program is certainly not the most radical, philosophically. On the contrary, it is a most deliberately conservative program under carefully radicalized conditions, within the range of an extremely delimited philosophical taste. For example, even within the analytic tradition, its extensionalism is not motivated by a nominalism with regard to either predicates or classes (*à la* Goodman),[20] and its adherence to one actual world as opposed to many actual worlds (again, *à la* Goodman) is primarily motivated by a cautionary view of the uncertain requirements of clarity and coherence (that Goodman fails to address). How else (since no argument is given) to understand Quine's countering reference (to Goodman's plural worlds) to "my special deference to physical theory as a world version, and to the physical world as the world"?[21] His is, then, not the most radical thesis; but it is, already in 'Two Dogmas,' the embodiment of the most cautious radicalizing disposition of recent analytic philosophy—which, of course, might well take (against certain of Quine's own preferences) divergent or extreme alternative forms. Nevertheless, in admiring its rigor, we must not ignore its singlemindedness—*or* its deficiencies of philosophical scope *and* adequacy within its own programmatic limits. For example, it surely fails, as we have just seen, to come to terms (in both regards) with the full import of natural language, cognitive activity, human existence, (second-order) philosophical questioning, and history. And that surely is to fail to come to terms with a lot. The gains of the

'Two Dogmas,' however, are obviously quite sturdy; and to that extent, analytic philosophy is entitled to continue with its radicalizing sweep.

If the gains mentioned are reasonably in place, then, the realism of science can only be legitimated in what may be called a pragmatist manner, that is, on the strength of the biological viability of a species that depends on the interventions of cognitive inquiry, but *not* in any cognitivist (or foundationalist) terms focused either holistically or distributively; and yet it *can* be legitimated thus, *as* a second-order surmise upon, produced within, the bounds of our experience, a surmise that respects the minimal realism of science but finds itself unable to segregate its separate realist and idealist structures.[22] Quine himself correctly remarked (in 'Two Dogmas') that the rejection of a "fundamental cleavage" between analytic and synthetic truths and of (what he perceptively called) "reductionism" has the double effect of "blurring . . . the supposed boundary between speculative metaphysics and natural science [and of promoting] a shift toward pragmatism."[23] Here, a quite remarkable further gain toward radicalizing philosophy is brought very nearly into view—which Quine was not particularly disposed to pursue but which (whatever its mention here is worth) could be fairly said to be implied in the very achievement of the 'Two Dogmas' paper: namely, that (any and all would-be) transcendental, phenomenological, pragmatist, or second-order legitimating arguments of the 'apparent' accomplishments of science (where, precisely, 'appearance' is—in a sense already clarified in Kant and Hegel, straddling transcendental and phenomenological arguments—not 'illusion' [*Schein*] but "the cognizable appearings of things" [*das Erscheinen*]) *cannot themselves be privileged as against, or as conceptually segregated from, first-order inquiries.*[24] A trim way of fixing the point, in the light of the foregoing argument, is this: in rejecting any cognitiv*ist* powers to resolve the 'external' question of legitimating science, we cannot (at our peril) also repudiate the 'apparent' cognit*ive* powers *of,* 'internal' to, the very science we mean to legitimate. To favor the first move *is* the distinctive radicalizing feature of contemporary philosophy—both Anglo-American and continental; to risk the latter is nothing but a conceptual lapse of some extraordinarily self-defeating sort, since it would utterly eliminate the very cognitive achievements we mean to understand by the first effort. The oddity of Quine's project is that he attenuates (to the point of eliminating) any cognitively functional grounds for comparative appraisals *within* science, in affirming his strong holism with regard to the external legitimation *of* science. There simply cannot be a *Quinean*-like holism *within* science: such a holism (unlike Duhem's) has and can have nothing to do with the differential details of science itself.

The issue at stake is absolutely pivotal to the current fortunes of phi-

losophy: of analytic philosophy in particular, but also, however surprisingly, of continental philosophy as well. For here, we begin to see signs of an unexpected convergence (however opposed the idioms and styles of argument) between the two—may we say, between Quine and Heidegger?[25] Certainly, in Quine, the rejection of the two dogmas cannot be anything but a second-order argument; *and* the distinction between first- and second-order arguments is itself a second-order distinction *not* privileged in any cognitive or formal sense (which, on Quine's own grounds, come to the same thing).

This perhaps explains, though it cannot of course justify, Quine's flattening the distinction, as, most pointedly, in the thesis of 'Epistemology Naturalized' (written as a response as well as a concession to Carnap):

> it may be more useful to say rather [against Carnap's and Wittgenstein's opposition to 'metaphysics' and 'epistemology'] that epistemology still goes on, though in a new setting and a clarified status. Epistemology, or something like it, simply falls into place as a chapter of psychology and hence of natural science. It studies a natural phenomenon, viz., a physical human subject. This human subject is accorded a certain experimentally controlled input— certain patterns of irradiation in assorted frequencies, for instance—and *in the fullness of time* the subject delivers as output a description of the three-dimensional external world and its history. The relation between the meager input and the torrential output is a relation that we are prompted to study for somewhat the same reasons that always prompted epistemology; namely, in order to see how evidence relates to theory, and in what ways one's theory of nature transcends any available evidence.[26]

The expression 'in the fullness of time' deliberately obscures (like 'for the nonce') the second-order *function* of philosophical theorizing, that (for all that) remains and must remain cognitively continuous with and unprivileged with regard to our first-order competences. But even Quine's oddly persistent behaviorism—which refuses to distinguish between 'inputs' and cognitively pertinent activities involving 'inputs' (the flattening already remarked)—betrays the best part of what (as we were saying) is at least implicit in the 'Two Dogmas', namely, *the naturalizing of second-order legitimations of would-be first-order competences* (now, more freely conceived, 'stylistically', as transcendental, phenomenological, or pragmatist), *without which those first-order competences could not even be identified as such*. For Quine himself acknowledges that "Epistemology is concerned with the foundations of science";[27] and the entire essay can hardly be read except in the context of the kind of pragmatist legitimation Quine had already (ambiguously) affirmed in both *Word and Object* and 'Two Dogmas'.

The upshot is a pretty one. The best part of the radicalizing drive of the 'Two Dogmas' paper is that it demonstrates—just by its own concep-

tual stinginess: (i) that we cannot see our way to supporting a would-be science in any rational sense, without attention to its legitimating foundations; (ii) that we can no longer vindicate the study of such foundations in terms of the privileges the rejection of the "two dogmas" now disallows; (iii) that there are eligible, perhaps many, perhaps nonconverging, ways of speculating (coherently and economically) about such foundations; and (iv) that such speculations, as no longer cognitively privileged, can hardly escape the contingent constraints of what, at a given time, proves to be a society's consensus regarding its effective (first-order) science.[28] Now, what is especially surprising is that these same conclusions may be drawn with equal force (though on the strength of quite different considerations, also with a quite different emphasis) from what we have already remarked in Heidegger's criticism of Western metaphysics. This is not to deny that there are significant differences between transcendental, phenomenological, and pragmatist versions of second-order legitimation. But if legitimation is unavoidable, and if the dogmas of the 'Two Dogmas' paper, or similar doctrines unearthed in any of the sustained sub-traditions of Western philosophy, be disqualified, then the differences (at whatever cost, of course) that may distinguish these and related versions of legitimation can no longer be supposed to depend on: (a) a privileged hierarchy of reflexive and increasingly fundamental inquiries, or (b) privileged sources of pertinent information, or (c) privileges of scope, necessity, priority, universality, absoluteness or the like with respect to findings. To be sure, neither Kantian synthetic a priori arguments nor the necessities of Husserlian transcendental phenomenology can any longer be supported either by the 'naturalizing' of Quine or the 'historicizing' of Heidegger; but that entails at most heterodox revisions of transcendentalist and phenomenological undertakings, not the dismissal of second-order questions as such.[29] Alternatively put, first- and second-order questions regarding (the foundations of) science or knowledge are methodologically inseparable but functionally distinct from one another; and Kantian, Hegelian, Husserlian, Heideggerian, and Quinean questions of legitimation are and must be merely so many "horizontal" distinctions within the single, reflexive enterprise of understanding what we may take ourselves as knowing. The symbiosis of first- and second-order questions does not entail, or support, a hierarchy of cognitive privilege or graded cognitive power. Kant and Husserl, in quite different ways (the one in 'naturalistic' terms, the other in 'phenomenological' terms), reject this finding; and Quine and Heidegger (again, in different ways) adopt it (respectively, once again, 'naturalistically' and 'phenomenologically'). It is not pertinent to the validity of the latter strategy, which marks in effect the strong convergence of naturalism

and phenomenology, that (inconsistently) Quine privileges extensional-ism and Heidegger, the analysis of *Dasein*.

II

Now, in a rather extraordinary way, these conclusions have *all* been put in jeopardy by an entirely different reading of the history of philosophy, that has recently attracted a great deal of attention—certainly in American philosophical circles and, in a way that is hardly misperceived, even in wider European, perhaps particularly German, philosophical circles. That counter-reading is currently, though hardly exclusively, promoted in a convenient summary of the philosophical tradition offered by Richard Rorty—in his remarkably popular book *Philosophy and the Mirror of Nature*. Its avowed objective is to radicalize philosophy so completely as to preclude, by its own instant validity, philosophy's ever having any other continuing, more positive function. A few lines from Rorty's account should make the challenge entirely explicit:

> Wittgenstein, Heidegger, and Dewey are in agreement that the notion of knowledge as accurate representation, made possible by special mental processes, and intelligible through a general theory of representation, needs to be abandoned. For all three, the notions of 'foundations of knowledge' and of philosophy as revolving around the Cartesian attempt to answer the episte-mological skeptic are set aside This is not to say that they have *alternative* 'theories of knowledge' or 'philosophies of mind.' They set aside epistemol-ogy and metaphysics as possible disciplines.[30]

Rorty moves on at once to his own project:

> The aim of [my] book is to undermine the reader's confidence in 'the mind' as something about which one should have a 'philosophical' view, in 'knowl-edge' as something about which there ought to be a 'theory' and which has 'foundations,' and in 'philosophy' as it has been conceived since Kant. Thus the reader in search of a new theory on any of the subjects discussed will be disappointed The book, like the writings of the philosophers I most ad-mire, is therapeutic rather than constructive. The therapy is, nevertheless, parasitic upon the constructive efforts of the very analytic philosophers whose frame of reference I am trying to put in question [Sellars, Quine, Da-vidson, Ryle, Malcolm, Kuhn, and Putnam].[31]

Rorty's thesis cannot be discounted solely by way of the following con-siderations; but they do call it into serious question nevertheless. They are these: first, *none* of the thinkers mentioned (with the possible exception of Wittgenstein—hence, also, Malcolm) ever supposed that his best argu-ments—radicalizing philosophy in the spirit already sketched—entail, or lead or encourage us to, "set aside epistemology and metaphysics as possi-

ble disciplines." On the contrary, they all invariably suppose that, by their very efforts, they are bringing errant philosophy back to its viable and important undertaking; secondly, *all* of them (again, excepting Wittgenstein—and Malcolm) respect the conceptual symbiosis of first-order and second-order questions of the legitimating or foundational kind, and so they regard it as a matter of course that that undertaking includes fundamental metaphysical and epistemological issues. Wittgenstein's position is admittedly uncertain; but even so, if we recall his famous analysis of the private-language argument, it is extremely difficult not to regard Wittgenstein (against his own pronouncements) as doing philosophy of a perfectly standard sort.[32] Certainly, the *Tractatus* and its temporal place in Wittgenstein's career support the same picture.[33]

What Rorty claims, therefore, is simply false, as far as his mentors are concerned. They do indeed oppose the philosophical model he opposes, but they do not draw the conclusion he would have them draw. Rorty's more careful claim is that *his own* thesis is "parasitic upon the *constructive* efforts of the very analytic philosophers whose frame of reference [he is] trying to put in question." That is, Rorty is persuaded that *if* his philosophical heroes *have* succeeded in demolishing a certain pervasive dogma of professional philosophy—broadly, the 'mirror' theory of the mind, championed most notably by Descartes and Kant—then *they should have drawn* the conclusion Rorty now draws, namely, that epistemology and metaphysics should be "set aside . . . as possible disciplines." In this form, the argument is certainly not a *non sequitur*: it is, however, also, not yet supplied. Rorty's sanguine claim is that "the dialectic within analytic philosophy . . . needs [only] to be carried a few steps further"[34]—to demonstrate, in effect, that no matter how far it advances in radicalizing philosophy (in a sense common to Rorty's account and the one here favored), analytic philosophy is doomed to subscribe to the failed dogma it has so successfully exposed, *if it continues to maintain that metaphysics and epistemology are defensibly viable and worthwhile undertakings.* So the intended argument *is* a *reductio* or something very much like a *reductio*: the failure of that argument, therefore, would be a *non sequitur* or something very much like a *non sequitur*.

It seems preposterously easy to dismiss Rorty, since, on his own admission, his heroes appear to have a 'constructive' purpose (read: pursue metaphysical and epistemological issues in their own variously radicalized ways) and since he does not actually demonstrate that they contradict themselves *in doing so*. But the point of his challenge is ultimately too important to allow us to rest content with such a shallow reply. The better strategy, if feasible, would be to agree (assuming the relative accuracy of his reportage) with the radicalizing force of the accumulating attack on

the "mirror" theory mounted by the small army of philosophers Rorty follows; *and then* to show that *that* achievement itself invites—perhaps even already embodies—a more resilient, more fully pertinent, even more compelling philosophical venture of the sort Rorty dismisses.

Perhaps it would be best to collect at this point a quick sense of the various currents we are trying to disentangle. There has surely been, as Rorty observes, a most influential vision of philosophy (*and* of science as well, we should add) ranging from ancient times to the present—extraordinarily protean in its cunning—that may be collected in various partial and alternatively apt ways. Rorty prefers to speak of a picture of the mind construed "as a great mirror" (since he favors the roles of Descartes and Kant), that is, of the mind as a nondistorting, representing power.[35] There are, however, other metaphors apter for particular portions of the tradition in question. For example, Rorty finds that he is obliged to concede that, on Aristotle's view of intellect, "knowledge is not the possession of accurate *representations* of an object but rather the subject's becoming *identical* with the object."[36] He adds that the versions of the "dualism" common to the Cartesian and Aristotelian models of the "mind" (very loosely speaking) may then be regarded as "equally optional"—by which, presumably, he means (but does not quite argue) that the "mirror" model can do well enough for all the versions of the deeper thesis under fire.[37] Perhaps. But we may note, also, that it would be quite impossible to understand Wittgenstein's "version" of the "thesis"—in the *Tractatus*, of course—in either the Cartesian or the Aristotelian way; and that the model Nietzsche is at such pains to subvert, in the *Will to Power* and in that small gem that nearly collects his entire conception, 'On Truth and Lie in an Extra-Moral Sense',[38] could also not be easily assimilated to the Aristotelian or Cartesian model. (The Nietzschean conception of course, is an indispensable condition of the distinctive therapeutic function of both the Heideggerean and Derridean exposés of philosophy.) The point is that it is quite unlikely that, for what we intuitively understand Rorty to be challenging, there is any single, compendious, universally apt, or essential version of the philosophical disorder alleged, in accord with which we might straightforwardly diagnose the entire tradition uniformly; *and* that, lacking such a formula, we may be overly zealous about dismissing any number and variety of philosophical programs that merely resemble or merely run the risk of being committed to the mirror model or to any other model alleged to share the underlying disorder.

For example, *is* Quine's adherence to physicalism and extensionalism (or, for that matter, is insistence on the adequacy of an objectual as opposed to a substitutional conception of quantification[39]) *a version of the underlying disorder* Rorty means to free us from—once we remind our-

selves that, in 'Two Dogmas', Quine utterly undermines the conceptual grounds on which Carnap's confidence in those doctrines originally depended—in a way, frankly, that cannot fail to expose as well the sheer, undefended partisanship with which *Quine* pursues his own honorable prejudice? After all, adherence to the adequacy of an extensional treatment of attributes or to the objectual interpretation of quantification presupposes—*what the real-time conditions of human existence and human inquiry effectively disallow*—at least an infinitude of time within which alone Leibniz's law *might* cease to be confronted by apparent violations of its own dictum.

It is difficult to say what Rorty's answer would be. It's clear that *he* thinks Quine should have abandoned metaphysical and epistemological questions: perhaps, then, he secretly believes that Quine *has* reverted to that 'error'. But he does not show that physicalism and extensionalism are philosophically insupportable projects *or* insupportable for reasons suitably linked to the conceptual disorder of the 'mirror' metaphor. There is some reason to think Rorty actually shares the physicalist program,[40] though he somehow presents his allegiance as a prophecy about science and not as a philosophical loyalty; on the other hand, although there's good reason to think that, on the strength of his own philosophical arguments, Quine's program *cannot* legitimate either the presumed adequacy of a behaviorist, physicalist, extensionalist canon as a reasoned replacement for the recalcitrant discourse of natural languages *or* demonstrate the distinctive superiority of such a canon with respect to the descriptive and explanatory work of the actual sciences, there's no reason to suppose that Quine is just advocating a form of the mistake Rorty claims to have exposed[41] or is confused about the philosophical bias he shares with Carnap and so many others.[42] It's entirely possible, after all, that Quine believes that physicalism and extensionalism are particularly promising programs in the short run, even though, in the short run, conceptual challenges would be bound to arise that Quine would have to handle by his "for the nonce" formula *and* even though, in the long run, Quine's own argument (in 'Two Dogmas') would have completely obviated any possibility of holistic or exclusive confirmation. Here, we begin to glimpse the dawning of an entirely new kind of radicalized philosophy.

What Rorty fails to show, what he must show to gain his point, and what he cannot possibly show, is that whenever one pursues questions of *legitimating* some form of inquiry into some sector of the world—second-order questions, questions about the putative foundations of some (first-order) inquiry or science—*one cannot fail to do so in a way that commits one to the mirror thesis, either in its narrow or its ampler (more metonymic) form.* Quine is an extraordinarily good test case. Because: (1) consistently

with 'Two Dogmas', Quine refuses to claim *any* cognitively privileged status for his physicalism and extensionalism; (2) he pursues clearly manageable programs of extensional reduction open to disciplined criticism and correction—of a standard philosophical sort; and (3) he is open to particular charges of incoherence, inconsistency, and the like, here and there, even along the lines of Rorty's more detailed criticisms,[43] though not, or not necessarily, as an entailed result of being committed to the mirror thesis.

In a fair sense, the global disorder Rorty identifies, more by part than by whole, is what we may mark as the thesis of the *cognitive privilege* (of the inquiring mind) or the *cognitive transparency* (of the world inquired into), that is, that human inquiry not only succeeds in discerning the structures and properties of reality as they obtain independently of such inquiry (the first-order competence of our science) but can actually demonstrate that it is able to do so (the second-order legitimating competence of philosophy). Now, it is entirely reasonable to construe philosophy therapeutically as exposing and explaining the nature of *that* error—and as, in a sense, self-obviating to the extent it succeeds. This *is* indeed the project shared by Nietzsche, Heidegger, Wittgenstein, Dewey, Sellars, Quine, Davidson, Feyerabend, Derrida—and Rorty. But on that reading, Rorty's conclusion remains an utter *non sequitur*; for, by its very inclusiveness, the disorder becomes extraordinarily easy to avoid. (That was just the point of examining Quine's efforts *after* 'Two Dogmas'.) There is no argument provided—and there is none that could conclusively show—that, once the therapeutic correction were achieved, *no philosophical concerns of the legitimating sort conformable with it could possibly still yield a useful, even ineliminable, function with respect to the rational pursuit of any science.* Here, it needs only to be grasped that, granting the therapeutic correction itself, not only philosophy but *science as well* will be conceptually affected. For, if the 'privilege' or 'transparency' thesis is exploded, then the very operating practices of any (first-order) science would have to be brought into line accordingly; and that confirms both that first-order and second-order questions are conceptually continuous and symbiotically connected, and that a philosophically disciplined inquiry of some sort must be supposed to have been called into play to the extent that our (first-order) science manages *not to violate the therapeutic constraints imposed.*

Thus seen, philosophy becomes—has already become, among Rorty's own heroes—the systematic study of the possibilities of legitimation under the condition of having repudiated the cognitive transparency of any first- or second-order inquiry: *that* finding is simply the abstract formula of the increasingly radicalized project of contemporary Western

philosophy. Hence, the counterargument against Rorty's thesis is a plain *reductio*. Short of invoking an extreme skepticism, which Rorty hardly favors and which, of course, *is* a philosophical option, we must concede that, in some way, human society has shaped a viable science subject always to earlier and ongoing rationally motivated adjustment. But that adjustment is as much philosophy as science, particularly since, on the defeat of the 'mirror' hypothesis, science would be seriously distorted or restrictively encumbered *if it did not pursue its perceived self-correction within the limits of the therapeutic constraint.*

We may put all of this in a pair of very modest claims—it's hard to say whether one should call them philosophical at all or as yet, but they seem 'conversationally' irresistible: (a) modern science has fashioned a way of discovering and has already discovered important features of the actual world; (b) in order to sustain that ability, we need to reflect on the conditions that have made it possible and that might support it in the light of new discoveries. Translated into philosophical jargon, we can hardly deny: (a') the achievement of science supports a minimal realism of some kind; (b') there are no rationally sustained first-order inquiries without second-order (legitimating) inquiries, and no legitimating inquiries without first-order inquiries; and (c') consistent with our therapeutic finding, both first- and second-order inquiries can and must be pursued without appeal to privilege or transparency.

A small puzzle remains, nevertheless. How could Rorty have failed to see this, to draw the same conclusion? The answer is instructive, because it suggests a promising way of construing the radicalized undertaking of contemporary philosophy.

Here, Rorty himself emphatically states—against the would-be presumptions of epistemology, against the presumptions of the unity of science program, in strong support of the insight of hermeneutic discourse—that: "We have not *got* a language which will serve as a permanent neutral matrix for formulating all good explanatory hypotheses, and we have not the foggiest notion of how to get one. (This is compatible with saying that we *do* have a neutral, if unhelpful, observation language.)"[44] But then, a radicalized epistemology or metaphysics need not presume to pursue, to capture, or to be formulable in, "a permanent neutral matrix": *if* we have "a neutral observation language," epistemology and metaphysics could at least work in a way congruent and illuminating with regard to such a language; *and* whatever may be claimed as that "neutral" (first-order) language could not fail to be so designated by way of some second-order, non-neutral, non-"privileged" but distinctly philosophical effort of legitimation. The point is that, on the argument, there would be no single, uniquely correct account of reality, no "notion of truth

about reality which is not about reality-under-a-certain-description," no "privileged description which makes all other descriptions unnecessary because it is commensurable with each of them":[45] of course, that was never—and certainly is not now—necessary at all. There is no such neutral science and there is no such neutral philosophy. But to say that is *not to disqualify philosophy* (in disqualifying the "mirror" model): it's only to begin to grasp the fresher, more radical possibilities of philosophy—the dialectically indicated extension of a well-demarcated practice and tradition. At any rate, that is just the venture we may reasonably pursue as the upshot of the variously therapeutic achievements of Dewey, Heidegger, Wittgenstein (and others), however small, hesitant, uncertain, misleading, biased, inexplicit, self-defeating, or inadequate we may suppose those contributions to be. To put the argument in the shortest possible way: *if*, as Rorty is prepared to hold, with Thomas Kuhn, science can work without a "permanent neutral matrix" or language, and without any assurance that whatever matrix or language we have (granting the contingency and unknown limitations of our own historical life) must be adequate for whatever new experience our science may engender,[46] *then philosophy can do so as well: if* first- and second-order questions are conceptually interdependent, which the therapeutic reading of philosophy ironically (but inconsistently) confirms, then the Kuhnian-like thesis cannot be admitted with regard to science without admitting it with regard to philosophy as well. Q.E.D.

III

Once this much is granted, we need draw out only the natural form the current 'problematic' of philosophy (and science) must take. Clearly, the radicalized project before us is, precisely, how to articulate, in second-order terms, the kind of objectivity and methodological rigor that could obtain in first-order discourse: possible, that is, under the conditions (already fixed by 'Two Dogmas') of an uncompromising holism, the rejection of cognitive transparency, the impossibility of formulating a conceptual framework neutral to, or totalized for, or nondistorting or descriptively and explanatorily adequate with respect to, all possible inquiry—now, further, *under the condition of the historicized nature of human existence.* It would not be unreasonable to claim that Quine, the Wittgenstein of the *Investigations*, Hempel, Davidson, Putnam and Goodman (though with a bit of stirring in the direction of history), even Kuhn (only grudgingly with regard to history, if we admit Kuhn's increasing insistence on reconciling normal and revolutionary science) have all flattened, if not actually ig-

nored, the historical dimension of human cognitive work—which, in a sense (the recognition of history, that is), is really already implicit in their own questioning of what Rorty means by the 'mirror' metaphor. It is not merely that they have flattened out the acknowledgment of history: in doing so, they have also failed to characterize *what remains* promising or defensible or even unavoidable with regard to their own second-order projects, in terms of an analysis of historical processes. One cannot really understand Wittgensteinian 'forms of life' except historically, although Wittgenstein does not pursue the matter. There is no way to take Quinean 'analytical hypotheses' as genuinely working proposals for the field linguist's study of alien behavior, except in terms of the historically contingent habits of mind and practices of an actual society, although Quine never concedes the point systematically (and although the indeterminacy of translation thesis argues a kind of methodological solipsism that, in effect, precludes a more finely gauged accommodation of mere historical complexities). And though he emphasizes the diachronic shifting of the working problems and practices of investigative communities, Kuhn never directly addresses the question of the historicized nature of cognition itself: he considers incommensurability (synchronically) and the impossibility of an omnicompetent neutral language (over the whole of time); but he never turns to the epistemological complications of the intrinsically historicized nature of inquiry, and has only belatedly come to realize that there must be an affinity between his own views and those of the recent hermeneuts (Gadamer, for instance). It is a matter almost totally ignored, even denied, in the analytic tradition; and it is very nearly the life's blood of contemporary phenomenology, Marxism, revived Hegelianism, Frankfurt Critical theory, hermeneutics, semiotics, even latter-day structuralism, even deconstruction.

Here is the source of the inexorable convergence of analytic and continental philosophy: what is largely implicit in the analytic is distinctly salient in the continental. Furthermore, both traditions (if we may so grossly oversimplify matters) are equally zealous about the rejection of cognitive privilege and cognitive transparency, albeit with quite different emphases. The analytic has pursued, at times almost singlemindedly, the prospects of a totalized extensionalism—although always within the space of somewhat nagging, incompletely acknowledged concessions regarding the complexity of natural language and natural culture (history, of course); whereas the continental has proved immensely hospitable, even if often without sufficient rigor, to the intensional complexities of the intentional life of man (history, again)—although always with a telltale nervousness about accommodating the natural and formal sciences and the very conditions of methodological rigor.

There is a use, therefore, to bridging the special benefits and differences between the two traditions; and there is an inevitability in reconciling each to the compensating work of the other. They have already converged in their global rejection of transparency; and *we* may now diverge among ourselves, as their somewhat more radical beneficiaries.

But what does that mean?

First of all, it means that first- and second-order inquiry fall within the same history: this is the sense, Quine's sense, in which epistemology must be 'naturalized', the sense in which the legitimation of science cannot but be informed by cognitive resources no more powerful than those that inform science. Here is the *reductio* of Husserl's will-o'-the-wisp of the ultimate science of phenomenology; on the other hand, well in accord with Husserl's grasp of the function (as distinct from the cognitive privilege) of philosophy, here is the *reductio* of Rorty's failure to concede the structural difference and symbiotic connection between first-order and second-order inquiry.[47]

Secondly, it means that realism and idealism can no longer be segregated within any legitimating effort—which is not to say that a first-order science cannot (by such an effort) be ascribed a reasonable realist status. On the condition of historicity, this also means that Popperian verisimilitude and Peircean long-run expectations are simply naive versions of the very transparency they have characteristically opposed.[48]

Thirdly, it means that our first- and second-order projects are contingently ('blindly', one may even say) confined within the necessarily limited horizon of our historical experience. Consequently, we can never preclude the possibility that, for any present fragment of inquiry, if any theory is admitted to function satisfactorily with respect to it (say, in an explanatory or legitimating regard), indefinitely many alternative, incompatible theories of a comparable sort may be fitted to the same fragment; and that, over time, even our conception of how to appraise such a fit may be substantively altered by our changed experience. Part of the point is a concession to the new prospects of relativism, since there can no longer, even in principle, be a uniquely correct resolution of any such puzzle; and part is a concession to the influence of history, to the completely openended nature of cognitive discovery, in a sense not entirely unsympathetic to the picture Popper paints—although of course he sketches it in order to reject the methodological claims of historicism.[49]

And finally, it means that our own critical efforts to penetrate the conceptual conditions under which we pursue our first- and second-order inquiries are as much hostage to the historical preformation of our cognitive abilities as are the abilities entailed in those inquiries. This of course is hardly more than the barest sketch of the master theme of Heidegger's

account of *Dasein*.[50] And so, quite rightly, it is the union of Quine and Heidegger, so to say, that identifies, however heterodox it may seem, the radical possibilities of the future extension of philosophical practice. In effect, the question before us is: What form can the legitimating inquiries of philosophy coherently favor under the condition that whatever may be the apparently gathering consensus of science and critical reflection, we must reinterpret our cognitive achievements in terms of the peculiar, insuperable contingencies of discontinuous, fragmentary, tacit, preformed, plural, divergent, skewed, diachronically changing, and unpredictably novel conceptual schemes? Our dawning enterprise is, precisely, how to pursue the question defensibly: between the threatening limits of skepticism and anarchy, in accord with a sense of history conformable with such constraints, and still linked in an explicable way to the entire past tradition that it is now obliged to reinterpret so radically.

This, then, is a proposal in the form of a prophecy. It's a proposal of an entirely viable, currently pertinent conception of the project of philosophy—against the deficiencies of recent contributions of the most important and influential kind; and it is a prophecy of how Western philosophy is likely to proceed—against the prophecies of its own most recent detractors. The essential philosophical theme is always judged to be perennial, though its perception changes. In our own time, it is perhaps the working out of the relationship between extensionalist and intensionalist claims that commands our attention most centrally, through an indefinitely varied array of detailed puzzles. The theme is perennial, not because it doesn't change but because no one would bother to advocate as a master theme a particular candidate, without supposing that it could, in a rather natural way, collect the entire tradition's history and work. Roughly, then, the tradition may be expected to radicalize its project in an increasingly profound way, by intensifying the difficulties (therefore, also, the perceived power) of sustaining any large extensional conception of a given domain of inquiry or of the cognitive powers that make such an achievement possible. By and large, the currents of our time strongly suggest that extensionalism will be seen to have run its course: in the sense that much of our first-order work and life will be seen not to fit satisfactorily the constraints of extensionalism itself, except piecemeal and provisionally; and in the sense that even such an achievement will be seen to depend, in principle, on the executive tolerance of large cognitive powers that cannot themselves be convincingly thus reduced.

But here, of course, a prophecy is a prophecy.

NOTES

1. Ludwig Wittgenstein, *Philosophical Investigations*, trans. G. E. M. Anscombe (New York: Macmillan, 1953), §§ 38, 109.

2. Martin Heidegger, 'The Onto-Theo-Logical Constitution of Metaphysics', in *Identity and Difference*, trans. Joan Stambaugh (New York: Harper and Row, 1969), 71.

3. See Jacques Derrida, 'Différance', *Margins of Philosophy*, trans. Alan Bass (Chicago: University of Chicago Press, 1982).

4. Martin Heidegger, *Being and Time*, trans. from 7th ed. John Macquarrie and Edward Robinson (New York: Harper and Row, 1962), 25ff (pagination to the German edition).

5. W. V. Quine, 'Two Dogmas of Empiricism', *From a Logical Point of View* (Cambridge: Harvard University Press, 1953).

6. Ibid., 41.

7. There is a very brief reference to transcendental arguments in W. V. Quine, *Theories and Things* (Cambridge: Harvard University Press, 1981), 22.

8. 'Two Dogmas of Empiricism', 41.

9. Cf. W. V. Quine, *Word and Object* (Cambridge: MIT Press, 1960), 68–79; 'Ontological Relativity', *Ontological Relativity and Other Essays* (New York: Columbia University Press, 1969).

10. 'Ontological Relativity', 35.

11. *Word and Object*, 151.

12. Ibid., 231; italics added. Cf. also, W. V. Quine, *Theories and Things*, 100, 184; 'Three Grades of Modal Involvement', *The Ways of Paradox and Other Essays*, rev. and enl. (Cambridge: Harvard University Press, 1976).

13. See Pierre Duhem, *The Aim and Structure of Physical Theory*, trans. from 2nd ed. Philip P. Wiener (Princeton: Princeton University Press, 1954); also, Bas C. van Fraassen, *The Scientific Image* (Oxford: Clarendon, 1980).

14. *Word and Object*, 231; italics added.

15. Ibid., 232; italics added.

16. 'On the Individuation of Attributes', in *Theories and Things*, 100.

17. Ibid., 107.

18. Ibid., 111–112.

19. See Donald Davidson, 'In Defense of Convention T', reprinted in *Inquiries into Truth and Interpretation* (Oxford: Clarendon, 1984); cf. Ian Hacking, *Why Does Language Matter to Philosophy?* (Cambridge: Cambridge University Press, 1975), chapter 12.

20. *Theories and Things*, 184.

21. W. V. Quine, 'Goodman's *Ways of Worldmaking*', reprinted in *Theories and Things*, 98. Cf. Nelson Goodman, *Of Mind and Other Matters* (Cambridge: Harvard University Press, 1984), Part II.

22. See Joseph Margolis, 'Pragmatism without Foundations', *American Philosophical Quarterly*, XXI (1984).

23. 'Two Dogmas', 20.

24. An extremely careful account of the continuity and distinction of Kant's and Hegel's accounts is conveniently summarized in Michael Allen Gillespie, *Hegel, Heidegger, and the Ground of History* (Chicago: University of Chicago Press, 1984), chapter 3.

25. For a fuller account specifically comparing Quine and Heidegger, see Jo-

seph Margolis, 'A Sense of Rapprochement between Analytic and Continental Philosophy', *History of Philosophy Quarterly*, forthcoming.

26. W. V. Quine, 'Epistemology Naturalized', in *Ontological Relativity*, 82–83; italics added.

27. Ibid., 69; cf. also, 87–88, where Quine clearly considers second-order questions of relativism, "epistemological nihilism," and the possibility of an "absolute standard."

28. Cf. ibid., 86–88.

29. For a sketch of a heterodox reading of transcendental arguments, see Joseph Margolis, 'Scientific Realism as a Transcendental Issue', *Manuscrito* 7(1–2):87–107.

30. Richard Rorty, *Philosophy and the Mirror of Nature* (Princeton: Princeton University Press, 1979), 6.

31. Ibid., 7.

32. The reasonableness of this assessment may be judged by considering the accounts of Wittgenstein's issue, in Saul A. Kripke, *Wittgenstein on Rules and Private Language* (Cambridge: Harvard University Press, 1982); and in G. P. Baker and P. M. S. Hacker, *Skepticism, Rules and Language* (Oxford: Basil Blackwell, 1984).

33. See Georg Henrik von Wright, *Wittgenstein* (Minneapolis: University of Minnesota Press, n.d.).

34. Op. cit., 7.

35. Rorty, op. cit., 12–13.

36. Ibid., 45.

37. Ibid., 46.

38. The fragment is collected in Walter Kaufmann (trans. and ed.), *The Portable Nietzsche* (New York: Viking, 1954).

39. See W. V. Quine, *The Roots of Reference* (La Salle, Ill.: Open Court, 1973), Part III. The point, here, it should be said at once, is not to take sides with either objectual or substitutional quantification. Quine acknowledges the linkage between the substitutional view and early learning (which is in *its* favor, in cognitive terms, no matter what its formal limitations); on the other hand, the putative *formal* advantages of the objectual view never come to grips with the issue of working with or reforming natural languages in cognitive and empirical terms. In short, we are simply not faced with a choice between objectual and substitutional quantification. (Cf. also, 'Ontological Relativity'.) But Quine's convictions, though they admittedly have to do with his sense that formal advantages do have ontological import (for instance, explicitly, at *Word and Object*, p. 275), have nothing as such to do with pretending that *he* has philosophical resources that he denies anyone else has.

40. See Rorty, op. cit., particularly pp. 354, 373, 387–389.

41. Cf. ibid., pp. 192–209.

42. For a very clear sense of Quine's loyalties and caution, see for instance *Word and Object*, pp. 231–232, 275–276.

43. Cf. for example Joseph Margolis, 'The Locus of Coherence', *Linguistics and Philosophy*, VII (1984).

44. Rorty, op. cit., pp. 348–349.

45. Ibid., pp. 377–378.

46. Ibid., ch. 7.

47. See for example Edmund Husserl, *Phenomenology and the Crisis of Philosophy*, trans. Quentin Lauer (New York: Harper and Row, 1965).

48. See for example Karl R. Popper, 'The Aim of Science', in *Objective Knowledge* (Oxford: Clarendon, 1972), for one formulation of his opposition to essentialism.

49. See Karl R. Popper, *The Poverty of Historicism*, 3rd ed. (New York: Harper and Row, 1961).

50. See Heidegger, *Being and Time*, pp. 19–20, 150–153, 328–331.

11

Amelie Oksenberg Rorty

SOCRATES AND SOPHIA PERFORM THE PHILOSOPHIC TURN

Philosophy is not, and never has been, a subject. It is, and should be, a variety of activities, performed in a variety of ways. Historically, it has served different cultural functions at different times, with shifting alliances and oppositions to logic and science, theology and visionary poetry, social and political reform. Philosophy is what *we* do. But who are *we*? And what should we now be doing. With whom and for whom should we engage in philosophic exploration? In hopes of what?

On the one hand, *we* are an old-fashioned guild, with a self-selecting membership, with master craftsmen and apprentices who differ in their styles and specializations, but who nevertheless roughly recognize one another's abilities across those differences. On the other hand, *we* are inquirers of a certain kind, kindred spirits not necessarily including all and only card carrying professional philosophers. *We* might well include critically reflective lawyers, scientists and physicians, some literary critics, and perhaps exclude some noninquiring professional philosophers. What should *we* be doing? On the whole, the variety of activities—and the varieties of fields we are cultivating—is happily so diversified that, more by chance than by intelligent design, we are doing those things we ought to be doing. But there are some things we ought to be doing that we are leaving undone.

In addition to all the activities which the guild of philosophers are presently performing, we need to engage in a new version of Socratic inquiry, to raise basic questions about our fundamental activities and practices. On some deep level, few of us know what we are doing. Not only as philosophers, but as citizens, parents, teachers, friends, we do not know what is central to performing our activities well. We guild-philosophers are good at discussing whether answers to the question "How should one/ we/I live?" are objective, or whether they can be rationally justified. But we are not, as philosophers, very good at actually examining the details of

competing substantive answers to that question, tending as we do to protect ourselves by moving straightway to methodological issues. So quickly do we make that move that we rarely even ask questions about the most basic and fundamental features that shape our lives.

I want first to sketch a day-dream about what philosophers could now usefully be doing. After outlining a program of work, I shall try to answer objections that, as day dreams for philosophy go, this one is an unrealistic, naive remnant of the worst of the sixties. I want to argue that this proposal is practical, both in that it brings philosophy closer to our practices, and in that it is feasible.

We need a new Socrates and Sophia to goad and sting us. They should enter all sorts of institutions, not only medical schools to help the physicians avoid guilt and malpractice suits, not only law schools to help jurists define rights, privacy, and the limits of government interference, not only schools of education to give courses on the history of education and cross-cultural comparisons of curricula. The new Socrates and Sophia should be wandering apprentices and questioners, entering every walk of life, Everyman's King's Fools, who understand nothing, and who (without becoming philosophical Luddites, dogmatic knee-jerk skeptics) question everything. They should go to the police stations and to the jails, to advertising agencies and the New York Stock Exchange, to Amtrak and the Pentagon, factories and publishing houses to ask questions about our fundamental activities. They should raise issues for discussion, rather than propound answers or solutions. If the new Socrates and Sophia are to be heard, they should be lovable and loving philosophers, capable of genuinely cooperative common inquiry, ironic and firm but without a trace of arrogance. Well, that is a ridiculously high-minded job and employee description: they should be interesting and fun, and above all, neither defensive nor offensive in questioning our most ordinary enterprises. They should ask: Who should be raising children? For whom, with what ends and goods in view, are we educating the next generation? Should we organize our lives—and educate our children—primarily to promote individual achievement and personal contentment? Or should we (also?) stress the primacy of individual contributions to community welfare? What range and sorts of relationships should we have with one another? What is the place of sexuality in friendship? What is marriage? What attitudes should we promote towards the varieties of equality, to status, authority and hierarchy? To what extent and how should the community as a whole define and direct the goods we pursue? How should the general aims of the economy be defined? Who should determine the criteria for defining the unit size of work and production? What values besides profit and efficiency should go into determining production patterns?

Such a Socratic inquiry might be thought to rest on too many assumptions that we have learned to question. And indeed some moral philosophers are questioning the assumptions of Socratic inquiries: are substantive moral claims objective, verifiable, justifiable? Do subcultural values vary so dramatically that we cannot evaluate other cultures' primary values? Under what conditions might an individual or group rationally or at any rate justifiably violate the deepest values of their culture? Though discussions of these fundamental meta-ethical issues have become increasingly subtle and refined, they remain ungrounded abstractions unless their effects on practices and institutions are made explicit. In the end, after clearing out the rubbish of bad arguments, we are left with some well-constructed, sound but quite diverse philosophical positions on these questions. To evaluate competing claims about the epistemological status of moral discourse and the metaphysical status of fundamental values, it is necessary to determine how the various alternatives would affect our institutions and practices. And to do that, we have to understand the import and significance of our current practices.

Even if—and precisely because—the answers to the substantive Socratic questions are subculturally variable, even if there were no objective answers, even if ethical realism were indefensible, we still need to consider these questions from the positions in which we find ourselves. Even if it were true that our positions and situations do not affect our most general principles and obligations, applying these general principles in an appropriate, substantively action guiding way requires specifying the contexts in which we (ought to) find ourselves. But few of us have a good understanding of our situations and basic activities because we do not have a good understanding of ourselves. Among the questions that Socrates and Sophia should goad us into asking are those which would help us to specify, in a full and detailed way, not only what we do, but what we should do. We need to think about how best to define and understand our many *personae*, as philosophy professors, friends, parents, sisters; alien residents; neighbors and colleagues; employees and employers; fellow citizens of Vietnamese immigrants, child abusers, exploited parents. What do these various roles presently demand of us, and what priorities do we presently accord our various commitments? With a better understanding of our current practices, we then need to ask whether gender, class, age, religion, health, vitality and intelligence have or should have any bearing on determining what we should do.

Even those who think that the answers to these questions, when raised in the proper practical mode, must be in the first person singular, still rarely discuss these substantive, action guiding issues. In any case, many of these matters are still partially indeterminate: there is room for negotia-

tion and specification. Questions that must be raised and answered in the first person singular need not be deliberated only *in foro interno*: on the contrary, those are just the issues whose examination most requires open discussion, help from our friends and fellows. Our solitary perspectives on these issues are, in the nature of the case, perspectival, even partial. Even our friends are likely to be like-minded; and their special relation to us can make the most searching, and sometimes searing investigations overly charged. Besides help from our friends, we need an impersonal, yet contextualized public forum for debating the basic issues of our time.

What questions should Socrates and Sophia ask of whom?

Placing themselves within Schools of Architecture, Socrates and Sophia might ask: how does the definition of spaces affect the interactions among those who use them? Should there be a distinction between public, domestic and private spaces? How should such distinctions be drawn? How does the definition of various sorts of spaces affect the performance of various activities, e.g. as performed alone or communally, sequentially or simultaneously? What activities and modes of life should be visible and what enclosed? What activities should take place inside (a house, a building, the city) and what outside? What should be the style (e.g. archaic or 'futuristic', accessible or inaccessible, imposing or unimposing) of public buildings? Where is it best for the elderly to live? (With their families? In the buildings that house legislative assemblies? Near day care centers and kindergartens?) Where should basic scientific research take place? (Within universities, mixed with teaching laboratories? In separate research institutions?)

Placing themselves within public and private schools, as well as within Schools of Education, Socrates and Sophia might ask: for whose benefit are the young being educated? (For themselves, their families, the polity, future generations?) Who should educate whom for what? What faculties and gifts should be developed, what restrained? And in what sections of the population? What modes of teaching are appropriate to the varieties of skills we learn? How should history and 'how things are done' be presented? What should the relations between teachers and students be? How solitary or cooperative should learning be? How should we assess the implicit conflicts between our current elitist and populist assumptions? Should the curriculum of a school in Harlem be the same as that for a small school a hundred miles mountainward from Butte, Montana?

Placing themselves within all sorts of work places—factories, medical research laboratories, farms, police stations, courts, universities, legislatures—Socrates and Sophia might ask: For whose benefit is this labor done? How and by whom should tasks and their goals be defined? How should this work be coordinated with other work? Evaluated and re-

warded? What criteria besides efficacy and efficiency should serve to determine for the division of labor and the definition of unit-tasks? How and by whom should decisions about the distribution of goods be made?

Placing themselves within public and private social agencies (state welfare agencies, research foundations) Socrates and Sophia might ask: Who are the ultimate clients of this work? Who (funding agencies, clients, practitioners) should participate in making the varieties of policy decisions, at what level and how? How can the agencies participate in the social and economic planning which would foresee and prevent the problems with which agencies deal?

Of course architects, educators, researchers and social planners might be thought not to need the intrusion of presumptuous philosophers to incite them to ask these questions: reflection is an essential part of practice. But their special relation to their work—their being deeply engaged in the middle of it—can prevent practitioners from seeing it. Sometimes what is seen too closely, is not seen clearly.

Before considering whether philosophers can add anything to the reflections of thoughtful practitioners, let us consider whether Socratic inquiry adds anything to the work of guild-philosophers, who have, it might be argued, discussed all these issues for a long time. Although there is a strong resemblance between Socratic inquiry and some varieties of applied ethics, the two differ in scope, in co-workers and audience. By now, applied ethics has a set of received topics, problems that arise in the midst of our current practices: abortion and euthanasia, just wars, reverse discrimination, paternalism, 'whistle blowing' against collegial corruption. While philosophers working on these problems often make extremely constructive and subtle contributions, they tend, understandably enough, not to examine the basic institutions and practices within which these problems arise. It is just because these unexamined assumptions often provide the sting and the force of the problems of practical ethics, that they require Socratic investigation, an inquiry that might engage all members of the community. Unfortunately, with some exceptions in medical ethics, the co-workers and the audience for applied ethics tend to be fellow philosophers. But Socrates talked with all comers in the Agora, and himself searched out rhetoricians, sophists, and, until he gave up on them, astronomers and cosmologists. As Socrates and his friends knew, moving such fundamental questioning to the market place can be perceived as politically subversive. But while Socratic inquiry is often normative, and usually disturbing, it is not distinguished by any particular political orientation: it does not entail a revolutionary, a reformist or a conservative outlook. Of course Socrates and Sophia cannot escape from the nexus of power relations that are manifest in all action and practice.

They will be perceived as powerless or powerful, as endangering or as reinforcing existing distributions of power. Their great advantage might be that, as marginal figures both in philosophy and in the agencies they enter, they would be in a position to question and to make explicit whatever ambiguities and complexities exist in their own practices. Indeed issues of power, including the power of intellectuals as ambiguous marginal figures, would be central among their investigations.

'But who would want to listen to Socrates and Sophia, these amateurs, these interns, unless they actually enter into the activities they question, becoming journalists, mathematicians, musicians? Since practitioners are in any case always already engaged in reflective inquiry, might it not just be better for them to extend and deepen their philosophical reflections?' In a way, it doesn't matter whether practitioners become philosophical or philosophers become practitioners. Certainly unless Socrates and Sophia become reasonably well versed in the various enterprises they are investigating, they are likely to be perceived as naive and arrogant meddlers. For their critical reflection to be successful, they must be astute and tactful learners, good at being the sorts of apprentices who ask questions that are sufficiently within a practice to accredit them as worthy of serious consideration. At the same time, they must be sufficiently detached from current definitions of practices to be able to unearth their hidden assumptions and to consider genuine alternatives.

But while in one way, it doesn't make much difference whether practitioners become philosophers or philosophers become practitioners, the direction of expansion makes some difference to the character of the inquiry. The balance between being sufficiently absorbed in a practice to ask sensible questions about it, and being sufficiently detached to ask deep and sometimes perhaps undermining questions, is a difficult one to achieve. By virtue of their guild training, and by virtue of their marginality, philosophers may have a better chance of achieving it than those who have continuously been enmeshed in the detailed work of institutions, particularly when they have been socialized and formed by those practices, having their community, livelihoods and self-esteem at stake. It is difficult—and perhaps even unwise—for anyone immersed in the details of a practice—especially those central demanding and dynamic practices where there is always too much to attend—to step back reflectively from the tasks at hand. The kind of reflection that is crucial to performing a practice well is highly particular: it does not question the basic assumptions of the practice. As philosophers, Socrates and Sophia can have the breathing space of relative institutional independence; and yet as institutionally established reflective interns, assigned the task of assessing the needs of the labor force, they would not be mere interlopers or amateurs.

But why should we suppose that conventionally educated philosophers should be good at this sort of Socratic investigation? After all, philosophy has remained a distinctive discipline by virtue of a set of historical accidents: at different times, and for different reasons, it has incorporated or discarded distinctive activities. The genre, the style, the modes of analysis and argument have changed, sometimes the point and purpose as well. Each change leaves a layer and an area of work. Is there any reason to think that current philosophic training would prepare Socrates and Sophia to engage in such constructive reflection? Indeed those whose intellectual and psychological temperaments naturally incline them to reflective discussions of this sort might well initially be perceived as marginal figures within the philosophical community. And this would be a good thing. Just as the marginality of philosophers enable them to be participant observers of their culture, ambiguously both engaged in, and yet also detached from its activities, so too Socratic philosophers are likely to be marginal to academic professional philosophy. Even as traditional philosophers, they are independent observers, questioning the assumptions of current philosophical practices. And all of this is a good thing. As participants of their culture, marginal figures have the understanding that is required to make inquiry respectable; and as independent observers, their detachment allows more fundamental questioning. With some of the natural pleasures that Hume catalogues as inducements to a life of inquiry—the pleasures of the chase, the pleasures of clarification—Socrates and Sophia would presumably question the existing practices and institutions of philosophy, just as they do those of other professions. Philosophy cannot create, but can only discover and develop a Socrates or a Sophia.

But what are the sources of new Socratic philosophy? Where and how are we going to find Socrates and Sophia? What psychological and intellectual habits and capacities can be called upon to be exercised in such philosophy? Mid-despair about philosophy, Hume asked "What are the sources of curiosity, of the love of truth?" (*Treatise*, Bk. II, Pt. III, Sec. X, pp. 448ff) He gives a surprising answer: having distinguished that kind of truth that is "the discovery of the proportions of ideas considered as such" from that kind of truth which involves the conformity of our ideas to their objects, he remarks that the former (and presumably philosophic truth is primarily this kind of truth) gives the pleasure of natural capacities well exercised in invention and discovery. (*Treatise*, 448–9) Of course we want to discover and invent important and useful truths, but we also take direct delight in the exercise of the imagination for its own sake. With his usual inventiveness and irony, Hume echoes his solution to the devastations of philosophical skepticism, by showing how philosophical thought arises from natural psychology. He develops an analogy between philosophy and

hunting: both afford the pleasures of the chase, of focused attention, of overcoming difficulties; both are guided by an extended idea of utility, made possible by the use of the empathic imagination. "In both cases the end of our action may in itself be despised, yet in the heat of the action we acquire such an attention to this end, that we are very uneasy under any disappointments." (*Treatise*, 542) Finally, he adds, curiosity into the thoughts and lives of others is enlivened by the sympathetic imagination: we hope our investigations will be of use. All these psychological activities are, in Hume's sense, natural: they require no special motives beyond the pleasure of their exercise to set them in motion. Indeed, these are, along with the principles of association, among the natural actions of the mind. This is what it is to have a mind: to think and act in this way.

Hume is right: philosophy is, in this sense, natural to the mind. Because the habits and activities exercised in philosophy are just those exercised in all thought, we need not look for special motives or special capacities to find a Socrates and Sophia. The natural bent of pleasure and power of the exercise of our capacities is enough to generate good questioners. To Hume's list, we can add other habitual actions of the species. Because these do not involve noble gestures but simple pleasures, the new Socrates and Sophia can be counted on to engage in philosophy as: playing; day dreaming; quarreling; struggling for power; wooing; exhibiting plumage; gnawing at details; building and destroying beautiful systems; making and unmasking friends and enemies; finding practical solutions to particular problems; denying and fleeing from those very same problems; setting and upsetting moral and political ideals; exploring, expressing and justifying their perspectives; reconciling themselves to necessity; denying and detaching themselves from necessity; controlling and reforming society; constructing poetic visions; getting things clear; protecting themselves from the tyranny of dogmatic authority; communicating and sometimes just passing the time of day with friends; trying to understand strangers; desperately trying to endow their lives with significance; giving despair and joy a name and a description; exposing injustice and protecting the defenceless. Academic philosophy has often pretended to rise above all these activities; but in truth it has, as have all our practices, expressed them. That is what it is to be creatures like ourselves, to commingle these basic activities in all we do, including our most elevated purely investigatory, truth-bound reflections.

Philosophy requires contrary traits and tasks. Like the functions of universities, government, and other active institutions, the various functions of philosophy are best defined in a system of checks and balances. Socrates and Sophia must speculate and unmask speculation, synthesize and distinguish, question and justify, systematize and undermine sys-

tems. The various habits and capacities exercised in philosophy should be counterpoised, not necessarily in each individual, but in the culture at large. Tensed and opposed to one another as they are, all these activities pervade all our practices. They are exercised in city planning, in parenting and teaching, in business enterprises, in architecture, in collecting butterflies, in anthropological and mathematical exploration.

This proposal for bringing Socratic inquiry into the Market Place might seem a coy, naive piece of propagandistic utopian nonsense. An attempt to evoke if not provoke Socratic inquiry should not assume the rhetoric of a fundamentalist sermon. In the first place, what is all this about Sophia? This is supposed to be a serious philosophical essay, not a Mozart opera. Wouldn't it have been enough to argue for the return of Socrates, and splatter 'he (or she)' throughout a more respectably austere prose? In a way, it would have been enough. But the introduction of Sophia represents an additional hope. Often, outsiders are in the best position to see practices clearly and to raise basic questions about them. In a complex way, many women have been outsiders in our culture. However well—and even centrally—integrated into the culture we have been, however powerful we have been as women, daughters, wives, and mothers, still we have not held those positions which were perceived as positions of power. As freedom appears most vivid to those who lack it, so too power is more visible and perhaps most clearly understood by those who lack it. For what are surely a large range of complex reasons, women have not, until recently, been guild-philosophers. Certainly Sophia will not, solely by virtue of being a woman, have a special point of view to contribute to the Socratic task. Nevertheless, she will have the advantages—the bittersweet advantages—of distance and clarity that those who are not direct beneficiaries of socio-political arrangements can sometimes achieve. However astute and modest he may be, however sensitive to the place of accident and luck, Socrates will be heir to certain goods and powers that have not automatically been accorded Sophia. She will have more reason to question the practices of her culture. She must take care: her questioning may have an edge, the edge of the initial presumption that there is something wrong with the practices. There may well be! But if there are, Sophia should attempt to articulate, rather than assume those wrongs. In any case, her history may make her eyes sharp for issues that Socrates might not notice. So much for a mere tip of the iceberg concerning 'Socrates and Sophia'.

There is a more practical objection to the return of Socratic philosophy. How are Socrates and Sophia to move themselves out of the academy and the professional journals, into the range of institutions where they can best observe and discuss our practices? How can they gain entry in

these busy places, persuade overworked people to engage in philosophical reflection? This is not an insuperable problem. Universities and research foundations are in positions of considerable power: after all, it is they who train and socialize the labor-force. Without discussion, and indeed without much reflection, universities have been training middle-range government officials, company executives, bureaucrats in the private and the public sectors. University officials might well arrange for Socrates and Sophia to become philosophical interns, by the simple and truthful, if somewhat disingenuously manipulative, expedient of asking the directors and boards of the major institutions to join in a reflective inquiry on the kind of education and training the labor-force should have. Major universities could readily approach large corporations, government and private agencies, the media to ask: 'What kind of people do you need in your labor-force? What kinds of questions should they ask? How can we contribute to your employees being able to raise those questions in an appropriate way? What would an appropriate way be? We need—we academics and you practitioners—to investigate our respective roles and functions in the culture and the society at large. It is of interest to *you*, as well as to us, to ask: What should such people know? What should they be able to do? What sort of mentality should they have? It would benefit you to place some philosophers within your organization to study your needs and directions. Let us institutionalize the practice of Socratic reflection within our major central organizations.' Because such inquiries can serve the interests of corporations and agencies, they might reasonably be approached to subsidize the cost of philosophic interns.

Of course one might well worry that philosophic interns might only serve as yet more sleek modern office furniture, tax deductible 'in-house philosophers'. For if Socrates' and Sophia's questions really subverted or threatened the power structure, their investigations would quickly be deflected or stopped. Even if they did not, all their earnest and resourceful caution might not prevent their being used as high gloss advertising. Yes, so it might be. But isn't something—even if it is only a trace of a serious and disturbing question planted in the mind of a city planner or an Amtrak bureaucrat (people who, after all, themselves once hoped to do something good with their power)—better than nothing?

The greatest resistance might come not from industry and the agencies, but from the members of the Academy who fear that an alliance with established institutions might endanger intellectual autonomy. The most serious grounds for this quite reasonable fear are that philosophic interns might form too close a substantive inter-connection between universities and other major institutions in the society. The problem is not that universities will lose their autonomy; it is not clear what sort of autonomy

they actually have. Far from increasing the dangers of universities becoming appendages, Socratic questioning would locate the danger we now court. We surely do not have a clear idea of the kind of autonomy that universities now have but might lose.

But how are we to get started on this project? Certainly one way—a very important way—would be for Socrates and Sophia to enter actively into schools of education, to incite and promote philosophic reflection among those who are teacherly models. Let Socrates and Sophia turn teachers into reflective questioners so the teachers can eventually affect everyone else. Fear of inquiry often begins with parents' fears of exposure or attack from their children's questions. We tragically treat questioning as accusatory, as a challenge for justification, rather than as an invitation to cooperative exploration. Perhaps because we are always aware of ourselves as judged and ranked, we are defensive rather than delighted by questioning. But we all need to acquire a sense of safety in reflective open-ended, unstructured investigation. Placing Socrates and Sophia as interns in the range of social institutions—exposing parents to the institutionalization of reflective investigation—is a way of preparing parents for their children's questions.

'And even if any of this were remotely possible, what good would any of it do?' The proposal for a philosophic turn to Socrates and Sophia suffers from an unquestioned intellectualistic assumption: it supposes that reflective discussion is either a good in itself, or that it moves to improving our condition. As the philosophic turn has been described, Socrates and Sophia are just raising questions, trying to get people to engage in reflective discussion: they are not themselves presenting new theories or solutions. Even if it were true that the unexamined life is not worth living, there is no guarantee that the examined life is any better. Although historically at least some of our most cherished goods, goods we prize as advances in civilization or freedom came from just such critical, and undirected discussions, there is no guarantee that discussions of this kind lead to better practices. It *is* quite possible—indeed it is likely—that not much good would come of Socrates' and Sophia's discussions in the Market Place. Nevertheless attempting to characterize and understand the problems of our practices is usually a step towards solving them; it surely is a step toward avoiding the Janus-faced dangers of an obdurate attachment to harmful practices and of a blind, impulsive movement to their transformation. In the nature of the case, we cannot now sketch the sorts of inventive answers and suggestions that could only develop contextually and cooperatively. Whether the solutions that might emerge from such discussion can be appropriately realized is itself a matter of historical and contextual determination.

In any case, what is the contrast? Is philosophy 'useful' now? More or less useful than, say, literary criticism, sociology or political science? Perhaps more significantly, raising reflective questions is, as Hume observed, one of our natural activities, something we just do—to our despair and delight—whether or not such reflection is as useful as, in the heat and history of the matter, we like to believe.

Since we have much to be modest about, we can begin modestly.

I am grateful to the Hannah Obermann Professorship for a generous grant; to Radcliffe College for hospitality and to Rüdiger Bittner, Tom Cook, Tamara Deutscher, Michael Hardimon, Aryeh Kosman, Jay Rorty and Richard Schmitt for comments and discussions. Avner Cohen tried to persuade me to be less naive and more reflective: this paper would have been far more responsible had I followed more of his suggestions than I did. I have not, I must confess, presented these proposals to the Cambridge Building Department, the executives of the New England Telephone company, or the editorial board of *The Boston Globe*.

12

Nancy Fraser and Linda Nicholson

SOCIAL CRITICISM WITHOUT PHILOSOPHY: AN ENCOUNTER BETWEEN FEMINISM AND POSTMODERNISM*

Feminism and postmodernism have emerged as two of the most important political-cultural currents of the last decade. So far, however, they have kept an uneasy distance from one another. Indeed, so great has been their mutual wariness that there have been remarkably few extended discussions of the relations between them.[1]

Initial reticences aside, there are good reasons for exploring the relations between feminism and postmodernism. Both have offered deep and far-reaching criticisms of the institution of philosophy. Both have elaborated critical perspectives on the relation of philosophy to the larger culture. And, most central to the concerns of this essay, both have sought to develop new paradigms of social criticism which do not rely on traditional philosophical underpinnings. Other differences notwithstanding, one could say that, during the last decade, feminists and postmodernists have worked independently on a common nexus of problems: they have tried to rethink the relation between philosophy and social criticism so as to develop paradigms of 'criticism without philosophy'.

On the other hand, the two tendencies have proceeded, so to speak, from opposite directions. Postmodernists have focused primarily on the philosophy side of the problem. They have begun by elaborating antifoundational metaphilosophical perspectives and from there have gone on to draw conclusions about the shape and character of social criticism. For feminists, on the other hand, the question of philosophy has always been subordinate to an interest in social criticism. So they have begun by developing critical political perspectives and from there have gone on to draw conclusions about the status of philosophy. As a result of this differ-

ence in emphasis and direction, the two tendencies have ended up with complementary strengths and weaknesses. Postmodernists offer sophisticated and persuasive criticisms of foundationalism and essentialism, but their conceptions of social criticism tend to be anemic. Feminists offer robust conceptions of social criticism, but they tend, at times, to lapse into foundationalism and essentialism.

Thus, each of the two perspectives suggests some important criticisms of the other. A postmodernist reflection on feminist theory reveals disabling vestiges of essentialism, while a feminist reflection on postmodernism reveals androcentrism and political naivete.

It follows that an encounter between feminism and postmodernism will initially be a trading of criticisms. But there is no reason to suppose that this is where matters must end. In fact, each of these tendencies has much to learn from the other; each is in possession of valuable resources which can help remedy the deficiencies of the other. Thus, the ultimate stake of an encounter between feminism and postmodernism is the prospect of a perspective which integrates their respective strengths while eliminating their respective weaknesses. It is the prospect of a postmodernist feminism.

In what follows, we aim to contribute to the development of such a perspective by staging the initial, critical phase of the encounter. In section I, we examine the ways in which one exemplary postmodernist, Jean-François Lyotard, has sought to derive new paradigms of social criticism from a critique of the institution of philosophy. We argue that the conception of social criticism so derived is too restricted to permit an adequate critical grasp of gender dominance and subordination. We identify some internal tensions in Lyotard's arguments; and we suggest some alternative formulations which could allow for more robust forms of criticism without sacrificing the commitment to antifoundationalism. In section II, we examine some representative genres of feminist social criticism. We argue that, in some cases, feminist critics continue tacitly to rely on the sorts of philosophical underpinnings which their own commitments, like those of postmodernists, ought, in principle, to rule out. And we identify some points at which such underpinnings could be abandoned without any sacrifice of social-critical force. Finally, in a brief conclusion, we consider the prospects for a postmodernist feminism. We discuss some requirements which constrain the development of such a perspective and we identify some pertinent conceptual resources and critical strategies.

I. POSTMODERNISM

Postmodernists seek, *inter alia*, to develop conceptions of social criticism

which do not rely on traditional philosophical underpinnings. The typical starting point for their efforts is a reflection on the condition of philosophy today. Writers like Richard Rorty and Jean-François Lyotard begin by arguing that Philosophy with a capital 'P' is no longer a viable or credible enterprise. From here, they go on to claim that philosophy, and, by extension, theory more generally, can no longer function to *ground* politics and social criticism. With the demise of foundationalism comes the demise of the view that casts philosophy in the role of *founding* discourse vis-à-vis social criticism. That 'modern' conception must give way to a new 'postmodern' one in which criticism floats free of any universalist theoretical ground. No longer anchored philosophically, the very shape or character of social criticism changes; it becomes more pragmatic, ad hoc, contextual and local. And with this change comes a corresponding change in the social role and political function of intellectuals.

Thus, in the postmodern reflection on the relationship between philosophy and social criticism, the term 'philosophy' undergoes an explicit devaluation; it is cut down to size, if not eliminated altogether. Yet, even as this devaluation is argued explicitly, the term 'philosophy' retains an implicit structural privilege. It is the changed condition of philosophy which determines the changed character of social criticism and of engaged intellectual practice. In the new postmodern equation, then, philosophy is the independent variable while social criticism and political practice are dependent variables. The view of theory which emerges is not determined by considering the needs of contemporary criticism and engagement. It is determined, rather, by considering the contemporary status of philosophy. As we hope to show, this way of proceeding has important consequences, not all of which are positive. Among the results is a certain underdescription and premature foreclosing of possibilities for social criticism and engaged intellectual practice. This limitation of postmodern thought will be apparent when we consider its results in the light of the needs of contemporary feminist theory and practice.

Let us consider as an example the postmodernism of Jean-François Lyotard, since it is genuinely exemplary of the larger tendency. Lyotard is one of the few social thinkers widely considered postmodern who actually uses the term, having himself introduced it into current discussions of philosophy, politics, society and social theory. His book, *The Postmodern Condition*, has become the *locus classicus* for contemporary debates and it reflects in an especially acute form the characteristic concerns and tensions of the movement.[2]

For Lyotard, postmodernism designates a general condition of contemporary Western civilization. The postmodern condition is one in which "grand narratives of legitimation" are no longer credible. By

"grand narratives" he means, in the first instance, overarching philosophies of history like the Enlightenment story of the gradual but steady progress of reason and freedom, Hegel's dialectic of Spirit coming to know itself, and, most importantly, Marx's drama of the forward march of human productive capacities via class conflict culminating in proletarian revolution. For Lyotard, these metanarratives instantiate a specifically modern approach to the problem of legitimation. Each situates first-order discursive practices of inquiry and politics within a broader totalizing metadiscourse which legitimates them. The metadiscourse narrates a story about the whole of human history which purports to guarantee that the 'pragmatics' of the modern sciences and of modern political processes, that is, the norms and rules which govern these practices, determining what counts as a warranted move within them, are themselves legitimate. The story guarantees that some sciences and some politics have the *right* pragmatics and, so, are the *right* practices.

We should not be misled by Lyotard's focus on narrative philosophies of history. In his conception of legitimating metanarrative, the stress properly belongs on the 'meta' and not the 'narrative'. For what most interests him about the Enlightenment, Hegelian and Marxist stories is what they share with other, nonnarrative forms of philosophy. Like ahistorical epistemologies and moral theories, they aim to show that specific first-order discursive practices are well-formed and capable of yielding true and just results. 'True' and 'just' here mean something more than results reached by adhering scrupulously to the constitutive rules of some given scientific and political games. They mean, rather, results which correspond to Truth and Justice as they really are in themselves independently of contingent, historical social practices. Thus, in Lyotard's view, a metanarrative is meta in a very strong sense. It purports to be a privileged discourse capable of situating, characterizing and evaluating all other discourses, but not itself infected by the historicity and contingency which rendered first-order discourses potentially distorted and in need of legitimation.

In *The Postmodern Condition*, Lyotard argues that metanarratives, whether philosophies of history or nonnarrative foundational philosophies, are merely modern and dépassé. We can no longer believe, he claims, in the availability of a privileged metadiscourse capable of capturing once and for all the truth of every first-order discourse. The claim to meta status does not stand up. A so-called metadiscourse is in fact simply one more discourse among others. It follows for Lyotard that legitimation, both epistemic and political, can no longer reside in philosophical metanarratives. Where, then, he asks, does legitimation reside in the postmodern era?

Much of *The Postmodern Condition* is devoted to sketching an answer to this question. The answer, in brief, is that in the postmodern era legitimation becomes plural, local and immanent. In this era, there will necessarily be many discourses of legitimation dispersed among the plurality of first-order discursive practices. For example, scientists no longer look to prescriptive philosophies of science to warrant their procedures of inquiry. Rather, they themselves problematize, modify and warrant the constitutive norms of their own practice even as they engage in it. Instead of hovering above, legitimation descends to the level of practice and becomes immanent in it. There are no special tribunals set apart from the sites where inquiry is practiced. Rather, practitioners assume responsibility for legitimizing their own practice.

Lyotard intimates that something similar is or should be happening with respect to political legitimation. We cannot have and do not need a single, overarching theory of justice. What is required, rather, is a "justice of multiplicities."[3] What Lyotard means by this is not wholly clear. On one level, he can be read as offering a normative vision in which the good society consists of a decentralized plurality of democratic, self-managing groups and institutions whose members problematize the norms of their practice and take responsibility for modifying them as situations require. But paradoxically, on another level, he can be read as ruling out the sort of larger scale, normative political theorizing which, from a 'modern' perspective at least, would be required to legitimate such a vision. In any case, his justice of multiplicities conception precludes one familiar, and arguably essential, genre of political theory: identification and critique of macrostructures of inequality and injustice which cut across the boundaries separating relatively discrete practices and institutions. There is no place in Lyotard's universe for critique of pervasive axes of stratification, for critique of broad-based relations of dominance and subordination along lines like gender, race and class.

Lyotard's suspicion of the large extends to historical narrative and social theory as well. Here, his chief target is Marxism, the one metanarrative in France with enough lingering credibility to be worth arguing against. The problem with Marxism, in his view, is twofold. On the one hand, the Marxian story is too big, since it spans virtually the whole of human history. On the other hand, the Marxian story is too theoretical, since it relies on a *theory* of social practice and social relations which claims to *explain* historical change. At one level, Lyotard simply rejects the specifics of this theory. He claims that the Marxian conception of practice as production occludes the diversity and plurality of human practices. And the Marxian conception of capitalist society as a totality traversed by one major division and contradiction occludes the diversity

and plurality of contemporary societal differences and oppositions. But Lyotard does not conclude that such deficiencies can and should be remedied by a better social theory. Rather, he rejects the project of social theory *tout court*.

Once again, Lyotard's position is ambiguous, since his rejection of social theory depends on a theoretical perspective of sorts of its own. He offers a 'postmodern' conception of sociality and social identity, a conception of what he calls 'the social bond'. What holds a society together, he claims, is not a common consciousness or institutional substructure. Rather, the social bond is a weave of criss-crossing threads of discursive practices, no single one of which runs continuously throughout the whole. Individuals are the nodes or 'posts' where such practices intersect and, so, they participate in many simultaneously. It follows that social identities are complex and heterogeneous. They cannot be mapped onto one another nor onto the social totality. Indeed, strictly speaking, there is no social totality and a fortiori no possibility of a totalizing social theory.

Thus, Lyotard insists that the field of the social is heterogeneous and nontotalizable. As a result, he rules out the sort of critical social theory which employs general categories like gender, race and class. From his perspective, such categories are too reductive of the complexity of social identities to be useful. And there is apparently nothing to be gained, in his view, by situating an account of the fluidity and diversity of discursive practices in the context of a critical analysis of large scale institutions and social structures.

Thus, Lyotard's postmodern conception of criticism without philosophy rules out several recognizable genres of social criticism. From the premise that criticism cannot be grounded by a foundationalist philosophical metanarrative, he infers the illegitimacy of large historical stories, normative theories of justice and social-theoretical accounts of macrostructures which institutionalize inequality. What, then, *does* postmodern social criticism look like?

Lyotard tries to fashion some new genres of social criticism from the discursive resources that remain. Chief among these is smallish, localized narrative. He seeks to vindicate such narrative against both modern totalizing metanarrative and the scientism that is hostile to all narrative. One genre of postmodern social criticism, then, consists in relatively discrete, local stories about the emergence, transformation and disappearance of various discursive practices treated in isolation from one another. Such stories might resemble those told by Michel Foucault, though without the attempts to discern larger synchronic patterns and connections that Foucault sometimes made.[4] And like Michael Walzer, Lyotard seems to assume that practitioners would narrate such stories when seeking to per-

suade one another to modify the pragmatics or constitutive norms of their practice.[5]

This genre of social criticism is not the whole postmodern story, however. For it casts critique as strictly local, ad hoc and ameliorative, thus supposing a political diagnosis according to which there are no large scale, systemic problems which resist local, ad hoc, ameliorative initiatives. Yet Lyotard recognizes that postmodern society does contain at least one unfavorable structural tendency which requires a more coordinated response. This is the tendency to universalize instrumental reason, to subject *all* discursive practices indiscriminately to the single criterion of efficiency or "performativity." In Lyotard's view, this threatens the autonomy and integrity of science and politics, since these practices are not properly subordinated to performative standards. It would pervert and distort them, thereby destroying the diversity of discursive forms.

Thus, even as he argues explicitly against it, Lyotard posits the need for a genre of social criticism which transcends local mini-narrative. And despite his strictures against large, totalizing stories, he narrates a fairly tall tale about a large-scale social trend. Moreover, the logic of this story, and of the genre of criticism to which it belongs, calls for judgments which are not strictly practice-immanent. Lyotard's story presupposes the legitimacy and integrity of the scientific and political practices allegedly threatened by performativity. It supposes that one can distinguish changes or developments which are *internal* to these practices from externally induced distortions. But this drives Lyotard to make normative judgments about the value and character of the threatened practices. These judgments are not strictly immanent in the practices judged. Rather, they are 'metapractical'.

Thus, Lyotard's view of postmodern social criticism is neither entirely self-consistent nor entirely persuasive. He goes too quickly from the premise that Philosophy cannot ground social criticism to the conclusion that criticism itself must be local, ad hoc and non-theoretical. As a result, he throws out the baby of large historical narrative with the bath of philosophical metanarrative and the baby of social-theoretical analysis of large scale inequalities with the bath of reductive Marxian class theory. Moreover, these allegedly illegitimate babies do not in fact remain excluded. They return like the repressed within the very genres of postmodern social criticism with which Lyotard intends to replace them.

We began this discussion by noting that postmodernists orient their reflections on the character of postmodern social criticism by the falling star of foundationalist philosophy. They posit that, with philosophy no longer able credibly to ground social criticism, criticism itself must be local, ad hoc and untheoretical. Thus, from the critique of foundational-

ism, they infer the illegitimacy of several genres of social criticism. For Lyotard, these illegitimate genres include large-scale historical narrative and social-theoretical analyses of pervasive relations of dominance and subordination.[6]

Suppose, however, one were to choose another starting point for reflecting on postfoundational social criticism. Suppose one began, not with the condition of Philosophy, but with the nature of the social object one wished to criticize. Suppose, further, that one defined that object as the subordination of women to and by men. Then, we submit, it would be apparent that many of the genres rejected by postmodernists are necessary for social criticism. For a phenomenon as pervasive and multi-faceted as male dominance simply cannot be adequately grasped with the meager critical resources to which they would limit us. On the contrary, effective criticism of this phenomenon requires an array of different methods and genres. It requires at minimum large narratives about changes in social organization and ideology, empirical and social-theoretical analyses of macrostructures and institutions, interactionist analyses of the micro-politics of everyday life, critical-hermeneutical and institutional analyses of cultural production, historically and culturally specific sociologies of gender . . . This list could go on.

Clearly, not all of these approaches are local and 'untheoretical'. But all are nonetheless essential to feminist social criticism. Moreover, all can, in principle, be conceived in ways that do not take us back to foundationalism, even though, as we argue in the next section, many feminists have so far not wholly succeeded in avoiding that trap.

II. FEMINISM

Feminists, like postmodernists, have sought to develop new paradigms of social criticism which do not rely on traditional philosophical underpinnings. They have criticized modern foundationalist epistemologies and moral and political theories, exposing the contingent, partial and socio-historically situated character of what have passed in the mainstream for necessary, universal and ahistorical truths. And they have called into question the dominant philosophical project of seeking 'objectivity' in the guise of a 'God's-eye view' which transcends any situation or perspective.[7]

However, if postmodernists have been drawn to such views by a concern with the status of philosophy, feminists have been led to them by the demands of political practice. This practical interest has saved feminist theory from many of the mistakes of postmodernism: women whose theo-

rizing was to serve the struggle against sexism were not about to abandon powerful political tools merely as a result of intramural debates in professional philosophy.

Yet even as the imperatives of political practice have saved feminist theory from one set of difficulties, they have tended at times to incline it toward another. Practical imperatives have led some feminists to adopt modes of theorizing which resemble the sorts of philosophical metanarrative rightly criticized by postmodernists. To be sure, the feminist theories we have in mind here are not 'pure' metanarratives; they are not ahistorical normative theories about the transcultural nature of rationality or justice. Rather, they are very large social theories, theories of history, society, culture and psychology which claim, for example, to identify causes and/or constitutive features of sexism that operate cross-culturally. Thus, these social theories purport to be 'empirical' rather than 'philosophical'. But, as we hope to show, they are actually "quasi-metanarratives." They tacitly presuppose some commonly held but unwarranted and essentialist assumptions about the nature of human beings and the conditions for social life. In addition, they assume methods and/or concepts which are uninflected by temporality or historicity and which therefore function *de facto* as permanent, neutral matrices for inquiry. Such theories, then, share some of the essentialist and ahistorical features of metanarratives: they are insufficiently attentive to historical and cultural diversity; and they falsely universalize features of the theorist's own era, society, culture, class, sexual orientation, and/or ethnic or racial group.

On the other hand, the practical exigencies inclining feminists to produce quasi-metanarratives have by no means held undisputed sway. Rather, they have had to co-exist, often uneasily, with counter-exigencies which have worked to opposite effect, for example, political pressures to acknowledge differences among women. In general, then, the recent history of feminist theory reflects a tug of war between forces which have encouraged and forces which have discouraged metanarrative-like modes of theorizing. We can illustrate this dynamic by looking at a few important turning points in this history.

When, in the 1960s, women in the New Left began to extend prior talk about 'women's rights' into the more encompassing discussion of 'women's liberation', they encountered the fear and hostility of their male comrades and the use of Marxist political theory as a support for these reactions. Many men of the New Left argued that gender issues were secondary because subsumable under more basic modes of oppression, namely, class and race.

In response to this practical-political problem, radical feminists such as Shulamith Firestone resorted to an ingenious tactical maneuver: Fire-

stone invoked biological differences between women and men to explain sexism. This enabled her to turn the tables on her Marxist comrades by claiming that gender conflict was the most basic form of human conflict and the source of all other forms, including class conflict.[8] Here, Firestone drew on the pervasive tendency within modern culture to locate the roots of gender differences in biology. Her coup was to use biologism to establish the primacy of the struggle against male domination rather than to justify acquiescence to it.

The trick, of course, is problematic from a postmodern perspective in that appeals to biology to explain social phenomena are essentialist and monocausal. They are essentialist insofar as they project onto all women and men qualities which develop under historically specific social conditions. They are monocausal insofar as they look to one set of characteristics, such as women's physiology or men's hormones, to explain women's oppression in all cultures. These problems are only compounded when appeals to biology are used in conjunction with the dubious claim that women's oppression is the cause of all other forms of oppression.

Moreover, as Marxists and feminist anthropologists began insisting in the early 1970s, appeals to biology do not allow us to understand the enormous diversity of forms which both gender and sexism assume in different cultures. And in fact, it was not long before most feminist social theorists came to appreciate that accounting for the diversity of the forms of sexism was as important as accounting for its depth and autonomy. Gayle Rubin aptly described this dual requirement as the need to formulate theory which could account for the oppression of women in its "endless variety and monotonous similarity."[9] How were feminists to develop a social theory adequate to both demands?

One approach which seemed promising was suggested by Michelle Zimbalist Rosaldo and other contributors to the influential 1974 anthropology collection, *Woman, Culture and Society*. They argued that common to all known societies was some type of separation between a 'domestic sphere' and a 'public sphere', the former associated with women and the latter with men. Because in most societies to date women have spent a good part of their lives bearing and raising children, their lives have been more bound to 'the domestic sphere'. Men, on the other hand, have had both the time and mobility to engage in those out of the home activities which generate political structures. Thus, as Rosaldo argued, while in many societies women possess some or even a great deal of power, women's power is always viewed as illegitimate, disruptive, and without authority.[10]

This approach seemed to allow for both diversity and ubiquity in the manifestations of sexism. A very general identification of women with the

domestic and of men with the extra-domestic could accommodate a great deal of cultural variation both in social structures and in gender roles. At the same time, it could make comprehensible the apparent ubiquity of the assumption of women's inferiority above and beyond such variation. This hypothesis was also compatible with the idea that the extent of women's oppression differed in different societies. It could explain such differences by correlating the extent of gender inequality in a society with the extent and rigidity of the separation between its domestic and public spheres. In short, the domestic/public theorists seemed to have generated an explanation capable of satisfying a variety of conflicting demands.

However, this explanation turned out to be problematic in ways reminiscent of Firestone's account. Although the theory focused on differences between men's and women's spheres of activity rather than on differences between men's and women's biology, it was essentialist and monocausal nonetheless. It posited the existence of a 'domestic sphere' in all societies and thereby assumed that women's activities were basically similar in content and significance across cultures. (An analogous assumption about men's activities lay behind the postulation of a universal 'public sphere'.) In effect, the theory falsely generalized to all societies an historically specific conjunction of properties: women's responsibility for early childrearing, women's tendency to spend more time in the geographical space of the home, women's lesser participation in the affairs of the community, a cultural ascription of triviality to domestic work, and a cultural ascription of inferiority to women. The theory thus failed to appreciate that, while each individual property may be true of many societies, the conjunction is not true of most.[11]

One source of difficulty in these early feminist social theories was the presumption of an overly grandiose and totalizing conception of theory. Theory was understood as the search for the one key factor which would explain sexism cross-culturally and illuminate all of social life. In this sense, to theorize was by definition to produce a quasi-metanarrative.

Since the late 1970s, feminist social theorists have largely ceased speaking of biological determinants or a cross-cultural domestic/public separation. Many, moreover, have given up the assumption of monocausality. Nevertheless, some feminist social theorists have continued implicitly to suppose a quasi-metanarrative conception of theory. They have continued to theorize in terms of a putatively unitary, primary, culturally universal type of activity associated with women, generally an activity conceived as 'domestic' and located in 'the family'.

One influential example is the analysis of 'mothering' developed by Nancy Chodorow. Setting herself to explain the internal, psychological dynamics which have led many women willingly to reproduce social divi-

sions associated with female inferiority, Chodorow turned to the activity of mothering. Her question thus became: how is mothering as a female-associated activity reproduced over time? How does female mothering produce a new generation of women with the psychological inclination to mother and a new generation of men not so inclined? The answer she offered was in terms of 'gender identity': female mothering produces women whose deep sense of self is "relational" and men whose deep sense of self is not.[12]

Chodorow's theory has struck many feminists as a persuasive account of some apparently observable psychic differences between men and women. Yet the theory has clear metanarrative overtones. It posits the existence of a single activity, 'mothering', which, while differing in specifics in different societies, nevertheless constitutes enough of a natural kind to warrant one label. It stipulates that this basically unitary activity gives rise to two distinct sorts of deep selves, one relatively common across cultures to women, the other relatively common across cultures to men. And it claims that the difference thus generated between 'feminine and masculine gender identity' causes a variety of supposedly cross-cultural social phenomena, including the continuation of female mothering, male contempt for women and problems in heterosexual relationships.

From a postmodern perspective, all of these assumptions are problematic because essentialist. But the second one, concerning 'gender identity', warrants special scrutiny, given its political implications. Consider that Chodorow's use of the notion of gender identity presupposes three major premises. One is the psychoanalytic premise that everyone has a deep sense of self which is constituted in early childhood through one's interaction with one's primary parent and which remains relatively constant thereafter. Another is the premise that this 'deep self' differs significantly for men and women but is roughly similar among women, on the one hand, and among men, on the other hand, both across cultures and within cultures across lines of class, race and ethnicity. The third premise is that this deep self colors everything one does; there are no actions, however trivial, which do not bear traces of one's feminine or masculine gender identity.

One can appreciate the political exigencies which made this conjunction of premises attractive. It gave scholarly substance to the idea of the pervasiveness of sexism. If masculinity and femininity constitute our basic and ever-present sense of self, then it is not surprising that the manifestations of sexism are systemic. Moreover, many feminists had already sensed that the concept of 'sex-role socialization', a concept Chodorow explicitly criticized, ignored the depth and intractibility of male dominance. By implying that measures such as changing images in school text-

books or allowing boys to play with dolls would be sufficient to bring about equality between the sexes, this concept seemed to trivialize and coopt the message of feminism. Finally, Chodorow's depth-psychological approach gave a scholarly sanction to the idea of sisterhood. It seemed to legitimate the claim that the ties which bind women are deep and substantively based.

Needless to say, we have no wish to quarrel with the claim of the depth and pervasiveness of sexism nor with the idea of sisterhood. But we do wish to challenge Chodorow's way of legitimating them. The idea of a cross-cultural, deep sense of self, specified differently for women and men, becomes problematic when given any specific content. Chodorow states that women everywhere differ from men in their greater concern with 'relational interaction'. But what does she mean by this term? Certainly not any and every kind of human interaction, since men have often been more concerned than women with some kinds of interactions, for example, those which have to do with the aggrandizement of power and wealth. Of course, it is true that many women in modern western societies have been expected to exhibit strong concern with those types of interactions associated with intimacy, friendship and love, interactions which dominate one meaning of the late twentieth-century concept of 'relationship'. But surely this meaning presupposes a notion of private life specific to modern western societies in the last two centuries. Is it possible that Chodorow's theory rests on an equivocation of the term 'relationship'?[13]

Equally troubling are the aporias this theory generates for political practice. While 'gender identity' gives substance to the idea of sisterhood, it does so at the cost of denying differences among sisters. Although the theory does allow for some differences among women of different classes, races, sexual orientations and ethnic groups, it construes these as subsidiary to more basic similarities. But it is precisely as a consequence of the request to understand such differences as secondary that many women have denied an allegiance to feminism.

We have dwelt at length on Chodorow because of the great influence her work has enjoyed. But she is not the only recent feminist social theorist who has constructed a quasi-metanarrative around a putatively cross-cultural, female-associated activity. On the contrary, theorists like Ann Ferguson, Nancy Folbre, Nancy Hartsock, and Catharine MacKinnon have done something analogous with 'sex-affective production', 'reproduction' and 'sexuality' respectively.[14] Each claims to have identified a basic kind of human practice found in all societies which has cross-cultural explanatory power. In each case, the practice in question is associated with a biological or quasi-biological need and is construed as func-

tionally necessary to the reproduction of society. It is not the sort of thing, then, whose origins need be investigated.

The difficulty here is that categories like sexuality, mothering, reproduction and sex-affective production group together phenomena which are not necessarily conjoined in all societies, while separating off from one another phenomena which are not necessarily separated. As a matter of fact, it is doubtful whether these categories have any determinate cross-cultural content. Thus, for a theorist to use such categories to construct a universalistic social theory is to risk projecting the socially dominant conjunctions and dispersions of her own society onto others, thereby distorting important features of both. Social theorists would do better first to construct genealogies of the *categories* of sexuality, reproduction, and mothering before assuming their universal significance.

Since around 1980, many feminist scholars have come to abandon the project of grand social theory. They have stopped looking for *the* causes of sexism and have turned to more concrete inquiry with more limited aims. One reason for this shift is the growing legitimacy of feminist scholarship. The institutionalization of women's studies in the U.S. has meant a dramatic increase in the size of the community of feminist inquirers, a much greater division of scholarly labor and a large and growing fund of concrete information. As a result, feminist scholars have come to regard their enterprise more collectively, more like a puzzle whose various pieces are being filled in by many different people than a construction to be completed by a single grand theoretical stroke. In short, feminist scholarship has attained its maturity.

Even in this phase, however, traces of youthful quasi-metanarratives remain. Some theorists who have ceased looking for *the* causes of sexism still rely on essentialist categories like 'gender identity'. This is especially true of those scholars who have sought to develop 'gynocentric' alternatives to mainstream androcentric perspectives, but who have not fully abandoned the universalist pretensions of the latter.

Consider, as an example, the work of Carol Gilligan. Unlike most of the theorists we have considered so far, Gilligan has not sought to explain the origins or nature of cross-cultural sexism. Rather, she set herself the more limited task of exposing and redressing androcentric bias in the model of moral development of psychologist Lawrence Kohlberg. Thus, she argued that it is illegitimate to evaluate the moral development of women and girls by reference to a standard drawn exclusively from the experience of men and boys. And she proposed to examine women's moral discourse on its own terms in order to uncover its immanent standards of adequacy.[15]

Gilligan's work has been rightly regarded as important and innovative.

It challenged mainstream psychology's persistent occlusion of women's lives and experiences and its insistent but false claims to universality. Yet insofar as Gilligan's challenge involved the construction of an alternative 'feminine' model of moral development, her position was ambiguous. On the one hand, by providing a counterexample to Kohlberg's model, she cast doubt on the possibility of any single, universalist developmental schema. On the other hand, by constructing a female countermodel, she invited the same charge of false generalization she had herself raised against Kohlberg, though now from other perspectives such as class, sexual orientation, race, and ethnicity. Gilligan's disclaimers notwithstanding,[16] to the extent that she described women's moral development in terms of *a* different voice; to the extent that she did not specify which women, under which specific historical circumstances have spoken with the voice in question; and to the extent that she grounded her analysis in the explicitly cross-cultural framework of Nancy Chodorow, her model remained essentialist. It perpetuated in a newer, more localized fashion traces of previous, more grandiose quasi-metanarratives.

Thus, vestiges of essentialism have continued to plague feminist scholarship despite the decline of grand theorizing. In many cases, including Gilligan's, this represents the continuing subterranean influence of those very mainstream modes of thought and inquiry with which feminists have wished to break.

On the other hand, the practice of feminist politics in the 80s has generated a new set of pressures which have worked against metanarratives. In recent years, poor and working class women, women of color, and lesbians have won more of a hearing for their objections to feminist theories which fail to illuminate their lives and address their problems. They have exposed the earlier quasi-metanarratives, with their assumptions of universal female dependence and confinement to 'the domestic sphere', as false extrapolations from the experience of the white, middle class, heterosexual women who dominated the beginnings of the second wave. For example, writers like Bell Hooks, Gloria Joseph, Audre Lorde, Maria Lugones, and Elizabeth Spelman have unmasked the implicit reference to white, Anglo women in many classic feminist texts; likewise Adrienne Rich and Marilyn Frye have exposed the heterosexist bias of much mainstream feminist theory.[17] Thus, as the class, sexual, racial, and ethnic awareness of the movement has altered, so has the preferred conception of theory. It has become clear that quasi-metanarratives hamper rather than promote sisterhood, since they elide differences among women and among the forms of sexism to which different women are differentially subject. Likewise, it is increasingly apparent that such theories hinder alliances with other progressive movements, since they tend to occlude axes

of domination other than gender. In sum, there is growing interest among feminists in modes of theorizing which are attentive to differences and to cultural and historical specificity.

In general, then, feminist scholarship of the 1980s evinces some conflicting tendencies. On the one hand, there is decreasing interest in grand social theories as scholarship has become more localized, issue-oriented and explicitly fallibilistic. On the other hand, essentialist vestiges persist in the continued use of ahistorical categories like 'gender identity' without reflection as to how, when and why such categories originated and were modified over time. This tension is symptomatically expressed in the current fascination, on the part of U.S. feminists, with French psychoanalytic feminisms: the latter propositionally decry essentialism even as they performatively enact it.[18] More generally, feminist scholarship has remained insufficiently attentive to the *theoretical* prerequisites of dealing with diversity, despite widespread commitment to accepting it politically.

By criticizing lingering essentialism in contemporary feminist theory, we hope to encourage such theory to become more consistently postmodern. This is not, however, to recommend merely *any* form of postmodernism. On the contrary, as we have shown, the version developed by Jean-François Lyotard offers a weak and inadequate conception of social criticism without philosophy. It rules out genres of criticism, such as large historical narrative and historically situated social theory, which feminists rightly regard as indispensable. But it does not follow from Lyotard's shortcomings that criticism without philosophy is in principle incompatible with criticism with social force. Rather, as we argue next, a robust, postmodern-feminist paradigm of social criticism without philosophy is possible.

III. TOWARDS A POSTMODERN FEMINISM

How can we combine a postmodern incredulity toward metanarratives with the social-critical power of feminism? How can we conceive a version of criticism without philosophy which is robust enough to handle the tough job of analyzing sexism in all its 'endless variety and monotonous similarity'?

A first step is to recognize, *contra* Lyotard, that postmodern critique need forswear neither large historical narratives nor analyses of societal macrostructures. This point is important for feminists, since sexism has a long history and is deeply and pervasively embedded in contemporary societies. Thus, postmodern feminists need not abandon the large theo-

retical tools needed to address large political problems. There is nothing inconsistent in the idea of a postmodern theory.

However, if postmodern-feminist critique must remain 'theoretical', not just any kind of theory will do. Rather, theory here would be explicitly historical, attuned to the cultural specificity of different societies and periods, and to that of different groups within societies and periods. Thus, the categories of postmodern-feminist theory would be inflected by temporality, with historically specific institutional categories like 'the modern, restricted, male-headed, nuclear family' taking precedence over ahistorical, functional categories like 'reproduction' and 'mothering'. Where categories of the latter sort were not eschewed altogether, they would be genealogized, that is, framed by a historical narrative and rendered temporally and culturally specific.

Moreover, postmodern-feminist theory would be nonuniversalist. When its focus became cross-cultural or transepochal, its mode of attention would be comparativist rather than universalizing, attuned to changes and contrasts instead of to 'covering laws'. Finally, postmodern-feminist theory would dispense with the idea of a subject of history. It would replace unitary notions of 'women' and 'feminine gender identity' with plural and complexly constructed conceptions of social identity, treating gender as one relevant strand among others, attending also to class, race, ethnicity, age, and sexual orientation.

In general, postmodern-feminist theory would be pragmatic and fallibilistic. It would tailor its methods and categories to the specific task at hand, using multiple categories when appropriate and forswearing the metaphysical comfort of a single 'feminist method' or 'feminist epistemology'. In short, this theory would look more like a tapestry composed of threads of many different hues than one woven in a single color.

The most important advantage of this sort of theory would be its usefulness for contemporary feminist political practice. Such practice is increasingly a matter of alliances rather than one of unity around a universally shared interest or identity. It recognizes that the diversity of women's needs and experiences means that no single solution, on issues like child care, social security and housing, can be adequate for all. Thus, the underlying premise of this practice is that, while some women share some common interests and face some common enemies, such commonalities are by no means universal; rather, they are interlaced with differences, even with conflicts. This, then, is a practice made up of a patchwork of overlapping alliances, not one circumscribable by a single essential definition. One might best speak of it in the plural as the practice of 'feminisms'. In a sense, this practice is in advance of much contemporary feminist theory. It is already implicitly postmodern. It would find its most appropriate and

useful theoretical expression in postmodern-feminist forms of critical inquiry. Such inquiry would be the theoretical counterpart of a broader, richer, more complex, and multi-layered feminist solidarity, the sort of solidarity which is essential for overcoming the oppression of women in its 'endless variety and monotonous similarity'.

NOTES

*We are grateful for the helpful suggestions and criticisms of many people, especially, Jonathan Arac, Ann Ferguson, Marilyn Frye, Nancy Hartsock, Alison Jaggar, Berel Lang, Thomas McCarthy, Karsten Struhl, Iris Young, Tom Wartenburg, and the members of Sofphia. We are also grateful for word processing help from Marina Rosiene.

1. Exceptions are Jane Flax, 'Gender as a Social Problem: In and For Feminist Theory', *American Studies/Amerika Studien* (June 1986); Sandra Harding, *The Science Question in Feminism* (Ithaca, N.Y.: Cornell University Press, 1986) and 'The Instability of the Analytical Categories of Feminist Theory', *Signs: Journal of Women in Culture and Society*, Vol. 11, No. 4 (1986): 645–64; Donna Haraway, 'A Manifesto for Cyborgs: Science, Technology and Socialist Feminism in the 1980's', *Socialist Review* 80 (1983): 65–107; Alice A. Jardine, *Gynesis: Configurations of Woman and Modernity* (Ithaca, N.Y.: Cornell University Press, 1985); Jean-François Lyotard, 'Some of the Things at Stake in Women's Struggles', Deborah J. Clarke, Winifred Woodhull, and John Mowitt, tr., *Sub-Stance*, No. 20 (1978); Craig Owens, 'The Discourse of Others: Feminists and Postmodernism', in *The Anti-Aesthetic: Essays on Postmodern Culture*, Hal Foster, ed. (Port Townsend, Washington: Bay Press, 1983).

2. Jean-François Lyotard, *The Postmodern Condition: A Report on Knowledge*, G. Bennington and B. Massumi, tr. (Minneapolis: University of Minnesota Press, 1984).

3. *Cf.*, in addition to ibid, Jean-François Lyotard and Jean-Loup Thébaud, *Just Gaming* (Minneapolis: University of Minnesota Press, 1985) and Lyotard, 'The Differend', Georges Van Den Abbeele, tr., *Diacritics* (Fall 1984): 4–14.

4. See, for example, Michel Foucault, *Discipline and Punish: The Birth of the Prison*, Alan Sheridan, tr. (New York: Vintage Books, 1979).

5. Michael Walzer, *Spheres of Justice: A Defense of Pluralism and Equality* (New York: Basic Books, 1983).

6. It should be noted that, for Lyotard, the choice of Philosophy as a starting point is itself determined by a metapolitical commitment, namely, to anti-totalitarianism. He assumes, erroneously, in our view, that totalizing social and political theory necessarily eventuates in totalitarian societies. Thus 'the practical intent' which subtends Lyotard's privileging of philosophy (and which is in turn attenuated by the latter) is anti-Marxism. Whether it should also be characterized as 'neo-liberalism' is a question too complicated to be explored here.

7. See, for example, the essays in Sandra Harding and Merrill B. Hintikka eds., *Discovering Reality: Feminist Perspectives on Epistemology, Metaphysics, Methodology, and Philosophy of Science* (Dordrecht, Holland: D. Reidel, 1983).

8. Shulamith Firestone, *The Dialectic of Sex* (New York: Bantam, 1970).

SOCIAL CRITICISM WITHOUT PHILOSOPHY 301

9. Gayle Rubin, 'The Traffic in Women', in Rayna R. Reiter, ed., *Toward an Anthropology of Women* (New York: Monthly Review Press, 1975), 160.

10. Michelle Zimbalist Rosaldo, 'Woman, Culture and Society: A Theoretical Overview', in Michelle Zimbalist Rosaldo and Louise Lamphere, eds., *Woman, Culture, and Society* (Stanford: Stanford University Press, 1974) 17–42.

11. These and related problems were soon apparent to many of the domestic/ public theorists themselves. See Rosaldo's self-criticism, 'The Use and Abuse of Anthropology: Reflections on Feminism and Cross-Cultural Understanding', *Signs: Journal, of Women in Culture and Society*, Vol. 5, No. 3 (1980): 389–417. A more recent discussion which points out the circularity of the theory appears in Sylvia J. Yanagisako and Jane F. Collier, 'Toward a Unified Analysis of Gender and Kinship', in *Gender and Kinship: Toward a Unified Analysis*, Jane F. Collier and Sylvia J. Yanagisako, eds. (Stanford: Stanford University Press, 1988).

12. Nancy Chodorow, *The Reproduction of Mothering: Psychoanalysis and the Sociology of Gender* (Berkeley: University of California Press, 1978).

13. A similar ambiguity attends Chodorow's discussion of 'the family'. In response to critics who object that her psychoanalytic emphasis ignores social structures, Chodorow has rightly insisted that the family is itself a social structure, one frequently slighted in social explanations. Yet she generally does not discuss families as historically specific social institutions whose specific relations with other institutions can be analyzed. Rather, she tends to invoke 'the family' in a very abstract and general sense defined only as the locus of female mothering.

14. Ann Ferguson and Nancy Folbre, 'The Unhappy Marriage of Patriarchy and Capitalism', in Lydia Sargent, ed., *Women and Revolution* (Boston: South End Press, 1981) 313–338; Nancy Hartsock, *Money Sex and Power: Toward a Feminist Historical Materialism* (New York: Longman, 1983); Catharine A. MacKinnon, 'Feminism, Marxism, Method, and the State: An Agenda for Theory', *Signs: Journal of Women in Culture and Society*, Vol. 7, No. 3 (Spring 1982): 515–54.

15. Carol Gilligan, *In A Different Voice: Psychological Theory and Women's Development* (Cambridge, Mass.: Harvard University Press, 1982).

16. Cf. ibid, 2.

17. Marilyn Frye, *The Politics of Reality: Essays in Feminist Theory* (Trumansburg, N.Y.: The Crossing Press, 1983); Bell Hooks, *Feminist Theory: From Margin to Center* (Boston: South End Press, 1984); Gloria Joseph, 'The Incompatible Menage À Trois: Marxism, Feminism, and Racism', in *Women and Revolution*, Lydia Sargent, ed. (Boston: South End Press, 1981) 91–107; Audre Lorde, 'An Open Letter to Mary Daly', in *This Bridge Called My Back: Writings by Radical Women of Color*, Cherríe Moraga and Gloria Anzaldúa, eds. (Watertown, Mass: Persephone Press, 1981) 94–97; Maria C. Lugones and Elizabeth V. Spelman, 'Have We Got a Theory for You! Feminist Theory, Cultural Imperialism and the Demand for The Woman's Voice', in *Hypatia, Women's Studies International Forum*, Vol. 6, No. 6, 573–581; Adrienne Rich, 'Compulsory Heterosexuality and Lesbian Existence', *Signs: Journal of Women in Culture and Society*, Vol. 5, No. 4 (Summer 1980): 631–660; Elizabeth Spelman, 'Theories of Race and Gender: The Erasure of Black Women', in *Quest*, Vol. V, No. 4, 36–62.

18. See, for example, Hélène Cixous, 'The Laugh of the Medusa', Keith Cohen and Paula Cohen, tr., in *New French Feminisms*, Elaine Marks and Isabel de Courtivron, eds. (New York: Schocken Books, 1981), 245–64; Hélène Cixous and Catherine Clément, *The Newly Born Woman*, Betsy Wing, tr. (Minneapolis: University of Minnesota Press, 1986); Luce Irigaray, *Speculum of the Other Woman* (Ithaca New York: Cornell University Press, 1985) and *This Sex Which is Not One*

(Ithaca, N.Y.: Cornell University Press, 1985); Julia Kristeva, *Desire in Language: A Semiotic Approach to Literature and Art*, Leon S. Roudiez, ed. (New York: Columbia University Press, 1980) and 'Women's Time', Alice Jardine and Harry Blake, tr., *Signs: Journal of Women in Culture and Society*, Vol. 7, No. 1 (Autumn 1981): 13–35. See also the critical discussions by Ann Rosalind Jones, 'Writing the Body: Toward an Understanding of l'Écriture féminine', in *The New Feminist Criticism: Essays on Women, Literature and Theory*, Elaine Showalter, ed. (New York: Pantheon Books, 1985); and Toril Moi, *Sexual/Textual Politics: Feminist Literary Theory* (London: Methuen, 1985).

13

H. Redner

ETHICS IN UNETHICAL TIMES—
TOWARDS A SOCIOLOGY OF ETHICS

Moral philosophers frequently take it for granted that there is something permanent, some perennial sphere of social life called 'ethics', that it is present now as it was in the past and will be in the future. Few, apart from Nietzsche, and perhaps Foucault and one or two others, have enquired into the historical constitution, the origins and transformations of the modes of thought and practices, in short, the specific cultures, that later came to be called ethical—an inquiry that Nietzsche referred to as the genealogy of morals. A fully-developed sociology of ethics along these lines is still lacking. Even the academic discourse known as the subject Ethics has not been investigated sociologically and its formation as a specialty of philosophy has not been explored or explained. At least part of the reason for the latter omission is that we do not as yet possess a sociology of philosophy in the sense in which we have sociologies of science or culture in general.

An important start toward a sociology of philosophy has been made by Richard Rorty, but largely in peripheral comments scattered throughout his large opus. Rorty tells us much about how philosophy became a *Fach*, how it conceived of itself as a *strenge Wissenschaft* and how it sought to purify itself of all outside concerns.[1] One might disagree with him as to where the line of professional purism is to be drawn, whilst accepting that it is the relevant line. There is scope for doubting his too easy exemption of the later philosophy of Wittgenstein and that of Heidegger, his two so-called "edifying" thinkers, from the full strictures of purism and professionalism and challenging his claim that, unlike their predecessors Russell and Husserl, they did not seek to "found new schools within which normal professional philosophy can be practiced".[2] This might not have been their intention, but was precisely the unintended consequence of the popularization of their philosophies throughout the academic establish-

ments. And this was not an accidental result; it was inherent in the nature of their thought and the way it was taken up in the circles for which they wrote.

In the present context it is not helpful to magnify potential disagreements about such specific sociological insights into disciplinary philosophy, for they do not in themselves lead to serious criticisms of Rorty's approach to the sociology of philosophy. However, a more serious criticism can be launched if it is noted that Rorty does not undertake the study of the constitution of specific philosophical discourses or the interrelation of such discourses either to each other or to those falling outside philosophy within the total economy of knowledge of a given period. More specifically, one might ask how the discourse called Ethics arose and how it differentiated itself from those that came to be called Law, Politics, and Economics, which originally were so closely related to it? Why did Ethics remain part of philosophy and why did Law, Politics, and Economics secede from philosophy to establish themselves as separate, independent disciplines? What effect did this have on the development of the intellectual content of these subjects? Why did Law become a profession and Politics and Economics evolve into multiple kinds of sciences, whereas Ethics gradually reduced itself to the purist preoccupation of philosophers with largely formal issues, in the process divesting itself of most of the substantive and scientific concerns of its own earlier stages? It is questions such as these that Rorty does not ask, and they are among the key questions of a sociology of philosophy. In what follows we shall seek to adumbrate the basis of such a sociology by concentrating on such issues in relation to Ethics, the philosophic discipline, as well as ethics or the actual moralities of social life.

I

It is worth stressing from the start of such an investigation that its emphasis falls on whole discourses or partial symbolic systems, not on specific, individual concepts. Conceptual analysis in Ethics as elsewhere is futile without a grasp of the symbolic systems or "languages", for short, in which such concepts inhere and in the context of which they gain their meaning in relation to all the other concepts of the given system. The history of the changes of concepts is equally the history of the transformation of one such system into another. Ethics as a social practice is an historically complex sequence of transformations of symbolic systems having multiple cultural origins and outcomes. Ethics as a specialized philosophic discourse is an intellectual construct within philosophy that

is much more restricted to its largely Greek origins and it maintained its continued dependence on that basic formulation throughout its long history, one which was largely part of the history of philosophy with occasional legal and theological extensions.

However, it is undeniable that, at least in Western history, the two modes of discourse, the practical and theoretical, were always related and though the latter was dependent on the former, it also exerted a counterinfluence. Hence the key to solving the problem of the sociology of the subject Ethics is to be found in the sociology of ethics, that is, in the genealogy and evolution of morals. The ultimate reason the subject Ethics formed itself so differently from the subjects Law, Politics, and Economics is that the legal, political and economic development of Western society, especially in its modern phase, was more rationalized that its ethical development. To begin with, the subject Ethics as it arose in Greek philosophy was not all that different from the subjects Law, Politics, and Economics which were also incipient in these philosophies. Although already functionally separated discourses in the work of Aristotle, they were still closely related and unified as joint approaches to practical activity. This remained the situation within philosophy till well into the modern period, as late as the eighteenth century when they were further differentiated as separate sciences. Until then Ethics was the traditional subject of widest scope and diversity, embracing within itself at various times issues and studies which we would now segregate and assign to such new sciences as sociology, psychology, psycho-analysis, linguistics and such new humanities as literary criticism, cultural criticism and hermeneutics. It embraced issues to do with action and will, with values and norms—as we would now put it—with personality and character, with cultures and outlooks which have mostly been taken over by the above sciences and humanities and ceased to be the concern of moral philosophers.

Such a process of purification and segregation did not take place in Law, Politics, and Economics, though these also formed themselves in a variety of ways. The ultimate explanation for this, as we have said, lies in the diverse development of these practical spheres in society. As early as the Roman Republic law became a self-validating and partly autonomous model of social regulation, codified eventually during the late empire as Roman Law and passed on more or less intact to feudal Europe. Politics commenced an analogous process of self-definition only much later, with the rise of the modern State during the formation of European early absolutist monarchies in the sixteenth century. Economics began to develop into a distinct sphere of activity at about the same time with the removal of religious and moral controls on economic pursuits—such as the ban on usury—during this period of the rise of early capitalism.

Ethics, too, began to assert its own autonomy at this time due largely to the Reformation. But the ethical sphere separated and distinguished itself, as it were, at a slower pace than the others. Moral life was still firmly under the control of religion and theology till well into the Enlightenment, when the processes of secularization began to free it by gradual stages. This was not fully registered intellectually until Kant postulated the categorical as against the hypothetical imperative, and thereby for the first time clearly formulated a purely moral 'ought' as distinct from every other—which MacIntyre has dubbed "... the emergence of *ought* in the modern sense."[3] However, even after Kant the ethical sphere was not as clearly articulated as the others because throughout the nineteenth century, the period of so-called Victorian morality, ethics continued to lay claim to being the superior guide for the whole of social life, as we shall show in what follows. This was one of the underlying sociological reasons that Ethics remained part of philosophy. The prestige of this most ancient and elevated of discourses could not be relinquished by a subject that took itself to be supremely important. As a result Ethics conceived of itself in a more traditional and eventually more confused manner than did the modernizing disciplines of Law, Politics, and Economics.

Among the confusions is the common and unspoken traditional assumption of moral philosophers that there is an area of social life demarcated throughout history as the 'ethical' and that all ethical writings, no matter from what period, are about this same thing. Hence it is assumed that if two moral philosophers from different periods say opposed things about good or right, or whatever other traditional ethical topic, they must be disagreeing, and consequently that one or the other is likely to be more correct. From this ensue the continual debates in Ethics between Aristotle and Kant, Aquinas and Hume, carried on through their contemporary philosophical representatives, which is still the staple of present-day moral discussion. Such misconceptions have long since disappeared from the subject Economics. Nobody supposes that Aristotle's *oikonomia* is about the same thing as Adam Smith's Economics. Aristotle cannot disagree with Smith because Aristotle is writing about household management within the slave-based, handicraft mode of production of the Greek polis, whereas Smith is writing about free labor and markets within the semi-mechanized capitalist economy of eighteenth-century Britain. These constitute two diverse discourses referring to utterly different social formations. For Aristotle oikonomia is not separate from ethics and politics because a distinct economic sphere, with its own norms and laws, had not developed in the polis. For Smith economics can be divorced from moral and political concerns because capitalism had transformed economic activity into an autonomous sphere. The distance separating

Smith's writings on morality from Aristotle's *Ethics* is perhaps not quite as large as that separating their respective economic writings—morality tends to remain more tradition-bound than production—but the span is large enough for these not to be treated as the same discourse. Smith and Aristotle are talking about different things in the sense in which Smith and Kant are not; the latter can meaningfully disagree, the former cannot.

Thus the word 'ethics' does not always refer to the same phenomenon. It has something of the ambiguity that political scientists understand so well in the word 'state'. It might be said in a vacuous sense that all political writing is about something called the 'state'. In this sense Engels speaks about the capitalist state as well as about the origins of the state among the primitive Iroquois. But neither Engels nor anyone else is deceived by this locution into believing that the Iroquois had a political organization in the same sense as that of nineteenth-century Europe. Yet most moral philosophers believe that the Greeks had a morality in the same sense as nineteenth-century Europe. It would be semantically less confusing if the word 'ethics' were restricted to post-Reformation moral developments in Europe in the way that the word 'state' is sometimes restricted to the post-Renaissance development of the modern state, in line with the historical origin of the word which derived largely from the writings of Machiavelli who first speaks of *lo stato* in the modern sense. In politics, etymology and history coincide nicely to make this an appropriate usage. Unfortunately the words 'ethics' and 'morals' have Greek and Latin roots which would make it difficult to postulate that the Greeks had no ethics and the Romans no morality, in the way in which it is more plausible to argue that they had no real state since the concept was unknown to them.

The original meaning of the Greek *ethos* and the Latin *moris* has nothing ethical or moral about it; these words, almost identical in meaning, simply denote customs or habits. Some moral philosophers, especially those with anthropological predilections, think it a conceptual innovation if they revert to using 'ethics' and 'morals' in their root sense, referring to any kind of social norms as ethics and morals. Thus Harré speaks of Eskimo morality, duelling morality, and the honor moralities of knights, football fans, and cowboys.[4] One assumes that he would not balk at speaking of Mafia morality; though he might at Eskimo state. Yet the Eskimos have a morality only in the same sense as they have a state—they have mores but no morality, leaders but not statesmen. In a different way and for different reasons, this is also true of Mafiosi. We can only begin to speak of ethics or morality when a customary code or the mores of a people begin to differentiate themselves according to abstract principles and higher values, as happened historically among the post-Homeric Greek city-states. It is this social process that underlies and explains the first

attempts of early Greek philosophers to distinguish certain mores as against others and begin to consider them in terms that would later be called ethical. This lengthy historical process of definition culminated for Greek civilization in the ethical intellectualization and philosophical self-consciousness of Aristotle's *Ethics*—as this work subsequently came to be called—for its author it was merely a sub-section of Politics. Prior to this historical process there is little sense of speaking of ethics among the tribes of Greek warriors up to Homer.

This historical process of the constitution of an ethics—which, as we shall soon see, took place in different ways among other peoples and civilizations of world-history apart from the Greeks—we shall refer to as a process of moralization. Moralization in this sense is a specific but heterogeneous historical development closely related to rationalization in Weber's sense. However, it is a different process from legal, political or economic rationalization. Legal rationalization issues in the compilation of a comprehensive code to cover all social contingencies such as Roman Law and eventually the modern Code Napoleon; moralization, by contrast, is not concerned with codification but with the establishment of value distinctions or ethical discriminations—moral judgment being in so many respects different from legal judgment. Political rationalization results in power centralization and diversification of organization; moralization, by contrast, is concerned with the interiorization of conscience and the formation of psychological subjectivity. Economic rationalization has to do with productivity and efficiency; whereas moralization is a matter of the quality and refinement of character and social life which need serve no utilitarian practical purpose. The historical outcome of the long process of moralization is the formation of the European moral individual as a subjective and freely autonomous being. Obviously this would have been sociologically impossible outside a society that was legally, politically and economically highly rationalized, namely, outside modern European society.

In such a society the autonomy of the moral individual is paralleled by the growth of the autonomy of the ethical sphere and its separation from law, politics, and economics. Such a functional separation of spheres can only occur where the hold of religion has been weakened and become restricted and specialized. This is why it is difficult to locate such developments in Western Europe prior to the Reformation and why they are only evident some time after it. A Universal Church that claims authority over every dimension of life in the name of sacred values and scriptural commandments can never permit autonomous legal, political, economic, or ethical activities, each bound only by its own intrinsic norms: those of law to property and the freedom and enforceability of contracts, those of poli-

tics to representation, sovereignty, and reasons to state, those of economics to free exchange and profitability and those of ethics to right and duty. As Weber demonstrates, each of these spheres in developing its autonomy had to come into conflict with religion: "the tension between brotherly religion and the world has been most obvious in the economic sphere. . . The consistent brotherly ethic of salvation religions has come into an equally sharp tension with the political orders of the world."[5] As Weber also shows, resolutions of these tensions were first achieved in various ways within the Protestant religions; the Roman Church eventually had to accept such resolutions as a *fait accompli* when homo politicus and homo oeconomicus could no longer be resisted. Lutheranism and Calvinism sought more openly to regulate these developments and to shape a new ethics accordingly—with the result that, as MacIntyre puts it,

> Luther, like Calvin, bifurcated morality; there are on the one hand absolutely unquestionable commandments which are, so far as human reason and desires are concerned, arbitrary and contextless; and on the other hand, there are self-justifying rules of the political and economic order.[6]

There were, of course, important differences between Lutheranism and Calvinism which MacIntyre fails to note, but which for Weber were crucial for developing the ethical notion of the inner-worldly vocation so essential for capitalism and the Puritan influence on politics and science.[7] Calvinism was in this respect 'more advanced'—though, of course, progress in any naive evaluative sense is not in question. In general, the autonomy of ethics, or for that matter, moralization itself, is not to be treated as a progressive trend in that simple sense—unless one wishes foolishly to judge progress towards modernity as a value in itself.

Lutheranism, however, was more 'progressive' in another way, in that it had a greater impact on the philosophical discourse of Ethics as most of the great German thinkers—above all Kant—derived from a Lutheran background. It was Kant who propounded the autonomy of philosophical Ethics on the basis of the already partly established autonomy of social ethics within Lutheranism. Kantian Ethics is substantively Lutheran ethics rationalized and formalized. This formalization consisted in laying down universal principles which would unambiguously demarcate the moral sphere and separate it from all others; as MacIntyre states, it was a way of addressing the question "what form must a precept have if it is to be recognized as a *moral* precept?"[8] The answer to this was the notion of the categorical imperative as defined in terms of the principle of universalizability.

The social effect of this, and other later philosophical Ethics, was to confirm and justify the ever increasing subjectivity and privatization of practical ethics within a capitalist economy, liberal state, and bourgeois

society. Ethics tended to become something the individual practiced in the privacy of personal relations in his own subjective sphere. British In-tuitionist Ethics went even further in this than German deontology, for according to Moore "by far the most valuable things, which we know or can imagine, are certain states of consciousness which may be roughly described as the pleasures of human intercourse and the enjoyment of beautiful objects"[9]. On this view ethics had ceased to have anything to do with law, politics, or economics. An even more radical step in this respect had already been taken earlier by Kierkegaard who opposed the aesthetic, ethical, and religious attitudes and made the whole of ethical life a matter of commitment or fundamental choice, which meant that it could also be refused in favor of an amoral aesthetic life. As we shall see, a contempo-rary follower of Kierkegaard, the existentialist philosopher Sartre, did in fact make such a refusal.

II

Out of the autonomy of ethics arose the possibility of rejecting ethics alto-gether. This kind of paradoxical reversal might almost come to seem the outcome of a peculiar cunning of unreason. But before we need to resort to any such trans-historical supposition, let us simply note that a fully auton-omous ethic is conceptually, socially, and psychologically unstable. This feature is already apparent in Kantianism itself, for this formalized Ethic can be sustained only as long as it is "parasitic upon some already existing morality, within which it allows us to sift. . ."[10] those norms which stand up to its rational demands. When the morality upon which it is based—Lutheran *Sittlichkeit* in the case of Germany—weakens and becomes merely conventional, the Kantian conception of *Pflicht* can become a pre-scription for conformism if not much worse—I was only doing my *Pflicht*, said Eichmann. MacIntyre notes that "the consequences of his doctrines, in German history at least, suggest that the attempt to find a moral stand-point completely independent of the social order may be a quest for an illusion, a quest that renders one a mere conformist servant of the social order. . ."[11]

Thus we strike on the peculiar paradox: excessive moralization can produce its own opposite, which might be called de-moralization. The process of moralization, if pushed to the degree where it leads to the total autonomy of ethics, gradually topples over into the intellectual possibility and eventually the social actuality of an abandonment of ethics alto-gether. This paradox of moralization could be compared to the 'dialectic of Enlightenment' as expounded by Adorno and Horkheimer, especially

in the chapter entitled 'Juliette or Enlightenment and Morality'.[12] But there are crucial differences, which must be stressed, between their treatment and the one offered here. According to the dialectic of Enlightenment, the negative counterpart of Kant within bourgeois society is de Sade, one of the "black writers of the bourgeoisie. . . . (who) have not postulated that formalistic reason is more closely allied to morality than to immorality".[13] According to Adorno and Horkheimer, de Sade is the logical negative outcome of the Enlightenment, exemplified in its positive spirit by Kant; and from de Sade there is a direct line of continuity to the seemingly Sadean doctrines of Nietzsche and the sadistic practices of the Nazis.[14] Morality formalized and rationalized becomes immorality. This is not the conclusion propounded here in this account of the dialectics of morality, which only supposes that de-moralization, not immorality, ensues on the separation and formalization of ethics as an autonomous sphere. De-moralization, as we shall further explain in what follows, is merely a certain kind of indifference to morality, one that is equally indifferent to immorality as well and is no longer fascinated by it as something forbidden in the spirit of de Sade—who is not simply to be identified with Nietzsche either. Nietzsche has his own version of de-moralization as moral Nihilism, although he calls it immorality and frequently confuses it with sheer immorality as when he advocates class brutality in the manner of a legislator de Sade.

It is Nietzsche, however, who offers most insight into de-moralization as an historical process, one that even an Aristotelian like MacIntyre has recently come to acknowledge by implication when he refers to "the key episodes in social history which transformed, fragmented and . . . largely displaced morality. . . ."[15] As Nietzsche also shows, such a destruction of morality can occur as a theoretical or practical outcome. Amongst intellectuals it can take a theoretical form which need not be reflected in actual practices of everyday life. During this century there have been many intellectual movements that favored abandonment or relegation of morality in favor of other preferred values and aims, those of politics, art or personal fulfillment. Even such a moral writer as Thomas Mann at one time declared that the most important issues of our century present themselves in political terms. And no lesser an intellectual than the moral philosopher Sartre also followed this dictum in abandoning his earlier fervent adherence to an Existentialist Ethics and the morality he had developed on this basis before and during the war:

> There was a moralising period before the war, with demystification of certain moral concepts and ideas. But not morality itself. At that period I always wanted to show . . . that no matter what we do, we do it within some moral frame of reference . . . Anyway the idea was a kind of moralism. And from the time I became more involved, politically, this moralism began to yield to real-

ism, if you like. In other words, it began to give way to the political realism of certain Communists or of a great number of Communists: all right, you do it because it works, and you check it out, you evaluate it according to its efficiency rather than some vague notions having to do with morality...I...finally arrived at pure realism: what's real is true, and what's true is real. And when I reached that point, what it meant was that I had blocked out all ideas of morality...[16]

It is true that after 1968 Sartre sought to recover something of a moral perspective by identifying morality with Maoist politics, and he still held out hopes for writing his long unfinished Ethics, but nothing came of either undertaking.[17]

Sartre's case tells us something of how a philosopher might respond to the contemporary crisis of morality, but to see how ordinary people react we must look to the writings of contemporary sociologists. The sociologist of religion in everyday life, Bryan Wilson, tells us that modern society no longer depends on morality or on any norms drawn from shared values for its functioning. He maintains that "there has been a profound change not only in morals, but from morality to a different basis of social cohesion..."[18] He argues that "public life has become less dependent on moral regulation and increasingly controlled by external rules of a technical and legal kind..."[19] He examines what he also calls the "process of de-moralisation" as this affects work, interpersonal relations, law, and social life in general. Work became de-moralized when "work tasks became increasingly dominated by complex techniques so the equipment itself came to impose its own rhythms, and its own imperatives, on those who use it..."; as a result, under conditions of industrial production and capitalist market competition, eventually "work was no longer conceived as duty, but was seen as rational necessity and discussed in terms of '*interests*'."[20] And analogously a demoralization of the public arena takes place when "what has to be done in the public realm will increasingly be done by routine procedures, in accordance with legal requirements and, in ever greater probability, by technological devices"; consequently, this "liberates men from the need to consider their behaviour, from the obligation, indeed, 'to be considerate'...we no longer need to be nearly so polite, nearly so moral, in our inter-personal relations."[21] The law itself "changes to meet the more technical demands of rational order, abandoning traditional regulations which, from the economic and rational perspective, have lost social relevance..."[22] In short, the social system can function quite efficiently without morality, so people adapt and act accordingly—though Wilson warns that "men whose emotions are uneducated and undisciplined may yet wreak devastation with our culture and civilization."[23] It has not come to that partly because, as he puts it elsewhere,

"morality is not yet dead as a concept, and rationality has not yet gone so far as the pressures for calculable order may yet induce it to go."[24]

The concept of 'de-moralization', which Wilson also utilizes, will be of fundamental importance for our investigation and it ought to be treated as one of the key concepts of moral philosophy. It is quite different from concepts such as 'immoral' and 'amoral' entertained in traditional thought. The latter serve as judgments on action or character within the moral discourse of an accepted moral order. For, clearly, to declare something immoral is to say that it transgresses moral values or norms, and to declare it amoral is to say that it falls outside them. By contrast, to say that something becomes de-moralized is to presuppose that though it might once have been, it can no longer be so judged, for the moral values and norms have themselves become meaningless or irrelevant or somehow defunct. De-moralization refers to an historical and social reduction of moral values and norms, and this occurs—as we have argued elsewhere— in the general process of reduction of meaning and value that constitutes modern Nihilism.[25] This is a process of de-constitution that is the complementary opposite of the original historical process of moralization whereby morality first arose.

The starting point for any account of moralization and de-moralization is clearly Nietzsche's twin conception of 'the genealogy of morals' and 'devaluation' leading to moral Nihilism. To say that moral philosophy today must start with Nietzsche is not, of course, to agree with his account either of the origin or the end of morality; nor is one inclined to do so, as Nietzsche recklessly tried to further the very process of de-moralization that he was diagnosing, ultimately with disastrous political consequences. However, given the choice between Nietzsche or Aristotle offered by MacIntyre, we must choose Nietzsche for he was the first to see morality itself as the problem. Aristotle's philosophy cannot be a basis for understanding the problem of morality since, as we shall show, his Ethics involves a manner of moralizing—one characteristic of the Polis—that is quite different from those subsequently developed in our religious traditions. To understand this difference we must first consider further the historical process of moralization which alone can tell us what is meant by the word 'moral'. Such an investigation is the subject matter of an historically informed science of morality, the sociological study of past moral stages which Nietzsche advocated but which is as yet undeveloped. As we shall argue, developing such a science of morality ought to be one of the prime tasks of contemporary Ethics.

III

A short paper is hardly the place to attempt a history of moralization and de-moralization, since numerous volumes would not suffice for the undertaking. However, it is possible to indicate even here why such a history is necessary. One need only consider, for example, the enormous moral distance separating the Ten Commandments from Kant's Moral Law. That distance can only be spanned historically. In the Ten Commandments there is no conception of a norm that is specifically moral, and thus distinct from religious adjuration and injunction, not to speak of theological dogma, or even from customary practices, legal principles or maxims of prudent behaviour; there is no distinction between intention and action or between desire and performance; and there is no separation between desired objects and people (coveting one's neighbor's wife is no different from coveting his ox or ass—a far cry from treating people as ends in themselves). None of these moral concepts and differentiations figure in the Ten Commandments or for that matter in the older strata of the Pentateuch as a whole. They are the products of thousands of years of moral elaboration and definition which is the history of moralization, one which indeed begins with the Ten Commandments but is not even latent there. And something similar might be said of the works of Homer, the bible of the Greeks: there is no way of distinguishing within this heroic ethos between moral virtues or excellences and any other prized qualities of character, mind or body.

Somewhere beyond Homer and the Pentateuch moralization in earnest begins to develop from two major sources: the formulation of an abstract concept of God within the higher religions and the new rational modes of thought within philosophy. Notions of good and evil and concepts of duty begin to be differentiated and a notion of moral conscience begins to form within Zoroastrian dualism, within the conception of a higher justice promulgated by the prophets of Israel starting with Amos, within the Hindu Bhagavadgita, and eventually in the Buddha's eightfold path. At this stage the undifferentiated matrix of morality is soteriology, the quest for personal salvation, so there is as yet no distinction between morality and religion. The position of morality is not all that different in its other source, in philosophy, where the aim is not so much salvation as wisdom (Sophia) or blessedness (Eudaimonia) and the admired figure is not the prophet or saint, but the thinker or sage. In China the key moralizing sages were Lao-Tzu and Kung-Tzu, and in Greece they were the philosophers culminating in the decisive moral exemplar, the martyred Socrates, from whom much of subsequent moral philosophy derived. In the West the moralizing confluence of religion and philosophy is Christianity,

where in the later Church Fathers Socrates and the Stoics join hands with Christ and the Apostles and the Gospels are unified with the works of the philosophers. In this form religious morality instituted by the Church becomes the guiding determinant of the character and everyday life of all believers. This was a crucial practical step in the history of moralization but it was not yet ethics in the sense of post-Reformation, not to say post-Enlightenment, Europe.

The ancient world did not understand or define morality in a modern sense, as is obvious when one examines the most systematic attempt to deal with moral issues that it produced, Aristotle's Ethics. Ethics in Aristotle is not the same as our morality; it speaks, as it were, a different moral language, its concepts and distinctions are not ones that we employ. Aristotle does not make distinctions where we make them; thus law and morality are not separated, it being unthinkable that a man should reject all the laws of his city on the ground that they do not correspond to his moral conceptions. Where Aristotle does draw distinctions, they are quite alien to ours; thus his distinction between politics and ethics is not the same as our opposition of politics and morality; political man and ethical man are related in something of the way the ordinary believer is related to the Saint in Christian tradition, rather than opposed as the citizen is to the bourgeois in Enlightenment thought. And finally, Aristotle makes distinctions where we would not; thus he would separate the lower qualities pertaining to the stupid man, the slave, the woman, the barbarian or, for that matter, the poor man from the real excellence of the citizen philosopher, whereas obviously no post-Christian morality would regard these as grounds for sharp moral separation. All this is as much as to say that the moralization possible in the classical context of the Polis is of a different kind from that possible in a secularized nation-state. The latter situation marks out and separates the moral dimensions of life far more precisely and narrowly than the former would have believed possible or desirable. The modern moral individualist would have been considered an 'idiot' in the literal sense by the Greeks.

What distances modern notions and practices of morality from those of Aristotle is precisely the intervening history of moralization. In writing that history one would need to pay particular attention to Stoicism and the doctrine of natural law as opposed to customary law, to medieval casuistry and canon law, and finally to the Reformation emphasis on will and inner choice, or the Protestant ethic which gives rise to the interiorization of conscience and the historical construction of a private self, without which our modern moral language is meaningless. That done, we reach only the threshold of modern moralization which is inseparable from the secularization of morality and its separation from religion, law, politics,

economics and aesthetics. The differentiation of all these spheres of human action, as we have previously shown, is largely the work of the Reformation and Enlightenment and proceeds step by step with the rise of the modern state, capitalism, and the growth of science. As an intellectual process it begins with the Reformation theologians and continues with the scientist-philosophers Descartes, Hobbes, Spinoza, and Leibniz and culminates in the new definitions of morality in Rosseau, Kant, and Hegel from whom most of our contemporary philosophical ideas of what constitutes morality derive.

One must beware, however, of thinking of this historical process of moralization as something carried out by theologians or philosophers alone, as MacIntyre is in danger of doing. The philosophers, who tended to be morally conservative, were only anticipating and registering intellectually changes taking place in the depths of society, in ordinary ideas, practices and institutions. Thus the development of an aristocratic ethos—emerging from a generalized code of honor in the early middle ages and reaching its culmination in a code of gentility in the nineteenth century—proceeds through a number of stages: through the gradual refinement and definition of polite manners and gentlemanly bearing that Norbert Elias documents in his works, especially in *The Court Society*;[26] through the subtle revaluation of the Ancien Regime's aristocratic conjunction of manners and morals—in that initial order of importance— with the gradual superiority of morals over manners being established only in eighteenth-century polite society; and finally, after the Revolution, the merging of aristocratic gentlemanly bearing with bourgeois morals to constitute modern morality. A history of the refinement, restriction, and eventual abolition of duelling, the aristocratic mode of settling infringements of honor between men, would probably uncover some of these stages of moralization. Similarly, one would need to write a history of bourgeois morals, such as indirectly carried out by Lawrence Stone,[27] focusing particularly on the family, marriage and sex—matters with which aristocrats were morally less concerned—to discover parallel stages in the course of moralization which still strongly affect our sense of what it means to be virtuous. The aristocratic concept of virtue—always close to classical military virtue—and the bourgeois concept of virtue—always close to chastity and commercial probity—have very different histories. When these moralities merged during the nineteenth century they gave rise to the unified code for all classes which is too simply thought of as Victorian morality.

The Victorian age, or indeed the whole of the extended nineteenth century from the French Revolution till the First World War, was the age of moralization in earnest. Moral beliefs, ideas, concepts, and categories

assumed a prominence and priority in men's minds which they have never enjoyed before. It was during this century that morality was endowed with some of the force that religion had previously exerted. 'God is dead, long live Morality' was the unacknowledged cry of the time. The great literature of the period is a testament to the hold of morality on the minds of all but a few rebels. There was the German *Bildungsroman*, the novel of education as a process of moralization; there were the English novelists of Leavis's Great Tradition, from Jane Austen to Conrad and James, who transformed most life issues into moral matters; and the other European literatures of the period were no different in these respects. Perhaps the most exemplary of all these writers was Tolstoy; in him most of the moralizing tendencies of the age, from Kantian philosophy and educational reformism to political anarchism, meet and in his work religion, politics, art and most values are interpreted in moral terms. One can regard Tolstoy as one of the culminating points in the process of moralization in history which began with the sages—Christ, Socrates, Confucius, and the Buddha—whom he so admired.

But in the very midst of the unspoken declaration, 'God is dead, long live Morality' that other great Russian, Dostoievsky, said "If God is dead, all is permitted". Moral Nihilism was at hand as the Age of Morality was silently and invisibly being undermined by processes of demoralization. The economic and political forces of the age, above all Capitalism and Nationalism, were working against morality and insidiously eating away at the fiber of the moral individualism that seemed the last word in civilized progress. On deeper analysis one might even see a complementary relation between the overt and visible reign of morality as progress and the surreptitious, invisible erosion of it by demoralization as Nihilism. Thus, as Wilson argues, the early capitalist emphasis on the worker's moral character was implicitly negated by subjecting him to impersonal market mechanisms. The latter, as Marx showed, was the real demoralized truth of capitalism, the former only the hypocritical ideology of bourgeois morality. Nationalism carried a similar ambivalence within itself; on the surface it meant fraternity with its shared adherence to the civic virtues of the nation; but its real meaning was the implicit demand that the individual sacrifice himself on the national alter—as the First World War openly revealed to the soldiers at the front and as the totalitarian regimes that followed brought home to the people as a whole.

These dialectics of moralism and demoralization of the age prior to our own are exemplified by its greatest minds, above all Marx, Darwin, Nietzsche, and Freud. It is clear that as individuals these thinkers were the products of their time and imbibed all the moralizing tendencies of the Victorian age; but it has also since become apparent that Marxism,

Darwinism, Nietzscheanism, and Freudianism have become potent intellectual forces of demoralization in our time. We have seen the effect of Marxism on a no less morally inclined mind than Sartre, not to speak of the demoralizing consequences of totalitarian communism. Darwinism quickly aligned itself with racism to become one of the main sources of Nazism. Nietzscheanism also contributed to this, as well as to numerous other political and aesthetic movements of the twentieth century that shunned morality. The demoralizing effects of Freudianism are more subtle but equally apparent, both in the conformist orthodoxies of adjustment promoted by the main post-Freudian schools in Anglo-Saxon countries and in such radical off-shoots as Lacanianism in France, which seeks to deconstruct the Ego and dissolve guilt and conscience. The question of whether the original founders of these movements intended these demoralizing consequences cannot be answered without the detailed textual studies of the various works of Marx, Darwin, Nietzsche, and Freud that would elicit their highly involved but ambivalent attitudes to morality.

Political ideologies, aestheticizing movements, the practices of psychoanalysis and other psychologies are, however, far from being the most important demoralizing agents in our time, particularly if we consider the period after the Second World War. There is no need to spell out the demoralizing effects of totalitarian regimes and the dehumanizing bestiality of the concentration camps, which have not failed to affect society as a whole. Not as obvious, nor as devastating, are the demoralizing tendencies of democratic, liberal societies under capitalism and the affluent lifestyle. Just as the impersonal mechanisms of industrial production and the market place are denuding all work relations of any moral significance, so, too, in a parallel way, the bureaucratic regulations of all dimensions of life are reducing moral relations in all other spheres.

In this respect Law and the State play a highly ambiguous role. Increasingly, all relations and all forms of social action come to be contractually governed and policed by precise legal stipulations and other regulations enforced by the State. It is fortunate that in most democratic societies these are still based on humanitarian and equitable norms deriving largely from enlightenment values. As a result, the sheer immoralities and hypocrisies of the Victorian age and earlier periods become illegal and are largely banished. Thus, open brutality, sheer exploitation, personal abuse, destitution, graft and extortion, naked lies and hatreds—all such heinous practices, which in effect were suffered and implicitly condoned in earlier, more moral ages, have been gradually controlled by our Welfare State and its extensive legal and police systems. But as a result the individual is called upon less and less to concern himself with such things or to exercise any moral initiative or, for that matter, any moral conscience or feeling; all

that is required is conformity to the law and, it is hoped, morality will take care of itself. But where conformism out of habit, self-interest, or a fear of discovery and punishment supplants all inner inhibitions, the ground is prepared for every kind of legalized immorality. For the regime of the State has only to change and the law to be altered, and the very same law-abiding people become capable of perpetrating any moral crime in the name of obedience and duty, as the Nazi regime in Germany proved. By treating the law as an autonomous realm Legal Positivism, the dominant legal philosophy in our time, intellectually prepared the ground for acquiescence within the German legal profession.[28] As other writers have repeatedly pointed out, such contemporary moral philosophies as Intuitionism and Emotivism have also had a demoralizing effect, though the consequences in these cases were probably less severe.[29]

The moral philosophy that offers the sharpest insight into the present predicament of demoralization is Nietzsche's—a philosophy that deliberately and self-consciously seeks to destroy morality. And it is paradoxical that only by following through to the end Nietzsche's destructive thrust against morality, and, as it were, coming out on the other side can one see how a start might be made towards a new remoralization—a revaluation of morality adequate for our time. Nietzsche traces out historically the main forms of demoralization, the moral Nihilism which he believed was inevitable in Western Civilization and which has in fact ensued more or less as he predicted. Morality, or slave-morality as he diagnosed it, had to devalue itself, and along with it such moral concepts drawn largely from Christianity and philosophy as virtue, character, the identity of knowledge, virtue and happiness, disinterestedness, the categorical imperative, formalistic universalization, authenticity, bad conscience—what is for Nietzsche the moral-philosophical baggage of the tradition. Instead of morality Nietzsche proposes nobility, or what he calls master-morality, as the dominant value of a future ruling caste. This approach is no solution, however. Nobility as he defines it is largely a wish-fulfillment historicist construct, made up of values and qualities drawn from a variety of discrepant cultural ages; it expresses Nietzsche's own historical yearnings for greatness, and can be highly immoral when applied in practice, as recent history has shown. Nietzsche is least convincing in his positive proposals.

IV

This is made obvious in the writings of Max Weber, a critic of Nietzsche though strongly influenced by him. Weber has not as yet received any recognition as a moral philosopher, yet his ideas furnish a better positive

starting point for a contemporary Ethic and a current effort at remoralization—the two endeavors are essentially one—than those of anyone else. Weber's definition of the ethic of responsibility (*Verantwortungsethik*) and the ethic of conscience (*Gesinnungsethik*) promote a re-orientation of ethical thought provided they are not taken as Weber is assumed to have done, purely as formal principles in the Kantian sense.[30] Nor must they be seen as contradictory principles in the way that Weber himself initially presents them, though he does go on to insist that they "are not absolute contrasts but rather supplements, which only in unison constitute a genuine man"[31] Taken in unison, responsibility and conscience comprise the complementary outer and inner authorizing facets of morality. Conscience is the inner voice of authority, expressing the moral demand that one makes on oneself. Responsibility is the outer voice of authority, reminding one of the commitment one has made to others, those to whom one is answerable for one's conduct. Responsibility and conscience can contradict each other and be in conflict, and this is the basis for Weber's initial opposition of the two ethics, but in a genuine man they are in unison, with the result that conscience seconds the responsibilities one has undertaken and one is only responsible for that which conscience permits.

To be morally binding responsibilities must be freely undertaken by an autonomous moral agent; no imposed responsibilities can be given moral force. One is only answerable to oneself or to others for that to which one has knowingly engaged oneself. Where such an engagement of responsibility is assumed through a promise, or some other clearly expressed undertaking about which one has deliberated, the responsibility in question assumes the status of a duty. However, responsibility can also be assumed through a gradual process of coming to care for someone or something or some cause where the engagement is largely implicit and lacks deliberate choice; in such cases responsibility takes on the status of a commitment or obligation. Responsibility can be established through emotional attachments of love and caring or through the activities of decision and choice, that is, either with the heart or with the head. Indeed, as Yeats maintained, responsibilities begin in dreams. But no matter from where they derive, they must be capable of being rationally justified or at least defended against hostile questioning and moral criticism.

The moral agent is that person capable of being held responsible, one who is answerable for his actions to himself and to others. We judge such an agent according to how much responsibility he can bear. What is excess responsibility for one person might not be nearly enough for another and better person. Those who take on themselves excess responsibility and are consequently unable to live up to it are deemed 'do gooders', who are

usually judged adversely. Those who do not assume enough responsibility are the slackers, the weak characters.

Throughout a lifetime a person's moral character will change as he assumes new responsibilities or unburdens himself of old ones, becoming better or worse in the process. Hence, moral character is not a fixed or stamped identity, governed by determinate virtues or rigid qualities of character. We judge people according to what they are able and willing to undertake in shaping themselves and their lives in their own way, not according to any pre-given traditional standards of what is the good or virtuous man or woman. For as Nietzsche puts it, "a virtuous man is a lower species because he is not a 'person', but acquires his value by conforming to a pattern of man that is fixed once and for all."[32]

Having thus briefly outlined the basic principles of an ethics of responsibility and conscience we must now consider what substantive values can serve as the content for such an ethic in this day and age. What ought people to be responsible for in our time? We must seek such responsibilities in the real concrete conditions of life at this historically determinate moment of the present and not in abstract considerations. We shall find our responsibilities if we search for the real problems, the crises that human beings are experiencing in the present predicament. The definition of such real problems is a task for rational argumentation, utilizing all the intellectual resources of science, the emotional ones of art and all our knowledge of history. Here it can only be provisionally asserted that three such problems are now widely recognized: the problematic relation of Man and Nature, due to the ecological crisis; the problematic nature of humankind itself, due to the possibility of nuclear annihilation; and, finally, the problematic status of the individual, itself partly due to the prevalent demoralization. The answer to each of these basic problems calls for a different kind of responsibility and suggests the moral content of a different basic ethics.

The problem of Man's relation to Nature, due to the depredation of the earth's ecosystem as a result of the population explosion, pollution, and other such well-known causes, must inevitably lead to Man assuming responsibility for Nature to avert environmental collapse. Such a responsibility is in fact being assumed as evidenced by the new ecological consciousness and its accompanying conservationist ethic. This new consciousness is at once a new scientific attitude to Nature and an ethical one—science and ethics are here indissolubly united. The new "alliance with Nature" that Prigogine outlines as a scientific project—one that the Systems Theorists and ecologists had already begun to practice from their respective scientific approaches—is not to be separated from an ethic of caring for Nature.[33] Living in accordance with Nature has, thereby, as-

sumed a new meaning, but one that harks back to the scientific and ethical theories of the Stoics and Epicureans—those of Lucretius, for example, whom Prigogine invokes, or Seneca.[34] However, the major shortcoming in this respect is that it is doubtful that a modern conception of responsibility for Nature can provide very much guidance for the individual in living his life. It seems to issue in some kind of collective, group ethics, applicable to nations, states, societies, and business enterprises, rather than directly to individuals, who, of course, must assume the duty of seeing that the larger entities exercise their responsibility for Nature, but who cannot do very much themselves as individuals.[35]

The other major responsibility placed on individuals collectively is that of ensuring the survival of humanity, given the very real possibility of nuclear extermination, for which there is now strong scientific evidence. Once again there is actually a current move towards a new ethic based on this overwhelming problem in the development of what is called a planetary consciousness, which takes a number of different forms. A planetary consciousness is in the first place an awareness that all people on earth are now interrelated and that the fate of one major group is sooner or later going to affect that of all others. In the second place it means that the earth has to be shared, hence that groups must cooperate even while they are locked in irreconcilable antagonisms. Some version or other of 'peaceful coexistence' has become ethically mandatory on pain of extinction. This gives rise to an ethic of political responsibility which is substantively much more robust in content than the formalistic one Weber initially proposed.

However, like the ethic of responsibility for Nature, an ethic of political responsibility does not provide guidelines for an individual life other than requiring social and political commitments. 'How shall I live' and 'what shall I make of myself' remain for each of us the basic ethical questions to which we are usually far from being able to provide satisfactory answers. To answer them at all most people tend to rely on their traditions on one level or another, either blindly as with the religious fundamentalists or intelligently as with such conservative moral philosophers as MacIntyre. There is much to be said for the latter, but ultimately they must be found wanting since the revivals they propose, neo-classical or neo-gothic, are too remote from contemporary conditions to be sufficiently meaningful. We must search our own predicament for the basis of an ethic of individual self-responsibility. We might find it precisely in the problem of the individual himself, whose continued existence as an autonomous being has become so difficult in the midst of the standardization and equalization of mass society and the affluent lifestyle. The very problem of demoralization which we have here examined is also the prob-

lem of the continued existence of the individual as an autonomous being. And this very fact provides us with part of the answer in our quest for an ethic of self-responsibility, for being responsible for oneself means individualizing oneself, refusing to surrender to conformism and mass pressure. I have expounded elsewhere how the individual might begin to do this through the development of a recollective self-consciousness which is the modern analogue to the Classical "know thyself".[36]

The three modes of responsibility—responsibility for Nature, responsibility for humankind and responsibility for oneself—together constitute the basis for a comprehensive ethic of responsibility which is at the same time an ethics of conscience. The constitution of such a compound ethic is the task for a new kind of Ethics, one capable of providing substantive answers for the problems of humanity which will be valid in theory and useful in practice.

V

How might Ethics as an academic philosophical discipline even attempt this task? How must it transform itself to become equal to carrying it out? What is being offered here in a brief afterword are only a few general suggestions which would need to be intellectually worked out in detail and tested in the institutional context of the teaching of Ethics. The sociology of Ethics, if such a sub-discipline were to be developed, might provide some guidance to the latter problem.

As for the main problem, one suggestion to be explored further is that a new attempt be made to bring together Ethics and science. This can be approached from two directions: from that of the moral sciences and that of the sciences of morality. The latter direction simply means that Ethics, in line with its coevals Politics and Economics, should develop scientific studies of its own subject matter. There should be numerous objective investigations of the phenomena of moral life both of the present and the past, such as we attempted above in presenting a sketch of the history of moralization and demoralization. Some branches of such sciences of morality already exist but they are scattered through the other sciences, above all in anthropology, sociology, and psychology and need to be brought together, concentrated, and given a moral focus.

The other direction, that from the moral sciences, also already exists in the form of numerous scientific specialties which presuppose moral values or principles in directing and shaping their researches. In the way that medicine presupposes the mainly non-moral, quasi-natural value of health, so numerous other practical sciences presuppose more pro-

nouncedly moral values; for example, branches of ecology which aim for a self-sustaining, beneficial environment, peace researches whose obvious intent is to address the causes of the evils of violence and conflict, policy sciences pursuing all kinds of social values, and psycho-analysis which seeks to provide deeper self-understanding and thereby promote the dissolution of neuroses. There are many other such morally-based practical sciences, more of which we shall mention presently.

Sciences based on presupposed value assumptions do not, however, merely accept externally imposed value orientations; they also define and justify their values through a kind of hermeneutic circle of value affirmation and confirmation. This is a conceptual process that is rarely noticed or discussed by either philosophers of science or moral philosophers, though it is the key nexus where morality and science come together in the modern world. It is one of the main ways in which moral values can be rationally established and defended in modern thought. Thus, to take a simple example, medicine not only presupposes the value of health as an external given, it also demonstrates the validity of this value by showing the nature, effects and consequences of disease. In the course of doing so medicine also serves to determine what is health through the negative procedure of defining diseases—which is also partly a social and cultural matter outside the ken of medicine as a professional activity. Of course, medicine has no way of judging the value of health as against other values; nor can it convince someone who is indifferent to his health—because of higher commitments or because he is suicidally inclined—that he should value his health. In a similar way to that of medicine and health, and with similar provisos, other more morally based practical sciences also affirm and confirm basic values in a hermeneutic circle of presupposition and justification. Such a science accepts a presupposed value in order to begin its researches, but in the course of developing into a body of knowledge it comes to confirm the value it initially accepted as a given.

To say that Ethics should be based on science means that it should relate itself closely to such value-based sciences and seek to elicit from them the ways in which they presuppose, develop and confirm their value assumptions. Those sciences dealing with the three fundamental problems of responsibility in the contemporary world: responsibility for Nature, responsibility for humankind and responsibility for oneself, will be of particular relevance to Ethics. These are the sciences that presuppose a morality of Nature, a morality of power, and an individual morality. The first category, which concerns natural morality, embraces many ecological and economic sciences, utilized jointly so as to show the effects of human industry on the environment, in the way that such eminent moral scientists as Boulding have done, and also more specific modes of research such

as Environmental Impact Assessment Studies. The second category, which concerns political morality, is also exemplified by the work of Boulding on conflict resolution, but equally by many conventional political sciences such as jurisprudence and international relations, as well as by the sciences of ideology critique. The third category, which concerns moral psychology, contains most of the therapeutic sciences and the psychological and educational sciences of the self-development, maturation, and integration of personality.[37] It is not possible to expound further all these moral sciences, but clearly each has a distinctive contribution to make to Ethics and morality in our time.

The sciences of morality relate very differently to Ethics. These are concerned with establishing in a purely objective spirit the moral 'facts', so to speak, of present and past societies. Obviously, such moral facts cannot be simply read off from social behaviour or from declared moral codes and values; they must be elicited by means of theories of moral sociology, anthropology and psychology. The total morality of any given society, including our own, is a deep and complex socio-cultural structure. Much of it is buried beneath the level of awareness; members of a society are rarely aware of more than just the exposed tip of the moral roots of their lives. They usually cannot identify all the partial remains of past mores and moralities which go to make up that structure. The morality of a society or group or even individual is like an old city that is being destroyed and rebuilt continuously over many generations: the buildings that are still currently in use might belong to any age, and beneath those standing buildings there are foundations which are the ruins of still earlier constructions. So, too, a morality retains old taboos of primitive life which can never be completely rationally explained, such as the prohibition against incest, as well as survivals of the ruins of earlier historical moralities, such as vestiges of feudal codes of honor, and only on top of all that are there the more modern constructions of rational moral thinking. It is the task of the sciences of morality, as it were, archeologically to reconstruct the strata of current moralities. It is these sciences, too, that must also assess the corrosive effects of demoralization so as to ascertain which parts of the moral structure are still functional and which have degenerated to mere historical curiosities, sentimentally preserved like the exhibits in a museum.

Without such sciences of morality it would be impossible to determine how such a complex moral structure might be changed and better adapted to contemporary problems and conditions. A rationally developed ethic of responsibility would be futile if it could not be integrated into the existing moral structures of societies and groups and thereby come to be accepted as an inherent part of their moral life. To work out moral solu-

tions and establish new values as a mere intellectual exercise in Ethics is not necessarily to know how these are to be made efficacious in ones own life or the lives of others. There is always scope for intellectual hypocrisy. Nevertheless, by utilising jointly the sciences of morals and the moral sciences, Ethics might be able both to devise new moral values and to show how these might be made relevant in practical life. However, in all caution and modesty one must stress that even at best what is likely to result is only a "minima moralia" in Adorno's sense rather than something approaching the Magna Moralia of Aristotle.[38]

NOTES

1. See Richard Rorty, *Consequences of Pragmatism, (Essays: 1972–1980)* (Minneapolis: University of Minnesota Press, 1982), 19; also, *Philosophy and the Mirror of Nature* (Princeton: Princeton University Press, 1979) 132–6.

2. *Philosophy and the Mirror of Nature*, op. cit., 369.

3. Alasdair MacIntyre, *A Short History of Ethics* (London: Routledge and Kegan Paul, 1968), 196.

4. Rom Harré *Personal Being* (Oxford: Blackwell, 1983), 88 and 239–40.

5. Max Weber, *From Max Weber*, ed. H. H. Gerth and C. Wright Mills, 'Religious Rejections of the World and their Direction,' (Oxford: Oxford University Press, 1971), 331–33.

6. Alasdair MacIntyre, *A Short History of Ethics*, op. cit., 124.

7. Max Weber, op. cit., 332–36.

8. Alasdair MacIntyre, *A Short History of Ethics*, op. cit., 192.

9. G. E. Moore, *Principia Ethica*, (Cambridge: Cambridge University Press, 1903), 188.

10. Alasdair MacIntyre, *A Short History of Ethics*, op. cit., 197.

11. Ibid., 198.

12. Max Horkheimer and Theodor W. Adorno, *Dialectic of Enlightenment*, trans. John Cumming (London: Allen Lane, 1973), Excursus II.

13. Ibid., 117–18.

14. See ibid, 86.

15. Alasdair MacIntyre, *After Virtue: A Study in Moral Theory*, (London: Duckworth, 1981), 35.

16. J. P. Sartre, *Sartre by Himself*, trans. Richard Leaver (Urizen Books and Outback Press, 1978), 122.

17. For the ins and outs of Sartre's relation to morality see Francis Jeanson, *Sartre and the Problem of Morality*, trans. with an Introduction by Robert V. Stone (Bloomington: Indiana University Press, 1980).

18. Bryan Wilson, "Forum 8134", an unpublished radio broadcast delivered for the Australian Broadcasting Commission. For similar published views of this author see his *Religion in Sociological Perspective* (Oxford: Oxford University Press, 1982), 161–168.

19. Ibid., 6.

20. Ibid., 5.

21. Ibid., 7.

22. Ibid., 10.

23. Ibid., 12.

24. Bryan Wilson, *Religion in Sociological Perspective*, op. cit., 164.

25. See my *In the Beginning was the Deed: Reflections on the Passage of Faust*, (Berkeley: California University Press, 1982), Act II.

26. Norbert Elias, *The Court Society*, trans. E. Jephcott (Oxford: Blackwell, 1983).

27. Lawrence Stone, *The Family, Sex and Marriage in England, 1500–1800* (New York: Harper and Row, 1977).

28. Legal philosophies that turn their back on these problems and revert to an earlier form of thought are of no help. Thus Rawls's famous *Theory of Justice* is considered by Rorty to be "a book which descends straight from Kant, Mill and Sidgwick. The same book could have been written if logical positivism never existed. It is not a triumph of 'analytic' philosophizing. It is simply the best update of liberal social thought which we have". *Consequences of Pragmatism*, op. cit., 216.

29. See in particular Collingwood's remark on Prichard, the Oxford moral philosopher, in *An Autobiography* (Oxford: Oxford University Press, 1976), pp. 48–94. See also MacIntyre on Intuitionism and the Bloomsbury writers in *After Virtue*, a verdict which only seconds the accusations previously levelled by D. H. Lawrence and assented to by J. M. Keynes. See F. R. Leavis, *A Selection From Scrutiny*, Vol. 1 (Cambridge: Cambridge University Press, 1968), 193.

30. For the complexities of Weber's position see *The Methodology of the Social Sciences*, E. A. Shils and H. A. Finch (eds.), (The Free Press, 1949), pp. 16–17.

31. Max Weber, 'Politics as a Vocation,' in *From Max Weber*, op. cit.

32. F. Nietzsche, *Will to Power*, (ed.) W. Kaufmann (New York: Vintage, 1968), sec. 319, 176.

33. See I. Prigogine and I. Stengers, *Order Out of Chaos* (London: Heinemann, 1984), chapter II.

34. "Why ravage the forests? Why ransack the seas? Food is accessible at every step, nature has made it available everywhere, but these people pass it by as though they were blind and roam every land and cross the sea to whet their hunger at great cost when they could allay it for a trifle. . . Why so acquisitive?" Seneca, "The Consolation of Helvia", in *The Stoic Philosophy of Seneca*, ed. M. Hadas (New York: Norton, 1958), 121.

35. See H. & J. Redner, *Anatomy of the World*, (Collins, Melbourne, 1983), chapter 13.

36. See my *In the Beginning was the Deed*, op. cit. 'Prologue'.

37. Harré's book *Personal Being*, op. cit., is of particular relevance in providing a comprehensive synthesis of many of these sciences of moral psychology so as to establish the foundation of an account of the moral self.

38. As a final note which I now append on publication, many years after this paper was completed, I should like to bring to the reader's attention Hans Jonas's, *The Imperative of Responsibility*, (Chicago: The University of Chicago Press, 1984), the only other attempt at an ethic of responsibility known to me. Unfortunately, I was not aware of it when I worked on this paper. The coincidental similarities and differences between Jonas's attempt and my own deserve a paper to themselves. Here it will suffice to point out that my attempt takes off from Weber's ethic of responsibility which does not figure in Jonas's book except for an incidental footnote (p. 235). Hence my treatment tends more to the historical and 'realistic', whereas Jonas's more to the formalistic and metaphysical.

NAME INDEX